P9-BJA-945

EARTHQUAKES AND EXPLORATIONS: LANGUAGE AND PAINTING FROM CUBISM TO CONCRETE POETRY

THEORY / CULTURE

Editors:
Linda Hutcheon, Gary Leonard, Jill Matus,
Janet Paterson, and Paul Perron

STEPHEN SCOBIE

Earthquakes and Explorations: Language and Painting from Cubism to Concrete Poetry

UNIVERSITY OF TORONTO PRESS
Toronto Buffalo London

© University of Toronto Press Incorporated 1997
Toronto Buffalo London
Printed in Canada

ISBN 0-8020-4141-8

Printed on acid-free paper

Canadian Cataloguing in Publication Data

Scobie, Stephen, 1943–
 Earthquakes and explorations : language and painting from cubism to
concrete poetry

 (Theory/culture)
 Includes bibliographical references and index.
 ISBN 0-8020-4141-8

 1. Cubism and literature. 2. Art and literature.
 3. Painting, Modern – 20th century. 4. Concrete poetry –
History and criticism. I. Title. II. Series.

PN53.S36 1997 759.06'32 C97-930955-7

The illustrations in chapter 9 are reproduced with the permission of Ian Hamilton Finlay.
Figures 3–7 are taken from Yves Abrioux, *Ian Hamilton Finlay: A Visual Primer*
(Edinburgh: Reaktion Books 1985).

Lyrics from Bob Dylan's 'Visions of Johanna,' page 22: Copyright © 1966 by Dwarf
Music. All rights reserved. International copyright secured. Reprinted by permission.

This book has been published with the help of a grant from the Humanities and Social
Sciences Federation of Canada, using funds provided by the Social Sciences and
Humanities Research Council of Canada.

University of Toronto Press acknowledges the financial assistance to its publishing
program of the Canada Council for the Arts and the Ontario Arts Council.

AUGUSTANA LIBRARY
UNIVERSITY OF ALBERTA

As the other guests had not yet come Miss Stein took me into the atelier. It often rained in Paris and it was always difficult to go from the little pavilion to the atelier door in evening clothes, but you were not to mind such things as the hosts and most of the guests did not. We went into the atelier which opened with a yale key the only yale key in the quarter at that time, and this was not so much for safety, because in those days the pictures had no value, but because the key was small and could go into a purse instead of being enormous as french keys were. Against the walls were several pieces of large italian renaissance furniture and in the middle of the room was a big renaissance table, on it a lovely inkstand, and at one end of it note-books neatly arranged, the kind of note-books french children use, with pictures of earthquakes and explorations on the outside of them. And on the walls right up to the ceiling were pictures ...

Gertrude Stein, *The Autobiography of Alice B. Toklas*

Contents

PREFACE ix

ACKNOWLEDGMENTS xiii

CHAPTER ONE
The Supplement of Language 3

CHAPTER TWO
'We Are a Man': The Narrativization of Painting 22

CHAPTER THREE
Apollinaire and the Naming of Cubism 35

CHAPTER FOUR
The Gospel According to Kahnweiler 57

CHAPTER FIVE
The Semiotics of Cubism 79

CHAPTER SIX
Metaphor and Metonymy in Cubism and Gertrude Stein 104

CHAPTER SEVEN
The Window Frame: Delaunay and Apollinaire 124

ENTR'ACTE
Signs of the Times 145

viii Contents

CHAPTER EIGHT
Gadji Beri Bimba: Abstraction in Poetry 153

CHAPTER NINE
Models of Order: Ian Hamilton Finlay 169

NOTES 195

WORKS CITED 219

INDEX 229

Preface

I remember when this book first began for me: it was on Pentecost (the feast of the gift of tongues) in 1974, and it was in Paris. Maureen and I were sitting at a café on the Boulevard St Germain. I had just come from an exhibition at the Orangerie of paintings by Juan Gris, which I had gone to because of the connection between Gris and the Scottish poet Ian Hamilton Finlay. Finlay has created several poems in tribute to Gris, and he had often spoken to me of the importance in his early work of the massive study of Gris by Daniel-Henry Kahnweiler, the Cubist painters' most important dealer and theoretician. The earliest premise on which this book was based, then, was that of the connection between Cubism and Concrete Poetry.[1]

Sitting at that café, I began jotting down names on a piece of orange paper – Gris, Finlay, Gertrude Stein, bpNichol – and drawing connections between them – a maze of arrows, broken lines, question marks, overlapping grids. Over the years, as I have tried on several occasions to write this book, much has changed in my own ideas and assumptions about both poetry and painting, but the basic configuration of that first diagram has remained as its ground plan.

As it has now emerged, this book has a double focus. On the one hand, there is a broad theoretical concern with the interaction between painting and poetry, between the visual and the verbal. I want to argue that this relation should not be seen as one of division or opposition, but rather as one of mutual implication and interpenetration. In trying to describe this interaction, I will evoke the notions of the supplement and the frame (parergon), as these ideas have been developed by Jacques Derrida. This relation is grounded, I will argue, in the pervasiveness of language (in its broadest sense), and in the ways in which language

surrounds, imbues, structures, and supplements both verbal and non-verbal images. So the book will concern painting as the supplement of language, language as the supplement of painting.

On the other hand, the book will also contain very specific discussions of writers and artists connected with Cubism (and, in the last two chapters, Concrete Poetry). One reason for this emphasis is, simply, that it is where I began: with Finlay, Gris, Kahnweiler. But another reason follows from the argument that, as W.J.T. Mitchell writes, 'modernism in the visual arts involves a certain resistance to language' (217).[2] It is precisely because the linguistic element is often seen as 'repressed' in modernism that I want to situate my discussion right in the heart of modernism, in the movement that was the most important of the modernist movements in painting: Cubism.

Working from this double focus – both a theoretical discussion and the examination of a specific period – this book does not so much develop a consecutive argument as circle around its topic(s), adopting a different approach, even a different methodology, in each chapter.[3] Thus, for example, chapter 2 is in the mode of a personal, speculative, or even polemical essay, while chapter 3 is a more 'academic' exercise in documentary art history. This book does not, then, have a conventional 'unity' in the sense of a single consecutive line of argument, or even methodological consistency. Its unity lies, rather, in its relation to a central complex of ideas (the interaction between language and painting; the specific case of Cubism; the extension of Cubism into Concrete Poetry), and in the portrait its pattern of choices implies about my own sensibility as a writer, poet, and critic.

A brief overview of the chapters may help to clarify these points.

Chapter 1 is a general theoretical discussion, in which I attempt to describe the ways in which the visual and the verbal supplement and frame each other. It also touches on the ways in which critical theory has been used, or resisted, in art history.

Chapter 2 deals with one rhetorical strategy of art criticism, here defined as 'narrativization.' Specifically, it looks at one of the verbal mannerisms that this mode of criticism seems to involve: a use of the word 'we' that seems to me both illegitimate and, in many cases, sexist.

Chapter 3 is, as mentioned above, a more 'traditional' piece of art-historical writing. It presents a retrospective narrative, with extensive documentation, of a particular moment in art history: the process by which the word 'Cubism' became accepted as the name of the movement. But precisely because it is concerned with *naming*, and because it

is a neat, logical, retrospective narrative, I hope the reader will see buried in this chapter an implicit deconstruction of its own method.

Chapter 4 deals with one of the original cornerstones of my project: Kahnweiler, his book on Gris, and the theory of Cubism advanced in that book. In some ways, Kahnweiler is the most orthodox of Cubist theorists; but he is also dogmatic and rigid to the point where his theory may be seen to distort the paintings themselves – so this chapter is also about the disjunctions between theory and practice.

Chapter 5 deals with Cubism as an art of semiotics, an art of the sign. It also looks at the explicit use of verbal elements (words, letters) in Cubist papiers collés, especially those of Georges Braque. (Thus, it also deals with the vexed question of the relative merits of Braque and Picasso: the reader should be advised from the outset that I am a partisan of Braque.)

Chapters 6 and 7 discuss two writers, Gertrude Stein and Guillaume Apollinaire, who were closely associated with the Cubist movement, and whose works may perhaps (and this is the point at issue) be described as 'Cubist literature.' Chapter 6 deals with Gertrude Stein; it also examines the ways in which literary terms (the rhetorical tropes of metaphor and metonymy) have been applied to painting. So the process is two-way: Stein's writing described in terms of painting, as 'Cubist,' and Cubist painting described in terms of writing, as metaphor and/or metonymy. Chapter 7 looks at another pairing, between the poet Apollinaire and the painter Robert Delaunay, and at the works that both of them, in 1912, entitled 'Windows.' It concludes by examining another collaboration on 'windows,' between the Canadian poet bpNichol and the Canadian painter Barbara Caruso.

At this point, the book moves away from the strict focus on Cubism itself to its 'working out' (in Steiner's term) in Concrete Poetry. A brief 'Entr'acte' attempts to situate the international concrete movement of the 1950s and 1960s within larger cultural tendencies, such as the transition from modernism to postmodernism. The term 'Entr'acte'[4] is intended to signify the supplementary nature of this section, which is and yet is not a regular 'chapter' in the book: it stands both inside and outside the book's main structure. It offers a bridge across the temporal gap between the Cubist period and the later developments of Concrete Poetry; yet it also interrupts the sequence of the argument from Stein to Dada to bpNichol. Stylistically, it ventures farther than the 'regular' chapters do into large-scale generalization and speculation.

Chapters 8 and 9 then correspond to the two major divisions within

Concrete Poetry, that is, sound poetry and visual poetry. Chapter 8 deals with sound poetry, and with its attempted analogy to 'abstract,' non-figurative painting. Since Cubism itself was never abstract (and was, at least in Kahnweiler's version, vehemently opposed to abstraction), the reference point here is more to such movements as Suprematism and Dada. In chapter 9, however, I return to Cubism – and return, indeed, to the starting point of the whole book: to visual poetry, to the 'rhymes' of Juan Gris, and to the work of Ian Hamilton Finlay.

Here, in fact, is the other key to the 'unity' of this book: namely, that *the whole book is heading for Finlay*. So if someone were to ask why I make some of my apparently idiosyncratic choices – why Cubism rather than Surrealism? why Braque and Gris rather than Picasso? why Kahnweiler rather than Maurice Raynal? why Stein rather than Joyce? why Apollinaire rather than Reverdy or Cendrars? why Concrete Poetry rather than Wallace Stevens or Charles Olson? – the answers in every case are the same: *these are the routes that lead to Finlay*. That's why chapter 9 caps the book; every theme I have treated all the way through (including 'the supplement') is summed up in Finlay's 1963 letter to Garnier, quoted in full in chapter 9.

In fact, I suppose, the 'beginning' of this book goes back even further than 1974. It goes back as far as 25 August 1970, when Ian Hamilton Finlay wrote me this letter:

I'm delighted you liked the Kahnweiler book (as I knew you would, which is a compliment to you). As a matter of fact, I can't honestly say when I read it, because you know I read a lot of books on Cubism when I was about fourteen, and the whole thing is surrounded by a romantic glow (the way I daresay poetry is, for some people) and sits as squarely in my heart, as fishingboats do. I do know that I *re*-read the Kahnweiler book carefully when we were in Easter Ross, about four years ago ... I agree with you, Kahnweiler's book is crying out for a concluding chapter on concrete poetry – one could almost write it *for him*, and that, by the way, would be a thing you could do: write the unfinished chapter on concrete poetry, by Kahnweiler – what a splendid idea. I grow more enthusiastic about that, every second.

Many years later, I am, finally, trying to respond to that suggestion.

Acknowledgments

It seems conventional for academic acknowledgments to leave until last the long-suffering wife or husband 'without whose support ...,' etc. I don't want to leave Maureen until last; after all, she was with me at the beginning, at the café table in Paris described in the preface; or even earlier, at Stonypath in 1967; and in how many museums and galleries since! As always, as everything, this book is for her.

Many friends and colleagues have helped me, over the years, in discussions of painting and poetry. I am always especially grateful to Barbara Caruso for our incisive but friendly arguments; she may not share the conclusions of this book, but she has certainly helped to form them. Doug Barbour has also accompanied me to many a museum, and has sometimes seen colours where I saw none; and most of what I know about sound poetry was evolved in practice during our joint performances. Richard Kostelanetz opened many doors for me, not least the one on Houston Street. Ian Hamilton Finlay has been unfailingly generous and friendly over the many, many years he has spent waiting for me to write this book. And in everything that I have to say about Concrete Poetry, the presence and the memory of bpNichol remain as a blessing.

This book has been a long time coming, and its writing has spanned several periods of sabbatical leave; so thanks are due to the University of Alberta, to the University of Victoria, and to the Social Sciences and Humanities Research Council of Canada for support at these times. Computer assistance from the University of Victoria has also been essential to the book's completion.

I am particularly grateful to Lynn Zelevansky, of the Museum of Modern Art in New York, who made available to me advance proof copies of *Picasso and Braque: A Symposium*.

I am deeply indebted to Linda Hutcheon for her enthusiastic and precise editing, and also to Joan Bulger for her continuing support through periods of difficulty in the publication process. I also acknowledge the contributions (sometimes in negative form) of the anonymous readers of the manuscript.

Some sections of this book have previously appeared in print, though all of them have been revised for their present context. Chapter 3 appeared in *The Canadian Review of Comparative Literature*; chapter 6 in *Gertrude Stein and the Making of Literature* (ed. Shirley Neuman and Ira B. Nadel); Entr'acte in *Cencrastus*; chapter 8 in *Canadian Literature*; and chapter 9 in *Wood Notes Wild: Essays on the Poetry and Art of Ian Hamilton Finlay* (ed. Alec Finlay). Shorter passages have also appeared in Richard Kostelanetz's two influential anthologies, *Visual Literature Criticism* and *Aural Literature Criticism*; in *Collaborations* (Cambridge Poetry Festival, 1977); in *Chapman*; and in my own *Signature Event Cantext*.

Finally, this book is dedicated to certain rooms in the museums of Paris, as they were before the opening of the Pompidou Centre and the Musée d'Orsay: to the overcrowded splendour of the old Jeu de Paume, where Cézanne first taught me to see; and to the vast gloomy basements of the old Musée d'Art Moderne, where I applied that lesson, and saw Georges Braque.

EARTHQUAKES AND EXPLORATIONS

CHAPTER ONE

The Supplement of Language

This book is about how language deals with the non-verbal; more specifically, it is about linguistic responses to painting. It is about how language supplements painting, frames it, conditions it, invests it, invades it, resists it, exploits it, distorts it, caresses it. It is about how language cannot leave painting alone.

It might be argued, then, that this book is not about painting at all, but rather about what is said *about* painting: the languages – critical, social, aesthetic, discursive – that surround painting. To some extent, this is a fair comment (the book will certainly deal more with art criticism than with art itself), except that my argument is directed, precisely, against the possibility of making any such distinction. Language does not simply 'surround' painting: insofar as a visual image is 'a painting,' language is inside it already. There are many ways of articulating this relationship: mutual dependence, cohabitation, necessary implication. The terms that I prefer are 'supplement' and 'frame,' in the senses proposed by Jacques Derrida.[1] Language and painting frame each other; they are each other's supplements.

Because a painting has a unique physical existence (more so than a poem or a piece of music), it is tempting to think that it survives all that is said about it: when all the talk falls silent, the painting will still be there, on the wall. But the painting on the wall is not really outside discourse or separate from language. Language constitutes it, as part of its structure. A painting is a visual image set apart from the general, indiscriminate totality of visual experience: that is, it is always already bounded, limited, *framed*. Without the frame it would not be 'an image.' But the frame itself is coded. It declares that someone (the artist) has shaped this image *as an image for* someone else (the viewer). The frame

separates the image from the world, but it also sets the image within the world: it provides a social location. And the social world is created and structured by language. A painting must be seen, and it can only be seen by a subject: a subject who is always already constructed by language within a social context. Thus, there is no pre-linguistic image; painting always exists within language.

Already, however, my own discussion is slipping across several different senses of the word 'language.' There are specific languages – English, French – and there is the sum of these languages, verbal language generally. Then there are non-verbal sign systems that may be described, metaphorically, as languages: 'the language of flowers,' 'body-language,' or, perhaps, 'the language of' music or painting. And then there is capital-L Language: a philosophical construct that frames, enables, and conditions all instances of language(s). At this level, Language may be defined simply as the systematic perception of difference. (Even the word 'systematic' may be redundant in that definition: in order for any two things to be perceived as different from each other, they must already be perceived in a system.)

All these further definitions of language are, to some extent, metaphors: extrapolations of the model of verbal language to higher degrees of abstraction. In some ways, it is possible to make clear distinctions between the different levels: the presence or absence of *words*, for instance. But in other ways, the force of the metaphor is that it does run all through the various levels: language(s) and Language are not discontinuous. When one talks about a 'non-verbal language,' the very use of the word 'language' ensures that the ghost of verbal language will continue to haunt every instance of the usage. This is why I choose to describe that very basic level, the perception of difference, as Language rather than, say, 'consciousness.' I am taking the Saussurean dictum, that in language there are no positive terms, only differential relations, and extending it, metaphorically, so that it becomes not just a feature of language but the condition of possibility for Language. In all these metaphors language is, *always already*, the controlling term: language is itself the medium in which the metaphor about Language is being created. There is no escape from this potentially infinite regression.

There are, obviously, many things that exist outside language(s) – but is there anything that exists 'outside' Language? There may well be, but if so, I have no way of knowing about it (and certainly no way of talking about it). All my perception is based on the initial gesture of

perceiving difference: even a perception as basic as light/dark or cold/hot is already, from this point of view, linguistic.

The extent to which this metaphor of language has invaded the discourse of all the arts produces what has been called (in another metaphor) 'linguistic imperialism.'[2] Language is taken as the controlling metaphor for all sign systems: verbal language is seen simultaneously as both an instance of the system and as a model for the system itself. This was the basic gesture of structuralism, which set out to use Saussurean linguistics as the key to all other fields of study, from anthropology to literature. 'We shall therefore postulate,' wrote Roland Barthes, 'that there exists a general category *language/speech*, which embraces all the systems of signs; since there are no better ones, we shall keep the terms *language* and *speech*, even when they are applied to communications whose substance is not verbal' (1967, 25). (The entire linguistic hubris of structuralism can be seen in that casual assertion, 'since there are no better ones ...')

The critiques produced by structuralism, many of which proved to be reductive and over-rigid, demonstrated the limits of the metaphor by which 'language' is applied to other systems of signification. In painting, for example, there has been some rather futile discussion of whether one can find exact analogies for linguistic terms: is the brush stroke a phoneme?[3] In one of the most sophisticated structuralist accounts of visual signs, *Semiotics of Visual Language*, Fernande Saint-Martin proposes a basic unit called 'the coloreme,' which she defines as 'that aggregate of visual variables perceived in the visual representation by way of an ocular fixation, or focus of the gaze' (5). Saint-Martin is at pains to distinguish herself from earlier structuralist attempts that had based a visual 'language' or 'syntax' too closely on the model of verbal language, and her account of visual signs is very rigorous in its exclusion of the referential or thematic dimensions. Nevertheless, she continues to use the words 'language' and 'syntax' – 'visual language,' she writes, is 'one of the most important nonverbal languages' (xiv) – so her discourse remains firmly within the large-scale linguistic metaphor.

In post-structuralism, this linguistic metaphor is taken more as a founding assumption ('Il n'y a pas d'hors-texte') than as an everyday tool. This aphorism by Derrida, which has become a sort of slogan for post-structuralism, has been the target of a great deal of criticism. See, for example, David Carrier in his book *Artwriting*: 'Some literary critics espouse the slogan "There is nothing outside the text." In a discipline in

which both the objects of study and the commentaries on them are texts, maybe it is natural to have some difficulty finding any relevant evidence outside of the texts. Because artwriters describe visual artifacts, they are not likely to have this problem' (5). Carrier, however, confuses two quite distinct meanings of 'text': as a specific piece of discourse (a book, a poem, an essay, a painting), and as the general text, textuality itself. Of course there is 'relevant evidence' outside of individual texts; but there is none outside of textuality, since the very word 'evidence' already presupposes something that exists in discourse. Carrier is right to point to the fact that, in literature, writers and critics share the same medium, and that the critics are thus drawn into a complicity with the 'object' of their discourse; but he is naive to suppose that 'artwriters' can escape this double bind any more easily.

'Visual artefacts' are surrounded by language, invaded by language. In the course of this book, I will be looking at various ways in which this happens, various strategies by which language appropriates the non-verbal. I realize that my metaphors here (invasion, strategy, appropriation) are military. I do think that there is an element of violence in this appropriation: and also, I will argue, an element of desire. This dominance of language may be regretted (we all have a nostalgic longing for non-verbal innocence), but it is unavoidable. The painting is invested with language, from the moment that it is given a title (and even 'Untitled' is a title) to the moment that the viewer or critic stands in front of it and attempts to articulate a response.

But even before this, the painting exists in Language by its very status as a framed image. The frame sets the image off from the total visual field, and it provides the space within which visual elements can be set in meaningful relation to each other. At the same time, however, the frame always allows the contamination of what is 'inside' (the supposedly 'pure,' self-contained work of art) by what is 'outside' (the social context, circumstances of economic production, particularities of political reception, and so on). Derrida argues that 'the parergonal frame stands out against two grounds, but with respect to each of these two grounds, it merges into the other. With respect to the work ... it merges into the wall, and then, gradually, into the general text. With respect to the background which the general text is, it merges into the work' (1987, 61). That is, the frame is always permeable: it does not allow for any absolute distinction between the visual and the non-visual; the 'inside' of the image (so-called visual 'purity') is always

already contaminated by the 'outside,' language. So framing is, always already, the action of language, the frame of writing.[4]

Many artists regret or resist this condition of discourse. They would like to invoke what Michael Carter calls a kind of 'perceptual fundamentalism, where a Golden Age of visual innocence is posited – a state of being where viewer and work can encounter one another unencumbered by the word' (175). Such a state, I would argue, is not possible. One reader of this work in manuscript commented on my 'poet's bias against visuality as such.' But this comment simply begs the question: my whole point is that there is no such thing as 'visuality as such,' if by that is meant a visual realm independent of the frame or supplement of language. There is no 'pure' visuality separate from what Mitchell calls 'the inextricable weaving together of representation and discourse, the imbrication of visual and verbal experience' (83).

Works of art exist in environments that have been saturated in language. Carter shows how this is true of the social conditions in which art is produced, circulated, and viewed; the artist and the audience are always historically located – and located, even, in specific places (such as opera houses or art museums) that carry enormous accumulations of socially coded meaning. 'Once launched into the world,' write Mieke Bal and Norman Bryson, 'the work of art is subject to all the vicissitudes of reception; as a work involving the sign, it encounters from the beginning the ineradicable fact of semiotic play' (179).

The desire for visual 'purity' was very strong in certain strains of modernist or formalist criticism, which suggested that each art had to define, and then to concentrate on, its own 'essence,' that which distinguished it from the other arts, rather than anything that it might have in common with them. Thus painting was defined, by critics like Clement Greenberg, solely in terms of the flat, framed surface covered with pigment. 'Literary' became a term of abuse. Modernist aesthetics attempted to downplay or deny any linguistic element in painting.[5] As Johanna Drucker puts it, 'The notion of purity as nonverbal, antilinguistic, became a keystone of the high modernist position.'[6]

Those who pursue purist definitions, and insist on the exclusivity of the arts, define those arts in terms of their generic limit, of what it is that each one lacks. Music lacks visual images; painting lacks words. Metaphorical transferences between the arts (the 'rhythm' of painting; the 'colours' of music) may then be attempts, within the critical discourse of each art form, to overcome this limit, to fill this lack. In psy-

choanalysis, lack is the focus for desire. Each absence recalls the primal separation from the body of the mother; that is the plenitude that we always desire to recover. (And in Lacan's terminology, language itself, the register of the Symbolic, is the most crucial division from that lost plenitude.) We move towards the lack, and we attempt to fill it, even knowing that the gap can never truly be filled. Desire will always reconstitute itself, creating a new object even in the moment at which one desire is, apparently, fulfilled.

If one theory of interartistic relationship held that the arts should practise a kind of aesthetic apartheid, each preserving its own essence and purity, another theory had it that the arts always aspire towards each other. ('All art constantly aspires towards the condition of music,' wrote Pater; but at other times, other arts have been held up as the ideal. In the first half of the twentieth-century, it seemed as if all art was aspiring towards the condition of painting.) Thus, one can also insist on the metaphorical presence of one art in another: on colour in music, or rhythm in painting. In the very nature of its own lack, each art seeks its Other, its supplement.

In analysing the notion of 'the supplement,' Derrida begins by noting that this word 'harbors within itself two significations whose cohabitation is as strange as it is necessary.' On the one hand, something may have a supplement added to it as a kind of optional extra, 'a surplus, a plenitude enriching another plenitude' (1976, 144). In this sense, the supplement does not imply any deficiency in the original to which it is added; it comes as a bonus, on top of what is already complete. On the other hand, and simultaneously, the supplement *does* imply a deficiency, a gap that it comes to fill. The supplement 'adds itself ... to fill an emptiness which, within fullness, begs to be replaced' (1976, 145). The supplement reveals a paradox within the 'original' to which it is added: the original is both complete in itself (the supplement comes to it as something extra, from the outside) and incomplete (its apparent fullness includes a lack that the supplement comes to fill; so the supplement comes, as it were, from the inside). The structure of supplementarity is open-ended: the supplement itself can and must be supplemented, in a continuing series. This notion of the supplement deconstructs the whole notion of the 'original.' 'One wishes to go back,' Derrida writes, *'from the supplement to the source*: one must recognize that there is *a supplement at the source'* (1976, 304). All origins are always already non-original, always already supplemented.

Several aspects of this account of the supplement are critical to my argument. In the first place, there is the notion of reciprocity, of a two-

way action. The word 'supplement' is often used, in a weak sense, to mean one or other of these two movements in isolation: either as a bonus or as a correction, but always in a rather friendly, supportive way that preserves the notion of the supplement as secondary to the 'original' in an orthodox hierarchy. The force of Derrida's usage – and the sense that should be understood throughout this book – is that he insists upon *both* movements simultaneously. The great weakness of metaphors like 'linguistic imperialism' is that they suggest only a one-way movement, of an element intruding where it does not belong – the verbal invading the visual – whereas 'supplement' suggests a two-way, reciprocal movement into areas where the elements do, paradoxically, always already belong – the verbal inside the visual and vice versa. In Derrida's use of both 'supplement' and 'frame,' the emphasis is on the ways in which two supposedly distinct elements (original and supplement; inside and outside) are in fact not distinct from each other at all. Not only does the one necessarily imply the other; each is structurally built into the other, in ways that deconstruct any attempt to grant either term priority. The supplement is not a friendly accessory but rather a structural necessity, and the effect of this double movement is to deconstruct any notion of hierarchy. Neither the visual nor the verbal can be attributed priority, because each is always already the supplement of the other. Thus, while I began this paragraph with the notion of 'reciprocity,' I must close it by saying that this reciprocity is not a matter of smooth collaboration or easy complementarity; rather, between the supplement and its 'original' there will always exist a certain tension – often, though not always, a productive one. The supplement is profoundly subversive of any notion of 'presence,' of self-sufficient purity – and this comes as a particularly disturbing challenge to most traditional notions of the visual arts.

The visual arts, more than any other art form, depend on the notion of the original, self-complete object. Books exist in multiple copies, music in multiple performances. But while paintings can be reproduced, there is a value attached to the unique object that has no parallel in literature or in music.[7] (This value is both aesthetic and economic – to command a top price, a painting must be authenticated – hence the complicity between art criticism and connoisseurship, and the whole resistance, discussed below, to any theory of the 'Death of the Author.') To suggest that 'there is a supplement at the source' is to insert a theoretical division into the structure of the unique object itself. The artistic text (whether it is a painting, a poem, or a piece of music) both is and is not complete in itself. As an aesthetic object, it has a structure, it has an organic unity,

that renders it complete and self-sufficient; but this unity can only be defined by the frame, which sets the image apart as a text – and, as a text within Language, it is always self-divided and incomplete.

Thus, language comes as a supplement to painting. As a thing complete in itself, painting does not *need* language: titles, audience responses, museum and marketing networks, critical commentaries – all are superfluous, added on. The work would continue to exist without them (though this is, in our present historical situation, a purely hypothetical possibility). And this sense of self-containment, of simply *being* a complete and satisfying object, is among the most profound pleasures that a great painting can offer. (I feel it whenever I stand before a canvas by Braque or Cézanne.) At the same time, however, the structure of the painting necessarily includes the gap that is the location of the supplement. Put quite simply, the painting lacks words, and it reaches out towards them. From the moment that it exists as a framed image, it invites the supplement of language.

The reverse is also true: painting acts as a supplement *to* language. As Mitchell comments, 'If it is hard to keep discourse out of painting, it is equally difficult to keep visuality out of literature' (99). Michael Phillipson writes that language 'adds to painting [what] is already part of it from its beginning. Criticism seems to begin with the hope of being true to painting, by meeting its need – by being its necessary supplement; knowing itself to be part of the work of art, its Desire is to begin the interminable work of fulfilling painting by supplementing it with writing. But what draws the need to supplement into the region of the work to begin with? Perhaps art's lack is complemented by a sense of lack within the respondent' (181).[8] Language also has a gap: it lacks the visual, it lacks the non-verbal. And language is obsessively attracted to this gap. This whole book is about the compulsive verbalization that seems to surround painting; writers can't leave the non-verbal alone. It forms a challenge, an affront, something writers feel they have to respond to. Some of these responses are more useful than others; but the gesture of response is inevitable and inescapable. Rightly or wrongly, writers see in painting a lack – the lack of words – and they rush to fill up that lack. Perhaps that rush even stems in part from an unconscious wish to end language, to expend language into the blissful silence of the non-verbal. Writing's response to painting is its own death-wish: never fulfilled, always deferred.

Painting brings to language what language lacks: silence, muteness. (I think 'muteness' may be the more suggestive term, since it implies

the *possibility* of speech, a possibility that has been denied, either by will or by incapacity.) A visual image (of, say, an apple or a mountain) cannot be named or discussed except in language; but in painting, however much it is coded, the image also *resists* language. Painting is a stubborn muteness that elicits the supplement of words.

Resisting the claims of 'linguistic imperialism,' art critics often stress 'the irreducibility of painting to writing.'[9] I agree that such irreducibility exists, in the stubborn muteness of the visual; but it does not exist simply, or in isolation. Inevitably, this irreducibility provokes and indeed *produces* the supplement of commentary; so the paradox is that 'writing' is structurally built into the very condition of irreducibility to writing.

Language supplements that which is complete in itself (the apple and/or the image of the apple) by adding to it what it lacks (the word 'apple,' the interpretation of the sign for 'apple'). At the same time, the supplement itself is lacking: the word lacks silence, the discourse lacks muteness. What painting brings to language is its own non-verbal nature, its silence – a silence that may still be within the realm of the sign (that *is* an image of an apple or a mountain) but that is nevertheless a mute sign, one that challenges words to interpret it. Words, of course, never fail to rise to the bait.

How then do words respond to the muteness of the image? How do these various modes of representation interact with each other? I would like to approach this topic by way of a commentary on a passage from Gertrude Stein.[10] It comes from her lecture on 'Pictures' in *Lectures in America* (originally delivered in 1935):

And then slowly through all this and looking at many many pictures I came to Cezanne and there you were, at least there I was, not all at once but as soon as I got used to it. The landscape looked like a landscape that is to say what is yellow in the landscape looked yellow in the oil painting, and what was blue in the landscape looked blue in the oil painting and if it did not there still was the oil painting, the oil painting by Cezanne. The same thing was true of the people there was no reason why it should be but it was, the same thing was true of the chairs, the same thing was true of the apples. The apples looked like apples the chairs looked like chairs and it all had nothing to do with anything because if they did not look like apples or chairs or landscape or people they were apples and chairs and landscape and people. They were so entirely these things that they were not an oil painting and yet that is just what the Cezannes were they were an oil painting. They were so entirely an oil painting that it was all there

whether they were finished, the paintings, or whether they were not finished. Finished or unfinished it always was what it looked like the very essence of an oil painting because everything was always there, really there ... This then was a great relief to me and I began my writing. (1985, 76–7)

In commenting on this passage, I will try to distinguish four modalities of representation, using the Cézanne/Stein 'apple' as a convenient example of what is being represented:

1 / There is, first of all, the actual apple, an object in the world, a fruit. One could talk *about* this apple in many ways: horticultural, sociological, economic. A painting can always be appropriated into another discourse: used, for example, as an illustration in a history book, or as evidence of what people's clothes and houses looked like in a specific culture.[11] Such uses, however, seem secondary to the simple fact of the apple's presence as a mute physical object: 'The apples looked like apples ... and it all had nothing to do with anything.' As Stein might also have said, an apple is an apple is an apple. There is something irreducible about the 'thingness' of the object.[12]

For many viewers, there is a vast reassurance in the identifiable presence of familiar objects in painting, and I suspect that this feeling of reassurance depends upon the simple *muteness* of the objects. They have nothing to do with anything; they are simply *there*. In a world dominated by the babble of discourse, the continued silence of an apple or a mountain or a chair offers a point of resistance to language.

This reassurance in the presence of the familiar also accounts for the persistent refusal to accept non-figurative art. After almost a century of 'abstract' painting, one can still encounter the exasperated response 'What *is* it? What is it supposed to *be*?'[13] In such sentences, the verb 'to be' is being used in the same rhetorical way as it would be if one were to look at a painting by Cézanne and say, 'That "is" an apple.' Indeed, the identity implied by this 'is' is so strongly felt that the rhetorical nature of the iconic sign is forgotten: the convention becomes naturalized. Stein acknowledges this illusion of identity when she says that 'they *were* apples' (I add the italics, though the emphasis is surely there in the rhythm of the sentence). They were apples, she says, even 'if they did not look like apples.' Even if the visual sign is so stylized that iconic resemblance is minimal, still, Stein says, we feel the presence of the apple so insistently that only the verb 'to be' will account for our feeling.

2 / But for Stein, of course, this is not the whole story; she also knows, very well, that 'That "is" an apple' is a mis-statement. More accurately, one would have to say, at the least, 'That is *a sign of* an apple.'[14] As soon as the marks on the canvas are taken to be *a sign*, we are in the field of semiotics. And again, as with the sociological level, various levels of discourse open up, not so much about the apple as about the sign-of-an-apple. What kind of sign is it? Does it carry mythological or allegorical coding? (That is, is it the apple of Eve or the apple of Paris? Is it a visual symbol for the city of New York?) In order to know how to interpret the sign, one must know which semiotic code to put it in. And there are, as it were, meta-codes. For example, if the painting shows just an apple (no goddesses in sight), if it is simply a 'still life,' then that very choice of code will itself be coded. The painter's choosing to paint a still life rather than an allegorical scene is itself a meaningful act, and one whose meaning has changed at various historical epochs, depending on the high or low esteem in which the genre of still life is held.[15]

There is a further level of semiotic coding in the very fact that the work of art *is* a work, something framed. The work of art is often described as something complete, self-sufficient, an organic unity; yet a *sign* can never be self-sufficient. A sign is always a sign *of* absence: it is only the absence of the referent that allows a sign to *be* a sign. Equally, however, the object, the thing in itself, is not a sign (though of course all objects can, in certain contexts, be *used* as signs). The image of the apple displays the apple as 'complete in itself,' a thing; yet it also shows that the apple *is not an image*, that is, that the apple in its thingness nevertheless lacks something – it lacks 'imageness.' The lack is reciprocal; so the structure of the lack is, as always, the structure of the supplement.

3 / Semiotic codes, however, exist to be used, adapted, creatively broken. The visual conventions which determine that we accept a certain series of marks on a canvas as a sign for 'apple' allow a great deal more flexibility on the part of the individual user than does the linguistic token 'apple.' Since there is no exact analogy between the visual sign (the accumulation of brush strokes that creates an image that may be seen as depicting an apple) and the individual word, this is one of the key places at which the argument that 'painting is a language' breaks down.[16] The writer may create a new style by finding fresh combinations of words, or even syntax; but the painter is constantly reinventing the 'words' themselves. Cézanne presents signs-of-apples that are un-

like any signs-of-apples the viewer has ever seen before; so the viewer will respond both to the familiar (I recognize that these are signs-of-apples) and to the new (I recognize that these are unique signs, *Cézanne's* signs). The viewer's appreciation of the painting will balance between these two responses: as a result of seeing the Cézanne, the viewer will never see either apples or paintings of apples in quite the same way again.

4 / The fourth 'subject' of a painting is neither an apple nor the semiotic sign of an apple but is rather the painting itself. The degree to which the first two levels impose themselves as 'natural' may lead the viewer to suppose that '[t]hey were so entirely [apples] that they were not an oil painting' (the classical ideal of the art that conceals art); but Stein will not leave it there. For her, the opposite assertion is equally necessary: 'and yet that is just what the Cezannes were they were an oil painting.' Indeed, the success and intensity of these various levels are, in Stein's view, dependent upon each other: 'They were so entirely an oil painting that it was all there' – the reference of the pronoun 'it' is vague, but I believe 'it' must refer to *both* the apples and the oil painting.

As oil painting, the work is, in the classic definition of Maurice Denis (1890), 'une surface plain recouverte de couleurs en un certain ordre assemblées,' 'a flat surface covered with colours arranged in a certain order' (33). From this point of view, the apple is, if not quite irrelevant, certainly secondary. The apple is simply the form taken by a certain concern with shape and colour, roundness and redness. Juan Gris wrote that his method of composition was 'deductive': 'It is not picture "X" which manages to correspond with my subject, but subject "X" which manages to correspond with my picture ... The quality or the dimensions of a form or a colour suggest to me the appellation or the adjective for an object ... If I particularise pictorial relationships to the point of representing objects, it is in order that the spectator shall not do so for himself, and in order to prevent the combination of coloured forms suggesting to him a reality which I have not intended' (194). For Gris, the most important consideration is 'the quality or the dimensions of a form or a colour'; but this emphasis does not render the 'subject-matter' of the painting irrelevant. When he chooses to make a form (a curved line, for example) manifest in a painting, it is still of significance that he chooses to make the curved line 'correspond with' a guitar, rather than leave it as a non-iconic abstraction. Gris's painting, like all Cubism, insists upon retaining at least some measure of figuration. (And it is

also of significance that he chooses a guitar rather than, say, a machine-gun barrel.) In Cubist painting, visual elements (such as a curved line) always serve a double function: the line may help to 'represent' an apple or a guitar, but at the same time it exists for its own sake, as a line and as a curve.

For many viewers, it is this fourth level that is the essence of painting. Certainly, when I walk into a museum and see a Cézanne on the wall alongside, say, a Guillaumin,[17] what makes the Cézanne jump off the wall at me has far more to do with this fourth level of response than with anything I could say about the first three. (And, again, this sheer intensity of visual experience involves a degree of muteness, of resistance to language.) But I do not see these four modalities of the visual as being necessarily in opposition or contradiction to each other; they can coexist. Stein's paradoxical language, with its continual play of repetition and difference, of assertion and denial, shuttles back and forth across these divisions in such a way as to suggest that their continuities are greater than their discontinuities.

This briefly sketched scheme of four modalities of visual representation is, of course, largely irrelevant to non-figurative or 'abstract' painting, which has to be approached principally in terms of the fourth modality. But if abstract painting bypasses issues of representation, it certainly does not escape Language. Quite the opposite. If Language is defined as a differential system with, in Saussure's words, 'no positive terms,' then abstract painting can be seen as a pure exercise in linguistics. Shape, line, and colour become pure signifiers, freed from the need or even the possibility of signifieds, and presented for the sake of their formal interaction. There is no clearer illustration of Saussure's definition than the Colour Wheel. Many writers have been especially attracted to minimalist abstraction: one reason for this may be that they see it as an escape from language; but equally strongly, they may see in it the possibility of a pure, non-referential language – language, to adapt a phrase of Roland Barthes, at the zero degree.

The logic of the supplement suggests that painting is both complete in itself and also, paradoxically and simultaneously, incomplete. At each of these four levels, I have suggested that there is in the painting a muteness, a resistance to language. Yet at each level there is also a lack, which opens up to the supplement of language. 'This then was a great relief to me,' Stein concludes, 'and I began my writing.' In chapter 6, I will discuss some of the specific ways in which Stein's writing responded

to the stimulus of painting, especially Cubism. For now, I would simply note that she sees her own starting to write as being an inevitable response to the whole problematic of Cézanne's representation: to the fact that his apples *were* apples, that they *looked like* apples, that they did *not* look like apples, that they *were* an oil painting, that they were *not* an oil painting, that 'it all had nothing to do with anything,' that 'everything was always there, really there' ... to all these things together, to the impossible, paradoxical, wonderful muddle of their coexistence, Stein's response was relief. And writing.

Language has sought to supplement painting in many ways: Gertrude Stein's own writing ranged from her idiosyncratic attempts to theorize what she saw in Cézanne to the complex 'Cubist' still-life poems of *Tender Buttons*. The most highly systematized form of writing about art, however, is to be found in the discipline of art history.

In the 1980s, this discipline sensed itself to be 'in crisis.' Thus, Donald Preziosi opens his 1989 book *Rethinking Art History: Meditations on a Coy Science*, with a chapter entitled 'A Crisis in, or of, Art History?' This chapter in turn opens by citing a 1982 issue of *Art Journal* 'devoted to the theme of "The Crisis in the Discipline"' (1). This 'crisis' arose from the reluctance of many art historians to come to terms with 'the linguistic turn'[18] in philosophy and critical theory, especially as applied to literature. And indeed, part of the 'crisis' was simply that art history felt itself left out, behind the times. In the early 1980s, the fashionable 'cutting edge' of studies in the humanities was to be found in literary studies, or, more specifically, in the adeptness with which literary studies absorbed the philosophical ideas of post-structuralism and deconstruction. Art history proved somewhat more reluctant to move in these directions.

However, if there was such a 'crisis' in the 1980s, it is now largely resolved. Contemporary art history embraces the full range of postmodern theoretical discourses.[19] Yet some aspects of that initial reluctance remain instructive, precisely because it is 'language' that was seen as the stumbling block. In an article entitled 'Traditional Art History's Complaint against the Linguistic Analysis of Visual Art,' published in 1987, Donald Kuspit expresses the bewilderment and frustration felt by some art historians:

Why has art history, more than have the studies of other, non-visual, arts, resisted the new interdisciplinarianism, most evident in literary theory? ... Why

has art history been reluctant to look at a work of art in structuralist and post-structuralist terms when so many works of modern art articulate themselves linguistically – i.e. transparently raise questions about the nature of significa-tion – and subvert themselves as works of art, questioning the premises which permit us to conceive them as art? Why is art history reluctant to reduce the work of art to text and to find, in Jacques Derrida's words, the 'lines of force and forces of rupture' that would permit 'the incision of deconstruction' to be carried out on it? (1987, 345)

Part of the answer to Kuspit's questions is to be found in the very way he phrases them: his choice of quotation from Derrida ('incision') suggests that he sees deconstruction as an act of violence against the painting. But the real giveaway word is 'reduce': the work of art is *reduced* when it is seen as a text, therefore it must be, in itself, something *more than* a text, something richer, fuller, more *present* than a text.

Kuspit himself projects an ambivalent attitude in his essay. At times he seems to share the impatience at the reluctance of 'traditional art history' to keep up with theoretical developments; at other times he is suspicious, to the point of sheer distortion, of 'linguistic analysis.' Take the following passage: 'It is this reductionism [of the work of art to 'text'] that art history is reluctant to admit, for it is fraught with impli-cations that undermine certain cherished assumptions about art. More implicit than explicit, they nonetheless are the bedrock on which a kind of mystical belief in the ultimate irreducibility and specificity of the visual experience rests. Despite all analysis of it, it remains ineffably itself. Perhaps in the end it is this emphasis on the ineffability of visual art that argues against its reduction to highly speakable – if complexly interlocking – texts' (1987, 346).' Again we have 'reduction,' twice in one paragraph, and it certainly seems as if Kuspit believes in 'the inef-fability of visual art.' But at the same time, he talks about 'cherished assumptions' and 'a kind of mystical belief,' both of which phrases could be read as defensive or dismissive. Yet when he outlines what some of these assumptions are, he offers no arguments against them. One can only conclude, then, that he sees them as valid points to be made against the 'linguistic analysis' of painting and in favour of the 'ineffability' of the visual. Among these assumptions are 'that the visual is in general closer to the primitive root of the subjective than is the verbal,' and 'that the visual work of art is inherently precious, which makes it what Murray Krieger calls an "elite object"' (1987, 346–7). Let me comment on each of these assumptions in turn.

Kuspit argues that visual images come from greater psychological depths than verbal images do, and are therefore 'closer to the madness of inner life' and 'repressed libidinal impulse[s]' (1987, 347). Setting aside the (highly questionable) romantic view of the artist as inspired madman that is implied here, I would comment that any reading of Freud or Lacan would demonstrate the extent to which all dream images, all 'repressed libidinal impulses,' are shot through with the verbal. For Lacan, the very act of repression is a result of the subject's access to the Symbolic: the 'unconscious' is created by language, and is, in Lacan's famous phrase, structured as a language.

I do not believe, then, that there is anything in the nature of the visual that gives it any greater access to the unconscious than the verbal; again, I would see the relationship of the two modes as supplementary rather than antagonistic. Kuspit himself, in this and other articles, goes on to lay considerable stress on psychoanalysis; psychoanalytic criticism is one of the areas of the 'new interdisciplinarianism' that he, and others, would like to see more fully integrated into art history. The paradox is that such criticism, far from stressing the 'ineffability' of the visual, tends to be heavily linguistic in character.[20]

The 'cherished assumption' that a painting is an 'elite object' is perhaps the strongest of Kuspit's points, though it too has its limitations. It can certainly be argued that the nature of our visual experience has been changed, in the twentieth century, by the proliferation of the technologies of reproduction, to the point that the multiple, mass-produced image (what Baudrillard calls 'the simulacrum') has become the norm, and that this is the field within which contemporary art forms such as video or computer-generated images now necessarily situate themselves. The 'elite object,' the original oil painting hanging on a museum wall or in a private collection, is only the fetishized reminder of a bygone age of bourgeois accumulation.

Fair enough: but there *is* an appeal (perhaps only a nostalgic one) in the physical presence of a unique canvas. For me, it is part of a great sadness that always attaches itself to painting. The work is so obviously vulnerable. It is possible that every single copy of a book or a piece of music could be destroyed, but this total loss is far less likely than the loss of a painting, through fire, theft, vandalism, or neglect. Of course, the work's mortality is also my own. Every time I walk away from a painting (a still life by Braque, say, in the Pompidou Centre in Paris), I wonder how many more times in the course of my life I will have the

opportunity to stand in front of it. Whenever I leave a museum, it is, potentially, for the last time.

To this extent, then, I am prepared to accept Kuspit's 'cherished assumption' about the 'elite object.' But even the elite object exists only within a social context (such as the Pompidou Centre in Paris) that is constructed by language. Our appreciation for a painting as a unique object in no way excludes the necessity for that unique object to be framed and supplemented. Further, Kuspit concentrates on the uniqueness of the *object*; perhaps revealingly, he does not refer to what I would have thought of as another, even more fundamental 'cherished assumption' of traditional criticism – the uniqueness of the *artist*. Of all the slogans connected to post-structuralism, the one that is surely least easily assimilable by traditional art history is 'the Death of the Author.'

As with literary studies, traditional art criticism has been, in the words of Roland Barthes, 'tyrannically centred on the author, his person, his life, his tastes, his passions ... The *explanation* of a work is always sought in the man or woman who produced it' (1977, 143). Thus, for example, John Richardson begins his massive, four-volume biography of Picasso by writing: 'After seeing at first hand how closely Picasso's personal life and art impinged on each other, I decided to try charting his development through his portraits. Since the successive images Picasso devised for his women always permeated his style, I proposed to concentrate on portraits of wives and mistresses. The artist approved of this approach' (3). Richardson's first volume is largely concerned with demythologizing Picasso's youth, exposing the inaccuracies of many of the stories that he encouraged about his early precocity. Nevertheless, the reference point of the discussion is always the genius of Picasso:[21] the myths reveal the man, even – or especially – when they are exposed as myths. Note how this opening passage appeals to the authority of the author ('The artist approved'),[22] and to the authority of 'first hand' observation. It even appropriates the style of Picasso's sexism ('his women'). Above all, it sees the business of the biographer-critic as being to explicate 'how closely Picasso's personal life and art impinged on each other.' And this certainly has been the orthodox task of the biographer in both art and literature; but it is one that has increasingly been challenged, or modified, in recent critical theory.[23]

One of the main reasons why art history was more reluctant than literary criticism to come to terms with this theory is the link between appreciation and attribution, between aesthetic judgment and commer-

cial evaluation. Precisely because paintings are 'elite objects,' they are also expensive objects; and their price depends upon the authentication of their uniqueness. The art critic as connoisseur is implicated in the workings of a market that, in recent years, has attained major international proportions. When paintings by Picasso or Van Gogh sell for millions of dollars, the expertise that certifies their provenance has far more at stake than an academic exercise. And it is also not very likely to be interested in theories of 'the Death of the Author.'

Preziosi suggests that this investment (in both financial and psychological senses) in the figure of the artist runs all the way through the discipline of art history. The commercial interest is continuous with an institutional one, which in turn has philosophical foundations. Preziosi writes:

The disciplinary involvement with artistic attribution and recuperative justification goes very far beyond a dispassionate librarianship concerned with archival order and system for its own sake. The discipline is grounded in a deep concern for juridico-legal rectification of what is proper(ty) to an artist and is thereby involved with the solidity of the bases for the circulation of artistic commodities within a gallery-museum-marketplace system. At the same time, it works toward the legitimization and naturalization of an idealist, integral, authorial Selfhood without which the entire disciplinary and commodity system could not function. The concern for fakes and forgeries, then, is no mere marginal curiosity: [it] is in one respect a key matrix wherein disciplinary, legal, and commercial lines of power converge and support each other – the keystone, perhaps, of disciplinary rhetoric. Not only must the property of different artists ... be clearly distinguished from each other, but the artist must be true to himself in all his works. He must always be self-identical, and his work over time must be woven together as a coherent fabric. (33)

Thus, there is an ideological investment in the figure of the author/artist at all levels: economic, institutional, psychological, philosophical, and aesthetic. No wonder there has been a certain resistance to modes of criticism that take a more disseminative or 'linguistic' approach. Nor do I mean to suggest that such resistance is wholly wrong: rather, I see it as a continuing allegiance and testimony to the muteness of the visual, which will always supplement language, bound as it is *to* language in the reciprocity of the frame.

This inescapability of language has often been presented in negative terms: as an invasion, an intrusion, a 'linguistic imperialism.' I agree

that there are times when language attempts to appropriate the visual in ways that are inapposite and unproductive – and in some of the chapters that follow I will be offering critiques of such appropriations. But for the most part, I prefer the metaphors of 'the supplement' and 'the frame' to the metaphors of 'imperialism' or 'appropriation.' For all that I have insisted on the necessity of painting's existence in a linguistic (social) space, I have also insisted on the counter-movement of the supplementarity: on the ways in which the visual *resists* language, the ways in which it preserves a stubborn muteness. T.S. Eliot wrote that 'Words, after speech, reach / Into the silence.' That is what language does, over and over again, as the supplement of painting.

CHAPTER TWO

'We Are a Man':
The Narrativization of Painting

Inside the museums, Infinity goes up on trial
Voices echo this is what salvation must be like after a while
But Mona Lisa musta had the highway blues
You can tell by the way she smiles

Bob Dylan

These lines by Bob Dylan come from his 1965 song 'Visions of Johanna.'[1]
I quote them here as an example of one of the major ways in which
painting may be appropriated by language: a rhetorical movement that
I will call 'narrativization.' Such appropriations are, I argued in chapter
1, inevitable; indeed, the space for them is built into the structure of
every visual image. But this is not to say that every linguistic supple-
ment is equally useful – indeed, what I want to point out here are
aspects of critical commentary on paintings that I find distinctly *not*
useful. In doing so, I will be rehearsing some well-established points
about the appropriative nature of the male gaze; but what I want to
stress here is not so much the gaze itself, but the way in which the gaze
is narrativized – set, that is, within a linguistic context that necessarily
tells a story.

Dylan's lines speak to the equivocal role of the museum (and, by
extension, the whole apparatus of public cultural discourse, the institu-
tions of art history and appreciation) in relation to paintings them-
selves. There is something about the museum setting that works against
the ideal conditions – of privacy, of peace, of prolonged exposure – in
which paintings should be viewed. In the museum, painting 'goes up
on trial': it is there to be ranked, catalogued, criticized, used as an object

in art history. The work of art is often seen as an emblem of freedom – of the creator's free imagination, of the liberating influence it may have on its viewers – but in the museum this freedom is compromised. In Dylan's line, this tension is expressed by the paradox of 'Infinity' being put 'on trial.' By definition, infinity is beyond all restrictions: it *cannot* be put on trial. What the museum does – what all the structures of cultural institutionalization do – is to *attempt* to confine, measure, categorize, and contain what is in fact beyond confinement, measurement, category, or containment.

So it is with some irony that Dylan himself proceeds to put infinity up on trial, by offering a 'reading' of Mona Lisa's smile. In some ways, it is a deliberately anachronistic, disrespectful reading, a parody, like Marcel Duchamp's *L.H.O.O.Q.*[2] It places the sacrosanct image of the *Mona Lisa*, our culture's archetype of 'the masterpiece,' within the context of blues, drugs,[3] and rock and roll. At the same time, however, the connotations of 'highway blues' – freedom, restlessness, the impulse to travel on – work to free both Mona Lisa, and Dylan's reading of her, from any limitation.

Dylan's 'reading,' of course, places him in a long tradition of writers (Walter Pater, Sigmund Freud ...) who have responded to the enigmatic image of the *Mona Lisa* with poetic interpretations of their own. (Feminist critics have noted that most of these poets and critics have been male: the assumption that the *Mona Lisa* presents a definitive image of feminine mystery is itself a male idea.) The *Mona Lisa* is open to such interpretations because so little about it is, in narrative terms, already determinate. Unlike an established figure from history or mythology, La Giaconda is not a figure whose story is already known. So the visual image 'floats,' unattached to a fixed history, subject to appropriation. And the famous smile, though it might be described as belonging to a code of 'body language,' resists any precise translation into verbal terms – a resistance that, of course, far from silencing verbal responses, only invites a multiplicity of them. In the face of her silence, writers feel compelled to tell stories.

One of the commonest ways in which language imposes itself on painting is through such narratives. A painting is held to 'tell a story' – except that, being a visual image, it can't literally 'tell' the story itself. Painting *implies* a story, and language steps in, conveniently and eagerly, to do the telling for it. This is the process that I am defining as 'narrativization': the imposition of a story (linear, consecutive, linguistic) on visual images (spatial, static, non-verbal). In cases where the

painting clearly *invites* such a response (as in genre paintings of historical or mythological scenes), narrativization may be seen as reciprocal supplementarity, language providing the element that the painting clearly needs. But other cases are more doubtful: the *Mona Lisa* itself, for instance. Do readings like Pater's (or Dylan's) really supply a lack in the original? Or are they, rather, instances of appropriation, of 'linguistic imperialism,' of the unwarranted imposition of one art form on another?

Part of what is involved here is the classical distinction between literature as an art of time and painting as an art of space. If the two media are seen as reaching out towards each other, then each seeks to supplement itself, to fill the gap within its own mode of being. In narrative, painting hopes to find the temporal extension that the single still image necessarily lacks; by contrast, poetry often seeks to escape from its own inexorable movement through time by aspiring to the stillness of painting (or, for instance, of a Grecian Urn). Again, the structure of the supplement is both reciprocal and unending.

In paintings that explicitly invite narrativization, the narrative is seized at what is called its 'pregnant moment': a decisive instant in which the rest of the story (what has gone before and what is still to come) may be inferred by the viewer from what is visible in the actions, stances, or facial expressions of the characters. In a kind of synecdoche, the part is made to stand for the whole, the one isolated moment for the complete length of the story. Of course, this device will work most effectively when the story is already known to the audience, as in narrative paintings based on historical, biblical, or mythological incidents. Such paintings, by their very choice of subject, place themselves right from the start firmly within language. They demand to be 'read.' (Indeed, Géricault's *Raft of the 'Medusa'* is intended to be read, quite literally, from left to right.) Thus, a linguistic idea of temporal progression is incorporated into the supposedly 'still' image.

The reciprocal movement is described by Wendy Steiner: 'Dependent as it is on literary sources, the pregnant moment in painting has in turn generated a literary topos in which poetry is to imitate the visual arts by stopping time, or more precisely, by referring to an action through a still moment that implies it. The technical term for this is *ekphrasis*, the concentration of action in a single moment of energy, and it is a direct borrowing from the visual arts' (41). This kind of supplementarity is displayed in poems about paintings, such as W.H. Auden's 'Musée des Beaux Arts' or Earle Birney's 'El Greco: Espolio.' In each case, the poet

takes a painting that is itself already ekphrastic, and, as it were, 're-ekphrasticizes' it. Breughel's *Landscape with the Fall of Icarus* takes a single moment from the narrative progression of the Icarus myth and uses it to imply the whole story; Auden in turn isolates a single detail from the painting and, in his poetic meditation on its placing within the composition, makes this detail a synecdoche not only for Breughel's whole canvas but for all the insights of all the painters: 'About suffering they were never wrong, the Old Masters ...' Similarly, El Greco's *Espolio* isolates one moment from the Crucifixion story (the gambling for Christ's robe), and Birney isolates one detail from the painting (the action of the carpenter), again turning it into a general meditation on suffering and responsibility.

In both these instances, however, we are moving away from the strict determinacy of the pre-existing story. That is, while the events of the Icarus myth or the Crucifixion may be common property, at least within certain culturally defined discursive communities, the interpretations put on these events by the painters and/or the poets are more idiosyncratic. And, in turn, the poets may have imposed *their* interpretations on the paintings. It is now almost impossible to look at Breughel's painting without seeing in it Auden's reading of the significance of the off-centre placement of the falling body. But these poems may definitely be read as impositions, as intrusions. An explicit narrative always has greater power than an implicit one. Once the narrative exists in words, especially the words of a great poem, it is much harder to ignore or to resist.

Any judgment on such matters – at what stage a linguistic response 'distorts' or 'appropriates' a painting – must of course be a subjective one. For some viewers, narrativization may add layers of richness and meaning to a painting; for others it may be irrelevant distraction, or worse. And a poem may still be a great poem even if it is entirely 'untrue' to the painting it describes. Whatever judgment one makes, however, the process is inevitable. As soon as a painting enters the museum, it goes up on trial; as soon as it enters the discourse of the social circulation of art, it becomes subject to appropriation. As a text, any painting exists in the general field of intertextuality. It will take a lot more than a shield of bulletproof glass to stop people telling stories about it.

Narrativization is especially common in certain types of sociological art criticism.[4] In recent years, a great deal of work of has focused on Impressionism, and on late-nineteenth-century French society. Who ex-

actly were the clientele of those bars and cafés so cheerily portrayed by Renoir? What hours did the barmaids work, and how much were they paid? What commercial and/or sexual arrangements existed between Degas's ballet dancers and the distinguished gentlemen in evening dress who sidle into the margins of his paintings? The answers to such questions invariably involve *telling a story* about the depicted scene.

For example, Robert L. Herbert, discussing Manet's *Chez le Père Lathuille*, which shows a couple at a café table, dismisses the obvious 'story' (that they are lovers), and substitutes one of his own. By close attention to visual details (the table has only one place-setting; the man, who appears to be crouching, does not have a chair), he arrives at a conclusion: 'The fact is that the young man did not come to this restaurant with her ... In the American vernacular, he is putting the make on her. She is a well-got-up woman dining alone, and he is a young artist or fashionable bohemian on the lookout for a conquest' (68).

I am willing to be convinced by this reading, while at the same time wondering if it does not promote a rather reductive approach, seeing the painting as a set of clues to be deciphered, a kind of visual crossword puzzle. But for the moment, I would like to concentrate on one rhetorical tactic of the verbal style in which Herbert presents his argument: 'Manet places us in the garden terrace of a famous café-restaurant in the Batignolles district ... On the table, in effect, we see the last course ... By now we have noticed that there is only one place setting' (68).

Who is this 'we,' and how are we located in respect to the space of the painting? When 'we' see the last course, or notice that there is only one place setting, 'we' could still be looking at Manet's painting, either in a gallery or in a photographic reproduction; but when 'Manet places us in the garden terrace,' then it appears as if 'we' actually occupy the physical, *diegetic*[5] space of the painting. Literally, of course, the viewer, standing in front of a painted canvas, is always extra-diegetic, *outside* this fictional space. But a surprising amount of criticism, especially criticism in the mode of narrativization, works to blur this very obvious distinction.

This placing of the viewer 'in' the painting has been the subject of a good deal of recent theoretical discussion, which is concerned as much with the construction of a 'subject position' *for the viewer* as it is with the subjectivity of the artist. Johanna Drucker, for example, writes: 'Point of view ... positions the viewer in a particular relation to [the] image and indicates the point at which he or she is sutured into the depiction.

Being, in effect, the place *from which* the image is (fictively) produced as a visual experience, the point of view of the subject reproduces the illusion of image production as visual mastery. Though not a 'real' point of view, this position provides a fictive place, producing the subject of the image as the place from which it is articulated' (111). Drucker is careful to insist on the 'fictive' quality of the position thus inscribed for the viewer: 'The enunciated subject should be distinguished ... from the viewer per se. The subject is a construct, a set of positions and effects structured into the work itself' (141–2). While this distinction may seem to be an obvious one, it is surprising how often it is lost sight of: how often, that is, critics like Herbert speak as if the viewer occupied an 'actual' position within the diegetic space. I believe that this naive (mis)understanding is produced by the force and appeal of narrativization, and by certain verbal strategies that go along with it – especially the use of that tricky word 'we.'

The narrative placing of the viewer in the diegetic space is even more firmly stated elsewhere in Herbert's book, as for example in his discussion of one of Degas's ballet paintings: 'In *Dancer in Her Dressing Room*, we are positioned in a corridor, looking into a dressing room. To specify our location, Degas devoted one-third of his composition to the inward-slanting door on the right, and gave the door jamb a narrow strip on the left. Like stage flats and corridor walls, these rectangular areas both reveal and conceal: partial concealment makes disclosure all the more intriguing. Here we see a star dancer whose pink tutu is being adjusted by an assistant or her mother (mothers often took on this role), crouched down behind her. To her left, only noticed upon a second glance, is the profile of a moustachioed man in formal dress, watching' (110). Here, Herbert's description of the painting implies not only a story, but a story in which 'we' are a protagonist. 'We are positioned' in this story, inside the diegetic space of the painting: we are not standing in a gallery looking at a painting; no, we are 'in a corridor, looking into a dressing-room.' Degas's composition, Herbert says, has been arranged for the benefit of this 'we,' this character in the story: 'to specify our location,' and further, to make this location 'all the more intriguing.' 'We' thus becomes a voyeur, peeking into the dressing-room. In that respect, it is possible that 'we' are already projected *into* the painting, in the shape of the 'mustachioed man in formal dress, watching'; or, if one wanted to extend the narrative even further, the man in formal dress is the *authorized* watcher (the dancer's patron), and thus a rival to 'we,' the *un*authorized watcher, the voyeur in the corridor.

All these narrative implications are present, I believe, in Herbert's commentary; I am much less convinced that they are present in Degas's painting. A painting may certainly be seen as positioning its viewer, through devices of composition, perspective, and focalization; but that positioning is not directed at a stance within the diegetic space of the painting. Rather, the viewer's stance is a strategic one: it is, simply, the position from which this topic can best be seen, without regard to whether or not that position is diegetically possible. (Frequently, the viewer's position, if conceived in literal diegetic terms, would be suspended in mid-air.) This position is, as Drucker says, 'a construct, a set of ... effects,' not a 'real' point of view. The *fiction* of diegetic presence is entirely produced by narrativization, and especially by the use of the word 'we,' a verbal gesture that silently extends that narrative from the critic to the viewer himself.

I say '*him*self' deliberately: as in the case of the Degas painting, the narrativized viewer is almost always male. There are sociological reasons for this: in many societies, only the male has the freedom of movement to be plausibly envisaged as the privileged viewer. There are also narratological reasons: as many feminist critics have argued,[6] within the context of a patriarchal society, any form of narrative tends to construct its fictional subject as male. The stories told by art criticism are not exempt from this bias.

As 'we,' the viewer is envisaged as part of the story; his supposed 'presence' within the diegetic space of the narrativized image is not only inferred but regarded as an integral part of the story. This narrativized viewer cannot, of course, be *seen* directly in the painting: he is held to occupy the position of the painter, the source of the gaze. Very occasionally, this narrativized viewer may, in fact, 'appear' on the canvas. He can only do so, of course, through the intervention of a mirror – as in Manet's *A Bar at the Folies-Bergère*.

The paradox of the mirror is that it reveals what should not be revealed: it makes visible an imaginary, fictional position. Thus, in *A Bar at the Folies-Bergère*, the mirror may be taken to reveal a site occupied by both the painter (Manet) and the narrativized viewer. Manet's position, however, is clearly fictional: no one suggests that he actually carried his canvas and brushes into the bar at the Folies-Bergère. But the position of the narrativized viewer is no less fictional: it has to be, if it is to occupy the 'same' space as 'Manet.' This position is the spot occupied by the gentleman in formal dress whose reflection we see in the mirror, and it is the position from which narrativization tells its story: an ob-

server faces the barmaid, and perhaps engages her in conversation. (Historical research on the Folies-Bergère of the 1880s strongly suggests that such conversation would have been for the purposes of prostitution.) The viewer is in turn encouraged to imagine him or herself in some narrative relation to this figure – but such a relation need not at all take the form of saying 'We are the gentleman in formal dress,' with its implied rhetoric of identification.

The viewer (especially the female viewer) may well wish to resist that identification, and may in fact see the whole meaning of the painting as lying in that resistance. The fictional position of the narrativized viewer is, in Manet's painting, the archetypal sexist position of the male voyeur, gazing at the woman as a sexual object that he may purchase or possess. By placing 'us' in this position, the painting may attempt to implicate the viewer in that sexism, as is suggested by Robert L. Herbert: 'We can't really be that man, yet because we are in the position he would occupy in front of the bar, he becomes our second self. His disembodied image seems to stand for a male client's hidden thoughts when facing such an attractive woman' (81). Thus, 'we' = 'our second self' = 'male client.' The effect of this narrativization is to suggest that the position of the observer in this painting is necessarily male and sexist. But the individual viewer, male or female, has every right to resist that implication.

It is this implied identification with the male gaze that I find most prevalent, and most distressing, in criticism that uses the trope of the narrativized 'we.' To offer another example: Richard R. Bretell, in Pissarro and Pontoise, while discussing the effect of figures painted frontally, so that they seem to stare directly at the viewer, writes that such figures 'engage us and not each other. They, like Manet's prostitutes, charge the pictorial surface with a tension grounded in social and psychological doubt' (138; italics in original). Again, 'us' equals the narrativized viewer/observer, and the fiction is that the figures in the painting can see 'us.' So the one thing that this narrative absolutely does not do is to 'charge the pictorial surface with ... tension' – for this whole trope dissolves the surface. The surface of the painting is no longer regarded even as an Albertian 'window': it is simply not there at all. The space between 'us' and the painted figures is regarded as a continuous one.

This assumption of a continuous space can also be seen in references to the narrativized viewer's assumed ability to move around inside the diegetic space. In Moving Pictures, Anne Hollander describes a fifteenth-century illumination showing the baptism of Christ: 'The configuration

of this shore and bank is given the natural appearance of a stream with someone standing in it, [as] if the viewer were approaching the bank from a certain distance. We can't yet see all of [Christ]; the grassy bank is in the way. But a party of other figures coming toward the scene from the distant right, and also half hidden from us by the near bank, can obviously see all of him already. We will, too, when we get to the edge' (64). This example is obviously ludicrous: it makes no sense at all to attribute to the viewer the potential for this kind of movement inside the diegetic space. But further, as I will now go on to argue, the viewer's freedom of movement within the imagined space is narrativized as an attribute of his maleness.

Thus, in addition to the notion that frontally composed figures 'engage *us* and not each other,' Bretell also writes that they 'keep the viewer *out* of the picture ... [and] make it all but impossible for us to imagine ourselves into the limited pictorial space' (137). Similarly, a depicted barrier in another painting 'hinders ... the viewer's plunge into a deeply gratifying pictorial space' (67). But what exactly is so 'gratifying' about such a 'plunge'? What is ('deeply') gratifying about this whole fiction of the viewer's entry into the diegetic space of the canvas? Why should he so wish to restore the third dimension that the nature of the medium specifically excludes?

The nature of this gratification is stated explicitly (and even proudly) by Leo Steinberg, writing about Picasso: 'If the fill of depicted space presses towards us, it also craves penetration, approaches to be approached, open-laned, as it were, open to impalement or entry, so that the paintings, whatever their ostensible subjects, whether landscapes, still lifes or figures, become simulacra of sexual acts more than of bas-relief' (1979, 121). This whole vocabulary – 'gratifying,' 'plunge,' 'entry,' and of course 'penetration' – is that of male sexuality.[7] 'Depth,' it proclaims, is gratifying only when you possess it, when you violate it. (In Steinberg, the sense of violence becomes quite grotesque: 'impalement.') The narrativized male viewer can possess the painting: imaginatively, by resituating it in three-dimensional space; fictionally, by constructing a narrative in which he has a role to play; socially, by assigning himself unimpeded freedom of movement within that space; sexually, by penetrating that space, or by asserting the power of his gaze to dominate a female object; and of course literally, in that the easel painting is a commodity designed for a bourgeois economy.

Anne Hollander, describing a Dutch painting, Willem Duyster's *Soldiers by a Fireplace*, writes: 'These men are smoking and speaking in low

tones in a clublike ambience; a purely masculine, low-keyed interplay is in process. The glance of the standing man takes neutral cognizance of our presence – we are a man and a member, too' (149). There, in a nutshell (and all the more remarkable for coming from a female critic), is the essence of the narrativized viewer: 'We are a man.'

In relation to Cubism, the problematical nature of a viewer narrativized as male is nowhere more apparent than in one of the most famous articles in the history of Cubist criticism: Leo Steinberg's 'The Philosophical Brothel.' First published in 1972, it was republished, with an introduction by Rosalind Krauss and a new postscript by the author, in *October* in 1988. By that time it was clear that this article, more than any other single piece of criticism, had decisively altered the way in which Picasso's *Les Demoiselles d'Avignon* was interpreted. The old orthodoxy, focusing in a narrowly formalist way on the 'distortions' in the painting's representations of figure and ground, saw it as the first Cubist painting. The new orthodoxy, which focuses on the expressionist reasons for that distortion, and thus on the view of women that the painting projects, holds that it is *not* the first Cubist painting. 'Indeed,' wrote William Rubin in 1983, 'this great and radical work pointed mostly in directions opposite to Cubism's character and structure' (1983, 628).

The change was due, to a surprisingly great extent, to the simple fact that the sexual content of the painting was now openly acknowledged. Steinberg has some telling fun in quoting extracts from earlier critics who had gone to absurd lengths to avoid talking about the subject-matter. In 1979, Steinberg wryly commented: 'I hate to get credit merely for pointing out that a picture of naked whores in a brothel may have somewhat to do with sex. (Far more remarkable, surely, is the feat of repression that enabled critics for 50 years to think otherwise)' (1979, 124).

Fair enough: but 'The Philosophical Brothel' does far more than simply point out that *Les Demoiselles* 'may have somewhat to do with sex' – as the coy tone of that 'somewhat' already begins to suggest. Rather, what it does is to produce a fully narrativized account of the painting, in accordance with the 'We are a man' motif, which reveals itself to be both sexist in itself and also complicit with the sexism of the painting.

In her introduction to the 1988 reprint, Rosalind Krauss writes that Steinberg 'does not secure his new reading by means of a text ... [Rather,] it is the viewer's body, as a matrix of reception, that Steinberg reconceives as the securer of meaning' (4–5). Krauss here is commenting on the following lines in Steinberg: 'The shift is away from narrative and

objective action to an experience centered in the beholder. [¶] The work, then, is not a self-existent abstraction, since the solicited viewer is a constituent factor' (14–15). My argument in this chapter has been that such a concept of the viewer is not at all a 'shift ... away from narrative' or from 'text': rather, it *is* narrative, it *is* text. This viewer who becomes a 'constituent factor' is fully narrativized; the viewer's body (the 'matrix of reception') is specifically textualized as male.

In Manet's *A Bar at the Folies-Bergère*, the male client, doubling as the narrativized viewer, was projected into the picture as a mirror reflection. The reverse process took place in the composition of *Les Demoiselles d'Avignon*. The early sketches show that Picasso originally planned to include two male figures in the scene: a sailor and a medical student. While Steinberg never says so explicitly, his argument seems to be that these male figures have now been displaced into the position of the viewer: how else can one account for his use of the word 'solicited'? 'We' are invited (solicited, like customers at a brothel) to narrativize ourselves *as* the sailor and the medical student; again, we are a man.

Steinberg goes on: 'The picture is a tidal wave of female aggression; one either experiences the *Demoiselles* as an onslaught, or shuts it off' (15). This may well be what 'one' does, provided 'one' is a man: but what does the female viewer make of this 'tidal wave'? Does she too see it as 'aggression,' an 'onslaught'? (Actually, she may well see it as an aggression, but on whose part, against whom?)

For Steinberg, pictorial narrative is always reciprocal; it is an active exchange between the depicted characters and the narrativized viewer. 'The assault on the viewer is only half the action, for the viewer, as the painting conceives him [sic, of course] on this side of the picture plane, repays in kind ... We are implied as the visiting clientele, seated within arm's reach of the fruit – accommodated and reacted to' (1988, 15).

Later in the essay, Steinberg returns to this assumed interaction: 'Hence the repetition of vectors that define the orthogonal axis – inward from the spectator's station, by way of the penetrant table, past the masked curtain raiser who unveils an event of overwhelming proximity: the sudden exposure of cornered whores startled by our intrusion and returning our gaze. Without the mutual dependency of aroused viewer and pictorial structure there is no picture. The whole picture, form and subject together, strives against educated detachment' (46–7). This passage reflects what I said earlier about the narrativized viewer's 'gratification' in 'penetrating' into the pictorial space. Steinberg's vocabulary

here is loaded with sexist implication: *penetrant* table, *exposure* of *cornered whores*, 'our' *intrusion, aroused* viewer.[8]

But Steinberg is just getting started. 'Picasso,' he writes, 'wanted his doxies depersonalized and barbaric' (53). *Doxies?* And later: 'Picasso's return to nature in the *Demoiselles* must be ironic – not to Arcady, but to the city stews. Hence the smell of the hothouse, the effect of a caged jungle whose graceless inmates, at once frightened and frightening, awesome and comical, start up like jerked puppets. That squatter at the right – was there ever a trollop more like a jumping jack?' (54). Stews – smell – hothouse – graceless – jerked puppets – squatter – trollop ... What is happening here? What is happening, I think, is that the critic is getting drawn into the stance of the narrativized viewer. 'We are a man': Steinberg is becoming the male client, and his language is becoming more and more pornographic.

I do not have the space here to argue in detail the much larger, more complex, and ultimately far more important question of the extent to which Picasso's painting itself is as sexist and misogynist as Steinberg's account of it. Briefly, I believe that it is: it portrays women as Other, so radically other that they can evoke fear, awe, disgust, admiration, worship, abhorrence – anything but love, anything but a reciprocal relation between two human beings. Even the political implications of Picasso's use of 'primitive' art reinforce this sense of otherness. For Steinberg, Picasso's 'reason for making them savage was the same as his reason ... for making them whores. They were to personify sheer sexual energy as the image of a life force. The primitive was let in because that's what the subject craved' (53). Again, 'sheer sexual energy' and 'life force' may be positive terms, but they are also depersonalized. Woman as 'life force' is no less Other than woman as 'jerked puppet.' The primitive 'was let in,' says Steinberg in an evasive passive, 'because that's what the subject craved,' not because it is what Picasso, the macho young Spaniard, desired. William Rubin tries to talk his way around this point: 'To be sure, comparable attraction/repulsion syndromes are commonplace in male psychology. But in the *Demoiselles*, as often in the work of a great artist, such inherently banal material is so amplified by the spirit of genius that it emerges as a new insight – all the more universal for being so commonplace' (629). This is sheer rationalization, using a very romantic notion of 'genius' to avoid any moral judgment. Steinberg, more unashamedly, thinks that Picasso's equation of sex and painting, of his penis and his paintbrush, is his ultimate profundity. Rubin is

evidently uneasy, but his sidesteps are unconvincing. What does 'amplified' mean in that quotation? How is sexism improved by being amplified?

However, my major point here is not concerned with Picasso's sexism, or even with Steinberg's: it is with the sexism that I see as being implicit in the whole trope of the narrativized viewer, 'we are a man.' Steinberg's essay is a prime example of how this trope takes on a rhetorical life of its own, of how it generates its own meaning. I do not wish to argue that *all* narrativization of painting is automatically bad, though I do think that we should always be suspicious of it. Nor do I wish to argue that all attempts to talk about the position of the observer are necessarily illegitimate. What I do wish to stress is that the ways we talk about the observer are, in a patriarchal society, inevitably informed by sexist assumptions and structures – and, particularly, that if we adopt the linguistic fiction of talking about the observer as 'we,' then we have to recognize that 'We are a man,' and be on our guard against the consequences.

Further, narrativization of this sort is an extreme example of the 'linguistic imperialism' against which critics who believe in the purity of the visual protest. In this particular case, their protest may be justified; but the justification lies in the abuses produced by this rhetorical strategy, not in the fact that the space for rhetoric is already there. Narrativization may not always be the most sensitive or productive response to a painting, but it is an inevitable one. It is part of what happens, for better or for worse, whenever infinity goes up on trial.

CHAPTER THREE

Apollinaire and the Naming of Cubism

Critics should help people to see for themselves; they should never try to define things or impose their own explanations, though I admit that if – as nearly always happens – a critic's explanations serve to increase the general obscurity that's all to the good. French poets are particularly helpful in this respect. Few of them have understood the first thing about modern painting yet they are always trying to write about it.

Georges Braque, 'The Power of Mystery'

The most important single way in which language frames and supplements painting is through the discourse of criticism. Criticism enters the field of painting as a narrative, most often as a retrospective narrative: it tells people not so much what they are seeing as what they have seen. It constructs lines of influence and successions of groupings; in the museums, it leads you from the room marked Impressionism to the one marked Post-Impressionism. It loves the linearity of cause and effect; it demands that both painters and styles be consistent. Above all, it exercises its power through the process of *naming*.

Every movement or style in painting needs to be named. The very coming-into-existence of a new style opens up a gap in the discourse (which is also a gap in the painting itself), and invites the supplement of naming. Within the institutionalized circles of the modern art world, it is the critic who appropriates this power. As Donald Kuspit writes: 'A sign of the critic's power, in modern times, is his *naming* of new art. Louis Vauxcelles' labels "Fauvism" and "Cubism," for instance, have had an enormous influence on the understanding of these styles. Through such names art assumes an identity for future generations ... Clement

Greenberg once wrote that the best moment to approach a work of art critically was after the novelty had worn off but before it became history. Yet it is at just that moment that the work is most unsettled and vulnerable, when the critic's swift "decision," in the form of an impromptu name, can seal its destiny forever' (1980, xvii).

The naming of a style or a school acts like a frame: it delineates a particular body of painting and sets it off from the rest of the visual continuum. However, in the manner of Derrida's parergon, the frame is always permeable. The effort to delimit and define always fails: the verbal gesture of naming leaks back into the general field of textuality. Any name given to a body of work (like 'Cubism') necessarily participates in this double status: the name belongs to the work, as its defining attribute, yet simultaneously does not belong to it, comes to it from the outside (like a supplement), and (like a supplement) betrays its interiority back into that linguistic 'outside.'

This chapter, then, will present a case study in naming. Despite the casual assertion, by Kuspit and so many others, that Louis Vauxcelles 'named' Cubism, the process by which that name became established was a long and complex one. In my naming of this naming, I assign the leading role to one critic, Guillaume Apollinaire, but my argument will be that, though he was more responsible for the naming of Cubism than any other single figure, he did so ambiguously, unwillingly, and in response to events over which he had little control. In the retrospective narrative, indeed, it seems as if the name were inevitable: as if language itself 'chose' to speak this name. But that, of course, is a fiction.

In his *Anecdotal History of Cubism*, published in 1912, the poet, critic, and novelist André Salmon[1] wrote that '[s]chools [in painting] disappear for want of convenient labels. This is annoying for the public, for it likes schools – they enable it to see clearly without effort.[2] The public accepted cubism very docilely' (quoted in Fry 1966, 86). These words come from a passage that is decidedly humorous in tone, and should probably be taken tongue-in-cheek. In 1912, the Parisian public was far from accepting docilely the value or even the integrity of Cubism; and if they did accept the word, it was mainly as an insult.

The purpose of this chapter is to trace, in some detail, the way in which the word 'Cubism' became accepted, the way it was transformed from an insult into the accepted label of the most important movement in the history of twentieth-century art. This process is neither as simple nor as straightforward as most brief histories of the period give one to

understand; it was a process complicated as much by the painters them-
selves as by the hostile critics.

The most important critical figure in this period, so far as Cubism is
concerned, is the poet Guillaume Apollinaire. It will therefore be useful
to look first at the vexed question of Apollinaire's standing and qualifi-
cations as a critic of painting.

There is no dispute about the extent and importance of Apollinaire's
activities; what has been questioned is the value of his theoretical and
critical *ideas*. In the introduction to *Apollinaire on Art*, the collected vol-
ume of Apollinaire's essays and reviews, LeRoy C. Breunig concludes
that 'his magnetism, his all-embracing enthusiasms, his very ubiquity
in prewar Paris made him beyond a doubt the main impresario of the
avant-garde' (xvii). During these pre-war years, Apollinaire wrote a
vast amount of art criticism. He contributed almost daily to the news-
paper *L'Intransigeant*, and later to *Le Journal*, as well as writing numer-
ous occasional articles, essays, and catalogue introductions. Breunig's
edited selection from these writings runs to 473 pages. Much of this
mass of material was of course ephemeral journalism; but once such
allowances have been made, there still remains a question as to whether
Apollinaire had any real competence as an art critic.

One of the strongest spokesmen for the negative view is Francis
Steegmuller, author of *Apollinaire: Poet among the Painters*. Despite his
title, Steegmuller does not think much of Apollinaire's merits as a critic
of art. He talks of Apollinaire's 'somewhat dim perception of painting'
(232), picks on a couple of debatable factual errors (out of the whole
mass of the art reviews), and goes on at absurd length about Apollinaire's
poem 'The Virgin with the Bean Flower at Cologne' – the point being
that in the original painting on which the poem is based the Virgin is
holding not a bean flower but a pea blossom. This may indeed say
something about Apollinaire's knowledge of botany, but it scarcely seems
sufficient ground for Steegmuller's conclusion that 'it is difficult to dis-
cover, in all of Apollinaire's art writings, a mention of a picture that
sounds as though the picture has been seen – let alone seen as an
artist's image' (145–8). In Steegmuller's version, Apollinaire's great gift
for spotting new talent is reduced to a clever sneer: 'For innovation in
art Apollinaire had an erratic flair, like that of a hound who picks up ·
too many scents, and he did a good deal of happy, excited barking
about it' (150).

Steegmuller does, however, assemble some devastating statements
from Braque, Picasso, and Kahnweiler. All of them protest that they

dearly liked Apollinaire as a friend, and that they have a great respect for his poetry; all of them freely admit that they gratefully made use of his gifts as a propagandist for their cause; but they are unanimous in their dismissal of his criticism. Braque had little use for critics in general, as is shown by the epigraph to this chapter, which was aimed directly at Apollinaire, who, Braque claimed, 'couldn't tell the difference between a Raphael and a Rubens' (18). (The only poet whom Braque excepted from his strictures was Pierre Reverdy, whose writings on art were held in high esteem by all the painters.)

Picasso is slightly more gentle: 'Discussing Apollinaire's collected art writings ... Picasso commented that it was sad to find how shallow they were, how little good sense they contained, when one remembered how important they had seemed to be at the time of publication' (Steegmuller 143).

As for Kahnweiler, his biographer Pierre Assouline records: 'From the first Kahnweiler recognized that Apollinaire was a great poet, and he sincerely admired him, but he did not trust his taste in art. Apollinaire's approach to painting was sensual and intellectual, and he reacted as a friend, supporting the works of artists he liked, drawn especially toward the experimental. No matter what others said, Kahnweiler did not believe that Apollinaire was a good art critic and never missed an opportunity to let him know it, which often strained the atmosphere' (52). Steegmuller quotes Kahnweiler as saying of Apollinaire, 'What vitiated his writings on esthetic matters was his complete lack of plastic sensibility' (143).

These are weighty opinions, and when one turns to the bulky volume of *Apollinaire on Art*, one finds certain aspects of them clearly borne out. Apollinaire's criticism is always subjective and impressionistic, and frequently vague. He rarely if ever discusses particular paintings in detail, and he has practically nothing to say on questions of painting technique. One turns to an essay entitled 'The Three Plastic Virtues,' expecting, from the adjective 'plastic,' to find something specifically and distinctively applicable to the visual arts; instead, one finds a three-page effusion on purity, unity, and truth. The essay places Apollinaire within a tradition of Symbolist criticism, but it offers no evidence in support of a specifically 'plastic' sensibility.

Apollinaire's writing, which is always impressionistic and frequently, in the gushy sense of the word, 'poetic,' becomes especially so whenever he is writing about Picasso. The earliest essays were written at the

time of the Blue and Rose Period paintings, which of course lend themselves all too easily to this sort of thing:

> Grown old the way oxen die at twenty-five, young men have carried infants suckled by the moon.
> In pure sunlight, women remain silent, their bodies are angelic and their glances tremble.
> In the face of danger, their smiles become internal. They await fear to confess innocent sins.
> For the space of one year, Picasso lived this painting, wet and blue like the humid depths of the abyss, and pitiful. (*Apollinaire on Art* 15)

That was written in 1905; but as late as 1913, when Picasso had moved to the lucid clarities of Synthetic Cubism, Apollinaire could still write, 'Picasso conceived the project of dying when he looked at the face of his best friend and saw his circumflex eyebrows galloping in anxiety' (ibid. 280).

What, then, are the virtues of Apollinaire's art criticism, and why does he remain an important figure in this connection? The beginnings of the answer may be found in this description of him by Gertrude Stein in *The Autobiography of Alice B. Toklas*: 'Guillaume was extraordinarily brilliant and no matter what subject was started, if he knew anything about it or not, he quickly saw the whole meaning of the thing and elaborated it by his wit and fancy carrying it further than anybody knowing anything about it could have done, and oddly enough generally correctly' (1960, 59).

'Oddly enough generally correctly': this was Guillaume Apollinaire's tremendous gift. In the confusing welter of styles, movements, fashions, and innovations of the Paris art world, Apollinaire was almost always *right*. He was, it must be admitted, often too kind in his daily reviewing, allowing some merit to many people whose work has not survived; but he was also a witty and merciless deflator of established reputations. With the possible exception of Van Dongen, whom he detested, none of the painters whom he attacked has in any significant way lasted.[3] He proclaimed the greatness of Ingres at a time when it was less than fashionable to do so in either established or avant-garde circles. He unerringly picked Cézanne and Seurat as the greatest artists of the preceding generation. After brief initial misgivings, he became the leading advocate of Henri Rousseau and of Robert Delaunay, while from

the very first sight of their work he championed Braque, Picasso, Gris, Léger, Matisse, Derain, Vlaminck, Picabia, Duchamp, Dufy, Chagall, De Chirico, Marcoussis, Metzinger, Gleizes, and Marie Laurencin. It is an astounding record. Admittedly he was close friends with many of these artists, and must have profited from their advice, but it is absurd to suppose that he was merely the mouthpiece for their opinions. No other contemporary critic was as effective or influential in picking out the artists who would come to be seen as forming the modern canon.

The question of Apollinaire's *competence* as a critic of art may well remain open; but of his importance, and, in a wider sense, of his value, there is no doubt. Two comments from recent writers may summarize the status of Apollinaire's reputation today. Lynn Gamwell concludes: 'To appreciate him, one must read Apollinaire both in totality and in context. Looseness in his style is outweighed by the remarkable breadth and quantity of his reviews and essays, most of which were written under deadlines. What appears sometimes as an uncritical attitude is rather Apollinaire's selfless support of the underdog. His instinct for the key issue is invariably accurate and is the basis for his extreme importance' (103). And Rosanna Warren writes: 'Apollinaire's art criticism is not criticism at all: it is notes for a new translation of painting into poetry, the visualization of a new poetic space' (552).

In the autumn of 1908, Georges Braque submitted six paintings to the Salon d'Automne; the jury, which included Henri Matisse, rejected them. One of the legends of Cubism is that Matisse, confronted with Braque's views of the houses at L'Estaque, commented scornfully, 'Ce ne sont que de petits cubes' – nothing but little cubes. This story was reported by Apollinaire as early as 1911, and Braque himself maintained its accuracy to the end of his life; Matisse, however, always denied it.

Braque withdrew all his paintings from the Salon, and exhibited them six weeks later at Kahnweiler's gallery. The preface to the catalogue was written, in ecstatic style, by Guillaume Apollinaire: Braque 'is an angelic painter. Purer than other men, he does not pay heed to anything foreign to his art that would make him fall from the paradise he inhabits' (*Apollinaire on Art* 50–2). On 14 November 1908, Louis Vauxcelles, the namer of Fauvism, reviewed this exhibition in *Gil Blas*: 'EXPOSITION BRAQUE Chez Kahn Weiler [sic], 28, rue Vignon. Monsieur Braque is a very daring young man. The bewildering example of Picasso and Derain has emboldened him. Perhaps, too, the style of Cézanne and reminiscences of the static art of the Egyptians have obsessed him dis-

proportionately. He constructs deformed metallic men, terribly simpli-
fied. He despises form, reduces everything, places and figures and
houses, to geometrical schemes, to cubes. Let us not make fun of him,
since he is honest. And let us wait' (quoted in Fry 1966, 50–1). It is
generally accepted that Vauxcelles picked up the word 'cubes' from
Matisse's spoken jibe. Despite the final sentences, this is clearly a hostile
review, as Dora Vallier points out: 'The context in which this word,
which was to become so famous, first appears allows us to recover the
initial sense of Cubism, which is *coldness* (Braque's figures are metallic),
poverty (terrible simplification, geometrical schemes), and above all *de-
formation*. To have recourse to geometric forms is, in the eyes of
Vauxcelles, to deform. This then is what people meant when they talked
about Cubism in 1908 – and it is natural that the word should have
been adopted as a slogan by the movement's adversaries' (20–1).

Vauxcelles returned to the attack when Braque exhibited at the Salon
des Indépendants the following spring, confirming his earlier reference
with the infamous phrase 'bizarreries cubiques': 'the cubic, and I must
admit barely intelligible eccentricities of Bracke [*sic*] (there is someone,
Pascal would have said, who abuses the geometric spirit!)' (quoted in
Golding 80). This time it is Braque's name that is misspelt, perhaps out
of a patriotic desire to make this bizarre Cubist appear, like Picasso and
Kahnweiler, foreign. (It was also at this time, perhaps for the same
reason, that Vauxcelles used the mystifying term 'Peruvian Cubism.')

After the spring of 1909, Braque ceased exhibiting at the public sa-
lons; Picasso never had; so the central works of Cubism over the next
few years were seen only by a small circle of intimates, and by the less
than numerous visitors to Kahnweiler's gallery. The general public saw
only the followers, the second wave of Cubism: Metzinger, Gleizes, Le
Fauconnier, La Fresnaye – the group that has come to be called 'the
Salon Cubists,' because their work was on display at the public salons.

Purists like Kahnweiler were always opposed to this group, and to
their identification with the name Cubism. Kahnweiler, writes Assouline,
'considered them imitators, without a spark of originality. He was ap-
palled that these were the artists thought to be representative of cub-
ism' (83). For Kahnweiler, to the end of his life, Cubism consisted of
Picasso, Braque, Gris, Léger, and no one else.

Some recent art history has attempted to revise this general denigra-
tion of the Salon Cubists. See for example Daniel Robbins, who argues
against the orthodoxy established by Kahnweiler and carried on by
Alfred H. Barr Jr. 'The work of the other Cubists,' he writes, 'was ruled

out because it failed to conform to the rigors of a very limited defini-
tion. At the least, the historian should analyze other Cubist works with
greater breadth of vision, even if in the process a qualifying adjective
must be added to differentiate between branches of the movement'
(283). The 'qualifying adjective' most likely to be applied to Gleizes and
Metzinger is 'minor,' and to my mind it still seems quite correct. The
kind of revisionism that one sees in Robbins's essay, and throughout
the collection *Revising Cubism* in which it appears, is part of a general
reaction against formalism. The Kahnweiler-Barr narrative of Cubism is
attacked because it is chiefly a formalist narrative. On non-formalist
grounds, once one is more interested in the subject-matter of the paint-
ing, Gleizes and Metzinger become more important. But this emphasis
does tend to gloss over the fact (at least, I would regard it as a fact) that
Gleizes is a terminally dull painter. There is a certain amount of chicken-
and-egg argumentation going on here: did the Kahnweiler-Barr narra-
tive *make* Gleizes a minor painter by calling him one, or was it the
weakness of Gleizes's paintings that prompted the Kahnweiler-Barr nar-
rative in the first place? My own opinion here is clear: I think that there
are some very fine paintings in this group (by Marcoussis especially,
and La Fresnaye), but on the whole they strike me as messy, incoherent,
and dull. But what is interesting about the recent revival of interest in
the Salon Cubists is the question it raises, again, about naming. Is there
such a thing as a 'true,' 'integral' Cubism (which only Picasso, Braque,
Gris, and possibly Léger understood), or do we take a purely nominal-
ist view, in which 'Cubism' is whatever was historically *called* Cubism?
To be sure, by this nominalist standard Robbins is perfectly right.
Metzinger and Gleizes must be included in Cubism simply because
they were called Cubists: that is part of the history of the term and,
while one may (like Kahnweiler) regret it, one cannot ignore it.

By the Salon des Indépendants in the spring of 1910, the new ten-
dency was visible in the exhibits of Gleizes, Metzinger, Delaunay, Léger,
and others. Vauxcelles dutifully leapt to the attack, still brandishing his
favourite phrase: the new painters are 'ignorant geometricians, who
reduce scenery and the human body to dull cubes' (quoted in Golding
22). Apollinaire, just as dutifully, leapt to the defence: but he clearly did
not see 'Cubism' as the central issue, or indeed any issue at all. He does
not even use the word.

There are two probable reasons for this omission. The first is that
'Cubism' was still a term of abuse, and none of the defenders of the
new painting had any wish to encourage its spread. In June 1910, at the

end of a sympathetic and intelligent review of a small private exhibition by Picasso, Léon Werth does speak of 'cubic roofs, cubic chimneys,' but the tone is still decidedly defensive (quoted in Fry 1966, 57–8).

The second reason is that Apollinaire was becoming aware of the split between the private work of Braque and Picasso and the public work of the group around Metzinger and Gleizes; and he was rather annoyed with the attention and publicity granted to the latter group at the expense of the former. This annoyance broke out in October 1910 in his articles on the Salon d'Automne. By chance, the paintings of Metzinger, Gleizes, and Le Fauconnier were hung together, and this increased the impact of the 'Cubists.' In his review for the newspaper *L'Intransigeant*, Apollinaire blithely ignores this juxtaposition and launches into an attack on Metzinger, the point of which seems to be that Metzinger is merely copying Picasso: 'Hung in a corner, as if in punishment, are the two canvases by Jean Metzinger. Metzinger has set himself the task of experimenting with all the various methods of contemporary painting. He is perhaps losing precious time and expending his energies to no advantage. This seems clear enough in the paintings he is exhibiting here, in both of which he appears to me to have taken a step backward. Let him find his own way and stick to it. It is sad to see an intelligent painter wasting his time on sterile undertakings' (*Apollinaire on Art* 111). Shortly afterwards, in an article on the salon for the magazine *Poésie*, Apollinaire made his attack more explicit, and in so doing wrote for the first time the word Cubism, coupling it with Vauxcelles's adjective 'bizarre': 'There has been some talk about a bizarre manifestation of cubism. Badly informed journalists have gone so far as to speak of "plastic metaphysics." But the cubism they had in mind is not even that; it is simply a listless and servile imitation of certain works that were not included in the Salon and that were painted by an artist who is endowed with a strong personality and who, furthermore, has revealed his secrets to no one. The name of this great artist is Pablo Picasso. The cubism at the Salon d'Automne, however, was a jay in peacock's feathers' (*Apollinaire on Art* 114).

During the winter of 1910–11, the group around Metzinger and Gleizes became closer and more organized. Gleizes later wrote: 'It was at this moment, October 1910, that we discovered each other seriously ... The necessity of forming a group, of frequenting each other, of exchanging ideas, seemed imperative' (quoted in Golding 24). Besides regular meetings at the famous Symbolist café, the Closerie des Lilas, there were weekly meetings at the studios of Le Fauconnier and of Gleizes himself.

Dora Vallier sees in the stress that the group (especially Gleizes) placed on their indebtedness to Cézanne 'a good indication of the group's desire not to be associated with Picasso' (22). The paradoxical result was that there were then in Paris two separate groups of 'Cubists,' neither of whom claimed that name, working in isolation from each other: on the one hand Braque and Picasso, roped together on their mountain; and on the other hand Gleizes, Metzinger, Delaunay, Léger, and Le Fauconnier, exhibiting at the public salons and attracting the derogatory name Cubists.

Apollinaire was aware of this split, and during the winter of 1910–11, while maintaining his close friendship with Picasso, and despite his harsh words about Metzinger at the Salon d'Automne, he drew closer to the public group. It was always one of Apollinaire's great gifts to be able to move on friendly terms between all the various groupings of the avant-garde. Douglas Cooper speaks of this rather scornfully when he says, 'It was ... Apollinaire, the perfect fixer, who in the name of friendship and The Modern Movement, was the most adept at glossing over irreconcilable differences of outlook' (104). More sympathetically, Gertrude Stein was later to blame the fragmentation of the Parisian art scene after the war not so much on the disruptive effects of the war in general as on the particular death of the soldier and war hero Guillaume Apollinaire. 'It was the moment just after the war,' she wrote, 'when many things had changed and people naturally fell apart. Guillaume would have been a bond of union, he always had a quality of keeping people together, and now that he was gone everybody ceased to be friends' (1960, 60).

For the spring Salon des Indépendants of 1911, the Gleizes/Metzinger group organized a very successful *coup* of the salon's annual general meeting, and appointed themselves to the hanging committee. As a result, they were able to show their work together in rooms 41 and 43 of the exhibition, with the intervening Room 42 being given over to a retrospective exhibition of Henri Rousseau, who had died the previous year. Apollinaire was deeply involved in these manoeuvrings, and at his request the group included in Room 41 two paintings by Marie Laurencin, who was still at that time Apollinaire's lover. This inclusion is a perfect example of what Cooper would call 'glossing over ... differences': Marie Laurencin is a charming and delicate painter, but by no stretch of the imagination could she be called Cubist. Her very presence in the central Room 41 is testimony to the strength of Apollinaire's

influence with the group that he had been attacking barely six months previously.

The opening of the salon proved a *succès de scandale*: the central rooms were packed all day with furiously arguing crowds. Most of the established critics, led as usual by Vauxcelles, published violent attacks. Gleizes in his memoirs recalls how the painters, taken aback by the intensity of the crowd's reaction, 'adjourned to the exhibition café, and waited quietly for what would happen next. At five o'clock *L'Intransigeant* appeared, with Guillaume Apollinaire's article. He stressed the importance of our demonstration and defended us vehemently' (quoted in Fry 1966, 173).

Apollinaire's review is indeed full of praise, especially for Delaunay and Marie Laurencin. But if he is now reconciled to the painters of this group, he is still not reconciled to the word Cubism. It does not appear at all in his discussion of Delaunay, Le Fauconnier, Gleizes, or Léger; Roger de la Fresnaye even turns up, in what was by 1911 rather an anachronism, as a 'young Fauve.' Only in relation to Metzinger does Apollinaire use the word Cubism, and his use of it is ambiguous and somewhat puzzling. 'Metzinger's are the only works here that can properly be called cubist,' he says; and his assessment of Cubism – 'On the whole, the method is not tiresome' – can scarcely be called enthusiastic (*Apollinaire on Art* 151). The formulation 'cubisme proprement dit' is, as Dora Vallier comments, 'an astonishing phrase, which clearly indicates that for Apollinaire there still exists a "cubisme proprement dit" separate from the rest, but he does not define just what it consists of' (22). Presumably Apollinaire had Braque and Picasso in mind; but if so, this is the first time that he has described *their* work, even by implication, as 'Cubist.'

This review, which Apollinaire's leading French biographer, Pierre-Marcel Adéma, nicely describes as 'très nuancée' (180), proved to be Apollinaire's last stand against the acceptance of the word Cubism. It appeared on 21 April; on 10 June an exhibition opened in Brussels that featured, among others, Delaunay, Léger, Gleizes, and Le Fauconnier, with a catalogue preface written by Apollinaire. 'The new painters who jointly proclaimed their artistic ideal at this year's Indépendants in Paris,' the preface begins, 'accept the appellation of cubists which has been bestowed on them' (*Apollinaire on Art* 172). Looking back at this event just over a year later, Apollinaire said, 'The first appearance of cubism outside France took place ... in Brussels; in the preface to that

exhibition, I adopted, in the name of the exhibitors, the appellations "cubism" and "cubists"' (ibid. 257). It is clear that Apollinaire sees himself as acting as an official spokesman for the painters, and so it is probable that he received some kind of authorization from them to speak on their behalf – but none of the histories or memoirs of the period points to a specific occasion on which this authorization might have occurred. It is also clear that the painters 'in whose name' Apollinaire 'accept[s] the appellation of cubists' are the Salon Cubists, *not* Braque and Picasso.

To some extent Apollinaire was simply making the best of a bad job. The term was widely used as an insult, and the painters did not (as yet) have any convincing alternative to offer. Apollinaire later tried to make a virtue out of this necessity, and in October 1912 he applauded the 'admirable courage' of those who had 'taken as their own the burlesque name with which people tried to ridicule them' (*Apollinaire on Art* 253). He also described them as 'the young French artists who, as proof of the profundity of their art, proudly bear the name cubists – a name originally used to ridicule them' (ibid. 262).

But for Apollinaire himself it was a complete about-face. He who as late as April 1911 had been willing to admit only Metzinger to the ranks of 'cubisme proprement dit' now begins to toss the word around with abandon. The same distrust and ambivalence that had for so long prompted him to restrict his use of the word now leads him, it could well be argued, to attempt to discredit its efficacy by as indiscriminate a use as possible. Certainly, his attitude towards the term Cubism is no less ambivalent *after* he 'accepts' it than it was before.

This continued ambivalence is clear as early as the Brussels catalogue itself. Immediately after that opening sentence, Apollinaire continues: 'Nevertheless, cubism is not a system; the distinctive differences, not only in the talents, but also in the manners of these artists are ample proof of that.' He blurs the distinction between Cubism and Fauvism: 'The result of these two artistic movements, which have succeeded and complemented each other so well, is a simple and noble art, at once restrained and expressive, ardent in its search for beauty.' And of these decidedly vague generalizations, he concludes: 'I think that in these few words I have indicated the real significance of cubism: It is a new and very noble manifestation of art, without being a system that fetters talent' (*Apollinaire on Art* 172).

Four months later, reviewing the 1911 Salon d'Automne, Apollinaire, now using the word Cubism freely for the first time to a Parisian audi-

ence, again stresses the looseness of his definition: 'Cubism can in no way be considered a systematic doctrine,' and it is certainly 'not, as is generally thought, the art of painting everything in the form of cubes' (*Apollinaire on Art* 183). This leads him into the first of several historical accounts of the origins of Cubism; and like the subsequent ones it is not entirely accurate. For Apollinaire here attributes to Picasso the paintings by Braque that Vauxcelles reviewed, and for which he himself, Apollinaire, had written the catalogue preface less than three years before!

By late 1911 to early 1912, the term Cubism was in general use by critics and painters alike, both friendly and hostile, both intelligent and stupid. Vauxcelles was still on the attack: 'The cubists are a bunch of jokers, followers of Picasso, who was a talented colorist and now an equally talented imposter. He composes nudes geometrically, pyramidically, rhomboidically. It's frighteningly ugly and of a ridiculous pretentiousness. The cubists reduce the human figure to a mass, a paralleliped cube.... [Léger] replaced the cube with tubes and he is a tubist. His model is the iron pipe, so that it's not painting, it's plumbing' (quoted in Assouline 82). Roger Allard, on the other hand, offers a definition considerably more precise than anything attempted by Apollinaire:

What is cubism? First and foremost the conscious determination to re-establish in painting the knowledge of mass, volume and weight.

In place of the impressionist illusion of space, which is founded on aerial perspective and naturalistic colour, cubism gives us plain, abstract forms in precise relation and proportion to each other. Thus the first postulate of cubism is the ordering of things – and this means not naturalistic things but abstract forms. Cubism feels space as a complex of lines, units of space, quadratic and cubic equations and ratios. (quoted in Fry 1966, 70–1)

In contrast to Allard's precision, and to the highly intelligent if unsympathetic criticisms of Jacques Rivière (quoted in Fry 1966, 75–81), Apollinaire in 1912 continued to use the word loosely and indiscriminately. Despite the fact that he had broken with Marie Laurencin, he approved and repeated the pleasantry that named her 'Our Lady of Cubism,' and provided the response, 'Hail, Marie, full of grace' (*Apollinaire on Art* 229).

In his review of the Salon des Indépendants in March 1912, two new and important tendencies appear in Apollinaire's attitude. The first is,

embryonically, the tendency to subdivide. A painter called Frank Burty, who was a friend of Picasso and a collector of Negro Art, is discussed as 'the Timid Cubist'; and Juan Gris, making his stunning debut with his portrait of Picasso, is said to represent something called 'Integral Cubism' (*Apollinaire on Art* 214–15). This particular category never reappears, but the impulse to subdivide was to become, later in the year, of major importance.

The second tendency is Apollinaire's unwillingness to see Cubism as an end in itself, but rather as the means to a greater end. In February 1912, in an essay entitled 'On the Subject in Modern Painting,' he had written: 'An entirely new art is thus being evolved, an art that will be to painting, as painting has hitherto been envisaged, what music is to literature. It will be pure painting, just as music is pure literature' (*Apollinaire on Art* 197). In 1912 Apollinaire began to see such a development in the work of Robert Delaunay. He regarded Delaunay's *Ville de Paris* as 'the most important picture' in the salon (ibid. 212), and he saw it as a definite accomplishment rather than as a provisional experiment. The conclusion is astonishing. Less than a year after the Brussels exhibition, Apollinaire writes: 'The time is perhaps past for speaking about cubism. The time of experimentation is over' (ibid. 216). And in another article written at the same time: 'It is no longer a question of experimentation, of archaism, or of cubism' (ibid. 219). This equation of Cubism with transient experimentation, and even archaism, is clear evidence of Apollinaire's continuing ambivalence towards the very concept of a Cubist movement.

This ambivalence was shared by a group of painters who, in the course of the year 1912, made the only serious attempt to promote an alternative name. At the Salon d'Automne of 1911, the group headed by Gleizes and Metzinger met for the first time the extraordinarily talented family of three brothers from Normandy, Marcel Duchamp, Raymond Duchamp-Villon, and Jacques Villon. The group began to meet at Villon's studio in Puteaux, where they also met the Czech painter Frantisek Kupka. This was the group that arranged, in October 1912, one of the largest and most important of the Cubist exhibitions. But they did not call themselves Cubists: they called themselves La Section d'Or.

Whereas Gleizes and Metzinger were saddled with the name Cubism by virtue of their history, the Duchamp/Villon brothers were not. Dora Vallier, in her essay on Jacques Villon, which is to a great extent a history and a defence of La Section d'Or,[4] points out that they had had 'a different evolution, in the sense that they hadn't seen any paintings by Braque, far less by Picasso' (24). This distancing, coupled with what

Vallier calls the 'fragility' of the word 'Cubism,' led them to accept the new name, which was suggested by Jacques Villon.

In classical geometry, the 'golden section' refers to the unequal division of an area in which the proportion of the small part to the large is the same as that of the large part to the whole. (For convenience I shall use the English term 'golden section' to refer to the geometrical figure, and the French term 'La Section d'Or' to refer to the painters.) The painters of La Section d'Or were in fact very interested in the golden section; one of their major pursuits in 1912 was the study of a recently published translation of Leonardo da Vinci's *Treatise on Painting*, which stresses the golden section's importance in establishing a picture's composition. Since 'orthodox' Cubism represented a decisive break with Renaissance concepts of perspective and composition, the very choice of the name La Section d'Or represented a political declaration of independence.

Ultimately, the most rigorous use of geometrical ideas such as the golden section was to be made by Jacques Villon, who also developed an equally exact and objective rationale for his choice of colours. Juan Gris also used the golden section, and made geometrical sketches in preparation for his paintings. There was a good deal of talk about mathematical concepts, some of which was very vague and more than slightly bogus, as with many of the references to a 'fourth dimension' in Cubist painting. Much of this talk centred on the figure of Maurice Princet;[5] Metzinger, as early as 1910, spoke of Picasso's 'free, mobile perspective, from which that ingenious mathematician Maurice Princet has deduced a whole geometry' (quoted in Fry 1966, 50). Of course, no such system existed for Picasso, and Princet's importance was greatly exaggerated by contemporary critics; but the stress on geometry, as an ordered, measurable, and traditional base for experimentation, was central to the ideas of La Section d'Or, and distinguished it from the less theoretical, more instinctive methods of Braque and Picasso.

The existence of La Section d'Or once more threw the name Cubism into doubt. In June 1912, Maurice Raynal grudgingly referred to the 'cubists' – in quotation marks – and added, 'They have to be given this label, misleading though it is' (quoted in Fry 1966, 92). In October, Olivier Hourcade wrote that 'the term "Cubism" ... means nothing if it is used to designate a school: there is no school of Cubist painting ... The main interest of Cubism is the total difference of the painters from each other' (quoted in Golding 26–7). Assouline records that Kahnweiler 'thought the term [Cubism] "pitiful," even if he had to use it'; but he adds, 'Even the name Section d'Or set his teeth on edge' (91).

This new doubt is clearly visible in the book written by Metzinger

and Gleizes, whose publication coincided with the Section d'Or exhibition of October 1912. In its first edition the book is hesitantly entitled *Du 'Cubisme.'* (The quotation marks disappeared in the new edition of 1947, and in the English translation, simply called *Cubism,* of 1913.) Most of the standard English histories of the period ignore this equivocation, and print the title as *Du Cubisme,* conferring an authority that Gleizes and Metzinger never intended. The very first paragraph of their book is in fact an elaborate disclaimer. 'The word "Cubism" is here employed merely to spare the reader any uncertainty as to the object of our inquiry; and we would hasten to declare that the idea which the term evokes – that of volume – cannot by itself define a movement which tends towards the integral realization of Painting' (quoted in Chipp 207). Dora Vallier stresses, further, that this book 'enunciates – with full awareness of what it is doing – *not* the theories of cubism in the strict sense (such theories never existed), but the theories of La Section d'Or' (28). This emphasis can clearly be seen in the authors' stress on geometry, especially their talk about non-Euclidean space, and in their references to Michelangelo and Leonardo da Vinci as authorities in support of the new painting.

The weakness in Gleizes's and Metzinger's position was that, however much they hedged it around with qualifications and quotation marks, they still felt constrained to use the term Cubism, since the phrase La Section d'Or was only just making its debut, as a description of the group, in the title of the October exhibition, and as the title of a *Bulletin* published at the same time, edited by Pierre Reverdy. This equivocation by Gleizes and Metzinger was then compounded by the activities of Apollinaire.

Although aware of them, Apollinaire had not been following the activities of La Section d'Or closely in the early part of 1912. He was more preoccupied with the irruption onto the Paris art scene of the Italian Futurists, and with the progress of Robert Delaunay, who was not a member of La Section d'Or, and did not, in fact, take part in their exhibition. Apollinaire greeted the appearance of the Section d'Or exhibition with a great flurry of articles and lectures in French and German periodicals, including a lecture at the opening of the exhibit, a stirring piece of invective for its *Bulletin,* and several different versions of the history of Cubism.

The most extensive of these histories appeared in *Le Temps* on 14 October (*Apollinaire on Art* 259–61), and it displays the most character-

istic quirk of Apollinaire's view, in that it begins in 1902 (an incorrect date, anyway), with the meeting of Maurice Vlaminck and André Derain, that is, with the origins of what we historically understand as not Cubism but Fauvism. Apollinaire was to continue to insist, over the next few years, on Derain's importance as a founder of Cubism, and this is one of the major points for which later art historians have taken him to task. In January 1913, writing for *Der Sturm*, he claimed that 'Picasso's cubism is the outgrowth of a movement originating with André Derain' (ibid. 268). In March 1913 his formulation was that 'the new aesthetics was first elaborated in the mind of André Derain' (quoted in Chipp 226). And at the 1914 Salon des Indépendants he professed to do away with 'labels of doubtful validity' and talk only about 'two main currents, one of them issuing from the cubism of Picasso, the other from the cubism of André Derain' (*Apollinaire on Art* 355–6).

It is easy enough, with the benefit of hindsight, to dismiss these claims; but as John Golding says, 'Apollinaire's statement is not as unreasonable as it might at first seem, for Derain has some place, albeit a very hard one to define, in the history of the movement' (138). Apollinaire saw less of a contrast between Fauvism and Cubism than do later generations, who are more aware of the personal division, even rivalry, between Matisse and Picasso. Braque, for instance, developed quite logically from the one to the other. Derain was, Golding further notes, 'the first painter to combine in a single work the influences of both Cézanne and Negro art' (139). This work was the monumental *Baigneuses* of 1906–7, one of the greatest paintings of the period; John Elderfield argues that it may well have influenced Picasso's *Les Demoiselles d'Avignon*, rather than, as is often argued, the other way round (118; see also Cooper 66–7). Derain's work, and his reputation, declined drastically after the First World War; but in 1912 Apollinaire's estimation, while certainly eccentric, was by no means unfounded.

Apollinaire's lecture for the opening of the Section d'Or exhibition, delivered on 11 October, bears the unexpectedly violent title 'L'Écartèlement du cubisme,' which may be translated The Dismemberment, or Quartering, of Cubism. Literally, the word refers to the old punishment of tearing a man to pieces with four horses pulling in opposite directions. Perhaps ironically, this is what Apollinaire set out to do to Cubism by proposing a division into four trends: Scientific Cubism, Physical Cubism, Orphic Cubism, and Instinctive Cubism. This division has been greeted with universal disbelief ever since it was first pro-

posed. Herschel B. Chipp suggests that it was never intended to be taken literally, and that it has 'more the spirit of an enthusiastic informal talk given before a strongly partisan audience than a careful attempt to discriminate between styles' (227). Such may have been their origin, but Apollinaire did reiterate and even expand upon the divisions the following spring when he published his book on the new painting, which was intended for anything but 'a strongly partisan audience.'

One of the few critics to take Apollinaire's classifications seriously has been Dora Vallier, in her essay on Jacques Villon and La Section d'Or – which is rather ironic, since Villon's own assessment of Apollinaire's lecture was 'Nothing whatever to do with painting!' (quoted in Steegmuller 141). Vallier's attempted defence is fascinating, and, though not wholly successful, it does go some way towards making sense of a set of definitions that are, even for Apollinaire, more than usually obscure.

Apollinaire's distinctions run as follows: Scientific Cubism is 'the art of painting new structures out of elements borrowed not from the reality of sight, but from the reality of insight'; Physical Cubism is 'the art of painting new structures with elements borrowed, for the most part, from visual reality'; Orphic Cubism is 'the art of painting new structures out of elements which have not been borrowed from the visual sphere, but have been created entirely by the artist himself, and been endowed by him with fullness of reality'; and Instinctive Cubism is 'the art of painting new structures out of elements which are not borrowed from visual reality, but are suggested to the artist by instinct and intuition' (quoted in Chipp 227–8).

Orphic Cubism, despite the fuzziness of Apollinaire's definition, has in fact become a relatively clear category: it applies to the work of Robert Delaunay (and also, presumably, of his wife Sonia, though the collected volume of *Apollinaire on Art* mentions her only once [337]). Apollinaire quickly modified 'Orphic Cubism' into 'Orphism,' and he uses it from 1913 on to describe everyone from Marie Laurencin to the Italian Futurists. Subsequent art historians have been more restrictive: Ken Adams, for instance, writes that 'Apollinaire's ideas were too general: they led to the inclusion within the orphist movement of almost all of the abstract painters of the time ... Orphism should be defined by reference to the work which Delaunay did between 1912 and 1914' (90–3).[6]

Scientific and Physical Cubism present more of a problem, but Vallier tackles it boldly: 'For us here there can be no doubt about "Scientific" –

it follows directly from the preoccupations of La Section d'Or, as well as "Physical," which is associated with it, and consequently opposed to "Instinctive"' (30). The theories of La Section d'Or do certainly provide a basis for this argument, and Vallier's own detailed exposition of these theories gives strong support for the appropriateness and utility of the word 'Scientific.' But Vallier's argument has two weak points. First, it fudges the distinction between Scientific and Physical – which is perhaps inevitable, since it is not at all clear what the latter amounts to. Second, it ignores the fact that Apollinaire does *not* confine Scientific Cubism to the members of La Section d'Or, but explicitly includes in it Braque, Picasso, and even Marie Laurencin. Since La Section d'Or's 'scientific' methods were specifically motivated by a desire to distinguish themselves from Braque and Picasso, it is clear that Vallier's argument fails to resolve the ambiguities, not to say downright contradictions, in Apollinaire's definition.

Finally, Vallier argues that Instinctive Cubism is 'nothing other than Fauvism,' and goes on to discuss Apollinaire's stress on Derain. She concludes that 'this manner of seeing things, which has been greatly disputed, gave Apollinaire a particularly clear view of the essential division between Cubism and La Section d'Or, which was shared by none of his contemporaries. Because he attached a particular importance to the Negro masks, he saw that early Cubism depended upon their aesthetic, as opposed to La Section d'Or, which turned towards what it itself called 'the great tradition' (that is to say, the western tradition), and that this produced two divergent attitudes, irreconcilable with each other' (31). Vallier's argument here is a persuasive one; the only drawback is that it is certainly an overstatement to say that Instinctive Cubism is 'nothing other than' Fauvism. The Fauve painters, especially Derain (but not, curiously, Vlaminck), are assigned to the category, but it is by no means confined to them. It was also, frankly, a capacious rag-bag into which the tactful Apollinaire stuffed just about every notable painter of the time, and most of the critics too, including even – incredibly – Louis Vauxcelles![7]

But if the inherent validity of Apollinaire's categories remains open to question, his 'dismemberment' is of immense historical importance in another respect. It was the first in a long line of attempts to elucidate Cubism by subdividing it, by naming different types and periods of Cubism. The most widely accepted of these divisions is that between Analytical and Synthetic Cubism.[8] Fry traces the first use of the word 'analytical' back to Roger Allard in 1910, and 'synthetic' to Charles

Lacoste in 1913, but he notes that the terms did not come into general use until the publication of Kahnweiler's *Der Weg zum Kubismus*, written in 1915–18 but not published until 1920 (Fry 1966, 62–3, 120–1). Most critics have noted that the word 'synthetic' can most justifiably and exactly be used in relation to Juan Gris (who was Kahnweiler's favourite), but that these particular terms are less useful and accurate in relation to Braque and Picasso. Nevertheless, they continue to be used, albeit with many qualifications.[9]

Other terms have been less favourably received. Some critics still talk about a 'hermetic' period, but one seldom hears now of Alfred Barr's 'Rococo Cubism.' In *The Cubist Epoch*, Douglas Cooper manages to propose two different schemes in one book: he starts off with a chronological division into early, high, and late Cubism, but a hundred pages later he tries out Instinctive Cubism (by which he does *not* mean the same thing as Apollinaire), Systematic Cubism, Kinetic Cubism, and Orphism (by which he *does* mean the same thing as Apollinaire) (13, 110–11).

The inadequacies of all these attempts at subclassification suggest that the difficulties with Apollinaire's scheme are inherent in the problem of definition itself, rather than the result of Apollinaire's stupidity. And the persistence of these attempts bears witness to the reality of the dilemma that Apollinaire was the first to perceive: namely, that the word Cubism was by itself inadequate but inevitable. It was inadequate because no single word, however well chosen, could meaningfully describe a body of work ranging from Braque and Picasso to Gris to Léger to Delaunay to La Section d'Or or, far less, include André Derain and Marie Laurencin as well. But it was inevitable because four years' history had made it so – and one of the chief ironies of that history is that the exhibition of La Section d'Or, the only really serious attempt to provide an alternative name, was the occasion for the two events that set the seal on the inevitability of 'Cubism.' One was the publication of Gleizes and Metzinger's book, with its insufficiently equivocal title; the other was Apollinaire's 'dismemberment.' In the bureaucracy of art history, nothing ensured the flourishing of the name 'Cubism' more than its division into separate departments. All dissatisfaction with the name was now channelled into devising different *types* of Cubism: 'Cubism' itself remained untouched.

A final note should be added concerning the name of the book that Apollinaire published the following spring, about which Braque commented, typically, that its 'only value ... is that, far from enlightening people, it succeeds in bamboozling them' (16). During the course of

1912, probably spurred on by the knowledge that both Gleizes and Metzinger and André Salmon were about to publish books on the new painting, Apollinaire prepared for the press a selection of his essays, lectures, and reviews from the previous few years. It was, in fact, a collection of miscellaneous pieces, making no pretence to be a unified book, as was suggested by its proposed title, *Méditations esthétiques*. The book was actually in press at the time of the Section d'Or exhibition in October 1912, but between then and March 1913, when it finally appeared, Apollinaire made extensive alterations and additions. Since most of the text consisted of reprints of earlier articles, it is not too surprising that the word Cubism is infrequently used. In fact, 'in the entire manuscript as it appeared in the first page proofs ... Cubism is mentioned only four times – in connection with Metzinger, Gleizes, and Gris – and then only to describe their adherence to the school'(Chipp 220). Apollinaire's additions first of all gave more importance to the ideas about non-Euclidean geometry, as emphasized by La Section d'Or, and by Gleizes and Metzinger in their book; and, second, inserted two sections discussing the nature of Cubism, in which he repeated and expanded the four categories of his 'dismemberment' lecture.

At some stage also, the title was modified. First a subtitle was added, *Les Peintres Cubistes*. Then, on the title page, the phrase 'Méditations esthétiques,' though still coming first, was printed in brackets and small type, whereas 'Les peintres cubistes' was put in large type and thus appeared to be the title. However, all the individual pages still carried the heading 'Méditations esthétiques.' The book is usually referred to as *Les Peintres Cubistes*, sometimes with *Méditations esthétiques* as a subtitle; this order was maintained in subsequent editions, and in the English translation. Apollinaire himself, however, always referred to it by its original title (*Apollinaire on Art* 497–8).

It is not clear whether this change was made by Apollinaire or by his publisher, but it seems likely that the reasons were primarily commercial. The word Cubism was current and controversial: a book called 'The Cubist Painters' was more likely to sell than a book called 'Aesthetic Meditations.' So Apollinaire's careful emphasis, like that of Gleizes and Metzinger in *their* title, was lost. As always, Apollinaire was caught in a paradoxical situation: his use of the term Cubism was forced upon him by the pressure of events, yet his prestigious use of it reinforced that pressure. Insofar as any single person *named* Cubism, it was Apollinaire: yet he did so ambiguously, unwillingly, and in response to events over which he had little control.

The process by which art-historical labels become accepted has, in the long run, the effect of naturalizing them. 'Cubism' is now a term that most people take for granted, as if it had always been there, or as if its attachment to the group and the style were obvious and self-explanatory. But as I have shown, the process of naming is very far from a natural one. It is a narrative, and a narrative has to be constructed – constructed by particular people, in a particular historical situation, who are competing to control that narrative, and to control the power of its language. As was the case with the narrative that named the viewer 'we,' the narrative that named 'Cubism' was neither neutral nor disinterested when it brought its supplement to fill the spaces opened up by the coming into existence of this strange new style.

The Gospel According to Kahnweiler

A new style in painting, I argued in the previous chapter, needs a name. As language moves to supplement the gaps created and prepared for it by painting, one of the first tactics is to name, to categorize, to frame the original work within a group identity. Another primary tactic is to explain: to expound, to defend, to write manifestos. A style like Cubism, which so explicitly engages questions of representation, creates within itself the space for the supplement of writing, the frame of definition. Both these tactics are clearly visible in Apollinaire's writings. But among the immediate Cubist circle – indeed, at its very heart – was someone who would undertake, in a much more systematic way, the task of supplying Cubist paintings with the supplementary discourse of aesthetic justification: Daniel-Henry Kahnweiler.

Kahnweiler's importance as a theoretician and propagator of Cubist ideology is all the greater for the comparative lack of explicit theoretical statements from the major painters themselves: Braque, Picasso, Gris. Most of what these artists had to say about their works came in the form of interviews, casual statements (often reported at second hand), or aphorisms. Gris was the most theoretically inclined (and this may partly explain his close affinity to Kahnweiler), but none of them ever attempted a full and formal statement of his 'aesthetic.' They didn't need to, of course: they all 'thought' in their paintings, one canvas at a time.

So it would be dangerous to assume that they necessarily agreed with everything Kahnweiler said:[1] partly because they themselves did not think in theoretical terms, and partly because Kahnweiler's view was often more rigid and dogmatic than any of them would have been entirely happy with. In this way, Kahnweiler's work again illustrates

the double movement of the supplement. It can be seen as an extra, as something that the paintings do not, strictly speaking, *need*; and it can be seen as supplying, urgently, the discourse that the paintings, precisely because they are non-verbal, leave as a lack. The mismatch between the rigidity of Kahnweiler's theories and the more flexible accommodations of the painters themselves shows that the supplement is not, in the weak and colloquial sense, a genial complementarity. It should certainly not be assumed that there is any simple hierarchy between the 'original' paintings and the 'secondary' theory. Nevertheless, of all those who have claimed to expound a Cubist ideology, Kahnweiler remains the one most closely associated with the original painters; and his work is worth examining closely for this reason alone.

Daniel-Henry Kahnweiler was born in Mannheim, Germany, in 1884.[2] As a young man, being prepared for a career in the financial world, he was sent to both Paris and London, where his interest in the arts, especially painting, competed with his duties in the banks and the stock exchange. At the end of 1906, his family proposed to send him to Johannesburg to oversee their mining interests there; but in January 1907, Kahnweiler countered with a statement of his wish to become an art dealer in Paris. His uncles in London offered to put up the money (one thousand pounds) for him to try to make a go of it for one year. Despite initial doubts about the adequacy of his capital, Kahnweiler did survive as a dealer, not just for that one test year, but for the next seventy, interrupted only by the catastrophic events of two world wars; he never did go to the gold mines.

Opening a gallery in Paris in 1907, the year of Derain's *Baigneuses* and Picasso's *Les Demoiselles d'Avignon*, Kahnweiler was committed right from the start to dealing in the most advanced art of his own time. His ideal was to set up relationships of mutual trust between himself and 'his' artists, as confirmed in contracts of exclusivity, whereby the painters assigned to him *all* the paintings they produced. He achieved this, at least for short periods, with Braque, Picasso, Gris, Derain, and Vlaminck, and in later years with Masson, Klee, and Picasso again in the 1950s. His insistence on exclusivity may seem stubborn and possessive, but he saw it as more than commercially advantageous:[3] he saw it as a special relationship between painter and dealer, one that he pursued with evangelical devotion. (One often ends up using a quasi-religious vocabulary in talking about Kahnweiler. In a letter of 1932, he himself wrote that 'mon état d'esprit est protestant' (quoted in Monod-Fontaine 1984, 147), and indeed a kind of Protestant, even Puritan, rigour is characteristic of his aesthetic positions.[4])

His first gallery was in the rue Vignon, and his first major show, of Vlaminck, opened in March 1908. Increasingly, however, Kahnweiler disdained one-man exhibitions; the current work of his painters was simply there to be seen, at the gallery, on a regular basis. Since Braque and Picasso did not exhibit at the public salons either, their work during the key years of Cubism was almost invisible to the general Parisian public. Kahnweiler did, however, circulate the paintings to exhibitions abroad, especially in Germany, in very impressive numbers. The most famous one-man show at the rue Vignon gallery, before the practice lapsed, was that by Georges Braque, from 9 to 28 November 1908. This included the Estaque landscapes that Matisse (perhaps) described as 'nothing but little cubes,' and that Louis Vauxcelles (as described in the previous chapter) reviewed in *Gil Blas* (referring to the gallery as 'Chez Kahn Weiler').

For the next six years, through the most intense phase of Cubism, Kahnweiler was in constant close contact with Braque and Picasso, and later with Gris. He saw each of their works as they delivered them, under contract, to his gallery. In 1912, when Picasso was in the process of leaving Fernande Olivier for Marcelle Humbert, there is a comic series of letters in which Picasso, in hiding at Ceret, asks Kahnweiler to fetch him paints and brushes from his old studio at Rue Ravignan without letting Fernande know where he is! During these years also, Kahnweiler began his career as a publisher, bringing out limited editions of works by those writers most closely associated with the new painting, illustrated by 'his' artists. The first of these to appear, in 1909, was *L'Enchanteur pourrissant* by Apollinaire, illustrated by Derain. Later authors would include Max Jacob, Pierre Reverdy, Erik Satie, Gertrude Stein, and Francis Ponge; the illustrators would include Picasso, Vlaminck, Gris, Leger, Laurens, Braque, Masson, and Marie Laurencin.

All this activity came to a crashing halt in 1914. As a German national, Kahnweiler lost all his holdings in France, which were subject to forfeit and seizure. For personal and political reasons he refused to fight for Germany, and spent most of the war in neutral Switzerland. Here he made a systematic study of aesthetics, and wrote his first major work of criticism, *Der Weg zum Kubismus* ('The Rise of Cubism'). Its circulation, however, was very limited; a full German text was not published until 1920, an English translation appeared only in 1949, and a French translation not until 1963.

At the end of the war, Kahnweiler returned to Paris and tried to pick up the pieces of his business and his life. His letters from this period make for pathetic reading, as he pleads for support from the artists who

had, necessarily, drifted away from him to other dealers. He was at-
tempting to recover the stock of paintings seized at the beginning of the
war, and was terrified that their value would be destroyed if they were
dumped on the market in mass sales – which, in 1921 and 1922, is
exactly what happened. The four public sales of Kahnweiler's seques-
tered collection were the occasion for outbursts of scorn in the press:
attacks on Cubism for its obscurity and meaninglessness, and attacks
on Kahnweiler (and the other major dealer, Wilhelm Uhde) as Germans
who had corrupted the national glories of French painting. Prohibited
by law from buying back his own paintings, Kahnweiler was able
through intermediaries to recover a pitiful few: for instance, in the first
sale, he was able to recover 8 out of 9 paintings by Gris, 11 out of 22 by
Braque, but only 3 out of 24 by Derain, and none of the 26 Picassos.

Nevertheless, despite the grave blows of the forced sales, Kahnweiler
was able to re-establish himself in the 1920s, with a new gallery, the
Galerie Simon, a renewal of his publishing, and a close circle of friends
who met at his house in Boulogne: especially Juan Gris, who lived
nearby. But Gris was in failing health, and his death in 1927 marked the
end of this second brief period of good fortune for Kahnweiler. The
gallery struggled through the years of the Depression with very few
buyers, with both Braque and Picasso committed to other dealers, and
with Kahnweiler casting an increasingly despondent eye on develop-
ments in his native Germany. He had tried to ignore the coming of the
first war; he was all too accurate in his premonitions of the second.

Persecuted in the first war by the French because he was German,
Kahnweiler was endangered in the second war by the Germans because
he was a Jew. The gallery was transferred into the name of his sister-in-
law (French, non-Jewish), Louise Leiris, and the deal was approved by
the Germans despite an anonymous denunciation. Kahnweiler and his
wife lived in the south of France, under false names, in daily danger of
arrest. It was during this period that he wrote his massive book on Juan
Gris, living 'with the unadmitted but ever-present feeling that catastro-
phe was possible from one minute to the next, which caused me to put
into this writing everything which pertained to the subject, closely or
distantly, for fear of never writing anything else' (quoted in Monod-
Fontaine 1984, 152). Pierre Assouline makes a very acute comparison
when writing about the nature of this book: 'Kahnweiler placed his
whole being into the work. One can hear his voice distinctly on reading
it. The book is in his words, using his expressions, his references, his

cosmopolitan culture, his likes and his dislikes. It would be an exaggeration to say he had essentially written *The Autobiography of Juan Gris* in the manner of Gertrude Stein's *Alice B. Toklas*,[5] but the work is as informative about the dealer as it is about the artist' (290).

Kahnweiler survived the war, though his wife died soon afterwards, and the remaining years of his life provided well-deserved prosperity and recognition. *Juan Gris: His Life and Work* was published in 1946, with an English translation in 1947, and a revised edition in 1969. The Galerie Louise Leiris flourished, and from 1948 on the relationship with Picasso was re-established. Kahnweiler died on 11 January 1979, at the age of ninety-four.

Especially in his later years, Kahnweiler wrote numerous articles and prefaces to catalogues, many of which are collected in *Confessions esthétiques* (Paris, 1963). However, his major aesthetic statements are contained in *The Rise of Cubism* and *Juan Gris: His Life and Work*. It should be noted that neither of these books was written when Kahnweiler was an active dealer; indeed, both were written in circumstances where it appeared highly unlikely that he would ever be a dealer again. This point has to be made, rather tiresomely, against the accusation that Kahnweiler's writings were merely the propaganda of a merchant advertising 'his' wares. Such a view of Kahnweiler, unworthy as it is, is not confined to the years of anti-German hate literature in the 1920s; it can still be found in supposedly respectable books of art history as late as 1982 (see Alibert 35).

There is no doubt that Kahnweiler's opinions about painting were narrow, rigid, dogmatic, and often based upon assumptions that later critics would regard as unsophisticated or simply mistaken. This chapter will deal as much with his weakness as with his strength. Yet Kahnweiler remains an essential figure in the study of Cubism, and in the continuing debate over the role of language in the experience of painting. The story of his life, as told in detail by Assouline, is both heroic and tragic; he fully deserves the tribute paid to him by a writer who is at the same time one of his severest critics, Yve-Alain Bois: 'Not only was he a great art dealer; not only was he a courageous and pioneering publisher (the first of Apollinaire, Artaud, Leiris, Max Jacob, and many others); not only did he have a fantastic "eye" during the heroic years of cubism; but beyond that he was from early on a champion of the painting that he both loved and sold, a passionate critic whose breadth we have only begun to appreciate' (1990, 65–6).

In the 'Aesthetica in Nuce' section of *Juan Gris*, Kahnweiler, echoing Maurice Denis, defines the painter as 'a man who feels an overpowering need to record his emotion on a flat surface by means of lines and forms of one or more colours' (63). He begins, that is, with the painter's 'emotion,' not with any object in the physical world, because 'the object only exists for him ... through his emotion.' The aim is to *communicate* this emotion, and this can only be done through an image that has 'objective existence for the spectator.' Note 'objective': Kahnweiler's emphasis is always directed towards a shared and accessible experience; this excludes, on the one hand, excesses of a merely private symbolism (as in Surrealism) and, on the other, all 'non-objective' or 'abstract' forms of painting. 'For the painter, every emotion ends in a plastic image and it is this image which he attempts to transmit' (63).

The aim of painting, then, is to 'transmit' something: painting is a means of communication, and thus presupposes both artist and spectator, and an intelligible exchange between them. Immediately afterwards, Kahnweiler appears to modify this view by describing, in conventional terms, the 'two-fold existence' of a work of art. The whole sentence is printed in italics: '*It exists autonomously in itself, by itself and for itself, as an object: but outside itself it has a further existence – it signifies something*' (64). Kahnweiler does not, however, always preserve the balance suggested by this sentence; indeed, his previous and continuing stress on the function of communication already tips the balance in favour of its second element. All works of art exist at different points, even fluctuating points, along the continuum between these two poles; it is often easier for the critic to talk about the pole of communication than about the pole of autonomous self-reflexiveness, but a general theory should allow due weight to both. As an aesthetician, Kahnweiler has surprisingly little to say about the work of art 'in itself, by itself and for itself.' Werner Spies goes so far as to say that 'Kahnweiler's rigour was without doubt marked by a completely Protestant hostility to images, which had been inculcated in him during the years of his youth in Stuttgart: the fear of sensuality, the priority of poetry and of music have always played an important role in the interpretation which he made of Cubism' (39).

'The painting,' Kahnweiler says, 'is a representation of thought by graphic means – *writing*' (64). Few statements on the relationship between painting and language have been as dogmatic or as striking as this one. The choice of writing as the master term, with the consequent subsuming of all discussion of painting within a literary vocabulary, is

all the more striking because it comes from, as it were, the painting 'side.' Writing, to extend the metaphor, calls for reading: so the painter will 'succeed' in his effort at communication 'if the spectator "reads" the picture' (64). Kahnweiler's contention is that Cubist paintings not only *can* but *must* be read: that to see them as 'non-representational' is not to see them at all.

As writing, painting deals in signs; its activity is a semiotic one. Kahnweiler does not of course use the word 'semiotic,' and subsequent critics (notably Yve-Alain Bois) have argued that his view of semiotics was a fatally unsophisticated one. Kahnweiler maintains that the 'simple spectator'[6] is unable to think of the work of art as a sign: for him it is linked to the object it "represents" by an identity which he feels to be "true" when the work of art resembles it, whereas he denies all *raison d'être* to the work which does not'; this confusion would not be made with written language, 'for he does not believe that the written word is identical with what it signifies' (66). Bois argues that the weakness of Kahnweiler's exposition at this point is that 'what the naive spectator, *along with Kahnweiler and most art historians*, confuses is not the sign and the signified but the signified and the referent' (1985, 43).[7] The signified of a painting, as of any other sign, is not the actual material object represented (bottle, guitar, landscape) but rather the concept, the total mental image of that object as it is conveyed by the signifier (the actual arrangement of paint on canvas). The irony is that, if Kahnweiler had made the further refinement in his argument that Bois suggests, it would have afforded him another way of talking about Cubism as a conceptual rather than a perceptual art. As it stands, the argument provides Kahnweiler with a neat but oversimplified rationale for the failure of many spectators to 'read,' and thus appreciate, modern art.

This view of painting as writing also leads him to challenge the idea that art has no practical purpose, that it merely seeks to create beauty. Kahnweiler wishes to prove 'that never in any period has the object of painting (or for that matter of any other art) been "the creation of beauty," but that this quality [beauty] has been mysteriously incorporated in certain works painted for purely practical ends' (66). Kahnweiler's 'hostility to images' thus allows 'beauty' to appear, fleetingly and grudgingly, only in that old Romantic word 'mysteriously.'

What then is the 'practical end' that Kahnweiler sees painting as serving? He distinguishes 'pragmatic' vision – that concerned with utility, survival, moving amongst things – from 'aesthetic' vision, which 'implies practical indifference': 'It is only by sharing the vision of con-

temporary painting that the aesthetic vision achieves totality. He alone *sees* clearly and fully who is familiar with the painting of his time. For him alone the outer world takes on form and colour, and becomes an image, in imitation of the paintings which he is accustomed to see. Painters do not *imitate* an outer world which we know but vaguely, within the limits of our senses; painters *create* the outer world in visible form, they make us *see* it in the likeness of their works ... And this is what one might call the biological function of painting' (78). The 'practical end' of painting, then, is no less than a 'biological function': we need painting in order to be able to see the world. This passage (with its echo of Oscar Wilde: life imitates art, where were all those gorgeous mists before the Impressionists painted them?) provides the justification for many of Kahnweiler's theories, even though it makes no attempt to offer any scientific basis; he asserts rather than argues that this is the way vision does work.

Kahnweiler regrets that 'it is only our own period which has fallen behind in its inability to read' (79). As at no other period in history, the painting of the modern age has become incomprehensible to the 'average spectator.' Kahnweiler blames academic schools of painting, such as the École des Beaux-Arts in France, which, he claims, 'artificially kept alive a vision that had been dead since the beginning of the nineteenth century, and thereby petrified the outer world for contemporaries and slowed up the reading of any new writing' (80). He might also have cited the sheer speed of artistic change in the key period from 1860 to 1920: the number and variety of conflicting '-isms' that succeeded each other at an ever-accelerating pace, so that very few 'average spectators' could really be in a position to keep up. But surely the basic gap in his argument is his failure to recognize that this biological or cultural function has increasingly been taken over by the primary visual media of our time: photography, cinema, and television.

This 'biological function' argument lies at the heart of Kahnweiler's vehement rejection of abstract painting. Abstraction, he claims, ignores 'the eternal interdependence of painting and the outer world ... These so-called painters have nothing to say, no message to transmit ... they have experienced no emotion which they wish to perpetuate. Mondrian's so-called paintings are unfinished because there is no means of finishing them; they are not painting, that is to say, writing' (168). Because non-figurative painting has no reference to the world, Kahnweiler argues, it is not 'writing.' It cannot fulfil the 'biological function' of

interpreting that world, of making it truly visible to the contemporary spectator.[8]

Abstraction, Kahnweiler argued, was only *ornament* (a word he always uses in a pejorative sense), the hedonistic decoration of surfaces. Such a view ignores a sizeable majority of human artistic production. From Greek fresco painting to Japanese vases, from the most primitive pottery to the most sophisticated Arabian carpets, art has served, precisely, to decorate pre-existent surfaces. In effect, what Kahnweiler is doing here is restricting the 'painting' that he is prepared to take seriously to a very narrow range: the Western post-Renaissance tradition of easel painting, a form that has a quite specific economic and ideological basis. The narrowness of this view is all the more surprising since Kahnweiler, like the Cubists, was not only aware of but actively interested in non-European traditions of art, especially African masks. 'Abstract' painting poses all sorts of problems that Kahnweiler ultimately ignores. On the one hand, it does look back to 'ornamental' arts that decorated pre-existent surfaces (walls, vases, and so on); on the other hand, it also operated, to Kahnweiler's dismay, within the system of easel painting: where, that is, there is no 'pre-existent' surface, only the canvas itself. In the end, Kahnweiler never really solved this problem; he just wished that it would go away. 'Let us hope,' he concludes, 'that all "abstract painting" – which is neither painting nor abstract – will soon disappear. It has done a great deal of harm, for it has largely prevented Cubism from being understood and has turned more than one painter and collector against real painting' (170).

Kahnweiler's violent hostility to abstract painting may be dismissed as the dogmatic quirk of a theorist whose rigour has strayed into rigidity, but in a less overstated form it does remain at the centre of Cubist ideology. It is worth remembering that none of the major Cubist artists – Braque, Picasso, Gris – ever painted a purely non-representational canvas.[9] The dynamic of art history was certainly towards abstraction, and Cubism became, despite itself, a stepping-stone on the road towards non-figurative painting. Many other artists (Delaunay, Malevich, Mondrian) passed *through* Cubism (or versions of Cubism) on their way towards an abstract style. But Cubism is not in itself abstract: on this point Kahnweiler's contention is both firm and accurate. Cubism was always representational; it was even, in some sense, realist.

For Kahnweiler, the representation of reality in painting was necessarily accompanied by distortion. The 'simple spectator' (our old friend)

'describes as "distorted" every object, or part of an object, which to his mind does not conform with that object as he imagines it in the outer world' (82) – as, that is, the painting of a previous generation has taught him to imagine it. Kahnweiler distinguishes between two kinds of distortion: Expressionistic distortion and Constructivist distortion. As its name suggests, Expressionistic distortion gives expression – to an idea, an emotion, an anecdote. It consists of 'graphic tricks' that are 'correctly read in their time': thus, mediaeval spectators understood that 'someone depicted as being larger than others was in fact not so, but simply more important' (82), just as the spectators of modern Expressionist painting understand that the lurid colours and contorted outlines refer not to the actual appearance of faces or buildings but to the state of mind or soul of the characters depicted, or of the artist (that is, to the signified, not the referent). What is fascinating and unusual, however, is that Kahnweiler also cites as an example of Expressionistic distortion *linear perspective*. It is a distortion, he notes, 'which has been digested, that is to say is no longer noticed by the spectator of to-day ... [who] "sees" this system of representation, which necessitates innumerable distortions, as absolutely identical with the appearance of the outer world' (82). Kahnweiler himself does not indicate what it is that linear perspective expresses, though more recent critics, such as Pierre Francastel, might propose that what is expressed is that whole view of the world, economic as well as optical, presupposed by Renaissance man's assumption of the position of the individual observer, regarding from a central fixed point a world that could be made to man's measure, and reproduced on a portable, purchasable surface.

Constructivist distortion, on the other hand, derives from the shape the painting must take, the demands of its composition, what Kahnweiler calls its 'architecture.' 'Constructivist distortion is born of the contradiction between the subject as presented by the artist's emotion and the form, proportions and substance of the object in which the subject is to materialize ... [The problem is] the fitting of the subject into the rectangle of the modern easel-painting' (83). For Kahnweiler, this kind of distortion is always present. The history of Western art amounts to a tracing of the different ways in which the conflict between representation and structure has been worked out.

This distinction between Expressionist and Constructivist distortion is not original or unique to Kahnweiler, though he does give it concise and useful formulation. It is a distinction that runs, very broadly, through the whole range of modern art.[10] One might use it to indicate (by way of

general tendency, not of exclusive dichotomy) the different routes by which Picasso and Braque arrived at Cubism itself; or, similarly, to distinguish between the literary experimentations of James Joyce and Gertrude Stein. Much later, the Expressionist/Constructivist division was very generally employed in theories of Concrete Poetry. Mike Weaver actually used the words Expressionist and Constructivist, while Ian Hamilton Finlay employed the more sophisticated variation of Fauve/Suprematist, and bpNichol, with homely reductiveness, translated the distinction into 'dirty' and 'clean.'

Allowing, then, for the inevitability of distortion, at least in its Constructivist form, Kahnweiler returns to his insistence that 'Cubism was above all a realistic art, since it aimed at as accurate a form of representation as possible' (111). Kahnweiler is one of the major spokesmen for the idea that Cubism is a *conceptual* rather than a *perceptual* art, that is, that its 'realism' consists of a fidelity to things as we *know* them to be rather than as we *see* them. (For further discussion of the 'conceptual' theory of Cubism, see chapter 5.)

'Cubism disregarded appearances. Unsatisfied by the fortuities of a single visual impression, it endeavoured to penetrate to the very essence of an object by representing it, not as it appeared on a given day at a given time, but as it exists ultimately composed in the memory' (110). Hence the basic Cubist technique of 'several views of the same object juxtaposed in one picture [that are] intended to be seen simultaneously and to compose together a single object in the eyes of the spectator' (117). Kahnweiler's aesthetic thus always assigns an *active* role to the spectator. He does not pretend that the painting is complete on the canvas: a Cubist painting is not 'realistic' until it has been 'read,' until it has been completed in the mind of the spectator: 'Amongst the first admirers of Cubism, there were those who said that it was enough for them to 'like' these new paintings without being concerned with what they represented ... As a matter of fact, they did not even know this picture, since it did not exist unless they had taken the trouble to understand it' (86).

So Kahnweiler insisted on a strictly literal reading of Cubist paintings: in his own portrait by Picasso, for instance, he would point out details of his own clothing, his face, the sculptures on the wall behind him. He was of course greatly helped by knowing all these things anyway, by being a first-hand witness of the models of the paintings, whether they were the objects lying around Picasso's studio or the houses at Estaque, painted by Braque in 1908 and carefully photographed by

Kahnweiler on a later visit. For spectators without this inside knowledge, such a detailed reading of Cubist paintings is more problematic: 'there is no doubt,' writes Werner Spies, 'that even a very long acquaintance with these pictures would not be conducive to such a literal decoding' (41). Once more we can note in Kahnweiler the confusion between the referent (these particular houses at Estaque, photographed from the exact spot at which Braque had set up his canvas) and the signified ('houses,' as projected onto canvas by a painter following on from Cézanne).

Spies summarizes Kahnweiler's exalted, idealistic view of art: 'Art is a hermeneutic of being, a way of forming consciousness. Art gives a foundation for the durable, it establishes categories which allow us to understand the world, thanks to which the accumulation of phenomena and their constant variation are given form. Everything else for him is laziness, experience devoid of energy, a spontaneous acceptance of a pleasant perception which engages nothing, an indulgence of the self which exploits the sensual faculties but does not go beyond them' (40). It is at this level of idealism that Kahnweiler's work must be judged. Whatever the shortcomings of his rigid dogmatism, whatever his failures of vision in relation to abstract art, whatever his exaltation of Cubism in general and Juan Gris in particular to a position of absolute primacy as the touchstone for all modern painting – whatever his faults, he was never a mean or small-minded critic. He had a vision of art, its function and its necessity; and in expressing that vision he gave the clearest and most intense expression (outside, of course, of the paintings themselves) of the aesthetics of Cubism.

So far, I have discussed the effects that Kahnweiler's view of painting as writing had upon his theories of painting; now I turn to his ideas about writing itself, and about literature. Here again, Kahnweiler tended to be dogmatic in his views, yet at the same time these views can be very challenging and useful. His view of literature was certainly a conservative one; he was less open to experimentation in poetry than in painting. Yet *Juan Gris* frequently seems to come up to the brink of providing a manifesto for Concrete Poetry; the argument stops one step short of future developments that Kahnweiler could not foresee.[11]

Kahnweiler approaches 'writing' through his understanding of the history of ideographic and phonetic writing systems. This understanding has largely been discredited (see Bois 1990, 94), so his schema must now be seen more as an ideological fiction, working to justify his conclusions, than as reliable 'evidence.'

He begins by distinguishing between several different kinds of writing, the first of which is pictography. This is defined as the transmission by pictorial means of 'information intended to *provoke an action*' (67). It has the advantage that it can be understood by people who do not share the same language, but the concomitant disadvantage that its signs 'often lacked the desired precision.' Further, 'the use of pictorial means limited the number of possible "scribes," since artistic gifts were necessary to "write" these images' (67). The limitation by the talent of the scribe means that pictographic writing is not, strictly speaking, iterable: that is, it does not meet one of the major criteria for what Jacques Derrida would call 'writing.'

Kahnweiler's attempt to evade this problem is not very satisfactory. He distinguishes between pictography and a general category that he calls 'pragmatic' writing. 'Pragmatic writing necessitated signs which everyone would be capable of making after some instruction, signs which could be executed rapidly and which, by convention, acquired a definite and invariable meaning. All these qualities are lacking in painting, which I call "formative writing"' (67). The argument is very tenuous here: having claimed painting as writing (and having based much of his aesthetic of Cubism on that claim), Kahnweiler has all but defined it away again. If one excludes all the features limited to 'pragmatic' writing, what is one left with in 'formative' writing that still makes it writing? Only, presumably, the idea of the communication of shared meaning.

Since pictography proved inadequate for complex communication, more advanced civilizations had to adopt some form of pragmatic writing, of which there were two main systems: ideographic and phonetic. Kahnweiler, venturing boldly and without offering any supporting evidence into the vast and controversial questions of the origins of written language, asserts his belief that 'there is a discrepancy between these two systems which makes a common origin impossible.' This discrepancy shows up in the languages using the systems, particularly in the poetry. 'Ideographic writing goes with concrete languages, for their basis is the image; phonetic writing with abstract languages, for their basis is the idea' (68). These are drastic oversimplifications – a neat distinction between 'concrete' and 'abstract' languages is obviously impossible – but the tone does accord with Modernist poetry's emphasis on the Image, as propagated by Ezra Pound, via Ernest Fennollosa, at roughly the same period as Cubism.

In ideographic writing, Kahnweiler continues, we find 'the supremacy of writing over language, whereas in western writing the pre-eminence

of language is evident, the purpose of writing being merely to transcribe it as faithfully as possible' (68). In this passage, 'language' is clearly being equated with 'speech': a classic illustration of the orthodox logocentrism that Derrida challenges. As Derrida deconstructs it, this assertion of the supremacy of speech over writing reflects a nostalgia for *presence*, for an assurance of meaning stabilized somewhere within the system of linguistic difference; whereas writing, iterable and detachable, grounds language rather in the infinite undecidability of *différance*. Kahnweiler's equation of 'language' with 'speech,' and his easy assumption that language can somehow pre-exist writing, thus become subject to a radical questioning.

Kahnweiler dismisses any notion of an evolutionary progression from the ideographic to the phonetic, stressing instead the basic discrepancy between them. '*Ideographic writings derive from painting,*' he claims. 'Their signs are pictorial ones, whose meaning is frozen by convention, but which nevertheless retain a sort of immediate efficacy' (69–70). Ideographic signs are always read as images, even though they may be juxtaposed or punned on. They are never arbitrary, whereas '[t]he peculiarity of *phonetic writing* lies in the *choice of entirely arbitrary signs*' (70). Phonetic writing could take over and use certain signs from an ideographic system, but this does not show an evolution; rather the contrary: 'It is precisely by using these signs in the wrong way, by giving them quite another meaning to that which they had before, that it shows itself indifferent to their direct action' (70).

Kahnweiler then goes on to diagram the progression of the reading act in each of these major branches of writing. In painting ('formative writing'), a painter may draw, for example, a tree; the sign he uses will need *some* conventional value in order to be intelligible, but the artist will 'vary and enrich it after his own fashion ... The sign will release a flood of impressions. What is read will not be a *word* but an *image* with its limitless possibilities. Painting, in so far as it is writing, transcribes images, not words. The painter tries to transmit images; the spectator first "reads" them and then transforms them into ideas' (70–1). This process is summarized as follows:

Graphic sign
Image
Vocal sign
Idea

Several comments can be made on this passage. First, it confirms again Kahnweiler's insistence on the representational task of painting. Second, the phrase 'in so far as it is writing' implies but does not pose the question of how the signs of painting operate in so far as they are *not* writing. Third, are an image's possibilities really 'limitless'? Kahnweiler himself insists that images must be 'correctly' read: surely that implies the possibility of an 'incorrect' reading, that is, of a limit. And fourth, it is not at all clear that the last three stages of this process can be separated distinctly enough to be arranged in a sequential order: is it possible to identify an arrangement of lines and colour as being the image of a tree without simultaneously evoking the word 'tree' as both signifier (vocal sign) and signified (idea)? However, Kahnweiler's purpose in insisting on this order becomes clear as we proceed to pragmatic writing.

The ideographic sign does have 'an established, conventional value, but its plastic origin is not entirely forgotten' (71). Again, the sign produces first an image, but Kahnweiler sees a reversal in the final two terms of the process, since ideographic writing, unlike painting, exists within a language system (Chinese, for example) and thus 'must end in vocal emblems':

Graphic sign
Image
Idea
Vocal sign

In phonetic writing, the *'appearance* has no meaning, no effective power of its own. Its equivalent is reconstituted in the form of a word, a vocal sign. The word inspires an idea and this idea finally produces an image' (71–2):

Graphic sign
Vocal sign
Idea
Image

The signs of painting (formative writing) and poetry (phonetic writing) thus neatly reverse and complement each other: the end result of a *painting* is an *idea*, whereas the end result of a *poem* (or of phonetic

writing generally) is an *image*. In each case, the act of reading supplies the supplement, provides what is missing: the idea to the image, and the image to the idea. The arguments behind these diagrams may be suspect at every stage, but this conclusion does provide a satisfying symmetry. The act of reading is necessary (as it was in the perception of Cubist painting) to complete the act of writing. Abstraction then (though for Kahnweiler this is so obvious that it doesn't need saying) would be as impossible in poetry as it is (or ought to be) in painting.

This set of distinctions between various kinds of writing enables Kahnweiler to keep the arts distinct; his view of poetry is traditional and not notably sympathetic towards inter-artistic experimentation. Yet his very use of 'writing' as the master term in his overall vocabulary continues to leave his discussion open to conclusions he was reluctant or unable to draw. 'There is a kinship between poetry and painting,' he goes on, 'for both are writing. The poet, like the painter, seeks to make the "reader" share his emotion by using graphic signs. Nevertheless the intervention of these in poetry is only secondary, for before there was any written literature there was a great body of spoken literature, whereas the very existence of painting is bound up with its signs, which in consequence have a value of their own. Not only do the *products* of painting exist autonomously, but also its *signs* work by virtue of a power inherent in them' (72). Again, Kahnweiler comes close to that aspect of painting that cannot be accounted for as writing, and again he has to sheer away from it for fear of conceding value to non-figurative art. The 'in consequence' is an interesting comment, suggesting a causal argument that is not, however, developed; one wonders how aware Kahnweiler was of the 'foregrounding' theories of the Russian Formalists, of Shklovsky's 'the process of perception is an aesthetic end in itself and must be prolonged' (12).

Kahnweiler's argument could easily be extended to Concrete Poetry, by arguing that the concretists were attempting to give to *phonetic* signs the kind of 'value of their own' attributed here to the signs of painting. But Kahnweiler veers back to the familiar, though not entirely satisfactory, argument for *ideographic* poetry, along the lines of Fennollosa and Pound. 'Graphic signs retain some of this power in the poetry of a language which uses ideographic writing, for they retain, albeit feebly, some *formative quality*: that is to say, the power to create images. The great painter invents new signs. So does the Chinese poet' (72). But the argument from Chinese poetry did not lead Pound or the Imagists to attempt writing in an ideographic manner: the main line of Imagism

was content to create its images within the conventional discourse of phonetic writing.

The only movement in the direction of Concrete Poetry with which Kahnweiler was familiar was the *Calligrammes* of Apollinaire; but on this subject Kahnweiler was not enthusiastic. 'When [Apollinaire] revived in his poems what, in the 17th century, had been merely fanciful decoration ... he intended to restore to French phonetic writing the "power to solicit or compel" ... [But] it is impossible deliberately to alter the nature of a language' (74; Kahnweiler is quoting Marcel Granet). The reference to earlier examples of 'shaped' poetry (of which the best-known seventeenth-century example in the English tradition is George Herbert's anything but 'fanciful' 'Easter Wings') is unjustly dismissive: such poetry has a long and distinguished tradition.[12] But the give-away word for Kahnweiler is 'decoration,' which immediately relegates visual poetry to the margins of serious discourse. Pattern poetry, like abstract painting, is merely ornamental; its shapes do not qualify as 'writing.'

It is perhaps true that no writer can 'deliberately ... alter the nature of a language': but the attempts to push against the borders of this impossibility have been both more extensive and more rewarding than Kahnweiler allows for. Visual poetry, he sniffs, is just 'a trick of typography: it seems that there is no other way for the occidental poet to create new graphic signs' (74). How often, and by now how wearily, have concrete poets had to respond to this critique! They do so, of course, by pointing to any anthology of Concrete Poetry: to the range, the inventiveness, and the beauty of which these 'tricks' have proved themselves capable. But again Kahnweiler seeks refuge in the traditional view: 'It seems there is no other way for the occidental poet to create new graphic signs. As a general rule he feels no need of them, since for him graphic signs only serve to transcribe ... vocal signs.... And he does not need to create *new vocal signs*. His task is to restore real meaning to words which have become stale through constant use ... to give them back concrete [*sic!*] meaning' (74). This is indeed the 'general rule,' the mainstream of Modernist poetry, Imagism; but on the experimental margins, poets have continually sought to transgress the principles laid down here.

Part of Kahnweiler's problem is that he is focusing on the level of the individual sign rather than on the level of combination of signs, syntax. He talks of the Chinese poet who creates new signs, and of how the occidental poet feels no need of new graphic signs. But a great deal of

visual Concrete Poetry continues to work with the graphic signs of a 'phonetic' language (letters, words), and inserts the visual element *as syntax*, in the meaningful arrangement of these signs on the page (or off the page – see especially Ian Hamilton Finlay). There have been attempts to create new visual signs, in 'semiotic poetry,'[13] but this has been less prevalent than the attempts to create either a new visual syntax, or to create, in sound poetry, not new graphic signs but new *vocal* signs.

Kahnweiler gives only passing mention to sound poetry, of which he was aware mainly through the Dada experiments. 'Efforts were made,' he writes, 'to enrich poetry by musical means, recitation by several voices, spoken choruses, etc. This attempt did not last long: a few public performances proved its useless and hybrid character' (76). Even in the 1940s such a comment is staggeringly unjust to the wealth and continuity of the works of Hugo Ball, Raoul Hausmann, Kurt Schwitters, et al.; the flourishing of sound poetry in the 1970s disproves it totally. (For further discussion of sound poetry, see chapter 8.)

Kahnweiler does, however, have an interesting general comment on what he calls 'a definite tendency [between 1910 and 1930] for artists to express themselves in forms which made use of the technique of more than one art' (75). His examples include Apollinaire's *Calligrammes*, the Blaise Cendrars/Sonia Delaunay 'Trans-Sibérien,' and Picasso's 'sculpto-architecture.' 'There may be technical mixture,' he writes, 'but the works themselves cannot be simultaneously two kinds of art ... *Calligrammes* and similar attempts are poetry' (75). In 1966, the Canadian concrete poet bpNichol arrived at the same conclusion: the poet who creates a physical object 'is not a sculptor for he is still moved by the language and sculpts with words. the poet who paints or sculpts is different from the painter who writes. he comes at his art from an entirely different angle and brings to it different concerns and yet similar ones. but he is a poet always' (1967, unpaginated). Nichol's statement is less tendentious than Kahnweiler's; nevertheless, both statements are questionable. Kahnweiler's view here is as dogmatic as it is elsewhere, in his insistence on a kind of generic purity, on the absolute self-identity and self-consistency of separate art forms. In the course of twentieth-century art, a contrary view has prevailed: the mixing of genres, the blurring of divisions between art forms, has been the rule rather than the exception.

So far, I have been examining Kahnweiler's application to painting of the general word 'writing'; but he also uses some more specific literary

terms. Writing about Gris's late paintings, Kahnweiler says, 'A new element – *the poetic element* – entered his painting and dominated it from 1920 until 1923. Gris was aware of it: "This painting is to the other what poetry is to prose"' (134). Kahnweiler was uneasily aware that 'poetic' is most often used in a very vague way, to mean no more than 'atmospheric,' 'irrational,' 'dreamlike,' or even simply 'beautiful,' by critics too lazy to describe exactly what they're seeing. But Kahnweiler was prepared not only to use 'poetic' but also to distinguish between what he called a poetry of *forms* and a poetry of *ideas* in painting. 'It is more difficult than ever,' he writes, 'now that we have experienced Surrealism, to explain what is meant by poetic painting, by plastic lyricism, a lyricism of forms and not of ideas.' Surrealist painting is 'literary' in that its 'poetry' is 'created by an association of ideas and feelings, of literary and other memories, which are produced in the spectator as he digests the picture; the poetry is quite separate from the purely plastic element. This conception is fundamentally opposed to that of Gris' (135). Most Surrealism is, for Kahnweiler, 'a debased form of academicism' (137), following a tradition in which the anecdotal or symbolic content of the subject matter (whether it be a Napoleonic general or a dreamlike juxtaposition of incongruous objects) counts for more than the ontological problem of the nature of the image on canvas. Indeed, many Surrealist paintings have to rely upon traditional perspective in order to show that their juxtapositions are incongruous, just as Surrealist poems need the traditional syntactic link of adjective to noun to create an irrational pairing.

What Kahnweiler meant by 'plastic lyricism' is most clearly seen in his use of the word 'rhymes' to describe effects in Gris's paintings. This inter-artistic analogy is made in very straightforward terms: 'Rather like rhymes in a poem, two forms, generally of different sizes, are repeated' (141). So the curve of a guitar 'rhymes' the curve of a mountain, uniting the indoor still-life with the outdoor landscape, the man-made with the natural.[14] These rhymes were 'intended by Gris as plastic metaphors to reveal to the beholder certain hidden relationships, similarities between two apparently different objects' (141). At the same time, the objects used in this way are still to be 'read' as themselves, not as 'symbols of' each other, let alone of anything else. (There are, apparently, no phallic symbols in Kahnweiler's aesthetics.) 'The signs which Gris uses are "emblems." They *are* a knife or a glass. They are never symbols, for they never have a dual identity ... They *are* the objects which they represent, with all the emotive value attaching to them; but

they never signify anything outside of these objects. It would be a mistake to imagine that the "rhymes" ... in any way imply a dual identity as symbols do. These "rhymes," like every other rhyme, are a form of repetition: the repetition of two forms, each of which retains its own unique identity' (140). This comment, I believe, remains fundamentally important for any 'reading' of the images presented in Cubist painting (guitars, wine-bottles, newspapers on café tables) – just as it will be, later, for the images in the poetry of Ian Hamilton Finlay (fishing boats rhymed with lemons).

This use of the word 'rhyme' has become orthodox in Gris criticism.[15] It is, within the limits of analogical thinking, a useful analogy; however, there are more difficulties with Kahnweiler's use of 'rhythm.' This word is generally used of a movement in time, 'but there is no doubt that rhythm exists also in space – rhythm of forms' (141). But when it comes to any closer definition of what this 'rhythm in space' consists of, Kahnweiler can only resort to the kind of vague impressionism more generally associated with the word 'poetic.' Thus, we are told that Gris manifests a 'rhythm which is not mechanical but which proceeds from within the very depths of its creator, which is re-born as something different with each new emotion, which creates its own laws each time afresh and is the actual manifestation of the spirit' (140–1).

A final point in Kahnweiler's treatment of literature concerns his contribution to the vexed debate on the validity or otherwise of such terms as 'Cubist poetry' or 'literary Cubism.' 'Now this term is even more absurd than plain "Cubism,"' writes Kahnweiler, 'but Guillaume Apollinaire, Max Jacob and Pierre Reverdy tolerated it simply because, as friends of the Cubist painters, they felt that it drew attention to their community of thought. Yet the label affixed to this group of writers was in a sense a significant admission of the fact that at that time painting was leading the arts' (178). This is a sound and sensible comment, but Kahnweiler goes on to the more hazardous suggestion that 'the poetry of these three writers is a literary equivalent of Cubism' (179), which lands him squarely in the problem of defining 'equivalent.'

In order to do this, he relies heavily on quotations from the theoretical writings of Jacob and Reverdy. He deals first with their insistence on the 'autonomous objective existence of the work of art' (179); thus Jacob: 'A work of art stands by itself and not by virtue of the comparisons that can be made with reality' (quoted by Kahnweiler, 180). But this point could be made about Modernist art as a whole; it is certainly characteristic of Cubism, but not exclusively or distinctively so. A closer

parallel to Kahnweiler's own ideas about the *conceptual* nature of Cubist representation may be found in this quotation from Reverdy: 'In order to penetrate to reality the artist's mind must disregard the fugitive appearance. It does not follow that his art must be abstract; on the contrary, by disregarding what is superficial and transient in appearances he has a guarantee which should lead him to the production of more substantial facts, more concrete works and a stronger real existence' (quoted by Kahnweiler 180–2). This is Reverdy on poetry; but it would need no change at all in the wording to be Kahnweiler on Cubism.

A second point of similarity is taken to be the unity of the work. Again, 'unity' is scarcely a category exclusive to Cubism, but the particular application is more specific: 'the Cubist poets, like the painters, conceive of this unity as something absolute, unshakeable and capable of absorbing any kind of heterogeneous element' (184). The reference is of course to the technique of collage, and Kahnweiler makes the standard comparison between Cubist collage and the 'conversation' poems of Apollinaire, such as 'Les Fenêtres' and 'Lundi Rue Christine.' (For further discussion of these poems, see chapter 7.) Again, however, Kahnweiler stops short of the most radical conclusions on poetic experimentation. Returning to the question of 'new signs,' discussed earlier, Kahnweiler raises a series of intriguing questions – 'Had [the Cubist poets] invented new signs? And if so, what is a new sign in poetry? Does it mean a word which is completely invented? What is a new form of linking up the signs in poetry? And does any such new form immediately imply the rejection of existing syntax?' (183) – only to dismiss them again. This time he does progress beyond the level of the sign in itself, and does consider 'linking,' the crucial question of syntax; but, as before, having opened the door to Concrete Poetry, he closes it again. Jacob and Reverdy, he concludes, had done 'Nothing more than the poet's *real* job has always been; *they had given existing words a completely new meaning*'; and so they 'never upset syntax,' but worked through the 'association' of words and phrases (183). The justness of this estimation, especially of Reverdy, might well be questioned; for now, it is sufficient to note, one final time, Kahnweiler's reluctance to abandon the classical conventions of poetry.

Perhaps Kahnweiler's most astute comment on 'Cubist' literature is to be found in a brief passage on Gertrude Stein. The Cubist spirit in her work, he writes, 'seems so intense and rigid that sometimes one has the false impression that she has reached the point of abstraction. She makes use of existing words without inventing any, but she uses the

raw material of language with absolute liberty dictated by the logic of her work (if I may so describe her imperturbable flow, which does not unfold logically) and not in accordance with pre-existing laws. She herself has written: "I like the feeling of words doing as they want to do and as they have to do"' (184). The insistence that Stein's work stops short of 'abstraction' (yet also, simultaneously, the perceived need to make this distinction) links that work directly to Cubism as Kahnweiler defined it.

. In literature as in painting, then, Kahnweiler's legacy is a mixed one. He was close enough to the major writers of his time – Apollinaire, Stein, Reverdy – to be aware of the formal problems they confronted in their work. But a strong conservatism in literary taste prevented him from applauding experimentation as much in poetry as he did in painting. Nevertheless, his musings on these problems point the way towards some later solutions, and in the work of Ian Hamilton Finlay at least they have borne rich fruit (fruit that, admittedly, Kahnweiler himself might not know what to do with).

Kahnweiler's legacy remains an important one. Whatever the problems inherent in his use of the word 'writing,' I believe he was correct to see that the discourse of painting always includes the supplement of language. He was one of the first critics to bring the supplementary power of aesthetic discourse to bear upon viewers' experience of Cubist painting, and he has had a lasting impact upon the critical discussion of Cubism. As I turn, in the following chapter, to more contemporary theoretical accounts of how Cubist painting works, the trace of Kahnweiler's arguments will still be there to be read.

The Semiotics of Cubism

Cubist guitars always have five strings.[1] Maybe that's because they have to play sheet music in which the staff only has four lines.

This systematic reduction in number (six strings to five; five staff lines to four) is one of the simplest indications that Cubist painters were not concerned with giving exact, realistic images of the external world. The five-stringed guitar declares its independence from photographic reproduction – declares itself, that is, as a painted *sign* of reality, never to be confused with reality itself. The reduction by one echoes the nature of painting as a two-dimensional medium representing a three-dimensional world. The absence of the sixth string is itself a sign for all the other absences that constitute the enterprise of pictorial reproduction.

At the same time, the combination of the five parallel lines with certain other lines (a curve, a circle) can still be 'read' as a guitar. Whatever structural role such lines may play in the composition of the painting, they also function as signs, that is, they *stand for* something other than themselves. This is true, of course, of all figurative painting; but Cubism, through such overt signals as the five-stringed guitar, always foregrounds its own nature as a play of sign systems. It is this self-reflexive concern for its own mode of existence and representation that makes Cubism the Modernist movement *par excellence* in painting. Cubism was always an art of semiotics.

During the course of its critical history, Cubism has been subject to many attempts to theorize it, to provide a discursive explanation or justification for its procedures. Indeed, the radical nature of Cubism, its dramatic flaunting of its own difference from traditional modes of representation, *invites* this theorizing. The baffled response of Kahnweiler's 'naive spectator' – 'What's *that* supposed to mean?' – is not entirely

uncalled for. The very nature of the paintings leaves obviously open the place of the supplement, the gap that begs to be filled by commentary. As I outlined in chapter 3, commentary moved quickly to fill the gap opened up right from the start by the name 'Cubism' itself. And in chapter 4, I showed how Kahnweiler felt the need to articulate what Braque and Picasso had left silent. Theory acts as the supplement, both in the sense that the space for it is already there, as part of the painting, and in the sense that it comes later, in the form of retrospective narrative. And like all retrospective narratives, any one account of Cubism will shape and select the material to meet the requirements of narrative itself, to provide a neat and logical sequence. For Braque and Picasso in 1909, or 1912, there was no such narrative; there was only the immediate involvement of each canvas at a time. They were creating the space for theory, but they were not themselves theorists.

There are many possible theoretical narratives of Cubism, but the three major ones are those that I would designate as the conceptual, the relativist, and the semiotic. This chapter will begin with a brief account of the first two, then go on to consider the third in more detail. The semiotic theory of Cubism, I will argue, is the one that most fully accounts for the playful obsession with systems of signification so evident in the paintings and collages of Braque and Picasso. Semiotics operates within the large-scale linguistic metaphor that I outlined in chapter 1, so a semiotic theory of Cubism necessarily brings to bear the supplement of language – but in Cubist painting, this supplement was also quite literal. The chapter will conclude with a discussion of the direct presence in Cubist paintings, not just of quasi-linguistic semiotic 'signs,' but of actual elements of verbal language: words, fragments of words, letters.

The earliest theoretical narrative of Cubism, and for a long time the most influential, held that Cubism was an art of conceptual rather than perceptual realism. This line of argument is already present in Kahnweiler, as I showed in the previous chapter, but it by no means ends with him. John Golding quotes Picasso as saying, 'I paint objects as I think them, not as I see them' (60). We *know* that the top of a glass forms a circle, even if we *see* it as an ellipse – so why not (the argument goes) paint it as a circle? We *see* only one side of an object at a time, but we *know* what the other side looks like – so why not include the back as well as the front in the same image? Hence the inclusion, within one painting, of many fragmentary views taken from different perspectives.

The implication of many such statements is that conceptual knowledge is not only different from, but *superior to* what Douglas Cooper calls 'the eye-fooling illusion of three-dimensional seeing' (19). Thus Kahnweiler: 'Cubism disregarded appearances. Unsatisfied by the fortuities of a single visual impression, it endeavoured to penetrate to the very essence of an object by representing it, not as it appeared on a given day at a given time, but as it exists ultimately composed in the memory' (110). Or Cooper again: '[Renaissance artists] abandoned the mediaeval way of representing reality, by means of experiential conceptions, and began to rely instead on visual perception, one-point perspective and natural light. In other words, [they] opted out of recording that fuller truth about reality which is known to the human mind in favour of recording only what the eye sees of things, incomplete and deceptive though this may often be ... Cubism involved a return to the earlier conceptual principle, insofar as the artist assumed the right to fill gaps in our seeing, and to make pictures whose reality would be independent of, but no less valid than, our visual impressions of reality' (11). The language here is clearly pejorative ('eye-fooling,' 'fortuities,' 'opted out,' 'deceptive'), and the claim that 'conceptual' painting is 'no less valid than' more traditional modes slips quickly into the assumption that it is somehow *more* valid. This valuation seems linked to the philosophical idealism implicit in the notion of an object having some ultimate 'essence' separate from all accidents of appearance. Instead of painting a mundane guitar, the painter is seen as attempting to capture something like the Platonic Idea of Guitar. To a great extent, the subsequent rejection of this 'conceptual' theorizing of Cubism has been due to the increasing suspicion of idealizing philosophies. (One can easily imagine a deconstructionist critique of Kahnweiler.)

But there are other questions to be raised about the conceptual theory. For one thing, is the eye really 'fooled' by 'three-dimensional seeing'? We may 'know' that the top of a glass is a circle, not an ellipse, but it is the elliptical perception that tells us where to pour the wine. Nor does linear perspective really make any viewer *believe* that a painting is three-dimensional: at best, what it produces is, like any other artistic convention, a willing suspension of disbelief. Even 'the naive spectator' is seldom *as* naive as Kahnweiler's theory would have us suppose.

Kahnweiler argued that the conceptual approach led to the fragmentation of the object, to 'several views of the same object juxtaposed in one picture ... [which are then] intended to be seen simultaneously and to compose together a single object in the eyes of the spectator' (117).

That is, the picture has to be *completed* by the spectator. But as I indicated in chapter 4, this approach frequently leads to a reductive view of Cubist painting as a kind of elaborate jigsaw puzzle, with the spectator 'fitting together' a string here and a curve there to create a 'complete' guitar. Cubist paintings simply don't work that way. You can never put all the pieces of a painting together to create one complete object with no remainder. There is far too much *else* going on at the same time.[2]

Indeed, the ultimate objection to the conceptual theory, beyond its philosophical assumptions or its simplistic views of perception, is simply that it is too reductive. Conceptualism offers a possible rationale for some aspects of Cubist painting, especially for its multiple perspectives, and as such it was embraced by some of the minor Cubist painters, like Gleizes; but it seems largely irrelevant to the rich, patient, and complex explorations of Braque and Picasso. At best, it provides a limited point of entry for the literal-minded. As a full-fledged theory of Cubism, it can no longer be taken seriously.

While the conceptual theory contended that Cubism gave, ultimately, a *more* precise and 'real' (if not realistic) view of the object, the relativist theory went in the other direction. It accepted the multiple viewpoints, the *lack* of definition of the Cubist object, as positive values in their own right. This theory is advanced most persuasively by Robert Rosenblum: 'For a century that questioned the very concept of absolute truth or value, Cubism created an artistic language of intentional ambiguity. In front of a Cubist work of art, the spectator was to realize that no single interpretation of the fluctuating shapes, textures, spaces, and objects could be complete in itself. And, in expressing this awareness of the paradoxical nature of reality and the need for describing it in multiple and even contradictory ways, Cubism offered a visual equivalent of a fundamental aspect of twentieth-century experience' (1966, 9).

The relativist theory certainly seems closer to the mark than the conceptual, if only because it acknowledges the complexity of the paintings, and accepts the fact that 'no single interpretation ... could be complete.' There is often in Cubist painting a sense of uncertainty and multiplicity, which Rosenblum sees even as early as the 1908 landscapes of Braque: 'For all the seeming solidity of this new world of building blocks, there is something strangely unstable and shifting in its appearance. The ostensible cubes of *Houses at L'Estaque* were to evolve into a pictorial language that rapidly discarded this preliminary reference to solid geometry and turned rather to a further exploration of an ever more ambiguous and fluctuating world' (1966, 34). To some extent, it is a matter

of personal interpretation (and thus relative) whether a viewer chooses to respond more to the certainties or to the uncertainties of Cubism. While Rosenblum emphasizes the sense of shift and instability, another viewer looking at the same pictures would see a massive authority and calm, a sense (especially in Braque) of classical order and tradition, that aspect of Cubism that represents a continuity of French tradition from Poussin and Cézanne.

Rosenblum sees the historical context of Cubism as a time of uncertainty and flux, both politically (in the events leading up to the First World War[3]) and culturally (within the general breakdown of traditional certainties ushered in by Darwin, Marx, Freud, and Einstein). The question is whether Cubism's procedures responded to that uncertainty by mirroring it, and participating in its ambivalences, as Rosenblum suggests, or by setting up a model of order in counterpoint to it. It is this counter-view that is argued, with great eloquence, by John Berger in 'The Moment of Cubism': 'Thus art, however free or anarchic its mode of expression, is always a plea for greater control and an example, within the artificial limits of a "medium," of the advantages of such control' (32). Berger sees the Rosenblum argument as applying, not to Cubism, but to the more blatantly nihilistic movements of the early century: 'It is being more and more urgently claimed that "the modern tradition" begins with Jarry, Duchamp and the Dadaists. This confers legitimacy upon the recent [that is, 1960s] developments of neo-Dadaism, auto-destructive art, Happenings, etc. The claim implies that what separates the characteristic art of the twentieth century from the art of all previous centuries is its acceptance of unreason, its social desperation, its extreme subjectivity and its forced dependence upon existential experience' (29). In contrast, Berger argues that 'the evidence of Cubism should prevent us ... concluding ... that anxiety and extreme subjectivity constitute the nature of modern art'; rather, with Cubism, '[t]he modern tradition ... began, not in despair, but in affirmation' (31, 30).

Personally, I find myself closer to Berger than to Rosenblum on this issue. While I acknowledge the shifting and unstable nature of Cubism's mode of representation, I do not necessarily see in this a reflection of doubt, uncertainty, or existential angst. Rather, I see the mobility of the Cubist sign as an affirmative gesture of semiotic play, of delight in the freedom of representation rather than despair at its ambivalence. I agree with Berger that Cubism is an affirmative art, and that its 'moment,' the last years before the Great War, represents the final moment in the

twentieth century when such confident affirmation remained unproblematic. I wonder, in fact, whether Rosenblum does not project back into the Cubist period an idea of 'twentieth-century experience' that fully begins only after the terrible watershed of 1914.

Another problem with the 'relativist' theory is that it invites a great deal of speculation, largely unprofitable, about the 'influence' on Cubism of scientific ideas of the time: Einstein, the theory of relativity, the Fourth Dimension, and so forth. In the same way as the 'conceptual' theory found a kind of pseudo-justification in the activities of the odd mathematician Maurice Princet, there is a whole critical literature on whether Picasso could have known of Einstein's theories, and if so when; and on the popular vogue for scientific and quasi-scientific ideas of the Fourth Dimension.[4] Like all influence studies, this criticism tends to resolve itself into speculations and hypotheses ('Picasso could have read ... ' 'It is possible that Picasso might have been aware of ... ') that are by nature unprovable, and that depend upon an uncritical acceptance of the priority of authorial intention.[5]

Both the conceptual and the relativist theories are also unsatisfactory insofar as they begin from an abstract idea (essence, relativity) rather than from a fact of pictorial practice. The semiotic theory can also become very abstract and abstruse, but at least it begins from one of the most basic gestures of painting: what does it mean to put a mark on a surface, and thus set up a differential relationship between that surface, that mark, and any other marks that may be added to it? In what ways can this relationship of marks then be construed to act as *signs*, as representations of something other than themselves? All the patient elaboration of Braque and Picasso, as they followed the possibilities opened up by Cézanne, by African masks, and by each other's paintings, returns always to the nature of the pictorial sign and its mode of representation.

The tradition of semiotics in the twentieth century stems from a double inheritance: that of Ferdinand de Saussure and that of Charles Sanders Peirce. These two founders of the modern discipline gave significantly different accounts of the sign, and, while Saussure has been more influential in the development of linguistics-oriented fields such as structuralism and post-structuralism, I believe that Peirce is more useful in dealing with visual signs.[6]

Peirce divides signs into three general categories – symbol, index, icon – with the icon in turn being subdivided into three – image, dia-

gram, metaphor. A good account of these terms is given by Wendy
Steiner:

... Peirce outlined three major sign types differentiated according to the kind of
relations existing between their material aspect (sign or representamen) and
referent (object). If this relation is a matter of convention, as in the case of most
words, the sign is termed a symbol. Thus, 'house' is a symbol because there
is no particular reason, except for social convention, for those phonemes to
refer to that concept. A finger pointing at a house, in contrast, is related to it
existentially; if the finger is not reasonably close to the house, in an uninter-
rupted line of vision and cotemporal with it, it will not fulfill its semiotic func-
tion. Such a sign, existentially or causally related to its object, is called an index.
The final category is that based on a relation of similarity. This is the icon, of
which there are three varieties ... A sign which *substantially* replicates its object,
e.g. a model of a house showing doors, windows, and other house properties, is
called an image ...; a sign whose *relations* replicate those of its object, e.g. a
blueprint of a house, is called a diagram ...; and a sign that represents what
Peirce terms the 'representative character' of another sign through a *parallelism*,
e.g. 'snail shell' used for 'house' to stress the house's protective nature, is a
metaphor. (19–20)

Within this scheme, verbal signs (words) function mainly as symbols.
Occasionally, a word can be an icon (such as an onomatopoeia), or can
act as an index (such as interjections like 'Look!' or 'That one over
there!'), but the arbitrariness of the relation between the signifier and
the signified means that the character of verbal language is essentially
symbolic. (The words 'arbitrary,' 'signifier,' and 'signified' are of course
terms associated more with Saussure than with Peirce; I use them here
to anticipate the point that a great deal of Saussure's account of 'the
sign' accords well with Peirce's 'symbol,' but is less well suited to
'icon' and 'index.') By contrast, icons are mainly visual, although the
issue is complicated by Peirce's inclusion of 'metaphor' under this cat-
egory.[7] Paintings are, clearly, image-icons – though it is possible to
argue that the non-representational aspects of painting function as indi-
ces, self-reflexively pointing to their own material condition as marks
on a surface.

The main point to stress, however, is that for Peirce the condition of
iconicity – the sign's *resemblance* to its referent – does not in any way
impinge upon its being a sign. Even a highly realistic painting, while
far more 'motivated' than a word, remains a sign: not to be confused

with its referent, and distanced from the referent by a condition of absence within it. On this point, I am not fully in agreement with Steiner, who writes: '[I]mage-icons, by directly embodying aspects of their referents, create a more immediate awareness of those referents than would other signs, since some aspect of the referent is physically present in the sign ... But symbols lack this feeling of presence' (21). I think it is misleading to talk about 'presence' in relation to any sign, even Peirce's image-icons. I agree with Jean-François Lyotard (or at least with the 'You' half of his dialogue on 'Presence') that 'presence escapes ... it can only be apprehended as deferred ... Speculation never stops encroaching on naive reception. The art of presence is dying. The art of deferring presence is growing' (11–12). 'Presence escapes' *all* signs: symbol, index, icon all partake, insofar as they are signs, in this condition of absence.

I come back to the missing sixth string of Cubist guitars: it declares, unobtrusively but perhaps more appositely than any other visual convention, the condition of the sign as *the absence of the referent*. The gap where the sixth string should be maintains the distance of the sign, and ensures that the painting can only be read *as* a sign.[8]

The stress on such absence is even stronger in the Saussurean system. Here the central point is the *arbitrary* nature of the sign: the fact that the sign is not motivated by any relation of resemblance but is the product of a system of differences. The term 'arbitrary,' Saussure explained, 'should not imply that the choice of signifier is left entirely to the speaker ... I mean that it is unmotivated, i.e. arbitrary in that it actually has no natural connection with the signified' (68–9). Yve-Alain Bois is careful to stress that '[f]or Saussure, the arbitrary involves not the link between the sign and its referent but that between the signifier and the signified in the interior of the sign' (1990, 86). This distinction leads Bois to an important comment: '[S]igns are arbitrary and oppositional, yet not everything is possible in a given sign system. In the same way as in language one cannot invent a neologism at random but must do so according to certain associative rules if one wants it to be understood, in a semiological system like figurative painting ... one cannot go beyond a certain limit, fixed by rather loose rules, if one wants the figure to be read at all' (1992, 174). Much of Cubism is devoted precisely to the exploration of that limit: in Bois's words, to 'defining the minimum level of semantic articulation a shape is obliged to perform to be read as a sign' (1992, 190). In their different ways, both Analytic and Synthetic Cubism play along this border of legibility: reducing or fragmenting

the sign, dispersing its elements across the grid of the picture surface, setting its attributes in new and paradoxical relationships to each other, deconstructing but never abandoning its codes of representation.

For Saussure, the sign operates through a synchronic system of differences: differences, he insisted, *'without positive terms'* (120). While this idea could be applied to visual signs (the colour-wheel is a good example of a Saussurean system of differences without positive terms), it is clear that Saussure himself was thinking principally of linguistics: 'Signs that are wholly arbitrary realize better than the others the ideal of the semiological process; that is why language, the most complex and universal of all systems of expression, is also the most characteristic; in this sense linguistics can become the master-pattern for all branches of semiology although language is only one particular semiological system' (68). In chapter 1, I discussed some of the problems raised by this 'linguistic imperialism,' and by the way that the metaphor of verbal language pervades and conditions even non-verbal languages or 'semiological systems.' Here, I would point out that the effect of Saussure's emphasis is to concentrate semiotics itself on the category that Peirce defines as 'symbol.' Index and icon, less obviously 'arbitrary' (though, I would argue, no less defined by 'absence'), tend to be left aside, or implicitly seen as inferior forms of the sign.

Thus Rosalind Krauss, expounding a Saussurean view of the sign in relation to Cubist collage, writes: 'Whereas illusionistic depiction attempts to simulate the *presence* of objects, words effect no such simulation. Instead, they are part of a system of *re*presentation, with the prefix "re-" distancing the word-as-sign both temporally and substantively from its referent. The sign is a surrogate, substitute or proxy acting in the absence of the actual object' (1980, 94). I have no problem with this as a description of the Saussurean sign, but I do wonder what this 'illusionistic depiction' is that 'attempts to simulate the *presence* of objects.' It almost seems as if this category covers, for Krauss, all visual art prior to Cubist collage; it also seems (to quote Wendy Holmes, in her excellent critique of this passage) that Krauss wishes to argue that such illusions are 'close enough to objects to call their semiotic status into question' (197). However, I do not accept any such contrast between visual signs based on illusionistic presence and visual signs based on semiotic absence. *All* visual signs are based on absence; but I think it is easier to see this within Peirce's model of symbol, index, and icon than within Saussure's more narrow focus on the linguistic symbol as the prototype for all other signs.

I do not mean to suggest that either Krauss or Bois is ignorant of Peirce. Quite the contrary: both of them use the idea of the *index* in very interesting ways.[9] Bois argues that the grid system of Analytical Cubism functions as 'a purely indexical sign ... which refers to the surface of the canvas as such' (1992, 180); and also that 'any flat surface represented parallel to the picture plane, without foreshortening, becomes congruent with it and thus at once an index of the referent and of the pictorial surface' (1992, 177). Krauss takes this argument even further: in collage, the pasted paper is itself a flat surface overlaid on the flat surface of the canvas. It thus both *obscures* the original surface and, as an index, *refers to it* in its absence: an absence that it itself has created by its covering action. 'Through the collage element the field which has been obscured is reconstituted inside itself as an *absence*, since its material presence has now been rendered literally invisible. The collage element thus eclipses one field in order to introject into it another field, but to introject it *as figure* – a surface that is the image of an eradicated surface' (1980, 96). This kind of play *between* various semiotic functions (image, index, symbol) is characteristic of Cubism in all its phases – more characteristic, I think, than concentration on any *one* function, such as symbol.

However, despite their speculations on the sign as index, I would argue that both Krauss and Bois are most at home with the sign as (Saussurean) symbol.[10] Indeed, for Bois, Cubism only fully comes into its own at the point, in 1912, when Picasso (in Bois's account) arrives at a semiological[11] understanding of the arbitrariness of the sign.

In his essay 'Kahnweiler's Lesson,' Bois argues that it was through African sculpture, and specifically through a Grebo mask that he acquired in 1912, that Picasso 'became aware ... of the differential nature of the sign ... as a mark on an unmarked ground, within a system that regulates its use' (1990, 89). That is, the signs that marked 'eye' or 'mouth' in the mask bore little or no *resemblance* to a human eye or mouth; they were not, in Peirce's term, iconic. The protruding cylinders were made to stand for eyes only by virtue of their semiological context, their differential relation to the other elements of the mask/system. Thus, if you change the context, the same signifier may bear an entirely different signified: 'Picasso's reduction of his plastic system to a handful of signs, none referring univocally to a referent, causes their value to meet with numerous significations. A form can sometimes be seen as "nose" and sometimes as "mouth," a group of forms can sometimes be

seen as "head" and sometimes as "guitar"' (1990, 90). It is with collage and papier collé that this semiological nature of the pictorial sign becomes most evident, and most complex. Picasso is able to use a signifier (such as a piece of newspaper) in an entirely symbolic way, separate from any iconic function; the sign breaks free from the necessity of iconicity, it severs the apron strings of resemblance. In practice, depending on context, which may shift even within one painting, the signifier may work in several modes. For instance, in *Bottle on a Table* (1912; Rubin 1989, 267), the piece of newspaper may be read iconically, as an actual newspaper on the surface of the table; or indexically, as the flat surface of the table and/or the painting; or symbolically – Bois would say semiologically – as the volume or even the contents of the bottle. This last reading has no iconic 'motivation': it arises solely from the placing of the newspaper fragment within the differential system of this collage.

I have no problems with this analysis in itself; it is an excellent account of the way that Cubism plays with the codes of representation. I do have problems, however, with some of Bois's extensions to this argument: for instance, that this fully semiological pictorial sign marks 'the birth of a new paradigm or an epistemological break' (1990, 79) not only in Cubism but in the whole history of Western art. I simply do not agree that this 'symbolic' use of the pictorial sign is *that much* different from iconic uses.

Are the two types of sign so sharply distinct from each other? Is the arbitrary sign (the 'symbol') really free from iconicity, and is the iconic sign really free from the arbitrary? I would argue, rather, that icon and symbol interact with each other in a relation of necessary supplementarity. Neither can ever be defined in a way totally free of the other (as might indeed be expected, since they both share the Peircean condition of the sign).

First, then, are symbolic signs really free of resemblance? At the level of the individual sign, Malcolm Gee argues that: '[h]owever "abstract" it may be, a drawing of a glass in a Cubist work draws on [*sic*] features of glasses as objects; when Picasso creates a metaphorical relation between heads and guitars, it is because he is able to select common aspects of both and emphasise them in his treatment; when a piece of wallpaper functions as both a sign for a table cloth and wine in a glass this "arbitrariness" also draws on elements of motivation – colour, pattern, shape and placing. Cubism is, from this perspective, a very special

case of so-called iconism and not a total rupture with it' (139). The same argument applies when we move from the individual sign to the context in which it is placed, to its relationship with the other signs in the painting. In Picasso's *Bottle on a Table*, for instance, the relation between the newspaper and the bottle may in part be a symbolic one; but the system that enables the newspaper to be read as bottle still contains lines that, in however minimal a way, outline (iconically) the shape of a bottle. The individual signs that stand for 'eyes' in the Grebo mask may bear very little iconic resemblance to eyes, but the 'context' in which they are placed (two round objects side by side above a long vertical one) still depends upon a minimal sketch of facial anatomy. However symbolic these signs become, they never lose the supplement of iconicity. Iconicity simply shifts from the level of the individual sign to the (syntactic) level of their combination (the 'semiotic context').[12]

This point is argued in further detail by Christine Poggi, who acknowledges the problem and tries to find a way out of it. 'If we are to accept in full,' she writes, 'the structuralist interpretation ... some account must be made of the lingering presence of resemblance (or iconicity) as a signifying principle' (*Defiance* 49). She accepts that the curved lines that act as part of the sign for a guitar do still bear a visual resemblance to the edge of a guitar; but she argues that they 'function as signifiers of a guitar's profile only because of their placement within the whole,' and that in other works 'the same double curve appears at the side of the head and therefore comes to represent an ear' (50). Fair enough: but how does she know that the lines are now 'at the side of the head' unless the new 'whole' bears at least a minimal iconic resemblance to a face? All this argument does is to transfer iconicity from sign to syntax, from the individual signifier (curved line) to 'the whole' within which it is situated. Poggi concludes that '[r]esemblance as a means of motivating the signs of the visual arts is thereby at least partially defeated' (50) – but 'at least partially' scarcely seems enough to sustain the kind of claim for the 'fully semiological sign' that Bois is advancing.[13]

Nor does the iconic sign, insofar as it is a sign, escape the arbitrary (this is the lesson of the sixth string). An icon, Bois claims, 'does not need contextual clarification to perform a semantic function' (1992, 185): that is, an iconic eye will look like an eye whether or not it is set in the context of the system 'face.' But how can an icon *not* have a context? Where would it be? To be 'an icon' at all, to be a sign, it must already be

within the context of *being a picture*: that is, it must be *framed*. And the frame always marks (is an index of) absence.

Within Peirce's scheme, icon index and symbol are simply three modulations of the sign; there is no implied hierarchy or evaluation. But within Saussure's scheme, the symbol becomes the prototype for all signs, and this elevation inevitably produces an implied hierarchy. The overtones in both Krauss and Bois are clear: when Cubist painting became 'semiological,' it didn't just change, it became *better*. And then, in another twist of the argument, this 'improvement' becomes one more way to use Picasso as a hammer to beat Braque over the head with.

The relationship between Braque and Picasso was defined by the painters themselves in two famous (or notorious) metaphors. Of their collaboration, Braque said: 'C'était un peu comme la cordée en montagne' – it was a little like being roped together on a mountain. More concisely, Picasso said: 'Braque? C'était ma femme.' Both are metaphors of collaboration, but the difference between them is instructive. Braque's metaphor is one of equal partnership, two climbers sharing the same rope; at any given time, one or the other may be in the lead, but each is always dependent on the other. Picasso's metaphor may be intended to speak of an equal, loving, sharing partnership (marriage), but in the context of a patriarchal society (and no one has ever denied that Picasso was anything other than patriarchal), it is necessarily a hierarchical image. If Braque is the wife, then Picasso as the husband holds the superior position.

This division between the metaphors used by the painters themselves has been perpetuated by the critics who have attempted to define their relationship. Supporters of Braque (among whom I count myself) have seldom argued for an absolute superiority of Braque over Picasso: rather, they have argued that, during the years of Cubism, the relationship was one of equality, of a shared enterprise to which each painter contributed his particular gifts, and in which each painter profited by what he learned from the other; while in the years after Cubism, each painter went his separate way, and their later work is so different from each other that comparisons are of limited point or value. Supporters of Picasso argue, more decisively, that Picasso is a greater painter than Braque before, during, and after Cubism, in all aspects of his work. The counter-arguments can easily be inferred: Picasso's supporters claim that Braque's supporters want to avoid hierarchical judgments only

because they know they would lose; Braque's supporters wonder about the insecurity betrayed by Picasso's supporters' hysterical need to denigrate Braque at every opportunity.

The arguments between the two camps are frequently enjoyable for the rhetorical quality of their invective. One of the best exchanges is that between William Rubin and Leo Steinberg in 1977–9.[14] Being biased, I think that Rubin gets the better of the argument; but certainly Steinberg has the funniest moment:

> When a landscape produced at L'Estaque
> Reveals modernist trends in Georges Braque,
> It takes but a minute
> To find something in it
> For the anti-Picasso Braque claque.[15]

This comment is witty but unfair: to argue for Braque's contribution to Cubism is not at all to be 'anti' Picasso – it could only be construed that way by critics who operate always in the confrontational mode, and for whom any modification of Picasso's supremacy is seen as a hostile attack.

This difference in temperament between the critics is perhaps a reflection of what is commonly seen as the difference in temperament between the two painters. In a formulation that has become dangerously oversimplified and stereotypical, Braque is portrayed as classical, constructivist, meditative, restrained, methodical, and French, while Picasso is romantic, expressionist, emotional, impulsive, inventive, and Spanish.[16] This contrast is then used to produce an appealingly neat and symmetrical narrative of Cubism: Picasso supplies the verve, the courage, the inventiveness, while Braque supplies the steadiness, the calm, the patience to work slowly and systematically through a long series of paintings. Or, in the terms derived from Kahnweiler that I outlined in the previous chapter, Picasso arrives at Cubism through 'expressionist distortion,' the influence of 'primitive' art, and his emotionally charged nudes and portraits; while Braque comes through 'constructivist distortion,' the influence of Cézanne, and his contemplative still lives and landscapes.

This narrative is of course oversimplified. It undervalues the spirited, whimsical side of Braque's nature,[17] and the fact that most of the major innovations of Cubism came from the 'sober' Frenchman, not the 'inventive' Spaniard. Equally, it ignores Picasso's capacity for thorough

and patient exploration of pictorial problems: the dozens of preparatory studies that he made, for example, for *Les Demoiselles d'Avignon*, and his capacity to develop some of Braque's 'inventions,' such as papiers collés, in directions that Braque could not have foreseen. Picasso as instinctive genius is an image just as reductive as that of Braque as stolid Norman.

In *Picasso and Braque: A Symposium*, Leo Steinberg assembles, from the press reviews of the Museum of Modern Art exhibition, a recent sampling of such reductive contrasts between the two painters. Steinberg complains, quite accurately, that many of the good qualities attributed to Braque also pertain to Picasso; he seems less willing to stress the corollary, that many of the good qualities attributed to Picasso also pertain to Braque. Personally, I would agree with the summation given by Mark Roskill: 'We've accumulated these pairs of binary oppositions for Picasso and Braque for fifty years ... They seem to repeat one another endlessly in different variations, sometimes pro-Braque, sometimes pro-Picasso; what I'm saying is that I don't think it makes any sense to continue to do this ... To fall back on traditional terms of discussion doesn't gain anything for the central question of how we're going to present the overall partnership as a collaboration' (Zelevansky 248).

To return, then, to the point at which my account of Krauss and Bois broke off: the semiological argument turns out to be, among other things, a sophisticated new way of asserting Picasso's superiority over Braque. William Rubin explicitly comments that the arguments advanced by Bois and Krauss 'have shown quite clearly that there is a consensus to the effect that the linguistic model says something very essential and convincing about what happens in 1912 ... At the same time, while it really does characterise something about Picasso, it does not tell us very much about Braque' (Zelevansky 293). I disagree. As I have indicated, I have serious reservations about Bois's argument; but insofar as it is applicable, I would also argue that it is applicable as much to Braque as to Picasso.

In 'The Semiology of Cubism,' Bois is at first very careful to appear even-handed in his dealings. On page 171, he deplores 'Picasso's incredible unfairness to Braque' in a comment he has quoted; when he later asks whether he himself is not siding with this comment, he answers, 'In a sense I am' (174), with apparent reluctance or regret. But as the article proceeds, Bois's bias begins to show. Any apparent change of direction in Braque's work is described in such terms as 'retreats' (182) or 'balked' (184); but similar variations in Picasso are only 'acceptance

of the heterogeneous in his work' (185). By the end of the article, there is no pretence: Braque is insultingly dismissed as Picasso's 'acolyte' (191), and his alleged lack of structuralist sensibility is 'one of the reasons his art failed to maintain a high level of quality after the Cubist adventure' (194). (At this point I will drop any pretence at objectivity, and say that this last remark of Bois strikes me as utterly ludicrous. The late work of Braque is, in my opinion, the greatest, most sustained, most profound, most deeply satisfying body of painting in twentieth-century art.)

Bois's argument, though largely implicit, may be stated in simple form. 'Semiological' Cubism is (according to the argument I outlined earlier) a superior, more advanced form of art. Picasso grasped and used the semiological principle; Braque did not. Therefore Picasso again demonstrates his superiority to Braque. I would contest both of these premises. I do not think that the semiological or symbolic use of the sign is *superior* to other uses, just *different*. Nor, however, do I accept that Braque did not practise it – though he did so, I will argue, in his own way.

Another of the traditional ways of distinguishing between Braque and Picasso has been to say that Braque was interested in the depiction of space, Picasso in the creation of form. As he moved into what Bois calls the semiological use of the sign, Picasso used the (Saussurean) arbitrariness of the minimal sign to create endless ambiguities of form. The same lines or shapes (signifiers) could be used to refer to a multiplicity of signifieds: a curved line could indicate a guitar, a woman's body, or a visual pun[18] between the two. Braque, I would argue, exploits the same principle of ambiguity, but in relation to space rather than to form.

Braque's early papiers collés concentrated on the use of fake wood-grain wallpaper (papier faux bois) rather than newspaper clippings.[19] Papier faux bois is itself a kind of semiotic sign: it 'represents' actual wood graining in a way whose artificiality is evident at the merest glance. It gives an illusion of mimesis so self-conscious that it becomes self-parody.[20] The effect in Braque's collages is, consistently, one of spatial ambiguity. Does the faux bois 'refer to' the wooden surface of a table, or of a guitar? Or does it 'refer to' *actual* wallpaper, imitating wood panelling? Is the plane of the pasted paper to be read as horizontal (a table-top; a guitar lying on a table-top) or as vertical (a guitar hung on a wall; wallpaper pasted on a wall; the collage itself hung on a wall)? As early as Le Compotier (#2), pencil lines are drawn over the top of the pasted paper in such a way as to render the spatial relations of

over/under completely undecidable. 'For Braque,' writes Christine Poggi, 'the wood-grain paper undermines spatial relations, can be both figure and ground at once, and is conceived as a sign for material substance independently of its location in space' (Zelevansky 138). In other words, for Braque as fully as for Picasso, the invention of papier collé meant that the sign (in this case, the sign for depth, not the sign for form) became fluid, undecidable, a matter of arbitrary play.

But even on Picasso's 'own' ground, that of signifying *form*, Braque's papiers collés display the arbitrary nature of the sign right from the start. *Nature morte à la guitare* (#3) and *La Guitare* (#4) both use papier faux bois in highly 'contextual' ways to 'signify' a guitar. In both cases, the wood grain of the pasted paper reads undecidably as figure and ground: as 'guitar' and as either 'table on which the guitar is lying' or as 'wall on which the guitar is hung.' Moreover, in both collages, the pasted paper includes printed vertical lines, which can be read either as 'actual' decorative lines on the margins of wallpaper or as 'symbolic' strings of the guitar.[21] *La Guitare* (#4) also presents a piece of papier faux bois cut in a straight-line, right-angled shape that may serve iconically (as the corner of a table), indexically (as the frame of the canvas), or symbolically (as the 'curves' of a guitar, the reference being determined not by resemblance but by semiotic context). That is, within the first four of Braque's papiers collés, all the elements of the semiological sign, which Bois denies to Braque, are clearly evident.[22]

I have made this argument in order to demonstrate that, even within Bois's own terms, the 'gulf' (1992, 174) that he claims to see between Braque and Picasso simply does not exist. But let me repeat: I do not accept Bois's own terms. I do not accept that an 'arbitrary' use of the pictorial sign is in any way necessarily better than a less arbitrary, more iconic use.[23] The difference between the papiers collés of Braque and Picasso is much more a matter of artistic temperament. For Picasso, papier collé, and Synthetic Cubism in general, released his expressionist, whimsical, and metaphorical inclinations from the restraint in which the joint discipline of Cubism had held them. His collages explore bizarre combinations of forms, jokes, puns, sexual references, the adolescent quality in his work that so appealed to Gertrude Stein. Braque, as I show in the final section of this chapter, was by no means averse to puns and wordplay; but his papiers collés are, by and large, more grave, considered, meditative, and (dare I say it?) *beautiful* than Picasso's.

So far, I have been dealing with the semiotics of Cubism insofar as they relate to visual, non-verbal signs. But Cubism is also famous for its

inclusion, within the visual composition, of conventionally verbal semiotic systems: letters and words. Such verbal elements had, of course, appeared in paintings throughout art history,[24] as titles, as 'legends,' or as part of the represented scene (words on books, posters, newspapers, and so on); what is new in Cubism is the radical dislocation of the lettering from any realistic 'support,' and the variety of semiotic purposes to which it is set. Although the use of lettering is sometimes seen as bringing Cubism back closer to 'reality,'[25] in fact the letters and words always act as signs, never as 'real' objects: you cannot even say that a pasted piece of actual newspaper 'is' a newspaper; it is always a *sign of* a newspaper. Braque and Picasso recognized lettering as another visual sign-system, and in much of their work at this period their point consisted precisely of the witty interplay between verbal and non-verbal signs.

As signs, these words and letters exploit the full range of semiotic possibility outlined by Peirce: icon, index, symbol. Take as an example Braque's *Le Portugais* (1911; Rubin 1989, 211).[26] This painting includes several groups of letters and numbers, painted with a stencil: D BAL, OCO, &, and 0,40. These letters signify in many different ways, and the play between these various readings is a major part of the viewer's enjoyment of the painting. It is often said that the lettering, in its flatness and frontality, in the regularity of its stencilled form, reaffirms the surface of the canvas, 'emphasizing its two-dimensional character' (Golding 93). In this way, it acts as an *index* of its own material support, in much the same way as was argued by Bois (in relation to the grid) and Krauss (in relation to the pasted paper). I think this function is valid, but only to a limited extent. As is typical of Braque, the situating of the letters in space is highly ambivalent. They may seem to sit 'on' the surface of the canvas, asserting its flatness with their own, but they also float in an indeterminate space 'behind' that surface. Several of the letters are overpainted, and the D of D BAL emerges from 'behind' the 'head' of the main figure. As Will-Levaillant comments: '[T]he word is submitted to changes of level and variations of colour, especially in what we call the Synthetic period, where a single object straddles several coloured planes ... The letter as a stable object in Cubism? What an illusion!' (57–8).

The lettering may also be seen as representational, in a way that hovers intriguingly between the iconic and the symbolic. That is, it is widely accepted that 'D BAL' refers in some way to a poster advertising a GRAND BAL, and that '0,40' represents 40 centimes, a price printed

on a menu or a placard on the wall of a bar. The signs are iconic insofar as they reproduce, exactly, the appearance that these letters would have on such a poster or menu: but nothing in the painting in any way 'represents' the ground on which the letters would appear – there is no iconic sign for poster or menu. The letters 'float free' of any represented support; their situation (on a poster or menu) can only be inferred from the totality of the picture. In this sense they are much closer to the symbolic (indeed, to what Bois would call an arbitrary semiological sign). This symbolic nature is striking enough if one indeed assumes that the painting is 'set' inside a bar, as most critics have. But William Rubin quotes a letter from Braque to Kahnweiler, written very shortly after the painting had been made, in which the subject is described as 'un émigrant italien [sic] sur le pont d'un bateau avec le port comme fond' (Rubin 1989, 56).[27] If the setting is indeed on the bridge of a boat, then the café appurtenances are even more strikingly symbolic, an arbitrary juxtaposition of the indoor and the outdoor. It should also be noted, however, that the words do *not* operate 'symbolically' in the 'normal' sense of verbal language: that is, they do not suggest the presence of either a group of dancing people or a pile of coins on a table. Sign refers to sign.[28]

The incompleteness of the words is also important. D BAL *invites* the viewer to guess its complete form, to supply GRAND BAL in full: and many Cubist paintings and collages involve this kind of game, challenging the viewer to take part. But at the same time, it is important to note for its own sake the Cubist commitment to what Will-Levaillant calls 'l'émiettement et la déchirure d'un texte' (50) – the crumbling, dispersal, or dissemination, and the tearing up (one might almost translate, the deconstruction) of a text. This process, as Shklovsky would say, defamiliarizes the text; it foregrounds what Bois calls 'the transformation of the letter into a spatial figure, which contradicts the linearity of the grammatical signifier "imitating" that of the verbal (oral) chain: in fragmenting words, in allowing their letters to dance independently on the surface of their canvases, Braque and Picasso emphasize their graphic nature, which is independent of their verbal counterpart' (1992, 202–3). In this sense the enigmatic OCO at the left edge of *Le Portugais* is just as important, in its resistance to being recuperated into an extended reading, as the D BAL, which offers itself to such recuperation.

The word fragments insist on their own incompletion in exactly the same way as the depictions of guitars omit the sixth string: they refuse any easy reading as iconic signs, as exact resemblances. In *The Architect's*

Table (1912; Rubin 1989, 216), Picasso included a painted representation of a visiting card reading 'Miss Gertrude Stein' – but in the painting, the card actually reads 'Mis Gertrude Stein.' The missing 's' is again the sixth string of the guitar.

Fragmented words and letters can be used, then, as arbitrary graphic elements – Golding notes that in *Le Portugais* 'the letters have a purely compositional value, providing a terminal note for a system of ascending horizontal elements' (93) – and also as playful challenges, teasing the viewer into games of reference. The words may be used in ways that can quite legitimately be described as *poetic*, depending either on witty puns or on lyric associations. Many Cubist paintings and collages can be seen as highly condensed poems: poems that do not depend on syntax or on linearity but on the visual-spatial juxtaposition of verbal elements. That is, Cubism includes the first fully developed instances of what came to be known later in the century as Concrete Poetry.

Early readings of Cubist collages that included verbal elements (especially newspaper cuttings) tended to concentrate on the formal aspects: on the compositional role of the papier collé, its flatness, its texture, its play between different levels of space and of representation. Only with Robert Rosenblum's pioneering 1973 essay, 'Picasso and the Typography of Cubism,' did critical attention focus on what the words in these newspaper clippings actually said. Rosenblum pointed out, for instance (1973, 93–4), Picasso's fondness for punning on the title of the newspaper LE JOURNAL, which was the source for many of the pasted fragments. Most obviously, dropping the NAL leaves JOUR (day); but the JOU may also be isolated, suggesting puns on *jouer*, to play, or *jouir*, to enjoy or (in sexual terms) to come.[29] Equally URNAL may be read as URINAL, as in one of the most famous of Picasso's papiers collés, *Table with Bottle, Wineglass, and Newspaper* (1912, Rubin 1989, 263). Here the (rather adolescent) joke is made by the association of URNAL not only with the bottle and wineglass, but also with the cropped headline UN COUP DE THE, which may be read as a pun on the English 'cup of tea.'[30] But that headline in turn disseminates the meaning in several other directions. It surely recalls Mallarmé's 'un coup de dés n'abolira jamais le hasard,' nicely playing on the fact that it is only 'par hasard' that Picasso has found this particular headline. In the original newspaper, UN COUP DE THE is part of the phrase 'un coup de théatre,' which might well be a self-referential description of the virtuosity of the collage's own wordplay, but is also a reference to current events in the

Balkan wars. The cut paper also contains the sub-headline's reference to 'La Bulgarie, la Serbie, le Monténégro.' Patricia Leighten has argued in detail[31] the case for reading this and other collages as direct political statements on Picasso's part. While there may be some doubt about Leighten's claims for the extent of Picasso's political commitment to anarchism, there can be no doubt about the importance of the Balkan wars as subject matter in these collages. Finally, however, note that the full sub-headline refers to Bulgaria, Serbia, and Montenegro signing some treaty or agreement, and that the headline is so cut off that its last word is, in English, 'sign.'

The wordplay in Braque's papiers collés is less flamboyant (and less obscene); it reflects the calmer, more restrained and meditative air of his images. But it is certainly present.[32] 'Braque's form of punning,' writes Mark Roskill, 'could be taken as more gentle and unobtrusive than Picasso's; his uses of assonance and homophony as more "poetic" in character than Picasso's corresponding wordplay' (1992, 229).

As a brief exercise in appreciation of Braque's poetry, I would like to look at a small group of papiers collés – mainly, though not exclusively, those in which the words and letters are pencilled in, either freehand or by stencil, rather than those that use pasted cuttings from newspapers. (In the definitive catalogue, *Georges Braque: Les Papiers collés*, the pieces I am looking at are those numbered 1, 4, 5, 6, 7, 11, 13, 15, 16, 17, 19, 20, 21, 25, 29, 31, 35, 43, 46, and 48, all dating from 1912 to 1914.) These collages may be taken to form a series, in which the repetition of key words and letters from one collage to another builds up a kind of poetic resonance. Although the works were not intended to be seen as a series, the verbal patterns are sufficiently tight and consistent to justify their retrospective selection as a corpus of texts.

The first thing that emerges from a reading of this corpus is the comparatively narrow range of words, even of letters, employed. JOURNAL may serve as a point of entry: it occurs in full only once (#16), but in fragments as JOUR (#4, 6); as NAL (#46); and split into JOU and AL (#35). The AL is echoed in ALE (#1) and BAL (#13, 16). The BA of BAL recurs in reverse as AB (#21); in BAR (#1); in TABAC (#17); and most often in BACH (#11, 16, 25 – and also, by implication, in #43, where JOH is presumably short for Johann). The AR of BAR repeats in MARC (#7, 19, 20) and in ARIA (#25). The common vowel through all this is A, which is given its musical key as L'ECHO D'A (#29), and which is implicit, though unwritten, as AS in the several depictions of ace play-

ing cards (#5, 21, 31, 48). In comparison to the wide variety of wording in Picasso, this selection shows a tight, almost obsessive, restriction of range.

What can be said about it? Thematically, two motifs predominate: the café (BAR, ALE, JOURNAL, TABAC, MARC, and the playing cards); and music (BACH, BAL, ARIA). #16 unites the two: it combines the words BACH, BAL, and JOURNAL with schematic drawings of a wineglass and a guitar. This combination is of course highly characteristic of what we know about Braque himself: that he was a talented musician, and that he enjoyed the life of the Parisian cafés. The celebration of that life, with its modest sensual enjoyments, is always central to Cubist iconography. In contrast to the nineteenth-century's Romantic worship of nature, it sets up the mundane life of the city as a valid artistic subject; in contrast to the increasingly gloomy political situation of 1912 to 1914, it offers a warm acceptance of everyday pleasures.[33]

Christopher Green extends even further the importance of this evocation of café society. In relation to the similar references in the work of Juan Gris, he comments: 'There is no speech in the *papiers collés*, only writing. But ... the conflicting idioms that they juxtapose so abruptly encourage an analogy with the babble of many voices, while their lack of clear syntactical cohesion, their fragmentariness, encourages an analogy with the language, not of writing, but of speech, especially the kind of volatile, spontaneous speech that must have been current in the cafés of Montmartre, Montparnasse or Céret. As the fragments of newspapers, the labels, the wood-graining, the false-marbling and the objects of the *papiers collés* work metonymically to signify the noisy social arena of the cafés, the *papiers collés* themselves became a kind of visual chatter: a chatter whose preoccupations (from the Cubists ... to pulp novels or the Balkan Wars) switch constantly from those of the avant-garde to those of the many other converging social groups that brushed against one another in the cafés' (151). In subsequent chapters, I will return to several of the points raised in this passage;[34] for now, let me stress that this important level of social reference is conveyed in Braque's work by both visual and verbal signs: by the semiotic inscription of bottles, glasses, newspapers, and tabletops as well as by the verbal insistence on BAR, ALE, JOURNAL, TABAC, and MARC.

To return, then, to the verbal 'poetry' of Braque's papiers collés: another cluster-point is #29, which shows a glass, a tenora, and a highly 'semiological' guitar (one rectangular strip of papier faux bois, in which the soundhole coincides with the mouth of the glass),[35] all 'keyed' by a

small cutting of newspaper, cropped to show only L'ECHO D'A. ('A' is the note played by orchestras tuning up.) The recurrence of A sets up echoes, or rhymes, that link the verbal elements of all these collages and key them to the musical motif. BACH, BAL, JOURNAL; BAR, MARC, TABAC: the echo of A plays all through the series. It is also, of course, the vowel of Braque's own name. So its recurrence throughout this series acts as a kind of abbreviated *signature*.

Of all the traditional occurrences of words in painting, the most common is the signature – and paradoxically, in Cubism it is often suppressed. The signature, as Jacques Derrida has shown,[36] is a highly paradoxical form of linguistic sign. It is more than the mere mention of the name: it is affirmation and claim, 'the act of someone not content to write his proper name (as if he were filling out an identity card), but engaged in authenticating (if possible) the fact that it is indeed he who writes: here is my name, I refer to myself, named as I am, and I do so, therefore, in my name. I, the undersigned, I affirm (yes, on my honour)' (1984, 52–4). The signature claims a kind of presence (authentication) – and on this is built the whole mystique of the original object, the unique artwork. (There is the famous story that Picasso used to pay for all his purchases, no matter how small, by cheque, since the cheques were never cashed; the signature itself was more valuable than the sum it countersigned.) Yet at the same time (as again the art market shows), forgery is always possible: indeed, the possibility of forgery (the iterability, the repetition of the signature in recognizable form) is a necessary part of the structure of the sign.[37] For if the signature lays claim to presence, it also requires absence: 'By definition, a written signature implies the actual or empirical nonpresence of the signer' (Derrida 1988, 20). Absence is, as always, at the heart of the sign.

The signature lies on the margin between the inside and the outside of a text. Looking back into the text, it authenticates what has gone before, it 'authorizes' the word that is the name of the author. Simultaneously, it points to the world 'outside' this particular text: the world in which that author continues to exist, whether as a living person or as the memory of a dead name. In literature, the signature initiates the text (on the title page) and provides its closure (in its actual or implied placement at the end of the final page); is it then *part of* the text, or can it stand, somehow, 'outside'? In painting, the signature usually adopts a similar position of closure (at the foot of the canvas), but the problem is the same. It is both *part of* the painting, present in its composition and visual field, and 'outside' it, not a part of its diegetic space.

Derrida is especially interested in cases where the signature enters the text through plays on the author's name: puns, but also 'Rebus, anagrams, metonymies, synecdoches, etymological simulacra, "geneanalogies," expropriations of words or things in representation' (1984, 106). The effect of such techniques is that 'by not letting the signature fall outside the text any more, as an undersigned subscription, and by inserting it into the body of the text, you monumentalize, institute, and erect it into a thing or a stony object. But in doing so, you also lose the identity, the title of ownership over the text: you let [the signature] become a moment or a part of the text, as a thing or a common noun' (1984, 56).

Georges Braque was particularly adept at this kind of play with the signature.[38] In *The Violin* (1914; Rubin 1989, 313), he paints into the canvas an exact simulacrum of a museum plaque, 'G. BRAQUE': the monumentalizing or institutionalizing of the signature playfully displayed within the textual space of the painting. The persistent repetition, in the papiers collés, of the letters B,R,A,C forms an extended and disseminated signature, 'l'echo d'A.' (Whatever Braque's love for Bach's music, the concentration on that name is surely in part due to its homophony.) Any occurrence of the type of jug or pitcher known in French as *un broc* may also imply a pun on the artist's name. Writing about *Violin and pitcher* (1910; Rubin 1989, 149), Alvin Martin points out that this canvas was originally known as *Broc et violon*. He argues that the forms at the top of the canvas may be read as a concealed self-portrait, with the 'head' doubled as a mask hung from the famous *trompe l'oeil* nail. Then he points out that the word *braque* can be used as a colloquial adjective meaning a little bit crazy (*Collins Robert* gives 'barmy' and 'crackers'), or as a verb meaning 'points, aims at.' Thus, he concludes, the visual game of the *trompe l'oeil* nail is doubled by a verbal game, in which the nail 'braque vers la tête braque de Braque' (51)!

Other people's names are also punned on. Mark Roskill (doubtless attracted to his own name) points out that MARC, besides being a good drink, and besides being a pun on 'marque,' is also, with the addition of the feminine ELLE, the name Marcelle – a name shared at this time by two women: Braque's own wife, Marcelle Lapré, and Picasso's new mistress, Marcelle Humbert.[39] Picasso himself appears, quite often, as the ace of spades: *l'as de pique*.[40] One papier collé in which this happens (#21) combines the ace of spades with the letters AB. Between them is an indeterminate shape, in which a semicircle is drawn over the vertical lines of edging on a piece of papier faux bois. It could be taken as a

minimal sign for a guitar (wood, strings, soundhole); but the vertical lines and the semicircle also combine to form a P in front of the AB. Thus, the whole piece 'reads': [AS DE PIQUE] PAB[LO]. Here, then, is a further 'echo of A': the B-A of Braque combined with the A-B of Pablo like two climbers on a mountain. Or, if you must, like man and wife.

But perhaps the most fully 'semiotic' occurrence of the signatures of Braque and Picasso is to be found, precisely, in the unsigned canvases. The usual explanation for this is that the painters found the signatures distracting from the intricate compositions being evolved in Analytical Cubism: that there was simply no place for them in the new pictorial order. Fair enough: but the *absence* of the signature also drew attention to itself. It was noticed; it became part of the game of saying that you couldn't tell Braque and Picasso apart. As absence, it points to all the other absences that have been crucial to this whole discussion: to the absence of the referent, which is always the condition of the sign; to the absence of the author, which is always the condition of the signature; to the absence of the third dimension, which is always the condition of painting; to the absence of the sixth string, which is always the music of the Cubist guitar.

Metaphor and Metonymy in Cubism and Gertrude Stein

In dealing with the verbal elements of papiers collés in the previous chapter, I went so far as to refer to 'Braque's poetry.' In doing so, I was practising one of the oldest forms of supplementarity: describing one art form in terms drawn from another. From at least the time of Horace ('ut pictura poesis'), critics have attempted to set up comparisons or analogies between different arts. The structure of the supplement, I have argued, necessarily produces such attempts. The lack within one art form calls out to the discourse (or non-discourse) of the other. But while inter-artistic analogies are, from this point of view, inevitable, they are also, from other points of view, incomplete and unsatisfactory. Such analogies are always tricky and unstable concepts – and the more so the more systematic they attempt to become. At best, I believe that they may serve heuristic purposes, as purely tactical devices at particular points in an argument. (I would certainly not wish my statements about 'Braque's poetry' to be extended any further than that.) But the very persistence of the attempt pays tribute to the sense in which it is widely felt that the arts tend towards each other, responding to each other's lacks.

One basic strategy for inter-artistic analogy is to use terms that are established and well defined in the critical discourse of one art form and to apply them to another. For example, one can take an art-historical term such as Cubism, which has a (more or less) clearly defined meaning in painting, and attempt to apply it to literature – saying, for instance, that Gertrude Stein is 'a Cubist writer.' Such comparisons are most useful, I would argue, when they attempt to define or illuminate those aspects of a work in which it is coming up against the limits of its medium, when there is a perceived need to supplement one discourse

with the vocabulary of another. The analogy to painting may be most productive at the point where a literary text strains against the limits of the verbal – when it appears, indeed, to court the annihilation of the verbal in the silence, or muteness, of painting. Stein's writing is felt to be 'like' painting precisely at the points where it seems to be on the edge of denying its own adequacy as words.

However, it is more common for the process to work the other way: that is, for a literary or linguistic term to be extended and applied to painting. Since criticism itself is a verbal discourse, it is always happier when dealing with terms that have a verbal foundation; hence all the accusations of 'linguistic imperialism.'

Among the literary terms that have recently been extended beyond their traditional bounds, none has received greater play than metonymy, especially when it is distinguished from, yet held in a complementary relation with, metaphor. The widespread application of the metaphor/metonymy distinction can thus be seen as one of the most effective strategies of 'linguistic imperialism.' In this chapter, I propose to examine some of the recent uses of 'metonymy,' especially in relation to Cubist painting, to Gertrude Stein, and to the description of Stein as 'a Cubist writer.'

In the simplest definitions of metaphor and metonymy, in the traditional rhetoric of figures of speech (and using here the definitions in the *Oxford English Dictionary*), both are concerned with *substituting one noun for another*. Metaphor is the 'figure of speech in which a name or descriptive term is transferred to some object different from, but analogous to, that to which it is properly applicable'; metonymy is a 'figure of speech which consists in substituting for the name of a thing the name of an attribute of it or of something closely related.'[1] The essence of metaphor is a similarity perceived across *difference*; the essence of metonymy is *contiguity*. Although both figures suggest a connection between their two terms, metaphor will initially foreground the apparent distance between them, while metonymy will focus attention on their apparent relationship. Since that relationship is very often that of the part for the whole, the commonest form of metonymy is synecdoche; synecdoche may indeed be seen as a subspecies of metonymy.

These traditional definitions were recast by Roman Jakobson, and it is Jakobson's reformulation that most deeply influenced the contemporary use of the term metonymy. Jakobson's distinction arose out of his 1954 essay 'Two Aspects of Language and Two Types of Aphasic Disturbances,' which projects metaphor and metonymy onto the structur-

alist schema of language as deployed along two axes: a vertical axis of selection by substitution and a horizontal axis of combination by contiguity. Jakobson places metaphor on the vertical axis, working by similarity, and metonymy on the horizontal axis, working by contiguity. The two figures of speech are then compared to two types of aphasia, each of which is seen as a 'disorder' in the functioning of the opposite axis. That is, metonymy is a disorder of similarity (the axis of metaphor), and metaphor is a disorder of contiguity (the axis of metonymy). As 'similarity disorder,' metonymy involves a 'major deficiency ... in selection and substitution, with relative stability of combination and contexture.' Specific nouns tend to be replaced by generalizing ones, or else to disappear altogether; 'words syntactically subordinated by grammatical agreement or government are more tenacious, whereas the main subordinating agent of the sentence, namely the subject, tends to be omitted' (245). All this is seen as an extreme instance of metonymy, in which '[t]he relation of similarity is suppressed' (254). Conversely, 'Contiguity disorder,' which is seen as an extreme instance of metaphor, produces a state in which '[t]he syntactical rules organizing words into higher units are lost; this loss, called *agrammatism,* causes the degeneration of the sentence into a mere "word heap" ... words endowed with purely grammatical functions, like conjunctions, prepositions, pronouns, and articles, disappear first' (251), leaving the discourse dominated by nouns, and by nouns used in a metaphoric way.

One effect of Jakobson's formulation is to shift the whole metaphor-metonymy distinction itself away from the axis of selection and onto the axis of combination. The traditional definitions of metaphor and metonymy saw *both* of them as ways of substituting one noun for another; in Jakobson's formulation, this remains the major function of metaphor, even or especially in the aphasic 'word heap,' but it has been drastically diminished as a function of metonymy, which is now seen as the *suppression* of nouns. The traditional definitions saw metaphor and metonymy as two different operations on the axis of selection, that is, vocabulary; Jakobson sees them both as operations on the axis of combination, that is, syntax. Metaphor survives this shift better, since it is still essentially conceived as a process of naming; but metonymy has become muddled, divided between the traditional sense – a vocabulary choice that still involves nouns – and the Jakobsonian sense – a syntactic deferral that suppresses nouns.

A second effect of this redefinition has been to align metaphor-metonymy with other paired terms: modernism and postmodernism, structuralism and post-structuralism. Metaphor, on its static vertical

axis, may be used to describe the modernism of such writers as Eliot and Joyce, and the structuralism of Lévi-Strauss, or of schematic narratologists such as Greimas. Metonymy, on its dynamic horizontal axis, leads to the postmodernism of such writers as (in the Canadian context) Robert Kroetsch and bpNichol, and to the post-structuralism of Derrida's 'dissemination.' Kroetsch especially has stressed the use of the metaphor-metonymy pair as a key to explaining forms of experimental writing that have rebelled against the tight, closed, hierarchic structures of metaphor in the name of the open-ended, disseminative accumulations of metonymy. 'To go from metaphor to metonymy,' he has said, 'is to go from the temptation of the single to the allure of multiplicity' (Neuman and Wilson 117). Similarly, Michael Phillipson, in *Painting, Language, and Modernity*, writes that 'modernity privileged metaphor over metonymy ... Post-modernity deconstructs metaphor ... in its attempt to stay with, to follow, the constant scattering of meaning, its dispersal, in the interpenetration of signifiers. It not only finds the threat to meaning in this dispersal, but delights in it and exploits it' (157).

If metonymy, in Jakobson's words, suppresses 'the main subordinating agent of the sentence, namely the subject,' then the term may be especially useful for describing writing that puts into question the whole concept of subordination to a single subject, whether grammatical, philosophical, or sexual: writing that is 'incoherent, open-ended, anarchic, irreducibly multiple ... indeterminate, anti-patriarchal (anti-logocentric, anti-phallogocentric, presymbolic, pluridimensional).' These adjectives are all offered by Marianne DeKoven as descriptions of the 'experimental writing' of Gertrude Stein (xiii, xvii).

However, before we wholeheartedly adopt the metaphor-metonymy distinction, and before we attempt to situate Gertrude Stein in relation to it, two caveats need to be made. The first is that this very fondness for classification by binary pairs is itself a characteristic of structuralism, an operation on the vertical axis, an instance of metaphor. The kind of radical multiplicity towards which metonymy seems to lead should itself prevent us from using metaphor-metonymy as a rigid conceptual grid into which any given writer can be neatly slotted. It is, indeed, far too easy to fall into the verbal game of describing *everything* in terms of metaphor and/or metonymy. What is needed is a way of using the terms in a less rigid, more open-ended way: to use the distinction itself, that is, more as metonymy than as metaphor.

Second, even if we do persist in using these terms (as I shall be doing in most of this chapter, albeit with a Derridean 'erasure' understood to hover over them), it is by no means certain that Stein can be usefully

situated within the limits of either category exclusively. Much of Stein's writing transgresses both the traditional and the Jakobsonian definitions. Insofar as both metaphor and metonymy are types of *naming*, they fail to account for Stein's *un*-naming, or *dis*-naming: her dislocations of the naming process itself. Furthermore, Stein refuses to sit easily in either the modernist or the postmodernist camp.[2] In fact, most of the attempts to apply the metaphor-metonymy distinction to Stein have concluded that both figures are to be found in her work; what is at issue is the distribution and balance between them.

In discussing this topic, I will be using the common distinction between two styles in Stein's writing of the period between 1906 (the completion of *Three Lives*) and 1914 (the publication of *Tender Buttons*). The first style – that of lengthy, convoluted repetitions in highly generalized language – is exemplified by *The Making of Americans*; the second – that of briefer, more lyrical sentences, sometimes in a fractured syntax, and using a much more vivid, concrete vocabulary – by *Tender Buttons*. There are, of course, several mixed or transitional texts, notably *A Long Gay Book* (1909–12), in which the change can quite dramatically be seen in progress. In this chapter, while I have taken some of my quotations from the 'exemplary' texts, I have chosen to concentrate on *A Long Gay Book* – partly because *The Making of Americans* and *Tender Buttons* are so fully treated elsewhere, and partly as a continuing reminder that even this initial gesture of distinguishing between the two styles is not as unproblematic as it might seem.

The application of the metaphor-metonymy distinction to the works of Gertrude Stein may be seen in representative form in David Lodge, whose 1977 book *The Modes of Modern Writing: Metaphor, Metonymy, and the Typology of Modern Literature* was one of the most influential works in promoting the use of Jakobson's formulations. Lodge describes Stein's first style as metonymic, the second as metaphoric. In relation to the first style, he cites the three techniques that Stein later described as 'using everything,' 'beginning again and again,' and 'the continuous present,' and sees them all as 'experiments along the metonymic axis of discourse' (147). Using Jakobson's formulations, he points to the stress on connectives and on non-specific forms of speech. Jakobson had noted that in the metonymic 'similarity disorder' of aphasia, '[a] specific noun ... is replaced by a very general one,' while '[w]ords with an inherent reference to the context, like pronouns and pronominal adverbs ... connectives and auxiliaries, are particularly prone to survive' (245–6). This does indeed seem like a fair description of the style of *The Making*

of Americans and of the early stages of *A Long Gay Book*: 'Any one being started in doing something is going on completely doing that thing, a little doing that thing, doing something that is that thing. Any one not knowing anything of any one being one starting that one in doing that thing is one doing that thing completing doing that thing and being then one living in some such thing ... Coming to be anything is something. Not coming to be anything is something. Loving is something. Not loving is something. Loving is loving. Something is something. Anything is something' (1972, 18–21).

Conversely, Lodge argues that with *Tender Buttons* Stein moved 'from length to brevity, from verbs to nouns, from prose to poetry and (in our terms) from metonymic to metaphoric experiment' (151–2). The vocabulary of *Tender Buttons*, replete with specific terms, 'is clearly a type of metaphorical writing based on radical substitution (or replacement) of referential nouns,' while its syntax moves towards Jakobson's 'contiguity disorder,' towards the state 'where grammar has disintegrated to the point where "word heap" seems an appropriate description' (153). Again, it is easy to cite examples from the later style:

The hour when the seal shows up slobber. Does this mean goat. It does yes.
Be a cool purpose and a less collection and more small more small.
Leave smell well.
Leaves in oats and carrots and curve pets and leaves and pick it ferns and never necessary belts. (1972, 115)

The contrast between the two styles thus seems to fit, very neatly, into a Jakobsonian distinction between metonymy and metaphor. Before examining the adequacy of this argument, however, I will first examine its further extension into the analogy between Stein's writing and Cubist painting.

Jakobson had suggested, very briefly, an application of the metaphor/metonymy distinction to movements in modern painting:[3] 'A salient example from the history of painting is the manifestly metonymical orientation of cubism, where the object is transformed into a set of synecdoches; the surrealist painters responded with a patently metaphorical attitude' (256). One may be a little suspicious of such words as 'manifestly' and 'patently,' which substitute assertion for argument; but for the moment let us simply note that Jakobson saw *all* of Cubism as metonymic. 'Metaphor' was reserved for the completely different, indeed opposed, procedures of Surrealism.

Lodge is content to accept Jakobson's classifications; thus, having described *Tender Buttons* as metaphorical, Lodge also has to argue that it is not, as has so often been claimed, 'the literary equivalent of cubism,' but is 'in fact much closer to surrealism' (152). Randa Dubnick also classifies *Tender Buttons* as metaphor, but, unlike Lodge, she is unwilling to abandon the description of it as Cubist. Her solution to this dilemma is to insert the metonymy-metaphor distinction into Cubism itself, along the lines of the conventional division between Analytic and Synthetic Cubism. If it were successful, this tactic would produce a very neat dichotomy, with metonymy, Analytic Cubism, and *The Making of Americans* on the one side, and metaphor, Synthetic Cubism, and *Tender Buttons* on the other.[4]

Dubnick attempts to argue that Analytic Cubism is metonymic because it constricts the pictorial vocabulary and emphasizes the connectives: '[M]ost lines and planes in cubist paintings,' she writes, 'refer only to spatial relationships (a concern with contiguity and therefore with the horizontal axis of language) ... In analytic cubism, contiguity is emphasized, as the spatial configuration of the subject extends over the ground of the painting and the lines delineating the object are extended and realigned into segments that form small, overlapping planes which repeat similar configurations' (26, 33). Conversely, in Synthetic Cubism, 'the vocabulary of signifying elements ... is extended,' while spatial syntax 'is suppressed ... by a use of the picture plane that emphasizes its flat surface more than its traditional illusion of depth' (5).

That last comment is indicative of the major weakness in Dubnick's argument. What are put forward as characteristics distinguishing Synthetic from Analytic Cubism are often, in fact, elements common to both, which distinguish *all* Cubist painting from more traditional forms. It is absurd to suggest, as that comment seems to do, that Analytic Cubism did not emphasize the flat surface, or that it gave a 'traditional illusion of depth.' Or take this passage: 'Lines do not clarify spatial relationships by providing perspective. Depth becomes ambiguous as relationships of *in front of, behind, forward,* and *back* become impossible to read ... We are looking at an opaque surface, not through a window on the world' (41). Again, Dubnick offers this as a description of Synthetic Cubism *as opposed to* Analytic; and again, it is nothing of the kind. It is an accurate-enough description of Synthetic Cubist syntax, but it would apply equally well to most Analytic works.

Jayne L. Walker presents the case in a much more careful and sophisticated way. Walker repeats the argument, out of Jakobson, for the

metonymic nature of the syntax in both Analytic Cubism and *The Making of Americans* – that is, that in both the 'compositions are dominated by connective signs' (131) – and also argues for the metaphoric nature of the syntax in Synthetic Cubism and in *Tender Buttons*. The signs in Cubist collage, she writes, 'are simply juxtaposed to one another or overlaid ... [producing a] stark "asyntactical" arrangement of iconic signs on a rigorously flat plane' (132). However, Walker recognizes that in Synthetic Cubism (and also in Stein) the *individual signs continue to be metonymic*. Pointing to the fundamental disparity that Jakobson introduced by treating metonymy both as syntax and as vocabulary, Walker writes that Jakobson 'never deals with the fact that characteristics of the two polar extremes sometimes coexist, at different levels of analysis, in the same structures. In cubist collage, the individual signs are metonymic, but the syntax is close to the metaphoric pole' (132).

Walker's view, while more accurate than Dubnick's, still seems to me to oversimplify the 'syntax' of Synthetic Cubism. It is true that the paintings and collages of this later period reduce or eliminate much of the 'armature' of Analytic Cubism, its delicate grid of connective lines and shifting spatial indicators, but they are still very far from 'simple' juxtaposition, or from any valid analogy to an agrammatical 'word heap.' By freeing both colour and texture from the contours of the represented object, Synthetic Cubism, collage, and papiers collés opened up possibilities of spatial depiction and ambiguity that rely more than ever on subtle forms of contiguity: that is, of metonymy.

Consider, for example, Braque's *La Guitare* (1912; Monod-Fontaine 1982, #4; see also my discussion in the previous chapter). Three separate 'objects' are depicted, each by a different form of metonymy. The guitar is suggested by synecdoche, part for the whole: a few sketched lines give the shape of its body, the soundhole, and the pegs; a newspaper is represented by its name, again partially, JOU and an obscured R; the table on which the two lie is a collage element of papier faux bois. The spatial relationships between these objects, however, far from being 'simply juxtaposed,' 'asyntactical,' or 'flat,' are highly complex and multivalent. Common sense would suppose that the guitar and newspaper must be on top of the wood surface; yet the papier faux bois is pasted *over* their drawn outlines. One corner of the newspaper is clearly *under* the guitar; but its top line disappears *into* the soundhole. The wooden texture of the (assumed) table might also be read as belonging to the guitar, and the decorative lines in the faux-bois effect could also be read as signs for the guitar's strings. Far from being used merely 'to

provide interest' (Dubnick 35), the various textures are used to intensify the indeterminacy of the spatial relationships. These relationships are, however, still based on contiguity (guitar, newspaper, and table would naturally be found next to one another), not on any far-fetched metaphorical identity.

In Synthetic as in Analytic Cubism, the concern is not the metaphoric suppression of syntax but its metonymic dissemination. The 'syntax' of spatial relationships is deconstructed – in, precisely, the Derridean sense of the word: neither the negation nor the simple reversal of a structure, but rather a putting into question of the terms of that structure *at the same time* as working within it. The visual syntax of an illusionistic three-dimensional space is disrupted, but the disruption is achieved *through* the system of syntax, not by ignoring or suppressing it. Even in its starkest and most minimal forms, Synthetic Cubism is never 'simple' juxtaposition; it is always working with the re-representation of space. In syntax as in vocabulary, Cubism is predominantly metonymic through *all* its phases.

That is not to say, of course, that metaphor is completely absent from Cubism. (As I argued above, the use of metaphor/metonymy as an *exclusive* binary pair would itself be metaphoric; a more open-ended use of the distinction allows for the recognition that the two frequently coexist.) Thus, one example of 'metaphoric' technique in Cubism would be what Walker calls 'complex visual and verbal puns [which] create relationships of equivalence' (132–3) – or what Juan Gris, and most of his critics after him, have called 'rhymes.' I have already discussed this idea in chapter 4, quoting Kahnweiler's definition: 'Rather like rhymes in a poem, two forms, generally of different sizes, are repeated' (141). Thus, the curved line of a guitar is 'rhymed' in the curve of a bottle, or of a pear. It could be argued that, as 'relations of equivalence,' these rhymes are, in Jakobson's terms, metaphor – and Kahnweiler does use that word, describing them as 'plastic metaphors to reveal to the beholder certain hidden relationships, similarities between two apparently different objects' (141). However, Kahnweiler is equally insistent that Gris's rhymes are *not symbols*: '[T]hey never have a dual identity ... They *are* the objects which they represent, with all the emotive value attaching to them; but they never signify anything outside of these objects ... These 'rhymes,' like every other rhyme, are a form of repetition: the repetition of two forms, each of which retains its own unique identity' (140). Even at the level of the syntax, Cubist 'rhymes' have as much to do with metonymic contiguity as with metaphoric equiva-

lence: guitar, pear, bottle are all naturally present in the same scene (a café, for instance) alongside each other.[5]

Kahnweiler's comment leads to the more fundamental argument, at the level of vocabulary, against the notion of Cubism as anything more than partially metaphor. The *signs* of Cubism are overwhelmingly metonymic. As I have argued in previous chapters, Cubism always retained its stubborn grip on the outside world, its representational refusal of abstraction – and it did so by means of synecdoche. Scattered across the complex grids of Analytic Cubism, or reduced to a few lines or collaged elements in Synthetic Cubism, the parts of objects stood for the whole – or, more accurately, *the sign of* the part stood for *the sign of* the whole. A single curve could evoke a guitar; five strings stood for six; two or three letters implied a complete word; the decorative fringe of a table cloth stood in for the whole cloth, and then, by metonymic extension, for the table on which the cloth was spread, for the café in which the table was situated, for the life and atmosphere of the café and its clientele. But none of this was metaphor: for metaphor implies *distance*, a jump from one area of signification to another, across a gap that cannot be encompassed within the normal associations of contiguity.

Occasionally, Cubist signs do function metaphorically, often as sexual symbols. A guitar's curves may be read as metaphoric for a woman's body, and Picasso could never resist the double entendre of a key in a lock.[6] But these are exceptions that prove the rule, occasional traces of metaphor within a predominantly metonymic system.[7] Cubism is *about* guitars and bottles and café tables: all these representational elements are linked to each other in an intricate pattern of metonymy, but they do not stand for, as metaphors, anything outside themselves.

I have argued, then, that the attempt made by Dubnick and, in a more modified form, by Walker, to divide Cubism into metonymic and metaphoric phases corresponding to the traditional division of the Analytic and Synthetic periods, is not a convincing one. While there are undoubtedly some metaphoric aspects to Cubism, its dominant mode is that of metonymy, both at the rhetorical level of its vocabulary and at the Jakobsonian level of its syntax.[8] It is time now to return to Stein. It will be recalled that Dubnick introduced metaphor into Cubism in order to preserve the alleged analogy between Cubism and Stein's *Tender Buttons* style, which Lodge had described as 'clearly a type of metaphorical writing.' If Cubism is not, however, metaphorical, then can Stein's 'metaphorical' writing still be described as 'Cubist'? Or, conversely, can the argument supporting the metonymic nature of Cubism

also be used to describe Stein? That is, can Stein's writing also be classi-
fied as predominantly metonymic rather than metaphoric in *all* its
phases?

Certainly, Jakobson's descriptions of the metonymic pole of 'similar-
ity disorder' do apply, at least superficially, to the prose style of *The
Making of Americans* and the early sections of *A Long Gay Book*. That is,
there is an evident avoidance of specific nouns (to the point of almost
total indeterminacy – 'anything is something'), and a concomitant em-
phasis on connectives, auxiliaries, and undifferentiated pronouns. The
novel's expansiveness, its continual adding on of instances in the at-
tempt to define a character's 'bottom nature,' may also be seen as an
exemplary process of metonymic *naming* along the horizontal axis. Talk-
ing about metonymy in *Labyrinths of Voice*, Robert Kroetsch says, 'I
guess I have the absurd hope that if I provide twenty names, then
somewhere I will reach a point where they all connect and become
more realized and identifiable ... one just moves on and around, and
there are further namings and renamings. I trust that process. I trust the
discreteness of those naming acts' (93).

The question arises, however, of just how 'discrete' the acts of nam-
ing are in Stein. For all its great length, *The Making of Americans* is
concerned with a strictly limited number of characters, and its avowed
intention is to reveal their unified 'bottom nature.' Repetition is not
here aimed at 'discreteness,' singularity or difference, but at the even-
tual discovery and emphasis of what is the same. In her chapter on *The
Making of Americans*, Walker provides a fine analysis of how this ambi-
tion breaks down, how the attempt to realize 'paradigms based on
identities' runs up against Stein's growing 'desire for comprehensive
factual data' (70–1), how repetition as identity is contaminated by rep-
etition as pure difference. In Stein's own terms, the structural model for
the writing moves from the *diagram* to the *list*.

Walker cites Stein's use of the word 'diagram' in her notebooks, and
in *The Making of Americans*. Whereas early in the novel Stein's ambition
was to 'make a kind of diagram' (1966, 225), later on the diagram has to
be supplemented by the list: 'It would be a very complete thing in my
feeling to be having complete lists of every body ever living and to be
realising each one and to be making diagrams and lists of them' (1966,
594). While there are proliferating lists towards the end of the novel, it
is in *A Long Gay Book* that the list really takes over from the diagram;
and the very process of the takeover is enacted in the following para-

graph: 'There can be lists and lists of kinds of them. There can be very many lists of kinds of them. There can be diagrams of kinds of them, there can be diagrams showing kinds of them and other kinds of them looking a little like another kind of them. There can be lists and diagrams, some diagrams and many lists. There can be lists and diagrams. There can be lists' (1972, 23).

The diagram is a form of metaphor, and the list a form of metonymy. While both *The Making of Americans* and *A Long Gay Book* appear metonymic in style, according to Jakobson's description, the deeper structural intentions of the two books reveal a progression from metaphor towards metonymy, from the diagram towards the list, from repetition as identity towards repetition as difference. The acts of naming in *The Making of Americans* are not in fact totally 'discrete'; they accumulate towards a totalizing definition of characters, and those characters are conceived of as *representative* (of, for instance, 'dependent independent being'). The acts of naming in *A Long Gay Book*, however, *are* 'discrete' – Sloan, Gibbons, Johnson, Hobart, Carmine, Watts, Arthurs, Brais, Jane Sands, Larr, Mrs. Gaston, George Clifton, and so on – never connecting, never consolidating into any stable sense of identity. These are *non*-characters, representative of nothing except the impossibility of being representative. Even when a name is repeated on several occasions – Clellan, for example – the different appearances do not coalesce or reinforce each other. Specific names ought, in Jakobson's terms, to be metaphoric, standing for unified identities; but, as I have insisted, metonymy is also a naming process, *substitute* naming, *deferred* naming. The 'proper' names of *A Long Gay Book* are in fact quite improper. They name no one; they can be used as title to no one's property.

Lisa Ruddick argues that *The Making of Americans* was a form of symbolic patricide, in which Stein broke away from the authority of her actual and substitute fathers, and that repetition was her major stylistic means of challenging the hierarchy of patriarchal writing (Ruddick, chapter 2, passim). In *A Long Gay Book*, Stein looks back at what she has accomplished, and realizes that the accretions of her repetition have indeed disrupted the father's order:[9] 'Largely additional and then completely exploding is one way to deny authorisation' (1972, 98). The accumulation of instances in *The Making of Americans* is 'largely additional,' but by *A Long Gay Book* the diagram is 'completely exploding' into the list, into the celebration of difference for its own sake: 'Say the difference, say it in the brook, say it in the perpendicular horizon, say it

in the retreat from St. Petersburg' (1972, 103). The effect then is 'to deny authorisation,' to deny the authority of the author, to retreat from the patriarchy of St Petersburg.[10]

A Long Gay Book is a 'transitional' text not only in the obvious sense that the prose style changes so dramatically but also in the sense that even its initial project, to give 'short sketches of innumerable ones' (1972, 17), is already a shift away from the metaphoric diagram to the metonymic list. One may suspect, then, that the whole text is more continuous with itself than the surface appearance would suggest, and that the metonymic impulse, in one form or another, continues into the last twenty pages of *A Long Gay Book*, and so into *Tender Buttons*. At this point, however, we return to the orthodox Lodge argument that the style of *Tender Buttons* is, in Jakobson's terms, metaphoric.

At the level of syntax, Lodge himself admits that '[t]he analogy is not exact,' and that much of the word order in *Tender Buttons* is 'still basically regular' (153). Certainly the writing has moved away from connectives, indeterminate pronouns such as 'some' and 'any,' and verbs in the continuous present; there is a far greater stress on nouns, and on short, enigmatic sentences. But the enigma is more often produced by semantic than by syntactic dislocation; indeed, a sentence such as 'A dirty bath is so clean that there is eyesight' (1972, 106) *depends upon* its syntactic regularity to produce its semantic puzzle. There are some agrammatical 'word heaps' in *A Long Gay Book* ('No no, not it a line not it tailing, tailing in, not it in' [1972, 115]) and they appear somewhat more frequently in *Tender Buttons* ('Please could, please could, jam it not plus more sit in when' [1971, 173]), but they remain, as Walker says, 'rare' (132). They do not dominate the syntax in the way that the 'metonymic' patterns of the earlier style did. Frequently, also, the 'word heap' is in fact a list, whose items are added to each other not by metaphoric equation but by metonymic association – as in 'Pale pet, red pet, pink pet, blue pet, white pet, dark pet, real pet, fresh pet' (1972, 97). Stein is working here with what Walker, citing Derrida, describes as 'the unlimited freeplay of association' (141) – and, indeed, the notion of 'play' will go further to account for this writing than any strict application of either metaphor or metonymy. (Metonymy, however, by its open-ended, horizontally accumulative nature, is more amenable to notions of play than metaphor is.)

The argument for metonymy holds true at the level of vocabulary also. Lodge and Dubnick both see the nouns of *Tender Buttons* as meta-

phor – for Lodge, '[t]he very title *Tender Buttons* is a surrealist meta-
phor' (152) – but Walker argues that 'this is clearly not the case,' since
'the nouns that are linked together in this text are not semantically
equivalent; their relationship is what Jakobson describes as metonymic,
not metaphoric. In a figural sense, they are all synecdoches, naming
contiguous "pieces of any day"' (162, 133). Just like the objects depicted
in Cubist painting, the objects described in *Tender Buttons* do not refer,
metaphorically, to anything outside themselves; rather, as Walker says,
the work 'describes a female world (circa 1912) of domestic objects, and
rituals – a world of dresses and hats, tables and curtains, mealtimes and
bedtimes, cleanliness and dirt' (127).

This range of association and imagery is evident very early in the
'new' style. Within a page of the first sentence in *A Long Gay Book* that
announces the new vocabulary ('A tiny violent noise is a yellow happy
thing' [1972, 82]), and before the new syntax is established, we find the
following paragraph:

A little way is longer than waiting to bow. Not bowing is longer than waiting
longer. It would sadly distress some powder if looking out was continual and
sitting first was happening and leaving first was persisting. It would not change
the color, it would not harmonise with yellow, it would not necessitate redden-
ing, it would not destroy smiling, it would not enlarge stepping, it would not
widen a chair or arrange a cup or conclude a sailing, it would not disappoint a
brown or a pink or a golden anticipation, it would not deter a third one from
looking, it would not help a second one to fasten a straighter collar or a first one
to dress with less decision, it would not distress Emma or stop her from tem-
perately waiting, it would not bring reasoning to have less meaning, it would
not make telling more exciting, it would not make leaving necessitate losing
what would be missing, it would though always mean that three and one are
not always all that remain if ten remain and eight are coming. (1972, 83–4)

The links through this paragraph are formed partly by associations of
sound, but all these associations lead into the domestic world, and thus
form a metonymic chain. 'Bow,' in one pronunciation, suggests 'pow-
der' by rhyme, while in another pronunciation it plays on 'bows' with
ribbons. The string of 'colors' leads to a 'collar' that must be straight-
ened, and perhaps to the callers who are enumerated at the end. Do-
mestic visits are also suggested by 'bowing' itself, by the 'little way'
that has to be gone, by the distressing (dressing) prospect of 'looking

out' being 'continual,' by the social graces of blushing and smiling, and by the arrangement of chairs and cups. Such a reading does not, of course, account for everything in the passage – right from the start, Stein's dislocations are too radical to be entirely recuperated – but it is just specific enough to indicate the sphere of association within which, for the most part, the language plays.

The centre of this 'iconography of domestic life' (Walker 127) is of course Alice B. Toklas: and metonymy is the key to understanding both Alice's presence in the text and her absence from it. For if Alice is the centre (of the text, and of the domestic life itself), she is so only as a displaced one. 'Act,' wrote Gertrude in *Tender Buttons*, 'so that there is no use in a centre ... If the centre has the place then there is distribution' (1971, 196). Alice is distributed throughout the text – its 'dresses and hats, tables and curtains, mealtimes and bedtimes' – so that she is both everywhere and nowhere.

There is an obvious danger in a kind of reductive interpretation of Stein's writing that sees all its obscurities as disguised erotic references and that 'solves' them like crossword-puzzle clues. A degree of displacement and deferral should be preserved in the reading as much as in the writing. Nevertheless, the erotic tone of many passages is unmistakable, even if the details remain unspecified. The change of style in *A Long Gay Book* is immediately accompanied by repeated assertions of the writer's pleasure:

If there are two and there is one there and another in the other direction then slightly being pleased is to be happy ...
 If the little that is not bigger has gone away it has not been there. That is the way to complete pleasure. It is alright ...
 The union is perfect and the border is expressing kissing. (1972, 93, 98, 100)

At times the erotic content is totally explicit: 'A lovely love is sitting and she sits there now she is in bed, she is in bed. A lovely love is cleaner when she is so clean, she is so clean, she is all mine' (101).

But Stein's urge to celebrate her love for Toklas was balanced by her need to conceal, disguise, or displace it. Metonymy, I have argued, is a kind of displacement, a deferred or substitute naming; the effect of this deferral can be seen in this extended passage from the end of *A Long Gay Book*:

Beef yet, beef and beef and beef. Beef yet, beef yet.
Water crowd and sugar paint, water and the paint.

Wet weather, wet pen, a black old tiger skin, a shut in shout and a negro coin and the best behind and the sun to shine.

A whole cow and a little piece of cheese, a whole cow openly.

A cousin to a cow, a real cow has wheels, it has turns it has eruptions, it has the place to sit.

A wedding glance is satisfactory. Was the little thing a goat.

A, open, Open.

Leaves of hair which pretty prune makes a plate of care which see seas leave perfect set. A politeness.

Call me ellis, call me it in little speech and never say it is all polled, do not say so.

Does it does it weigh. Ten and then. Leave off grass. A little butter closer. Hopes hat.

Listen to say that tooth which narrow and lean makes it so best that dainty is delicate and least mouth is in between, what, sue sense.

Little beef, little beef sticking, hair please, hair please.

No but no but butter.

Coo cow, coo coo coo.

Coo cow leaves of grips nicely.

It is no change. It is ordinary. Not yesterday. Needless, needless to call extra. Coo Coo Coo Cow.

Leave love, leave love let.

No no, not it a line not it tailing, tailing in, not it in.

Hear it, hear it, hear it.

Notes. Notes change hay, change hey day. Notes change a least apt apple, apt hill, all hill, a screen table, sofa, sophia. (1972, 114–15)

This passage illustrates the many different levels of Stein's evocation of Toklas. First, there is the metonymic suggestion of her presence distributed in the domestic imagery: beef, water, sugar, cheese, wedding, hair, prune, place, butter, hat, dainty, delicate, needles(s), apple, table, sofa. Second, there is a direct naming of Alice through a pun: 'Call me ellis.' (In *Tender Buttons*, she appears as 'ale less' [1971, 174]). Other women's names also appear in punned form: 'Sophia' from 'sofa' and 'Susan' from 'sue sense.' Third, there is the literary evocation of Walt Whitman ('Leaves of hair,' 'Leave off grass,' 'leaves of grips') – as Neil Schmitz points out, Whitman had also 'addressed the issue of "forbidden voices" in his poetry ... [and] spoke openly (a paradox Gertrude Stein might well have appreciated) about his encoded discourse' (196). And, fourth, there is the 'encoded discourse' or 'little speech,' Stein's private vocabulary for her erotic experience. Many phrases in this pas-

sage could be read as oblique references to sexual activity; the word
that is central to this reading is 'cow.' Elizabeth Fifer summarizes the
meanings Stein attached to this term: 'If, as Richard Bridgman suggests,
it is involved in both the nurturing aspect of Alice and some sort of
birth, it is also the orgasm, even the potential for it ... ['Cow'] alternately
bears the feeling of sexuality, the organ itself, food protection, or the
mythical idea of lesbian birth. It is both a derogatory female symbol (in
the beast's placidity, stupidity) and a positive symbol of mothering and
unselfishness, of pure animal sensuality and nurture in an Edenic world
of simplicity and warmth' (480–1).

To what extent, then, are these four modes of 'naming' Toklas met-
onymic? The first is clearly so – Alice is evoked by the repeated mention of
the domestic objects that surround her – but the others, it might be
argued, are closer to metaphor. In the use of terms such as 'cow,' the
distance between tenor and vehicle is more characteristic of metaphor
than of metonymy; there is no intention of evoking an *actual*, contigu-
ously present cow, except at one remove, through *its* metonymies (beef,
butter). Public sexual symbols (such as the key sticking in a keyhole in
Picasso's paintings) do operate metaphorically, but a private symbol
(such as Stein's 'cow') is less easy to pin down to a single determinate
meaning. Picasso's keyholes are all too obvious, too crude (they repre-
sent that level of sniggering adolescence in him that Stein herself, it
must be admitted, enjoyed and indulged); in its very privacy, 'cow' ex-
presses the depth and the desperation of Stein's need for concealment.

The rhymes on Alice's name raise the wider question of the status of
transitions by homophony in Stein's writing: 'Hear it,' she insists, 'hear
it, hear it.' Rhymes, puns, and all links based on sound rely upon
Jakobson's *vertical* axis: *similarity* of the signifier, if not of the signified,
renders them metaphoric. The structure is that of equivalence, not of
contiguity. It will be recalled that a similar argument was made for the
visual 'rhymes' in Cubist painting, especially that of Juan Gris. I argued
then that most of the 'rhymed' objects in Cubist painting are in fact
contiguous to each other – for instance, in the café setting; the same
argument cannot be used for Stein, whose linguistic 'rhymes' range
wide and free. But I also argued that Cubist rhymes did not imply
identity, that each object stood only for itself, not for a metaphoric
equivalence. In Stein, the *difference* of each object is so absolute that
frequently it defies not only metaphor but *any* appropriation into a
context of meaning wider than the individual word. The 'apple/apt
hill' transition is neither metaphor (there is no implied identity or

semantic similarity between the two terms) nor metonymy (there is no contiguity either): it is sheer play, an attempt, if you like, to 'sue sense.'

Though linguistic play is, as I noted earlier, closer to metonymy than to metaphor, it may be more useful to see this aspect of Stein's writing as going beyond the metaphor/metonymy distinction altogether. The systematic use of homophony is described by Gregory L. Ulmer as a central characteristic of experimental writing such as Derrida's.[11] Derrida, writes Ulmer, 'adopts as an operational device the exploitation of the pun,' creating 'a homonymic procedure ... allowing terms to circulate and interbreed in a festival of equivocality' (19, 26). Such a writing would surely be not unlike *Tender Buttons*. Ulmer refers to Derrida's essay 'Fors' (which is an introduction to Abraham and Torok's commentary on the language of Freud's Wolf Man), where Derrida notes that 'the allosemic pathways in this strange relay race pass through non-semantic associations, purely phonetic contaminations,' with the result that Abraham and Torok 'are hesitant to speak of metonymic displacement here, or even to trust themselves to a catalogue of rhetoric figures' (108). In other words, 'phonetic contamination' is seen as a *limit* to metonymy, to metaphor, indeed to all rhetorical figures.

In the same way, the substitution of 'ale less' for 'Alice' implies neither Alice's similarity to a smaller quantity of beer nor the contiguous presence of such liquid. A further pun, however – 'ail less' – might indicate a metonymic relationship, Alice being invoked by her association with the decrease in Gertrude's suffering. Again, when Alice is referred to as 'Ada' and then as 'aider' (1971, 176), it is clear that Alice's function as a helper is one of her metonymic attributes. Thus, while the process of homophony may be seen either as metaphoric (in Jakobson's terms) or as a phonetic contamination beyond rhetoric (in Derrida's), the terms produced by that process may frequently be referred back to the 'distributed' centre of the discourse by the familiar links of metonymy.

Such is the curious suggestion that lurks in 'Call me ellis.' Although the major literary reference of the passage is Whitman (and such references, in a literary household, are themselves domestic metonymies), the form of this phrase ('Call me xxxx,' plus the simple reversal of the *is* and *el* syllables) surely recalls Melville: 'Call me Ishmael.' Alice would thus be invoked as Ishmael to Gertrude's Ahab – and indeed, twenty years later, 'Alice' was to fulfil this role as narrator of Gertrude's epic quest, in *The Autobiography of Alice B. Toklas*.

I have indicated, then, some of the ways (and the limits of these ways) in which metonymy may be useful in explaining Toklas's presence in Stein's text; but I also claimed that metonymy is a key to her absence from it. Metonymy is a way of naming Alice when Alice herself cannot be named. The major reason for this absence is of course the social taboo that prevented the open acknowledgment of a lesbian relationship, the unspoken censorship that necessitated linguistic disguise. But 'what does man find in metonymy,' asks Jacques Lacan, 'if not the power to circumvent the obstacles of social censure?' (158).

The reason that Alice cannot be named is that the object of desire can *never* be fully or adequately named. Desire is always for the Other, for something *else* ('Call me ellis'). The operation of desire in language is, according to Lacan, metonymy: that is, the *displacement*, analogous to the Freudian 'dreamwork,' of signifier to signifier. 'Along this metonymic chain of signifiers,' writes Terry Eagleton, 'meanings, or signifieds, will be produced; but no object or person can ever be fully "present" in this chain ... This potentially endless movement from one signifier to another is what Lacan means by desire' (167). And 'desire *is* a metonymy,' writes Lacan (175); the 'enigmas' that it poses 'amount to no other derangement of instinct than that of being caught in the rails – eternally stretching forth towards the *desire for something else* – of metonymy' (166–7).

As the language of desire, metonymy breaks out of the logocentric, patriarchal world of 'presence,' the imposed 'identities' of metaphor; along the horizontal axis of combination, it offers the unlimited freeplay of dissemination; by offering a multiplicity of alternative names, it denies the authority of the single name, le Nom du Père, the Name that says No. Any book embarked along such an axis must of necessity be both long and gay.

I began this chapter by asking whether it was possible, or useful, to apply literary terms such as metaphor and metonymy to painting. I believe that my discussion has shown that such an application is indeed possible, and that Cubism, for example, is closer to metonymy than it is to metaphor. I also asked whether the reverse process would also hold: whether Gertrude Stein's writing, for example, could usefully be described as Cubist. I noted that several critics have attempted to establish this connection precisely by using the metaphor/metonymy distinction as a link between the two media, arguing that metaphoric and/or metonymic effects in Cubist painting illuminate similar effects in Stein's

writing. My own position has been that Gertrude Stein's writing, while exhibiting both metonymy and metaphor, as well as many features that cannot adequately be contained by either term, is certainly closest to metonymy in its deferred evocation of Alice as the object of desire. Critics like Lodge, Dubnick, and Walker have run into difficulties in applying 'Cubist' to Stein largely, I have argued, because they then had to distinguish between metonymy and metaphor within Cubism itself; while I have tried to disentangle these arguments, I have not advanced any strong argument of my own for the 'Cubist' nature of Stein's work. And indeed, I remain sceptical on this point.

Stein was, obviously, deeply influenced by Picasso on a personal level, and to some extent saw her own experimentation as analogous to his. (Her movement from writing 'portraits' to writing 'still lives' is an obvious sign of this influence.) And continually, throughout her career, Stein was pressing at the limits of language, the outside edges of the sayable. Her deep if idiosyncratic engagement with the experimental painting of her time provided her with repeated examples of the power of non-verbal images – of what I called in chapter 1 the 'muteness' of the visual. Much of her writing can be seen, like the 'earthquakes and explorations' depicted on the covers of the notebooks it was written in,[12] as tracing the fault lines of language itself, and exploring its un-known frontiers. In reading Stein, one is always aware of the limits of the verbal, and of the ways in which her writing strains against these limits, inviting, always leaving room for, the supplements of silence.

But rather than argue for direct parallels between Stein and Picasso, it may be safer to conclude that they shared similar concerns (with the nature of representation, and with the self-reflexive status of their cho-sen media), and that these shared concerns may sometimes be articu-lated using a common vocabulary (whether of Saussurean semiology or of Jakobsonian rhetoric). Or, to put this another way, the relationship between Picasso's painting and Stein's writing may itself more profit-ably be seen as one of metonymy rather than as one of metaphor. The whole project of inter-artistic analogy too often attempts to establish a metaphoric identity between two arts; my argument has been to see such relationships as more loosely defined and reciprocal – not as sup-planting but as supplementing. Rather than trying to assimilate Stein to Picasso by describing her writing as 'Cubist,' then, it may be more useful to see the two of them existing alongside each other, contigu-ously, metonymically linked, like a guitar and a wineglass on a Parisian café table.

CHAPTER SEVEN

The Window Frame:
Delaunay and Apollinaire

There is no such thing as an unframed picture. As I argued at the outset of chapter 1, a painting is, by definition, a visual image set apart from the totality of the visual surround. 'In a sense,' writes Norman Bryson, 'we can dispense with frames and regard them as extrinsic to painting; yet even without its actual frame Western painting is a structure of framing' (1988, 184). That is, the 'actual frame' – the rectangular piece of wood, or whatever other material, that surrounds the painted surface – may take many forms, including the apparent 'absence' of any frame at all; but always there is a 'structure of framing.'

One way of looking at the history of Western painting would indeed be to trace the evolution of the frame. In cave paintings, there often seems to be no definite frame at all: the area of the wall on which the image is drawn merges indistinguishably into the rest of the wall, and one drawing may well intrude upon the 'framed space' of another. Many 'frames' are predetermined as spaces that already serve prior functions: murals, for instance, are defined by the architectural demands of the wall. With the triumph of the easel painting, from the Renaissance onwards, the frame became a sign of ownership. It defined the painting as portable, detachable from any given surrounding, and thus as a commercial commodity. The heavily ornate frames beloved by the nineteenth-century, with masses of gilt and curlicues, are only the most ponderous assertions of this ownership. The twentieth-century fashion has tended towards plain, unassertive frames, or indeed no frames at all: the canvas showing its own mounting, declaring its own material status as support for the image. Yet that too is a style of framing, and, like all these styles, it carries its own ideological implications about the status of the visual image and its relation to the wall, to the surround.

It is the Renaissance invention of 'the frame,' in the more restricted sense, that marks the key point in this development. Stephen Heath writes:

[T]he first instance of the use of the word 'frame' in an artistic sense recorded by the *Oxford English Dictionary* is *c.* 1600 ... The new frame is symmetrical (the centred rectangle, clearly 'composable') and inevitable (the Quattrocento system cannot be realised without it, it becomes a reflex of 'natural' composition). Significantly, it brings with it the easel (first recorded instance *c.* 1634 – 'a frame or easel called by artists'), 'significantly' because the easel is precisely dependent on the idea of 'a painting' as single, central view. The painter stands as spectator in front of his easel (in this history it is men who are the professionals of painting, the authoritative gaze), capturing on the canvas screen the scene behind onto which it gives and which it sets as such; no longer englobed in the area of the painting (dome or arch or ceiling), the painter is definitely upright, an eye on the world, an eye that stations itself, with the easel carried from place to place, much like a tripod. (34–5)

The frame, that is, establishes the ideological implications that were to dominate Western painting for several centuries: the painter as 'an eye on the world,' separate, upright, even phallic; the framed canvas as portable, purchasable; and the frame operating as a window on the world.

Indeed, the 'window,' as phrased most memorably by Alberti, became the standard metaphor for the frame. (And also for the eye: the metaphor of the eye as the 'window of the soul' extends from Leonardo da Vinci to Robert Delaunay.) Renaissance systems of perspective depended on the notion of the painting surface as a transparent pane/ plane (a window) through which vision passed to a centrally defined (stationary, monocular) observer. Thus, in turn, the metaphor became a motif: Heath notes in Renaissance painting 'the powerful attraction of the window as theme, the fascination with the rectangle of tamed light, the luminously defined space of vision' (34). The paradox is, of course, that the window must be transparent: that which makes vision possible cannot itself be visible. Thus, any painting of a window cannot show the actual glass:[1] it can only show the frame. Within the painting, the window frame becomes again a metonymy for the painting frame. Frame within frame, it threatens a *mise en abyme* of framing, an endless recession, a continued deferral of the subject-position of both painter and spectator.

The Renaissance emphasis on the frame was both cause and effect of the concern with painting as producing an illusion of depth. Meyer Schapiro writes: '[W]hen enclosing pictures with perspective views, the frame sets the picture surface back into depth and helps to deepen the view; it is like a window frame through which is seen a space behind the glass. The frame belongs then to the space of the observer rather than of the illusory, three-dimensional world disclosed within and behind. It is a finding and focusing device placed between the observer and the image' (212). This function of the frame was radically challenged as painting moved away from the concern for depth-illusion; it is thus no accident that, in Cubism especially, the frame becomes as problematic as all the other semiotic signs. Schapiro again:

The frame was dispensable when painting ceased to represent deep space and became more concerned with the expressive and formal qualities of the non-mimetic marks than with their elaboration into signs. If the painting once receded within the framed space, the canvas now stands out from the wall as an object in its own right, with a tangibly painted surface ... The strips of wood or metal that now frame many paintings are no longer the salient and richly ornamented enclosures that once helped to accent the depth of simulated space in the picture and conveyed the idea of the preciousness of the work through its gilded mount. They are thin discreet borders often flush with the plane of the canvas, and in their simplicity they assert also the respect for frankness and integrity in the practice of the art. Without a frame, the painting appears more completely and modestly the artist's work. (212–13)

Implicit in Schapiro's account is a further paradox of the frame. He begins by declaring that 'the frame belongs ... to the space of the observer'; that is, the frame is not part of the painting. Yet the more he discusses the ideological implications of the frame, the more the frame comes to be seen as indeed part of the work. The 'richly ornamented enclosures' and the 'thin discreet borders' both make statements that are inseparable from the images they supposedly enclose. The frame is supposed to be a border, a definite line of division between inside and outside; but in practice, the frame is always a site of mutual contamination – it lets the outside in, it lets the inside out.

'Contamination' is perhaps too loaded a word. Rather, the effect is comparable to what I have previously presented as the action of the supplement. Indeed, most of what I have presented in terms of 'the supplement' could equally well be argued in terms of 'the frame.' Lan-

guage frames painting, and is in turn framed by it; language acts (in a term to which I will return later in this chapter) as painting's 'internal frame.' So it is understandable that 'supplement' should appear as one of a series of linked terms that Jacques Derrida uses in his discussion of the frame. This discussion occurs in the section of *The Truth in Painting* entitled 'The Parergon.'

Derrida draws the term 'parergon' from Kant, who defines it as *'orna-mentation* ... i.e., what is only an adjunct, and not an intrinsic constituent in the complete representation of the object'; Kant gives as examples 'the frames of pictures or the drapery on statues, or the colonnades of palaces' (cited in Derrida 1987, 53). That is, the parergon is typically placed in a position of subservience, secondary to the 'complete' work, of which it is only an 'adjunct'; and equally typically, Derrida seizes upon this subordination and uses it to deconstruct the binary pairs of work/frame or inside/outside. The parergon, he writes, 'comes against, beside, and in addition to the *ergon*, the work done [*fait*], the fact [*le fait*], the work, but it does not fall to one side, it touches and cooperates within the operation, from a certain outside. Neither simply outside nor simply inside. Like an accessory that one is obliged to welcome on the border, on board' (54). 'Neither simply outside nor simply inside,' the frame both is and is not a part of the work that it borders. It can be read either way: the frame is where the painting ends and the wall begins, or vice versa. The parergon 'stands out ... like a figure on a ground' (61), but it leaves open the question of *which* ground it stands out against: '[T]he parergonal frame stands out against two grounds, but with re-spect to each of those two grounds [*fonds*], it merges [*se fond*] into the other. With respect to the work ... it merges into the wall, and then, gradually, into the general text. With respect to the background which the general text is, it merges into the work' (61). There is no point at which one can say, Here is the limit, here is where the work ends and the frame begins. Any possible limit is always already transgressed, in both directions. 'Where does the frame take place?' asks Derrida, but he suppresses the question mark, turning his phrases into quasi-statements: 'Where does the frame take place. Does it take place. Where does it begin. Where does it end. What is its internal limit. Its external limit. And its surface between the two limits' (63).

One of the dictionary definitions that Derrida lists for the parergon is 'supplement' (1987, 54).[2] Like the parergon, the supplement belongs undecidably to both the inside and the outside: it intervenes in a sup-posedly complete original, in order to fill a lack. So too, the action of the

parergon is made possible by a lack in the 'finished' work that it frames: 'The *parergon* inscribes something which comes as an extra, *exterior* to the proper field ... but whose transcendent exteriority comes to play, abut onto, brush against, rub, press against the limit itself and intervene in the inside only to the extent that the inside is lacking. It is lacking in something and it is lacking *from itself'* (56). Inside and outside, painting and frame, ergon and parergon are bound to each other indissolubly; they make each other possible. Without the frame, the work would have no definition, nothing to mark it off from 'the general text'; but without the work, the frame would have no function, no raison d'être. It is obvious enough that the work fills what is missing from the frame; it is not so obvious, yet equally important, that the frame supplies what is missing from the work. Frames, margins, limits, edges, drapery on statues, colonnades on palaces: all are supplements, all are parerga – 'not because they are detached but on the contrary because they are more difficult to detach and above all because without them, without their quasi-detachment, the lack on the inside of the work would appear ... What constitutes them as *parerga* is not simply their exteriority as surplus, it is the internal structural link which rivets them to the lack in the interior of the *ergon*. And this lack would be constitutive of the very unity of the *ergon*. Without this lack, the *ergon* would have no need of a *parergon*. The *ergon's* lack is the lack of a *parergon*, of the garment or column [or frame] which nevertheless remains exterior to it' (59–60).

Paintings that include within themselves indexical emblems of their own frame (windows, curtains, archways, and so on) thus proclaim openly, at the level of the motif, the condition of all painting: namely, that the frame is always as much inside the painting as outside it. The frame never succeeds in containment; as the supplement of painting, it is inside the image, and the image permeates its borders. If the frame is a window, perhaps it is most like a French window: one that opens fully, to allow passage both ways through it.

In 1912, when Apollinaire performed his 'quartering' of Cubism (see above, chapter 3), he introduced the term 'Orphic Cubism.' Despite his usual tactful attempts to include as many artists as possible within his groupings, Apollinaire must have seen Orphic Cubism as primarily the creation of one man: Robert Delaunay. Then, as Delaunay himself grew increasingly uncomfortable with the idea of being any kind of Cubist at all, the term became simply 'Orphism.' It was, however, Apollinaire's

term; and it is the only major movement in painting ever to be named, explicitly, after a poet.[3]

A few other painters may legitimately be included under the designation of Orphism. Most obviously, there is Sonia Delaunay, Robert's wife. She had been a painter before their marriage, already working in strong, bold colours, in a style that combined Fauve and 'primitivist' influences. For some three years after their marriage (for reasons on which all their biographers remain tactfully silent), Sonia seems to have abandoned painting. When she resumed, in 1912, it was in a style almost identical to her husband's, as if she had silently followed each stage of his progression in the intervening years. Sonia Delaunay always maintained a dedication to the applied arts, to ornament and design: she created 'Orphist' clothing, furniture, women's fashions, playing cards, and so forth. Her work has thus been consistently undervalued, owing to the conventional masculine disdain for such pursuits, and the exaltation of easel painting as the only truly 'serious' domain of art.[4]

The other major 'Orphist' painter is Frantisek Kupka, though for obscure reasons Apollinaire, the great includer, left him out of his original definition.[5] Kupka's work is wildly various and inconsistent, but at his best he provides some of the most stunning non-figurative images in the early history of 'abstract' painting. In her 1979 book *Orphism: The Evolution of Non-Figurative Painting in Paris, 1910–1914*, Virginia Spate also includes Léger, Picabia, and Duchamp under the Orphist label. Much as I respect Spate's book, which is in many ways a definitive account, I cannot help feeling that she is stretching the definition of Orphism to include these painters. It depends, of course, on what you see as the central unifying idea of Orphism. I tend to see it as Light, or Colour; Spate sees it as Simultanism.

The Orphist painters, Spate writes, 'wanted to express what was called "Simultanism," the mind's grasp of the simultaneous existence of an infinitude of interrelated states of being. Each painter went through a phase in which he tried to express this form of consciousness by means of specific images. However, the actual process of trying to grasp such experience through painting seems to have made them aware of the inwardness of experience and to have led them to believe that it was form, not specific image, which could embody the experience they sought, since specific images tied them to the world of verbal concepts and they wished to transcend verbal consciousness' (3).

The 'specific image' with which Delaunay had first tried to capture the sense of Simultanism was the Eiffel Tower (and I will return shortly to the implications of this choice); but the 'form' to which he increasingly turned was that of Colour, pure Light. In 1912, at the same time as he was painting *Les Fenêtres*, Delaunay wrote a manifesto, entitled 'Light,' which was first published in German, translated by Paul Klee.[6] Here he stresses the superiority of painting as the art form most likely to attain the ideal of Simultanism:

> An auditory perception is not sufficient in our judgment to know the universe, because it does not abide within duration.
> Its successiveness leads fatally to its death.
> It is a species of mechanism where there is no depth, and therefore no rhythm ...
> Its quality resembles the Object. The Object is eternally committed to death.
> (Cohen 84)

Leaving aside the curious question of how an art form that is condemned precisely for its 'successiveness' in time can *also* be criticized for having 'no rhythm,' let us note Delaunay's emphasis on Colour and Light – 'Simultaneity in light is the *harmony*, the *color rhythms* which give birth to *Man's sight*' (Cohen 81) – as the basis of a non-figurative form of art. Yet at the time when he was writing this manifesto, Delaunay had not yet painted any purely non-figurative canvases. In retrospect (in his notebooks of 1939), Delaunay saw *Les Fenêtres* as the last intermediate stage in his progression towards the new art: 'In this period of the first *Fenêtres*, there were still thirteen canvases that were titled, containing abstract and concrete elements – like bits of curtain, Eiffel Towers, nudes, cities, etc. – and participating in a grammar, dare I say it, that was classical – with words become images. We were quivering at that time! These images, even treated abstractly, were memories of old habits, based more on an old spirit than on one that has been saturated and vivified by a new craft, a spirit of our time' (23).

Perhaps the most persistent image of that 'classical grammar,' and one that Delaunay repeatedly came back to (even after he had also begun painting completely non-figurative canvases), is the Eiffel Tower. In 1910, the Tower had already assumed its position as the symbol par excellence of the city of Paris, and of the modern spirit.[7] Michel Hoog writes:

What Delaunay, along with all his contemporaries, saw in the Tower was the symbol of modernism. Even though already twenty years old, the Tower, which had caused a scandal at the time of its construction, retained a character of aggression; it was, as Delaunay himself recalled, the tallest monument in the world. In 1910, the Eiffel Tower remained, in the common estimation, the symbol of modern technology, and of its possibilities, which the pride of European thinkers and engineers considered as unlimited ... Man's challenge to the old impossibilities, his power to do anything, conquer anything (the *conquest of the air*, as people said, in an expression taken up by La Fresnaye) bathed in a current of scientism, almost blasphemous, which recapitulated very exactly the idea of the Tower of Babel: 'Let us build a tower which will rise into heaven!' This pride, this defiance of God, is thus expressed by a *tower*, which constitutes a passage, a gate, a highway for the conquest of the sky. (40)

More specifically, the radio transmitter installed at the top of the Tower provided a very practical image of Simultaneity: it united countries and time zones (the latter a new and strange image of global consciousness).

A famous story about the Eiffel Tower tells how Guy de Maupassant, one of its most passionate opponents, was discovered dining in its restaurant; called upon to explain himself, Maupassant declared that this was the only place in Paris where he could have dinner, look out the window, and not see the Eiffel Tower. Roland Barthes uses this anecdote as the starting point for one of his characteristically incisive comments:

Like man himself, who is the only one not to know his own glance, the Tower is the only blind point of the total optical system of which it is the centre and Paris is the circumference. But in this movement which seems to limit it, the Tower acquires a new power: an object when we look at it, it becomes a lookout in its turn when we visit it, and now constitutes as an object, simultaneously extended and collected beneath it, that Paris which just now was looking at it. The Tower is an object which sees, a glance which is seen ... The Tower (and this is one of its mythic powers) transgresses this separation, this habitual divorce of *seeing* and *being seen*; it achieves a sovereign circulation between the two functions; it is a complete object which has, if one may say so, both sexes of sight. (1979, 4–5)

In Delaunay's paintings of the Eiffel Tower, the Tower is both the object of vision (broken, fragmented, subjected to multiple distortions), and also a metonymy of vision itself. Enclosed within the frame of the

painting, and (as we shall see) within the multiple internal frames of *Les Fenêtres*, the Tower also *looks back*, reflects back out of the frame. The form of the Tower is (classically) phallic, male; the revolving beacon at its summit is (almost too obviously) the scopic power of the gaze. The Tower has, always, an *eye* within the painting, gazing back at the eye that watches it.

In 1910–11, Delaunay's direct images of the Eiffel Tower were presented close-up, filling the frame. The Tower was depicted in twisted, distorted forms that, in Spate's words, 'strengthened the sharp, angular shapes which represent the forces of light and showed them piercing the tower, bouncing back into the buildings, tossing images of earthbound forms into the sky and splintering solid forms' (172). There is a great violence in these paintings, yet also, at the same time, the echoes of a Cubist serenity, as if the distortions of the shape of the Tower were, in Kahnweiler's terms, as much constructivist as expressionist distortion. It is no surprise that the Italian Futurists, the loud followers of Marinetti, seeing these paintings, should have hailed Delaunay as one of their own; yet equally, it is no surprise that Delaunay (and Apollinaire) resisted this identification.

By 1911, Delaunay had moved to a series of paintings called *La Ville*, of which the third (1911–12) is titled *La Fenêtre sur la ville*. This series shows a view over the rooftops of Paris, in which the Eiffel Tower is seen in the distance, barely visible, as a reference point, in the upper centre of the paintings. No longer fragmented, it is represented in shorthand by a pair of concave lines rising to a point. In this series, Spate observes, Delaunay 'tried to strengthen the composition by framing and partly veiling the view with the gauze curtain of an implied window' (177). The lines of the curtain intrude from the sides of the canvas, in convex curved lines, which thus parallel, or fill out, the concave lines that suggest the Tower.

This effect becomes much more pronounced in the 1912 paintings entitled *Les Fenêtres*. Spate comments that *Les Fenêtres* do not have any 'centralized structure, for, although the Eiffel Tower is, of course, central, it is simply a colour plane among other colour planes and does not act as a focus' (193). I have to disagree with this comment: the Eiffel Tower is, consistently, the focal point of the series. Indeed, the degree to which its simplified form anchors the composition to a referential point of identification is, I would argue, the most 'Cubist' aspect of these paintings. Spate notes that 'Delaunay has also altered its real

colour from red-brown to green so as to reduce its separate identity' (193) – that is, Delaunay represents the Tower by its colour *complement*, as if to suggest that his painting is complementary (or supplementary) to the Tower's reality.

The paradox of the 'window' as a motif in painting is that the window itself has no visual existence, only transparence; and that the referential concept of 'window' can be conveyed only by its metonymies of the frame and the curtain. The light coming through Delaunay's windows is fractured and disseminated across the surface of the canvas, as if it had hit a prism; if these are 'windows,' then perhaps they are stained-glass rather than transparent. Albert Cook contrasts Delaunay's painting to the 'broadly open windows of ... Vuillard and Bonnard and Matisse': '[I]n Delaunay the windows are windows in name only; color and light confound each other ... We cannot tell whether we are seeing through to a kaleidoscopic exterior or being dazzled by light breaking as it enters an interior: window and sun share each other's attributes ... It is a window that resembles ... the stained-glass window, a window meant not to permit a view but to structure the light as it enters' (80).

But the windows are not *just* 'windows in name only.' The most important factor in the composition of *Les Fenêtres* is the retention of the concave/convex echoes of Tower/curtain. Take, for example, the painting, now in the Hamburg Kunsthalle, which Delaunay entitled *1er Représentation. Les Fenêtres simultanées. Ville. 2e motif 1er partie.* At the centre of the composition, the Tower is represented in deep green by two up-sweeping concave lines. The curve of these lines is repeated and extended, throughout the whole canvas, by a series of curved lines. These curves may be taken to represent the tied-back curtains framing a window; or they may be seen purely as curved lines, generated by the shape of the Tower, and projected into the rest of the composition. But, given the precedents of the *Ville* paintings, and given the explicit reference to windows in the title, I feel it is safe to see these lines as, at least residually, the signs of curtains, the signs of framing.

In the Hamburg painting, and in the others in the series *Les Fenêtres*, the implied curtains act as a kind of *internal frame*. That is, the paintings are multiply framed; the frame (as in Derrida) is 'neither simply inside nor simply outside' the image. The title of the whole series, *Les Fenêtres*, implies that each image is a view through a window: that is, that the frame of the painting is coextensive with the frame of an (unseen) window. So the paintings carry all the metaphorical weight of the framed

image as a window for the eye (Alberti), or for the soul (Da Vinci). The window glass is 'visible,' insofar as it refracts the light into prismatic divisions, but also invisible, insofar as it is, simply, glass. In this latter sense, the 'frame' of the window is portrayed, metonymically, through the implied presence of the curtains, the internal frame. The Tower itself, framed and internally framed, is the object of sight, the spectacle; yet it is also, as Barthes suggests, a lookout. Its phallic shape, suggesting an upright eye, stares back out of the frame that supposedly 'contains' it.

And where does that 'frame' end? Does it end? For the Hamburg painting is 'framed,' conventionally, within a wooden frame: but *that frame itself is painted*, extending onto the frame the colour patterns of the canvas.[8] Lines and hues extend unbroken from the 'image proper' into the 'frame.' The influence here may well be Sonia Delaunay, for whom the work of art always took its place within the total visual surround and decoration of the environment. The effect is to extend the already implicit action of the internal frame (the curtain), and to present the total painting (canvas and wooden frame) as a 'window' whose boundaries cannot be delimited. The window is not a frame that 'contains' a view of the outside world; rather, it is the opening by which the outer becomes inner, without demarcation.

Furthermore, what is not always clear from reproductions of the Hamburg picture is that *the frame recedes*. The wooden border inclines back to the wall, pushing the central panel (canvas mounted on wood) quite literally *forward*, in advance of the frame. So the enclosed 'window' view, which should be conceived of as recessed into illusionistic distance, seen through and *behind* the frame, is in fact *in front of it*. All of the conventional uses of the frame – enclosure, marking of depth – are deconstructed by this use of the painted, receding frame.

The window in painting, the depiction of the transparent, is always a question of framing. What Delaunay does, in all the *Fenêtres* series but most explicitly in the Hamburg picture, is to show that question of framing at work, as it comes (in Derrida's words) 'to play, abut onto, brush against, rub, press against the limit itself' of the work, the window, and the frame.

Guillaume Apollinaire's poem 'Les Fenêtres' (*Calligrammes* 26–9) was first published as part of the catalogue for Robert Delaunay's show in Berlin in January 1913; it had been written in late 1912, at a time when Apollinaire was actually staying in the Delaunays' apartment on the

Rue des Grands Augustins. There is an almost legendary account of its composition, given by André Billy:

One day [Apollinaire] and Dupuy sat with me *chez* Crucifix, Rue Daunou, drinking vermouth. Suddenly Guillaume burst out laughing: he had completely forgotten to write the preface to Robert Delaunay's catalogue, which he had promised to mail that very day at the latest. 'Waiter, quick, paper, pen, ink!' The three of us got the job done in no time. Guillaume began at once:
 Du rouge et [sic] *vert tout le jaune se meurt*
and stopped there. Then Dupuy dictated:
 Quand chantent les aras dans les forêts natales
Apollinaire transcribed that faithfully, and added:
 Abatis de pihis
And once again he stopped.
Then I dictated:
 Il y a un poème à faire sur l'oiseau qui n'a qu'une aile
That was close to something I remembered from *Alcools*, but Apollinaire wrote it down without hesitation.
 'It would be a good idea,' I said, 'since the matter is urgent to send your preface as a message "téléphonique."'
 And that is why the following line reads:
 Nous l'enverrons en message téléphonique
 I can no longer remember all the details of this strange collaboration, but I can say with certainty that a great part of the preface for Delaunay's catalogue was composed that way. Guillaume called compositions of this kind 'conversation poems.' (as translated and cited in Steegmuller, 204–5)

Delaunay himself always indignantly rejected this account of the poem's composition, claiming that Apollinaire had written the whole poem in his (Delaunay's) studio. In a retrospective article on Orphism, written 1928–30, Delaunay refers to Billy's version as 'this anecdote (or rather this gross foolishness),' and proclaims: 'I have the manuscript of this admirable poem and I defy the journalists who fabricated this so-called collaboration to tell me in what color this poem is truly written, for it marks one of the best periods of the poet, his most sharply original period' (Cohen 108). (It is entirely typical of Delaunay that his ultimate criterion for the authenticity of the poem is the *colour* of ink in which the manuscript was written!) As several critics have pointed out, there is no real problem in reconciling these two accounts. It is perfectly

possible that the poem began in much the way that Billy describes, and that Apollinaire later, in Delaunay's studio, worked over the original notes and arrived at a more 'finished' version that nevertheless preserves the fragmented form of the 'conversation poem.'

By 1912, Apollinaire was well established as a leading art critic, and as the champion of Cubism; it is not at all surprising that he should have looked for ways to reproduce in his poems some of the effects that so impressed him in his friends' painting. He had in fact planned to publish a collection of his work under the title *Et moi aussi, je suis peintre.* The outbreak of war in 1914 delayed this project, but when his second major collection did appear, in 1918, its title – *Calligrammes* – emphasized the visual poems that would have made up 'Me too, I'm a painter.'

Apollinaire's calligrammes stand at a mid-point between works in the long tradition of visual 'shaped' poems[9] and the later development of Concrete Poetry. As S.I. Lockerbie comments, 'Since antiquity pictorial poetry had confined itself to a relatively small number of elementary shapes, which were solidly filled with unbroken lines of type. Departing from this static tradition, Apollinaire's calligrammes use single lines of type to trace bold or delicate outlines on the printed page with all the spontaneity of handwriting, producing a much wider range of plastic images' (*Calligrammes* 12). At the same time, however, Apollinaire's visual poems decisively retain linear syntax, and rhythm. The lines have to be traced through the visual patterns, but can still be read in ways that Lockerbie describes as 'richly lyrical' and 'incantatory' (ibid. 11). What really distinguishes the Concrete Poetry of the 1950s and 1960s is its radical abandonment of syntax, its readiness to commit itself completely to visual form as the basic structuring device of the poem.[10] Charming and enterprising as Apollinaire's calligrammes are, there is always the sense that the visual layout is detachable: that is, one could write out in standard linear form the words of 'Il Pleut,' for example (ibid. 100–1), and still have a good poem – something that could never be done with the works of Eugen Gomringer, Decio Pignatari, or Ian Hamilton Finlay.

In a sense, then, I would argue that the so-called conversation poems are more radically 'Cubist' poems than the more obviously visually oriented calligrammes. (The distinction need not be absolute: Peter W. Nesselroth, for example, describes the conversation poem as a 'printed sound calligram' [51].) The most obvious point of similarity is the use of

collage: Apollinaire's incorporation into 'Les Fenêtres' and 'Lundi Rue Christine' of fragments of overhead conversation is roughly equivalent to the Cubists' inclusion of scraps of newspaper or other heterogeneous materials in their canvases. Recall that Christopher Green, in a passage I quoted in chapter 5, described the papiers collés as 'a kind of visual chatter,' analogous to the 'volatile, spontaneous speech ... current in the cafés of Montmartre, Montparnasse or Céret' (151) – cafés, for instance, like the Crucifix on the Rue Danou, where André Billy describes 'Les Fenêtres' as arising out of, precisely, volatile and spontaneous speech.

But more important than the simple inclusion of collaged material are the effects that this technique produces on the ideas of unity and coherence in the poem, and in the reading process. And these effects are, to a great extent, questions of framing.

In *Méditations esthétiques: Les Peintres Cubistes*, Apollinaire remarks, almost in passing, on the idea of an 'inner frame':[11] 'Let me add that the formulation of the title [for a painting] is, for Picabia, not separable, intellectually, from the work to which it refers. The title should play the part of an inner frame, as actual objects, and inscriptions exactly copied, do in the pictures of Picasso ... Analogous to Picabia's written titles, to the real objects, letters, and molded ciphers in the paintings of Picasso and Braque, are the pictorial arabesques in the backgrounds of Laurencin's pictures. With Albert Gleizes this function is taken by right angles which retain light, with Fernand Léger by bubbles, with Metzinger by vertical lines, parallel to the sides of the frame cut by infrequent echelons. The equivalent will be found, in some form or other, in the works of all the great painters' (Chipp 244). (Apollinaire does not include an example from Delaunay at this point, but the window curtains of *La Ville* and *Les Fenêtres* would obviously fit well in this list.) In this passage, Apollinaire points to some of the same marginal features of the work of art that Derrida treats as parerga: frames, titles, titles on frames. The traditional place for a painting's title is on a plaque affixed to the frame; in several paintings, Braque and Picasso *painted* such plaques as part of the canvas, creating an 'inner frame.' To do so, they also had to paint imitation frames, 'molded ciphers.' Apollinaire sees the same thing happening in Picabia's habit of painting the title as part of the canvas: the frame brought into the work constitutes an 'inner' frame, and thus sets up the whole parergonal shift between inner and outer. Such effects of the frame are further analogous, Apollinaire argues, to collage: to the inclusion of 'real objects' and 'letters' by Braque

and Picasso. If, then, his 'conversation poems' use the technique of collage, then he too is using the incorporated elements as a kind of 'inner frame.'

The effect of the *title* as inner frame is crucial to the reading of the conversation poems. Peter W. Nesselroth uses 'Lundi Rue Christine' as a test case to determine how the effect of 'literariness' is produced; he argues that the reader's response of treating a certain text *as a poem* is produced not so much by any 'literary' qualities of the language itself as by its framing:

> If in oral communication the meaning of the message depends not only on its verbal components but also on the presence of the speaking subject and on the situation of the interlocutors, the written message depends on its framing, i.e. non-verbal context, title, signature, etc. This explains why two verbally identical texts can have completely different meanings when they are framed differently ...
>
> The verbal components of a poem may or may not be different from what we find in ordinary language, but literariness is more than just literary language. It is a specific type of communication, and its analysis cannot ignore the contextual frame which defines it. The reading of 'Lundi Rue Christine' does not begin at the first line, or even with the titles of the section and the volume, but with the name *Guillaume Apollinaire*, whose semantic markers include 'modernism,' 'poet of twentieth-century technology and of a new dawn for mankind,' 'precursor of surrealism,' etc. (43, 51)

That is, a poem's 'frame' – the context provided by 'title, signature, etc.' – asserts the status of the enclosed text as 'being-a-poem,' and thus influences the ways in which it is read. The reader will be more likely to seek for (and thus find) effects of unity and coherence in a text that is coded as 'a poem' than in a text that is coded as 'miscellaneous scraps of conversation overheard in a café.' (This is why Delaunay insisted on coding 'Les Fenêtres' as a poem; Billy's description gave it the 'wrong' frame – or, perhaps more accurately, Billy coded it within what we would now see as a Dadaist frame.)

Nesselroth's discussion again emphasizes the frame as a parergon that deconstructs the opposition of inner and outer. The traditional site of 'literariness' was securely *inside* the text (qualities of 'poetic' language, figures of speech, etc.); Nesselroth situates it rather in an 'outside' (title, signature, etc.) that is never fully 'outside,' but rather plays along and across the border. Albert Cook makes the same point, in

relation to both Delaunay and Apollinaire: 'Taken as a window, the painting of Delaunay looks like a stained-glass window rather than a window to see through; and yet inner and outer are fused; the painting is both and neither, and its Orphism presents a sort of model of intersubjectivity. So does "Les Fenêtres" of Apollinaire, where the elements of narrative, of image, and of logical proposition; of fantasy and reality; of rumination backwards and progression forwards, have lodged themselves into colorful bits of locution to become indistinguishable' (81). David Berry, in his study of Apollinaire's imagery, concludes that 'the window for Apollinaire represents a means by which his vision can embrace the world, a means of communication between inner and outer reality ... a boundary between reality and dream' (105–6).

'Les Fenêtres' is a poem that moves continuously across such boundaries. Its verb tenses shift from present to past to future; it moves in space from enclosed rooms to transcontinental railways, from the centre of Paris to exotic worldwide locations; and it conflates these two registers of time and space by punning place names (Hyères, Maintenon) as indications of past and present (hier, maintenant). It juxtaposes mundane details of everyday life (a poor young man blowing his nose on his tie) with surrealist alogic ('Les Tours ce sont les rues'). Idiomatic, grammatical phrases ('On commencera à minuit') follow asyntactical 'word heaps'[12] ('Beauté pâleur insondables violets'). The reader is never permitted to settle into any one mode of interpretation, except the mode of being unsettled. The frame of the text (the assertion of *being a poem* made by the title, the signature, the layout, the form of presentation) leads the reader to expect coherence; and the poem continually teases the reader with hints of that coherence (the recurrence of colour references; the quasi-systematic alternation between images of height and depth, vertical and horizontal) without ever quite delivering it unequivocally.

Is there then a unity to be discovered in 'Les Fenêtres'? Part of the poem's function, it seems to me, is to pose this very question: to face the reader with the problem of choosing between Delaunay's and Billy's 'coding' of its frame. A certain resistance to unity is built into the form of the poem; it is much more various, more heterogeneous, more miscellaneous than any of Delaunay's *Les Fenêtres*. In effect, though, there are two possible reference points that might provide ways of looking at the poem in a relatively coherent and unified way; and both of these points are to be found on the frame – the title, and the signature.

The title, and the first publication of the poem as part of the Berlin exhibition catalogue, are the most obvious indicators that the whole

poem should be read in relation to Delaunay's painting. Several lines have been taken to refer to objects in Delaunay's studio (the shell of the sea urchin; the old pair of yellow boots); and the ending of the poem – 'La fenêtre s'ouvre comme une orange /Le beau fruit de la lumière' – would not be at all out of place in one of Delaunay's manifestos. The repeated line 'Du rouge au vert tout le jaune se meurt' may well have arisen out of discussions on colour theory between the painter and the poet. Whatever its exact meaning,[13] it serves itself as a kind of frame. It sets the key for the whole poem, suffusing it in a rich wash of colour; the exotic names of birds and places respond to this intensity of hue. Its suggestion of the way in which colours change and transform themselves in different combinations as they are mixed on the palette also sets the tone for the abrupt changes and juxtapositions of mood that the poem effects from line to line. Its double occurrence in the poem, as the first line and the fourth-last, acts as a kind of internal frame, closing off the poem at each end – but not a complete enclosure (there are still three lines after its second occurrence), since the frame can never completely enclose. 'Le beau fruit de la lumière' will always escape it.

Apollinaire, no less than Delaunay, was obsessed with that lovely fruit of Light. He was strongly aware of his own adopted name, his signature, as proclaiming his affiliation to Apollo, the god of Poetry and the god of Light. One of his favourite quotations, to which he repeatedly refers, is from the 'Pimander' of Hermes Trismegistus. The opening poem of Apollinaire's *Bestiary*, and the Note that he added to it, make explicit the links between Apollo, Apollinaire, Orpheus, Orphism, poetry, language, and light:

ORPHEE

Admirez le pouvoir insigne
Et la noblesse de la ligne:
Elle est la voix que la lumière fit entendre
Et dont parle Hermès Trismégiste en son Pimandre.

ORPHEUS

Admire the power divine
And the nobility of line:
It is the voice we hear, the voice of light
Of which Hermes in his Pimander writes.

NOTE:

Cette 'voix de la lumière,' n'est-ce pas le dessin, c'est-à-dire la ligne? Et quand la lumière s'exprime pleinement tout se colore. La peinture est proprement un langage lumineux.

This 'voice of light,' is it not drawing, that is to say, line? And when Light expresses itself fully, everything becomes coloured. Properly speaking, painting is a luminous language, a language of light.

[my translations]

Painting is a language (the gesture, if you like, of linguistic imperialism again!), but it is a language illuminated by Light. Light belongs to the god Apollo, and to his servants, the poet Orpheus, and the poet Apollinaire, who will make the voice of Light speak: and what it speaks will be Orphism, the painted world in which everything becomes coloured.

Apollinaire's delight in light was also reinforced by the rhyme that it provided with his own name: Apollin*aire* / lum*ière*. This echo pervades 'Les Fenêtres' as a kind of internal signature. The effect is wonderfully described by Rosanna Warren: 'Listen now, in the poem's conclusion, to the flight of syllables, their metamorphoses, their undermining of syntactic and semantic order; listen especially to the syllable "ver," which is a color "vert" (green) and a line of verse "vers" but also the preposition "vers" (toward), essential but always suppressed in this poem of transition, of passage; "ver" shares also in the name of a city and a season: VancouVER, hiVER' (558). So the poem moves in its final lines through this series of rhymes: Vancouver, fuit l'hiver, du rouge au vert [ouvert], Vancouver Hyères [hier], fruit de la lumière ... to the unspoken signature at the end, the final rhyme, Apollinaire.

For where is Apollinaire in his own poem? The 'conversation poems' are remarkable, among the works of a poet so committed to the lyric expression of the self, in their complete lack of the pronoun 'I.' In 'Lundi Rue Christine,' Lockerbie comments, 'the poet is virtually absent, or is reduced to the role of an eavesdropper' (*Calligrammes* 5). He is the implied consciousness in which all the fragments find a unity: again, a unity that is situated, undecidably, inside and outside the viewer, both in what is seen and in the act of seeing. 'At the centre of Apollinaire's poetic universe,' writes David Berry, 'we discover a subject who watches and who sees himself watched' (37). In the same way as Barthes de-

scribed the Eiffel Tower as possessing 'both sexes of sight,' so Apollinaire both sees and is seen in these poems. He registers the multiplicity of light that floods through the window of his consciousness, but what he finds in that light (lumière) is always the echo of his own signature as the godlike poet. Berry again: 'Thus, for Apollinaire, the act of vision initiates a creative process, by means of which the outward scene at times becomes the emblem of his creative mind. In this active moment of creation the poet *is* what he sees' (160).

. Apollinaire's poem and Delaunay's paintings act as frames to each other, as windows through which each views the other. Neither one can be seen as having priority over the other; as each other's supplements, they deconstruct any notion of visual/verbal hierarchy. The title of the poem, and the colour references in its first line, set the poem 'within the frame' of Delaunay's paintings: the poem is contained within the paintings' window. Yet at the same time, the poem acts as a frame to the paintings. Its function as catalogue essay makes it a window through which the paintings are viewed. It occupies the classic position of the parergon or supplement: as an 'introduction' to the paintings in the show, the catalogue is added on, inessential, supplementary; yet at the same time it is never completely exterior. Where does the frame begin or end? At the wooden frame (which Delaunay painted)? At the wall (on which hang also the other paintings in the show, in the series)? At the door of the gallery (where they hand out the catalogue)? Poem and painting are parergonal to each other, each the other's frame; painting and poem supplement each other, respond to each other's lack. Locked together by the coincidence of their titles, they can never be seen except as a pair of windows, simultaneously open and reflecting.

The frame never closes completely – so I want to end this chapter, not with the image of Apollinaire and Delaunay 'locked together' in a self-enclosed pair, but with another, more recent poetic and visual response to the themes of this chapter, in the form of a collaboration between a poet, bpNichol, and a painter, Barbara Caruso. One of Nichol's long-standing obsessions was with comic books, and in his own work in that genre he experimented constantly with the idea of the *frame*. The comic-book frame encloses the action, yet also advances it: it always looks forward to the following frame. Even in the most conventional comic strips, the frame is infinitely flexible in size and shape; among more experimental artists, the frame is subject to constant transgression and manipulation. In Nichol's own work, the frame very rarely *contains* its

contents: characters and lettering move in and out of frames, and exhibit a self-referential awareness of the existence of the frame within their world.

As a painter, Barbara Caruso is best known (though she is not known nearly well enough) for her series of 'Colour Lock' paintings, that use shapes which in one sense look *like* comic-strip frames. In terms of Caruso's own work, this intent is not of course primary: for her, the free-drawn squares and rectangles are 'colour-shapes,' that is, forms in which colour *takes* shape and dominates the shapes. The many subtly varied and complementary shades of Caruso's colours play back and forth between the shapes and across the spaces between them: the subject of her paintings is first of all colour, not geometry.

Nevertheless, in several of her collaborations with Nichol, Caruso's colour-shapes have been made to function, at least in part, as comic-book frames (see especially the series of prints entitled *The Adventures of Milt the Morph in Colour*). Perhaps their most lovely collaboration is *From My Window* (1978). Here the basic unit is a set of four blue colour-shapes, rectangular and vertical, regularly edged and angled, set two above two on the page. The contexts of Nichol's and Caruso's previous works offer two different readings: these might be comic-book frames, or they might be colour-shapes. However, they are slightly *too* regular for either reading: both Nichol and Caruso preferred to draw their shapes freehand. Rather, the title suggests that these shapes should be seen as window panes. The 'frame' of the window, the wooden bars that hold the panes in place, thus disappears into the white of the paper. In one sense, this arrangement reverses the paradox of which I spoke earlier: namely, that a picture of a window can never 'show' the transparent glass, so that 'window' can only be depicted by the metonymy of 'frame.' Here, the 'frame' is not shown at all: it is assimilated into the ground of the paper. In another sense, Caruso and Nichol's depiction of 'window' here plays with the traditional notion of the illusion of depth. A window frame, Meyer Schapiro noted, 'sets the picture surface back into depth and helps to deepen the view' (212). Nothing of the sort happens in *this* frame: the blue shapes sit, self-assertively, at the surface of the paper. They do not recede at all. This is a window that gives onto no depth.

There are seven prints in the series. In each one, the name of one day of the week (in sequence, starting with Monday) appears above the window, while below it is the blandly unvarying word 'blue.' But the actual shade of blue in the panes varies on each day, delicately, subtly,

and beautifully. In one sense, what is being shown here is the inadequacy of verbal language: the fact that the one unvarying word refers, as a very blunt instrument, to an infinite range of subtle variations in colour. (Possibly there is an unstated pun at work also: Nichol's 'blue' is transformed by Caruso into 'blues' – the blues. The blues deepen as the week progresses, and only lighten up again when it gets to Sunday.) Yet these variations in colour themselves act in a quasi-linguistic way: without reference, they are distinguished from each other by pure difference. They are signifiers without positive terms. They create what Apollinaire called 'un langage lumineux,' a language of light.

'From red to green all the yellow dies.' The missing colour in Apollinaire's poem has always been blue; Nichol and Caruso finally provide it. Delaunay and Apollinaire, I am sure, would have appreciated *From My Window*.

ENTR'ACTE

Signs of the Times

SI~~GN~~S

– Jacques Derrida

S I G͡N S

– Ian Hamilton Finlay

Up to this point, this book has concentrated on the early years of the twentieth century, the 'heroic period' of Cubism. For the last two chapters, I wish to shift focus, and to look at more recent developments of the continuing relationship between poetry and painting. Specifically, I want to examine some aspects of the international movement known as Concrete Poetry, in its two major branches of visual and sound poetry. But before I do so, I would like to place Concrete Poetry itself within a wider speculative framework.

In November 1983, I attended a reading given at the University of Victoria by the Austrian poet Ernst Jandl. Aware that he was speaking to a student audience without much knowledge of German, Jandl read mostly sound poems, which he explained (in English) in great detail. These explanations entailed a patient exposition of the basic ideas and history of Concrete Poetry: the Noigandres group in Brazil, Eugen Gomringer in Switzerland, their meeting at Ulm in 1955, and the growth of a self-consciously 'international' movement over the next ten years. For me, both the poems and the commentary were familiar material: indeed, it was rather like hearing 'Ernst Jandl's Greatest Hits.' It had been almost twenty years since I had first heard Jandl's splendid evoca-

tion of trench warfare, 'schtzngrmm,' on the BBC's broadcast of a famous reading at Royal Albert Hall in London (11 June 1965), one of the key events in avant-garde poetry in Britain in the 1960s. Yet for most of these students, it was all new; they must have had somewhat the same reaction as I had had when I first heard the words 'Concrete Poetry,' in a lecture by Edwin Morgan at the University of St Andrews in 1964. Not quite the same reaction, though: for me, Concrete Poetry was an immediately contemporary movement, the avant-garde of my time, whereas for these students, what Jandl was talking about was ancient history, something that had happened before most of them were even born.

This incident has become emblematic for me of the sense of Concrete Poetry as being, now, *past*: something that belongs to literary history, and can be categorized, included in the Norton Anthology, dated. The best date for its beginning (making all due allowances for precursors from Apollinaire to Oyvind Fahlström) is still 1955, that meeting in Ulm between Eugen Gomringer and Decio Pignatari.[1] The best date for its demise is, ironically, 1967–8, the years of its apparent triumph, with the publication of the three major anthologies edited by Emmett Williams, Stephen Bann, and Mary Ellen Solt.[2] The very definitiveness of these collections 'froze' Concrete Poetry in its historical moment. In the 1970s, most of the major practitioners either ceased writing, or else (as, notably, in the cases of Ian Hamilton Finlay in Scotland and bpNichol in Canada) developed highly personal, post-concrete styles, too diverse to be meaningfully classified under the same heading. By 1977, Stephen Bann could offer the following analysis and epitaph:

In retrospect, the entire development of the phenomenon [of Concrete Poetry] in Britain (and elsewhere) throughout the mid-1960s can be seen to have perpetuated a strange illusion: the notion that concrete poetry was a novel artistic or poetic form, still in its primary stages, which would acquire its basic 'grammar' and then proceed to the task of large-scale achievement. Thus the concrete epic might be expected to succeed in due time, in the same way as Pound's *Cantos* or Williams' *Paterson* have been seen as the epics of Imagism. In effect, it would be more realistic to stress the fact that, from the outset, concrete poetry could be characterized not as a beginning but as an ending (or at least the beginning of an ending), not as a grammar but as a mannerism. The concrete poets were completing a cycle of linguistic experimentation which had begun in the early days of the Modern Movement. It would indeed be possible to argue that Gomringer and the Noigandres group succeeded in producing a

modernist poetry of high achievement precisely because of their acceptance of the constraints of late-coming. They offered a 'mythic' resolution to the enterprise of fragmentation proclaimed by the Futurists and Dadaists. (1997, 10)[3]

Bann, that is, is arguing for Concrete Poetry as a final statement of modernism, somewhat oddly stranded in the oncoming period of postmodernism. These terms are, of course, open to much debate and definition – and often, elements that are offered as characteristic of the one may also be found in the other. The 'post' of 'postmodernism' is not, strictly speaking, a chronological marker of clear-cut linear succession; rather it indicates a more complex relation of mutual implication. In *The Banquet Years*, for instance, Roger Shattuck characterizes the art of high modernism under the headings of self-reflexiveness, juxtaposition, and simultanism. Clearly, a high degree of self-reflexiveness is common to both modernism and postmodernism, though in the latter it may be more inclined towards parody and pastiche. Shattuck's other two criteria, however, may be more helpful in defining the 'modernism' of Concrete Poetry.

Shattuck defines 'juxtaposition' as 'setting one thing beside another without connective' (332), and he contrasts modernist art to the traditional arts of *transition*. In this respect, Concrete Poetry is an example even purer than the Apollinaire 'conversation poems' (such as 'Les Fenêtres') cited by Shattuck, since the essence of Concrete Poetry lies in its suppression of *syntax*, the traditional connective mode of language.[4] For Shattuck, 'juxtaposition' proves an inadequate term, since it still 'implies succession,' whereas Shattuck is trying to define an art in which the elements 'are to be conceived not successively but *simultaneously*, to converge in our minds as contemporaneous events' (345). So Shattuck adopts, principally from Robert Delaunay, the term 'simultanism.' Admittedly, there are visual concrete poems that extend for more than one page (and sound poetry significantly diverges from visual poetry at this point), but by far the majority of the concrete poems collected in the three definitive anthologies are 'single-image' constructions, deployed spatially across the page (or poster, photograph, wall, field) in a manner that invites comparison with the way in which one perceives a painting.[5]

In fact, the comparison to painting is in itself the most telling indication of the modernism of Concrete Poetry, since the evolution of modern painting (from, say, the Salon des Refusés in 1863 to the Cabaret Voltaire in 1916) presents the exemplary paradigm of modernism: paint-

ing, not music, became for that period the art towards whose condition all other arts aspired. Thus, Shattuck takes his ultimate term for all modernist art (simultanism) from a painter (Delaunay). Attempts to describe tendencies *within* Concrete Poetry have frequently used vocabulary drawn from the history of modern painting: Mike Weaver distinguished between 'expressionist' and 'constructivist' modes, while Ian Hamilton Finlay, more narrowly, described his own works as 'Fauve' or 'Suprematist.' Even more strikingly, Wendy Steiner's 1982 study of inter-artistic analogy, *The Colors of Rhetoric*, advances the 'bold hypothesis' that Cubism is 'the master current of our age in painting and literature' (177). From there it is only a short step for Steiner to advance the argument, which I have already cited in my preface, that '[t]here is no clearer working out of a cubist ideology than concrete poetry' (197).

Another criterion that has been proposed for distinguishing between modernism and postmodernism is one that makes use of the Jakobsonian distinction between metaphor and metonymy.[6] Metaphor, in this sense, has been identified as the central characteristic of modernism. Metaphor works, Jakobson noted, as a vertical system of correspondences; it depends upon highly structured and relatively stable works; it is a spatial rather than a temporal relationship; it is synchronic rather than diachronic. Thus, the whole of cultural history becomes simultaneously present and accessible, as Eliot proclaimed in 'Tradition and the Individual Talent.' Eliot and Pound redefined the usable past, demanding that their readers acquaint themselves with Sextus Propertius, Arnaut Daniel, or Sigismondo Malatesta. Similarly, readers of Ian Hamilton Finlay have found themselves called upon to explore the pre-Socratic philosophers, the revolutionary writings of Louis Antoine de Saint-Just, and the Spandau diaries of Albert Speer. Concrete Poetry, or at least Finlay's version of it, is simultaneously classical and avant-garde, a blend of innovative form and traditional sensibility – as indeed was the Cubism of Braque and Gris, if not always of Picasso.

Concrete Poetry, as a synchronic structure creating metaphors out of the relationships between spatially distributed elements, can further be related to structuralism, and it is perhaps no accident that Concrete Poetry's period of greatest activity (1955–70) roughly coincides with the ascendancy of structuralist thought. Finlay's critics have frequently referred to the work of Claude Lévi-Strauss, especially his notion of the 'small-scale model' (see, for example, Bann 1970, and Scobie 1979). In 1972, Stephen Bann wrote that 'the contemporary inquiry undertaken in the fields of linguistics, anthropology and biology promises a new

Classicism based on the constant relational figures that may be extrapolated from the operations of the human mind' (1972, 16). Bann linked the work of Lévi-Strauss with that of Noam Chomsky in linguistics and François Jacob in biology, and stated that Finlay's work 'relates intimately' to this 'new Classicism,' since it has 'an exemplary value for the notion of linguistic constants underlying visual structure' (1972, 17–19).

The confidence of Bann's structuralist faith in 'constant relational figures' was already, in 1972, under severe attack. Indeed, a major part of Jacques Derrida's *Of Grammatology* (1967; English translation 1976) is devoted to a deconstruction of Lévi-Strauss. The structuralist study of the relations *between* signs requires that the signs themselves remain stable; what Derrida did was to question and undermine the very possibility of a 'linguistic constant.' 'There is not a single signified that escapes,' he wrote in *Of Grammatology*, 'the play of signifying references that constitute language' (1976, 7). Saussure's synchronic system of difference is invaded by the endless recession of Derrida's 'différance'; the word, far from being the sign of meaning's presence, becomes the trace of its absence. Every sign is put 'under erasure,' simultaneously present (since we cannot do without it) and crossed out (since we cannot ever define it): sign becomes s~~ig~~n.

Derrida is the most important single figure in the general movements known, however unsatisfactorily, as post-structuralism and postmodernism. Derrida himself dislikes these terms. In an interview with Christopher Norris, he explained: 'I never use the word "post," the prefix "post"; and I have many reasons for this. One of those reasons is that this use of the prefix implies a periodisation or an epochalisation which is highly problematic for me. Then again, the word "post" implies that something is finished – that we can get rid of what went *before* Deconstruction, and I don't think anything of the sort ... Deconstruction is not simply forgetting the past. What has dominated theology or architecture or anything else is still there, in some way, and the inscriptions, the, let's say, *archive* of these deconstructed structures, the archive should be as readable as possible, as legible as we can make it' (Papadakis, Cooke, and Benjamin 72–3). Derrida's reference to architecture is somewhat ironic, since it has been in architecture that the term postmodernism has acquired its most precise meaning, its clearest designation of a style (or, to be unkind, of a mannerism). More recently, the term deconstruction has also been advanced in architecture, but otherwise, it has not really taken hold in the visual arts. As Geoff Bennington writes, 'If there were ever to be a deconstructive movement

in art, it would be a movement already dissolving its determination and resisting the restitution of its events to anything so stable as a nameable movement' (87).

Many other critics, less fastidious in their terminology, have seen a general move away from modernism to postmodernism: that is, a move away from stable, closed, tightly organized spatial systems to the open-ended, accretionary free play of loosely organized temporal systems. This description returns us to the shift of emphasis from metaphor to metonymy. David Lodge's influential book *The Modes of Modern Writing* (1977) advanced the metaphor/metonymy distinction as a fundamental change between modernism and postmodernism; but he also classified Cubism as metonymic, and Surrealism as metaphoric, and this argument poses problems for anyone who wants to argue (as I do) that Cubism is an exemplary instance of modernism. But, as I argued in chapter 6, I believe that the case is more subtle and complex than any simple dichotomy according to these categories. Insofar as it was a confident, self-reflexive examination of the visual modes of representation (and insofar as it remained, however uneasily, within the tradition of easel painting), Cubism is the central movement of modernism. Yet many of its techniques were clearly metonymic, so that it contained within itself the possibility of its own 'post.' Unlike Derrida, I do not see that the prefix 'post' necessarily implies that something is 'finished,' or that there is a clear break between two neatly defined 'periods': rather, I think that the prefix 'post' works precisely to deconstruct such divisions, to inscribe the 'archive,' and to reveal the extent to which the one movement is the supplement of the other. The importance of postmodernist metonymy within modernist Cubism is striking evidence of this supplementarity.

Similarly, Concrete Poetry, although its basic orientation is modernist and metaphoric, unravels into postmodern metonymy. Nowhere is this clearer than in the work of bpNichol. Nichol was one of the leading figures in the international Concrete Poetry movement; his first book was published in England, and he is the 'token Canadian' in Solt's *World View*. Nichol was also one of the most successful of the concrete poets in fashioning a post-concrete personal style. Though elements of visual concrete persisted in his work, they were embedded within a discourse whose overall direction was postmodernist, post-structuralist, and metonymic. His life-long poem, *The Martyrology*, could serve as the epitome of metonymic expansion and open-endedness. But also important here was his involvement in sound poetry.

Sound was the 'poor cousin' of visual Concrete Poetry in the 1960s, partly for the simple reason that it could not be reproduced so easily in the anthologies. But it flourished in the 1970s, culminating in a series of major international festivals (Toronto, 1978; New York, 1980). Sound poetry is open-ended, improvisational, temporal rather than spatial in its organization; it moves into the flux and uncertainty of language set free; it constantly places its own signs 'under erasure.' Sound provides the 'post' (perhaps the last post) for Concrete Poetry on the edge of postmodernism.

In its dependence on live performance and improvisation, sound poetry moves against the modernist ideal of the work of art as stable, established, organic form, the poem as ideal object, the 'well-wrought urn' of New Criticism. On the other hand, visual Concrete Poetry, by virtue of its inherent analogy to painting, always tends to present itself as a unique object, one of a kind, unrepeatable. Just as paintings can be reproduced, so concrete poems can be printed and duplicated: but in the work of Ian Hamilton Finlay especially, poems attain the status of paintings as objects in their own right. The most extreme instance is Finlay's garden at Little Sparta, Stonypath, Lanarkshire, where poem-objects exist in a unique relation to their setting and to the natural environment. (Not an *unchanging* relation: for poems in wood or stone, set in the open air, weather and decay, grow moss, decompose [if not deconstruct].) I have on my desk as I write a stone, which is also a poem: I 'own' it, it is credited to me in the catalogue of the exhibition *Unnatural Pebbles* (Graeme Murray Gallery, Edinburgh, 1981). These are not the terms in which one normally talks about a poem. Cut into the smooth surface of this stone are a series of signs, letters, that make up the word 'signs.' A line of alteration passes through them: but it is not the Derridean line of erasure, enforcing the notion that the sign is only a trace. It is the 'wave' sign, the undulant proof mark of transposition, which Finlay has so often passed through language. And it transforms 'signs' into 'sings.'

'I would like, if I could, to bring into this, somewhere the unfashionable notion of "Beauty,"' wrote Finlay thirty years ago, 'which I find compelling and immediate, however theoretically inadequate' (Solt 84). The ways in which Finlay is 'theoretically inadequate' have changed over these thirty years; the beauty has not. My purpose in this 'Entr'acte' has been to suggest that the position of Concrete Poetry in general, and of Finlay's work in particular, has changed in relation to cultural and intellectual trends. Whereas Concrete Poetry, for all its avant-garde ap-

pearance, was very generally in accord with the dominant mid-century modes of modernism, structuralism, and metaphor, what remains of it now (with the limited exception of sound poetry) stands in a more adversarial relationship to the dominant modes of postmodernism, post-structuralism, and metonymy.

In Canada, there have been some very recent indications of a revival of interest in Concrete Poetry, as both theory and practice, in the works of young academics and poets such as Darren Wershler-Henry and Christian Bök. It will be intriguing to see how this revival develops, and how it will situate itself in relation to a millennial cultural climate that has already moved beyond any easy encapsulation as 'postmodern.' Historically, however, we must still see Concrete Poetry as belonging to the modernist art with which our century, in the form of Cubism, first defined itself, though elements of postmodernism were already present in that modernist art – in Cubism (with its potential for metonymic dissemination), in the works of Gertrude Stein, and in the Dada sound poets – right from the start. As the classical period of Concrete Poetry recedes into retrospect, we can see it more clearly, not as an aberration of a short-lived avant-garde, but as part of a tradition that encompasses not only our own time but the other great periods of Western art. And in this tradition Ian Hamilton Finlay stands out, as all great artists do, both as a representative figure and as a unique one. He takes the signs of his times, and he makes them sing.

Gadji Beri Bimba: Abstraction in Poetry

I dreamed I saw Hugo Ball
the night was cold I couldn't even call
his name though I tried
so I hung my head and cried

I dreamed I saw Hugo Ball
and he looked fine he stood tall
but he lived in a world of pain
I never saw Hugo again

bpNichol

The action of the supplement, as I outlined it in chapter 1, is to supply something that is both needed and not needed; to fill a gap that both is and is not apparent; to move towards a lack in the 'other' that reflects a lack in the 'self.' In earlier chapters, I have described how various verbal techniques – naming, narrativization, theory, commentary – provide a linguistic supplement that the visual arts both resist and invite. My emphasis has been on the linguistic element in painting, though I have also touched on the ways in which the writings of Stein and Apollinaire admit the influence of the visual at the edges of language. In the final two chapters, I turn towards the complementary action of the supplement: the presence of painting in poetry – or, to be more precise, the ways in which a particular brand of experimental writing, Concrete Poetry, has been formed by its response to certain aspects of the visual arts. In chapter 9, I will deal with the visual poetry of Ian Hamilton Finlay, and specifically with the influences on his work of Cubism,

Kahnweiler, and Gris. In this chapter, which deals with sound poetry, my focus is on the question of abstraction.

Obviously, the most radical innovation in twentieth-century painting has been its move towards non-iconic abstraction (I take this term from Harold Osborne, whose definitions of 'abstraction' I will be discussing shortly). Some twentieth-century poets have reacted to the achievement of abstraction in painting with the desire to do the same in poetry. These poets saw in painting a capacity that they envied, and that they could not attain within 'poetry' as it was conventionally understood. The abstraction of painting became the supplement that poetry desired. The poets saw in painting what verbal language lacked: that capacity for absolute self-reflexiveness, for the self-sufficiency of its own materiality, for the extinction or transcendence of 'meaning' – the capacity, ultimately and paradoxically, for silence.

In this search for the supplement, I take the emblematic figure to be the Dada poet Hugo Ball, and the emblematic site to be a small cabaret on a narrow street in the city of Zürich, 1916 ...

Zürich, 1916: a city at peace in a world at war; a city of exiles, of refugees, of revolutionaries both artistic and political. On the Spiegelgasse, Alley of Mirrors, a narrow street climbing up from the banks of the river Limmat, Lenin sits waiting for his moment in history, for his closed train. And just down the street, obliquely across the Alley of Mirrors, in an emblematic juxtaposition that has delighted writers and historians,[1] is a café in which Lenin occasionally eats, and that also, in the evenings, houses the Cabaret Voltaire, the birthplace of Dada. In Switzerland, the linguistic crossroads of central Europe, there came together Jean or Hans Arp, sculptor and poet, from Strasbourg; Tristan Tzara, writer, from Bucharest; and Hugo Ball, dramaturge and religious visionary, from the Rhineland Palatinate of Germany. At a time when the nationalist ideals of European high culture had produced the institutionalized insanity of trench warfare, Dada proclaimed the end of that high culture. It promoted the cult of the irrational, the chance, the spontaneous; in the various possible (and later fiercely debated) origins of its name, 'Dada' was a child's rocking-horse, the doubled affirmation of the Russian 'yes,' the tail of a sacred cow, a repetition of the initials of Dionysius the Areopagite, or merely nonsense syllables. In place of art, Dada promised anti-art, and in doing so fell into the inevitable paradox of producing art again, such as the lovely, chance-generated drawings of Arp, or the oddly compelling poems of Hugo Ball.

On 23 June 1916, Ball wrote in his diary, 'I have invented a new genre of poems, "Verse ohne Worte" [poems without words] or "Lautgedichte" [sound poems]' (70). Ball's claim to have 'invented' this form of experimentation may well be challenged[2] (and even the date in his diary is in dispute), but the name he used for it – sound poetry – has persisted to this day. On that evening, the diary continues,

I gave a reading of the first one of these poems ... I had made myself a special costume for it. My legs were in a cylinder of shiny blue cardboard, which came up to my hips so that I looked like an obelisk. Over it I wore a huge coat collar cut out of cardboard, scarlet inside and gold outside. It was fastened at the neck in such a way that I could give the impression of winglike movement by raising and lowering my elbows. I also wore a high, blue-and-white-striped witch doctor's hat.

On all three sides of the stage I had set up music stands facing the audience, and I put my red-pencilled manuscript on them; I officiated at one stand or the other ... I could not walk inside the cylinder so I was carried onto the stage in the dark and began slowly and solemnly:

gadji beri bimba
glandridi lauli lonni cadori
gadjama bim beri glassala
glandridi glassala tuffm i zimbrabim
blassa galassasa tuffm i zimbrabim ... (70)[3]

Ball, who was later to retreat from this kind of experimentation into a both literally and metaphorically Byzantine mysticism, never developed a fully articulated theory for sound poetry. His remarks are scattered through his diary, *Flight Out of Time*, whose entries he often reworked and revised before publication. In the entry dated the day after his performance at the Cabaret Voltaire, he wrote: 'In these phonetic poems we totally renounce the language that journalism has abused and corrupted. We must return to the innermost alchemy of the word, we must even give up the word too, to keep for poetry its last and holiest refuge' (71). And the following year, on 5 March 1917, he concluded: 'The next step is for poetry to discard language as painting has discarded the object, and for similar reasons.'[4]

Sixty years later, in 1978, the Dutch sound poet Greta Monach repeated the same program, and the same justification: 'Familiarity with music from an early age led me to think in terms of abstract art. [¶]

Given the fact that, after music, the visual arts also emancipated from the figurative into the abstract, it seems a matter of course to me to follow this example in poetry' (23). It is not, however, 'a matter of course.' I would call these two statements – so strikingly similar, despite the sixty years of experience and experimentation between them – simplistic, even naive, precisely because they propose, as easy and obvious assumptions, that there is a direct parallel between painting and literature, and that abstract poetry is thus both possible and desirable. Not that these propositions are necessarily invalid; but they cannot be made as assumptions, they have to be argued. This chapter records some of the lines which that argument has followed.

By 'abstract poetry' I do not mean simply poetry that is about abstract ideas, or that uses abstract vocabulary, like Eliot's 'Burnt Norton': 'Time present and time past / Are both perhaps present in time future,' etc. Rather, I mean abstraction at the deeper levels of poetic structure, syntax, and semantics. But it will be useful, before going any further, to clarify the various senses in which the word 'abstract' is used, and in doing so I would like to make use of the scheme outlined by Harold Osborne in *Abstraction and Artifice in Twentieth-Century Art.*

Osborne speaks of the '[c]onstant misunderstandings and confusion [which] occur, even among artists themselves, owing to failure to grasp the difference between ... two uses of "abstract"' (25). The first use, which Osborne classifies as 'Semantic Abstraction,' derives from the fact that '[b]oth in philosophical and in everyday language "to abstract" means to withdraw or separate, particularly to withdraw attention from something or from some aspect of a thing.' Thus, 'a work of figurative or representational art, i.e. one which ... transmits information about some segment of the visible world outside itself, is said to be more or less abstract according as the information it transmits is less or more complete. In this sense abstraction is equivalent to incomplete specification ... Abstraction in this sense is a matter of degree and the term has no relevance or application outside the sphere of representational art. It is a factor of the relation between a work of art and that which the work represents' (25–6). Under this heading of Semantic Abstraction, Osborne is able to discuss such diverse schools of painting as German Expressionism, Neo-Impressionism, Cubism, and Futurism.

'But,' Osborne continues,

'abstract' is also commonly employed as a general descriptive term denoting all the many kinds of art production which do not transmit, or purport to transmit, information about anything in the world apart from themselves. Other terms

that have been used are: 'non-representational,' 'non-figurative,' 'non-objective,' 'non-iconic.'[5] 'Abstract' is the term which has obtained the widest currency although it is perhaps the least appropriate of all both linguistically and because of its established use in a different sense within the sphere of representational art. There are many types of pictures and sculptures within the wide spectrum of twentieth-century art which are not pictures or sculptures *of* anything at all; they are artefacts made up from non-iconic elements fashioned into non-iconic structures. These works are not more 'abstract' or less 'abstract.' There *is* no relation between the work and something represented because the work represents nothing apart from what it is. (26)

Under this second heading, 'Non-Iconic Abstraction,' Osborne discusses the work of such painters as Kandinsky, Malevich, and Mondrian, and such general movements as Suprematism, Constructivism, and Abstract Expressionism.

It is obviously in this second, non-iconic sense that Hugo Ball and Greta Monach intend the notion of 'abstract poetry,' and many of the rhetorical manifestos of sound poetry have postulated this kind of 'abstraction' as an ideal. At the same time, there is a large body of experimental work that fits into the loosely defined area for which the term 'sound poetry' is a generally accepted, if not entirely accurate label, but that is not 'abstract' at all, in the non-iconic sense. It may, however, be possible to see this writing as 'abstract' in Osborne's *first* sense, especially in terms of that suggestive phrase, 'incomplete specification.'

First, however, I have to consider the parallel to painting suggested by both Ball and Monach. They pointed towards painting because it was the clearest example (or even the *only* example) of an art form that had actually made the transition from an iconic to a non-iconic discourse. The painters, in turn, had sought their inspiration in music, whose ideal self-reflexive containment had been described, by Schopenhauer and by Walter Pater, as the 'condition' towards which all art 'aspires.' Kandinsky speaks of the 'envy' with which artists in other media regard music, 'the art which employs its resources, not in order to represent natural appearances, but as a means of expressing the inner life of the artist' (quoted in Vergo 41). Music had always possessed this characteristic; in the space of approximately sixty years, from 1860 to 1920, painting, through a conscious and heroic struggle, acquired it.

In 1890, at the mid-point of that struggle, the French painter and critic Maurice Denis wrote: 'We must remember that a painting, before it is a warhorse or a nude or any kind of anecdote, is a flat surface cov-

ered by colours arranged in a certain order' (33). This statement later came to be regarded as one of the first slogans of 'abstract' art, and as a foundation for the dogma of 'flatness' that Tom Wolfe burlesqued in *The Painted Word*; but, strictly speaking, it refers not to non-iconic abstraction but to semantic abstraction, or to a balance between representation and self-reflexiveness.[6] The painting is not yet *only* surface and colours: these things may come *before* the nude or the anecdote, but they do not displace them. The Impressionists had 'abstracted' light, in Osborne's first sense, by withdrawing attention from other aspects of representation. In doing so, they brought the painting forward to that 'flat surface' that Denis speaks of, thereby setting up an unresolved tension with the recessional 'depth' of the image, which they still tended to organize by traditional perspective. That tension in turn became the focal point for the semantic abstractions of Cézanne and the Cubists, who may push their visual analysis and synthesis to the very border of the non-iconic, but who never cross it. However, despite its own theory, Cubism became – historically – a stepping stone on the path towards non-iconic abstraction. The great Cubist painters – Braque, Gris, Picasso – never painted any non-figurative canvases; but other artists, like Delaunay and Malevich, passed through Cubism to the purified realms of, respectively, colour and form. By 1912 Delaunay was painting the brightly coloured discs of what Apollinaire christened Orphism; other painters, such as Kupka and Kandinsky, had achieved non-iconic abstraction through other, more idealist routes; and in 1914 the Russian Kasimir Malevich arrived in one giant stride at the minimal abstraction of form, painting a black square on a white ground.

It is an understandable error – though I think an error nonetheless – to see the history of modern painting as a steady progression (or, in Monach's word, 'emancipation') towards the non-iconic, the minimal, the conceptual, zero. The imagery of the 'avant-garde' supports this notion of an advancing line, and allows the dubious terminology of statements that Malevich was 'ahead of' Braque, who had 'gone farther than' Cézanne. Abstraction is not the sole goal of painting; and if there is a 'line of advance,' then it has been twisting back on itself ever since that black square. One problem of contemporary painting is that there is no front line any more for the avant-garde to occupy – or if there is, it no longer concerns the problematics of abstraction. Everything is possible, from minimal conceptualism through to photo-realism, so no one style occupies a privileged position. The contemporary painter must move eclectically through the whole range of possibilities the last century has opened up – or else, as a *naïf*, bypass them altogether.

Given this exemplary progression in painting, away from representation towards the many and various forms of abstraction, what possible consequences are there for poetry? Can language[7] in fact be rendered truly abstract, in either of Osborne's senses? A totally non-iconic art declares its own materials – sound, harmony, and rhythm in music; shape, line, and colour in painting – to be sufficient, without any need to support themselves by external reference, or to justify themselves in terms of their fidelity to some preconceived standard of 'the real.' Music – excluding for the moment such mixed media as opera and song – may indeed evoke emotions, may 'express this emotional substratum which exists, at times, beneath our ideas,'[8] but it does not refer directly to objects, or concepts, or fictional worlds. The note B-flat does not signify anything except itself, and its place in relation to a series of other notes: in this it is quite different from the word 'guitar,' or from the curved line, however abstracted or formalized, that signifies 'guitar' in Cubist painting. That line, in turn, is adaptable: while it may be made to signify a guitar, or a mountain, it may also be made to signify nothing but itself, or its place in relation to a composition of other lines. A word, however, is always significant. The word 'guitar' must always direct the listener to the mental image or concept of a wooden stringed instrument; it can never be construed purely as an arbitrary composition of the *g*, *t*, and *r* consonant sounds with the vowels *i* and *a*. Words are inherently referential. As a medium, they resist abstraction much more strongly than painting did: the difference is not simply one of degree, but of kind.

If, then, we are to talk about an 'abstract poetry,' we must look at techniques whereby the inherent referentiality of language may be circumvented or subverted. How can this be done? If the word is to be retained as a compositional unit, then it must be placed in a context that will drastically qualify, undercut, or cancel altogether its relation to its signified: such techniques will lead the writer towards what Bruce Andrews has called 'an experimentation of diminished or obliterated reference' (92) or, more simply, to Osborne's 'incomplete specification,' semantic abstraction. If the word is *not* retained, the poet moves to non-iconic abstraction, and must work with sub-verbal elements of speech: individual letter-sounds, phonemes, morphemes; or the whole range of pre-verbal vocalization: grunts, groans, yells, whistles, passionate gurgling, heavy breathing.

The kind of context in which word-meaning may be modified or cancelled is simply illustrated by Richard Kostelanetz in terms of a tongue-twister: 'If a Hottentot taught a Hottentot tot to talk 'ere the tot

could totter, ought the Hottentot to be taught to say ought or naught or what ought to be taught 'er?' Kostelanetz comments: 'The subject of this ditty is clearly neither Hottentots nor pedagogy but the related sounds of "ot" and "ought," and what holds this series of words together is not the thought or the syntax but those two repeated sounds' (1980, 14). The form cancels the content: the words are dis-contented, reduced to patterns of sound. This principle can be applied in a multitude of ways: through chant, through repetition, through simultaneous performance by several voices impeding the understanding of any single voice, or through all the technical devices of sound recording and tape manipulation, such as multi-tracking and phase distortion. Perhaps the most important of these techniques is repetition. Ernest Robson describes how a writer 'may destroy contextual meaning with such excessive repetition that attention to grammar or meaning is eliminated by exhaustion of all its information. Once this elimination has occurred the residual messages are acoustic patterns of speech. Then by default no other information remains but sounds, sounds, sounds' (113).

Hugo Ball may have picked up the notion of repetition from the painter whom he most admired, Wassily Kandinsky. John Elderfield, in his introduction to Ball's diary, notes:

In ... *Concerning the Spiritual in Art*, Kandinsky makes only a brief mention of literature, but it is a very significant one. Just as images are the outward containers of spiritual truths, he writes, so words have two functions: to denote an object or notion, and to reflect an 'inner sound' ('*innerer Klang*'). The inner sounds of words are dependent upon the words' denotive context – but the poet's task is to manipulate his material so as to efface this outer meaning, or at least to permit other meanings to emerge in 'vibrations' that will affect the audience on a spiritual level. Repetition of a word can 'bring out unsuspected spiritual properties ... [and] deprives the word of its external reference. Similarly, the symbolic reference of a designated object tends to be forgotten and only the sound is retained. We hear this pure sound ... [which] exercises a direct impression on the soul.' (Ball, xxvi–xxvii)

The mystical tone here would certainly appeal to Ball. Brian Henderson, in his perceptive account *Radical Poetics*, places particular stress on the idea of sound poetry as an attempt to recover an original Adamic language. 'Dada's dismantling of the word,' he writes, 'was a process that was to release the hidden energies of it ... This dismantling of the word for the Word is Hermetic, and would not only be an unmasking, but a

revolutionary spiritual act' (103; see also 11–12, and chapter 4 *passim*). Theorists of non-iconic abstraction, whether in poetry or in the visual arts, return frequently to such appeals to a mystical ground. Religious chants have long used repetition as a means of occupying and distracting the foreground of consciousness in order to facilitate the unconscious mind's access to a state of meditation. Ball himself noted that, while performing at the Cabaret Voltaire, 'my voice had no choice but to take on the ancient cadence of priestly lamentation, that style of liturgical singing that wails in all the Catholic churches of East and West' (71).

Infinite gradations are available to the writer/performer/composer, depending on the degree of intelligibility the piece allows, between semantic and non-iconic abstraction. The American musician Steve Reich has created a brilliant piece of what I would call sound poetry (though he presumably calls it music), whose sole acoustic material consists of a few words on tape. Reich describes the process of composition:

The voice is that of Daniel Hamm, then nineteen, describing a beating he took in the Harlem 28th precinct. The police were about to take the boys out to be 'cleaned up' and were only taking those that were visibly bleeding. Since Hamm had no actual open bleeding, he proceeded to squeeze open a bruise on his leg so that he would be taken to the hospital – 'I had to, like, open the bruise up and let some of the bruise blood come out to show them.'

The phrase 'come out to show them' was recorded on both channels, first in unison and then with channel 2 slowly beginning to move ahead. As the phrase begins to shift a gradually increasing reverberation is heard which slowly passes into a sort of canon or round. Eventually the two voices divide into four and then into eight. (Reich, 'Come Out')

The piece thus moves, through insistent but varied repetition, from a completely intelligible phrase, isolated from its context – in Osborne's term, given 'incomplete specification' – to purely abstract or musical noise, in which no linguistic element can any longer be detected – in Osborne's term, 'non-iconic abstraction.' Apart from its intrinsic fascination as a compelling and hypnotic work, 'Come Out' thus illustrates the range and limits of sound poetry.

Repetition, however, need not always be used as a means of cancelling surface meaning, but rather of insisting on it. bpNichol's 'You are city hall my people' uses its emphatic repetitions as a means of enforcing a very direct statement, which is clearly and syntactically *about* civic

politics. The work of Gertrude Stein, though it attenuates meaning to a precarious edge by its insistent and convoluted repetitions, never cancels it entirely. At times she does come close to what Robson describes as 'exhaustion of ... information,' but one should be wary of assuming too quickly that Stein's writing is devoid of reference. Often, even the most repetitive of her pieces will prove, on close reading, to be working with subtle and acute modulations of meaning. (See, for example, Jayne L. Walker's wonderful commentaries on Stein's early 'portraits' of Picasso and Matisse; Walker 87–98).

Another technique for undercutting the meanings of words is to arrange them, not in terms of their syntactic or semantic relations, but at random, using chance techniques to generate the text. Tristan Tzara, in 1924, gave his 'recipe' for a Dada poem:

Take a newspaper.
Take some scissors.
Choose from this newspaper an article of the length you want to make your poem.
Cut out the article.
Next carefully cut out each of the words that makes up this article, and put them all in a bag.
Shake gently.
Next take out each cutting, one after the other.
Copy conscientiously in the order in which they left the bag.
The poem will resemble you. (39)

And, indeed, it usually does. One of the theoretical advantages of chance structures is that they are supposed to be impersonal; they free artists from the compulsions of self-expression, and liberate their imaginations to operate in areas they would otherwise never have access to. While this impersonality holds true to a certain extent, the traces of an artist's signature are too pervasive to be entirely denied or disguised, even in chance-generated structures. Arp's drawings, for instance, determined by the positions in which dropped scraps of paper fell to the floor, are still identifiable as Arp's work. The same is true, as Tzara suggests, in poetry.

More complex chance structures have been worked out by recent writers, most notably by the American musician and composer John Cage. Refining on Tzara's elementary methods, Cage created and performed 'treated texts' based on Thoreau's *Journals* and on James Joyce's

Finnegans Wake. The Thoreau text – *Empty Words* – used the *I Ching* to determine the chance selection of phrases, words, syllables, and individual letters from the original, to form a text that was then performed by Cage in counterpoint to periods of silence whose frequency and duration were also chance-determined. The result was minimal and austere, yet also – thanks to Cage's compelling performance – totally fascinating.

The treatment of pre-existing texts in this way has sometimes been referred to as 'homolinguistic translation,' and has been practised in Canada by bpNichol, in *Translating Translating Apollinaire*; by Steve McCaffery, in *Intimate Distortions*; and by Douglas Barbour and myself, in *The Pirates of Pen's Chance*. Nichol's work, perhaps the most comprehensive of its kind, begins with 'the first poem i had ever had published' (iii), a 20-line poem called 'Translating Apollinaire,' which was a free adaptation of some lines from the closing of Apollinaire's 'Zone,' the last poem in *Alcools*. Nichol then 'decided to put that poem thru as many translation/transformation processes as i & other people could think of.' The words of the 'original' poem were replaced by synonyms, antonyms, dictionary definitions, or acrostics; the words and letters were rearranged alphabetically, or reconfigured on the page in new directions; friends who had read the original but did not have copies of it were invited to supply 'memory translations'; the poem was translated into visual and musical versions. Some of these translations produced perfect sense – 'reality's a noun/it's not simply the awareness nothing's there' (from *TTA* 17, acrostic of '[fo]r an instant') – while others produced purely formal ('abstract') effects – 'aflt no ehirt abcks in eht agrss' (from *TTA* 12, alphabetic arrangement of 'flat on their backs in the grass').

In many ways, this work conforms to Osborne's notion of 'incomplete specification.' Its text has been 'abstracted from' another text, Nichol's earlier poem, which was in its turn an intertextual transformation of Apollinaire. Even in Nichol's more extreme versions, the vocabulary is still capable of evoking Apollinaire; but the information that would allow the reader to specify the 'original' message is incomplete. In his essay 'The Death of the Subject,' Steve McCaffery wrote: 'Language is material and primary and what's experienced is the tension and relationship of letters and lettristic clusters, simultaneously struggling towards, yet refusing to become, significations' (1977, 63–4). This 'struggling' is precisely what happens in *Translating Translating Apollinaire*, and in many other works produced by techniques of incom-

plete specification. The result is a poetry that hovers on the edges of meaning, without ever totally abandoning or embracing it.

I have been dealing so far with poems that use complete and identifiable words, albeit in contexts that severely limit or obscure their intelligibility; all such works fall, I would argue, into the category of semantic abstraction. Non-iconic abstraction is possible only when the word is abandoned altogether, and the performer moves into the area of non-verbal vocal sound. Here the problem of the inherent referentiality of words is bypassed by resorting to fragments of vocal sound at a pre- or sub-verbal level. Although the elements of language are still present, they have been abstracted from any semantic context, in the same way as non-iconic painting abstracts line, colour, and shape from their figurative functions. Vocal sound becomes self-sufficient and self-reflexive, as the total material and subject matter of the composition.

Hugo Ball's attempts in this direction may now appear, in retrospect, quite tentative. Although his poems use invented 'words,' in no recognizable language, many of these words are in fact quite clearly onomatopoeic, and he gave most of his poems titles – 'Clouds,' 'Elephant Caravan' – whose specifications of a referential subject matter must inevitably affect and condition the response of the listener.

Ball's fellow Dadaist, Raoul Hausmann, asked the obvious question: 'Why bother with words? ... It is in this sense that I differ from Ball. His poems created new words ... mine were based on letters, on something without the slightest possibility of offering meaningful language' (quoted in Zurbrugg 63). From as early as 1918, Hausmann wrote poems at this level of non-iconic abstraction, which was taken to its highest pitch of sophistication by Kurt Schwitters in his great *Ur-Sonate*, begun in 1923. The subsequent history of sound poetry affords many further examples. I would cite particularly Tom Johnson's 'Secret Songs' (Kostelanetz 1980, 168–71), which use rigidly limited series of letter-sounds to produce vocal patterns of astonishing energy and grace.

It is not the purpose of this chapter to trace a complete history of sound poetry,[9] but it is worth noting that the principles of non-iconic abstraction in poetry had been fully stated and put into practice, at least three years before Hugo Ball's much-better-mythologized performance at the Cabaret Voltaire, by other poets who saw themselves as allied to an avant-garde movement in painting: the *zaum* poets of Russian Futurism. *Zaum* (two syllables) is a contraction of 'zaumnyj jazyk,' which may be translated as 'transrational speech' – though later Soviet critics tended to use it simply to mean nonsensical gibberish. The three

leading poets associated with *zaum* are Velimir Khlebnikov, Alexei Kruchenykh, and Ilya Zdanevich, known as Iliazde. The first of these poets to achieve recognition in the West was Iliazde, whose *zaum* play, *Ledentu as a Beacon*, was published in Paris in 1923.

Kruchenykh was the most extreme of the three; he had a genuine dislike for all previous literature, and Pushkin was his favourite target. He once declared that a randomly chosen laundry bill had better sound values than any of Pushkin's poetry; and he also claimed the following *zaum* poem of his was 'more Russian than all of Pushkin's poetry' (quoted in Markov 44, 130):

<div align="center">

dyr bul shchyl

ubeshshchur

skum

vy so bu

r l ez

</div>

This poem was first published in January 1913; later that year Kruchenykh published his manifesto *Declaration of the Word as Such*. He declared the bankruptcy of normal language, which keeps the word chained in subordination to its meaning. Vladimir Markov summarizes his argument: 'Whereas artists of the past went through the idea to the word, futurists go through the word to direct knowledge ... The word is broader than its meaning (this statement later became Kruchenykh's favourite slogan)' (127).

Velimir Khlebnikov held a more restrained view of *zaum*, believing it could be used to create a 'universal language of pure concepts clearly expressed by speech sounds.' He developed an esoteric linguistic theory based on the beliefs that 'the sound of a word is deeply related to its meaning' and that 'the first consonant of a word root expresses a definite idea.' For instance, he believed that the letter L expressed the idea of 'a vertical movement that finally spreads across a surface' (Markov 302–3). By discovering these original meanings he hoped to create a new, universal, and (in contrast to Kruchenykh) meaningful *zaum*, which he idealistically believed would put an end to all misunderstanding, strife, and war.

By 1919, however, Khlebnikov had abandoned his ideas, and wrote that '[a] work written entirely with the New Word does not affect the consciousness. Ergo, its efforts are in vain' (quoted in Markov 374). Similarly, Tristan Tzara eventually wrote that sound poetry 'became

ineffectual as soon as the poem was reduced to a succession of sounds' (quoted in Motherwell 397).

These reservations must, of course, be taken seriously. Just as many respectable critics, such as Kahnweiler, have argued that abstract painting betrays the very function of art, to provide an imaginative representation of material reality, so many listeners to non-iconic abstract poetry have concluded that it betrays the essence of language, and that it performs, less effectively, the functions of music. Response to this argument would have to stress those aspects of sound poetry that, even in its most abstract manifestations, continue to link it to poetry. It is an art that is based on the *voice*: not the singing voice, but the speaking voice – one might also say, paraphrasing Roland Barthes, the *written voice*. It is also an art that, in almost all of its forms, uses, or plays with, the notion of a *text*.

The most serious alternative to the name 'sound poetry' is the description 'text-sound,' which obviously places a strong emphasis on the presence of a text. That text may be a highly elaborate system of notation, or it may be a few squiggles on a scrap of paper; in the inventive work of the English poet Paula Claire, the notion of 'text' has been expanded to allow the poet to 'read' anything from the bark of a tree to the wall of a room. Most commonly, the text is simply the basis for improvisation. But the presence of a text, whatever its form, continues to imply a relationship to meaning. Even individual letter sounds – *b, k, u* – convey, if not meaning, at least an awareness of their potentiality to combine into meaning.

I suspect that it is this potentiality that ultimately distinguishes text-sound from music. Richard Kostelanetz, in the most thoughtful attempt to define text-sound, attempts to make that distinction by excluding from his definition any works that use specific pitch[10] – but this definition, it seems to me, runs into trouble with various forms of chanting, such as Jerome Rothenberg's 'Horse Songs,' or the works of bill bissett. Text-sound, I would submit, always deals *not* with sound *per se* (music), but with sound *as an aspect of language* – and even when that aspect is isolated (abstracted) from all other aspects, isolated even from meaning, its ground is still in language, and its practitioners are called, properly, poets.

Sound poetry is a manifestation of one of the most important general tendencies of twentieth-century art and culture: self-reflexiveness, the urge in all the arts to examine their own means of expression, to find their subject matter in the exploration of their own ontology and struc-

ture. The question becomes not so much 'What is language about?' as 'What is language?' Sound poetry is analytical, and often highly theoretical, in its approach to language; but it combines this intellectualism with a delight in the physicality of language, and the performance pieces that derive from the theory are often very entertaining, at an immediate level, even for audiences who know nothing of the theory.

Although one major branch of sound poetry relies on audio recording, and on the various mechanical possibilities of manipulating sound on tape, the genre has always relied very heavily on live performance, on the physical presence of the poet's body, and on the ideological valorization of presence and performance. The Swedish poet Sten Hanson writes: 'The sound poem appears to me as a homecoming for poetry, a return to its source close to the spoken word, the rhythm and atmosphere of language and body, their rites and sorcery, everything that centuries of written verse have replaced with metaphors and advanced constructions' (47). Perhaps the most extravagant of the manifesto-writers – he has a flair for these things – is Steve McCaffery. His 1970 statement, *For a poetry of blood*, described sound as 'the poetry of direct emotional confrontation' and as 'the extension of human biology into a context of challenge' (1970, unpaginated). He believed that the energy released in sound performance 'marks an important stage in establishing the agencies for a general libidinal depression. Sound poetry is much more than simply returning language to its own matter; it is an agency for desire production, for releasing energy flow, for securing the passage of libido in a multiplicity of flows out of the Logos' ('Text-Sound, Energy and Performance' 72). For McCaffery, the flow of this energy comes 'through fissures' ('Discussion ... Genesis ... Continuity' 36): through the tensions between sense and sound, between language as content and language as dis-contented, between semantic and non-iconic abstraction, and through the displacements between the decorum of the printed page and the unpredictability of live performance.

It is clear that the *energy* of live performance is a major component of the attraction of sound poetry, both for its performers and for its audience. Such comments as Hansen's 'rhythm and atmosphere of the human body' and McCaffery's 'extension of human biology' derive from a romantic ideology (which Hugo Ball would certainly have shared) in which the performer's body offers a guarantee of sincerity and of metaphysical presence. Roland Barthes (although he was not writing specifically about sound poetry) also rhapsodized about 'the language lined with flesh, a text where we can hear the grain of the throat, the patina

of consonants, the voluptuousness of vowels, a whole carnal stereophony' (1976, 66).

But it is worth noting that Barthes' description is of something that he called 'writing aloud' (*l'écriture à haute voix*); and I would strongly argue that performance (while it certainly includes all these energies of bodily presentation) is nevertheless *also* a form of writing, in the full Derridean sense. The poet is never fully 'present': the very act of performance introduces a division between the poet as creator of the text and the poet as performer. (Even improvization, in which there is the minimal possible gap between creation and performance, compresses but does not eliminate this split.) Performance is always iterable (one of Derrida's key categories for writing); the act that seems so impassioned and spontaneous on stage tonight can always be reproduced the next night, on the next stage. In its performance aspect, sound poetry produces a kind of 'writing with the body,'[11] but it remains writing, and I remain deeply sceptical of the 'rites and sorcery' romanticism of the manifestos.

To investigate the various forms of abstraction implicit in language may indeed lead one towards a mystical sense of Kandinsky's 'inner sound,' Ball's 'alchemy of the word,' or Henderson's 'Adamic language'; but it may also induce a sense of the precariousness of language, the sheerly arbitrary nature of those configurations of sound on which the whole of our human intercourse depends. Most of all, it may remind us of the incompleteness of verbal language, or even of non-verbal vocal articulation. Words too carry within themselves the lack, the structural space that opens to the supplement. In this respect, it makes perfect sense that theorists of sound poetry should have looked to painting to provide them with theoretical models. However problematic the resulting theories may have been, the poets' instinctive response – that their language needed to be supplemented – was a correct one. In the next chapter, I will turn to the work of another poet, Ian Hamilton Finlay, who had a very similar instinct (and who, indeed, articulates it quite explicitly, in a 1963 letter that I will quote), but who found the answering stimulus not in abstraction but in Cubism – specifically, in the supplementary pairing of Juan Gris and Daniel-Henry Kahnweiler.

CHAPTER NINE

Models of Order: Ian Hamilton Finlay

The French Revolution
Scorned circumlocution.
'It depends what you mean'
Meant Madame Guillotine.

Ian Hamilton Finlay, from 'Clerihews for Liberals' (1987)

Nineteen eighty-nine was the two hundredth anniversary of the French Revolution. For visitors to Paris that year, the iconography of the celebration afforded an interesting study. Images of the Bastille were everywhere; the tricolour abounded; and postcards offered endless risqué variations on the theme of 'sans-culottes.' Conspicuously absent, however, was any evidence of what is, arguably, the Revolution's most potent visual symbol: the guillotine.

The guillotine is the dark shadow of the Revolution. It's fine to proclaim Liberty, Equality, and Fraternity, but no one in Paris in 1989 wanted to celebrate the Terror. In the orthodox historical interpretation, the French Revolution is exemplary among revolutions in showing how the fervour of high ideals degenerates into factional bloodlust: how, in the famous words of the Girondin Pierre Vergniaud, 'it must be feared that the Revolution, like Saturn, successively devouring its children, will engender, finally, only despotism' (quoted in Schama 714). The guillotine is the emblem of this degeneration, the visual image of the Terror. As an image, it still has the power to terrify, to disturb, to disrupt the complacency of any 'politically correct' celebration.

What are we to make, then, of this emblem (figure 1, p. 170),[1] presented in 1991 by the Scottish poet Ian Hamilton Finlay? The image,

Figure 1: 'A model of order even if set in a space filled with doubt'

drawn by Gary Hincks, is based upon an engraving now in the Musée Carnavalet, and reproduced in Daniel Arasse's book *The Guillotine and the Terror*. In the original, the caption at the foot reads:

LA VERITABLE GUILLOTINE ORDINAERE
HALEBON SOUTIEN POUR LA LIBERTE!

Finlay's text – 'A model of order even if set in a space filled with doubt' – is somewhat more ambiguous, not least because it is a quotation. But before I discuss the relevance of the source for that quotation, I would like to consider the words as they stand. That the French Revolution was 'a space filled with doubt' is obvious enough; but in what sense, then, was the guillotine 'a model of order'?

Certainly, it was as 'a model of order' that the machine was first proposed to the National Assembly, in 1789, by Dr Joseph-Ignace Guillotin.[2] It was part of a typical Enlightenment proposal for the rational reform of the criminal laws; the guillotine would be the most efficient, humane, and egalitarian method of execution. It did away with the wide variety of different methods – most of them long-drawn-out exercises in torture, or else liable to hideous botching by incompetent executioners – that were applied, on a random and unequal basis, in *ancien régime* France. Henceforth, no one would be broken on the wheel or hung, drawn, and quartered; beheading, once the 'privilege' of the nobility, would now be the common lot of lord and peasant. Engravings presented by Dr Guillotin[3] show the executions taking place in private, rural settings; they suggest, as Simon Schama says, 'dignified serenity rather than macabre retribution' (621). By the time the guillotine was finally adopted, in 1792, it had also become very important for the state to reclaim the legal control of violence.[4] The guillotine replaced not only more barbaric methods of official execution but also mob lynchings, the kind of indiscriminate massacre that took place in the Paris prisons in September 1792.

In all these senses, then, the guillotine was 'a model of order.' It stood for the values of rationality, humanity, and control that formed the Revolution's ideology. Most of the revolutionary politicians, including Robespierre and Saint-Just, had gone through a school system that included intensive study of the oratory of the Roman Republic. The stern Roman ideals of civic duty, memorably presented in David's painting of Brutus and his dead sons, were at the centre of the Revolution's idea of Virtue. Virtue is no longer a very fashionable idea among politicians, and it is customary to scoff at the protestations of Robespierre and Saint-Just, to see their 'virtue' stained by the blood spilled by Dr Guillotin's humanitarian device. But they themselves saw no contradiction here. In a folder of cards entitled *4 Blades* (1986), Ian Hamilton Finlay presents four linked quotations, each one printed on a drawing of a guillotine blade:

Frighten me, if you will, but let the terror which you inspire in me be tempered by some grand moral idea.

The form of each thing is distinguished by its function or purpose; some are intended to arouse laughter, others terror, and these are their forms.

The government of the Revolution is the despotism of liberty against tyranny. Terror is an emanation of virtue.

Terror is the piety of the Revolution.

The first quotation is from Denis Diderot; the second from Nicolas Poussin; the third from Maximilien Robespierre; the fourth is by Finlay himself. To read the interaction of these quotations with each other, and with the simple visual form in which they are presented, is a complex matter – and is, indeed, an exemplary exercise in the 'reading' of Finlay's poetry. Diderot's reputation is that of a moderate, reasonable man, the epitome of the Enlightenment; Robespierre is usually dismissed as a totalitarian fanatic. Yet both insist on the moral function and value of terror. Poussin's description of form as determined by function relates not only to the aesthetics of painting but also to the single-minded efficiency of the blade on which it is inscribed; and his evocation of terror as one of the purposes of art echoes back to Aristotle and the classical doctrine of catharsis. Finlay's dictum hinges on the very equivocal reaction that a late-twentieth-century secular audience is liable to have to the word 'piety.' The visual format presents each quotation in an equivalent way – these are four *blades*, all of them aphorisms with a cutting edge – but also balances them against each other, allowing for their differences – these are *four* blades. None of this is to argue that Finlay is, in any simple-minded way, endorsing terror (The Terror; terror-ism); it is to suggest that the issues are nowhere near as simple as the conventional historiography of the French Revolution has come to imply.

4 Blades is balanced, in Finlay's work, by a lethally simple booklet entitled *4 Baskets* (1990). Each page features a drawing of a wicker basket by Kathleen Lindsley; the drawings are detailed, realistic, and charming. Each drawing has as a title a single word, an adjective drawn from the cultural repertoire of the Enlightenment. The first basket is entitled 'Domestic,' and it contains three French loaves and a bottle of wine; the second is entitled 'Pastoral,' and it contains a net and an abundant sheaf of corn; the third is entitled 'Parnassian,' and it contains a wreath

of laurel leaves; the fourth is entitled 'Sublime,' and it contains two severed heads.

The alliance of Terror and the Sublime was a central aspect of Enlightenment aesthetics, first proclaimed (ironically, since he was a bitter opponent of the French Revolution) by Edmund Burke:

Whatever is fitted in any sort to excite the ideas of pain, and danger, that is to say, whatever is in any sort terrible, or is conversant about terrible objects, or operates in a manner analogous to terror, is a source of the sublime ...

I know of nothing sublime which is not some modification of power ... That power derives all its sublimity from the terror with which it is generally accompanied ...

Indeed terror is in all cases whatsoever, either more openly or latently the ruling principle of the sublime. (39, 64–5, 58)

Finlay follows through on this association on numerous occasions: for instance, in the print *Two Landscapes of The Sublime* (1989; figure 2, p. 174), which juxtaposes the guillotine with the most traditional 'natural' instance of the Romantic Sublime, the waterfall. The same point is also made in a folding card entitled 'SUBLIME,' which takes a sentence from 'FH' (Friedrich Hegel) and adds to it a sentence by 'IHF':

Where the eagles circle in
 darkness, the sons of the
Alps cross from precipice
to precipice, fearlessly,
on the flimsiest rope
bridges.

In the Place de la Révolution
the man-made mountain
torrent clatters
and clatters.

(The 'man-made mountain' is also an allusion to the fact that the Jacobin faction in the Constituent Assembly was popularly known as 'The Mountain.')

For Finlay, then, the association of Terror and the Sublime is brought

Figure 2: Two Landscapes of The Sublime (with Gary Hincks)

firmly into the political arena (in ways of which Burke would have utterly disapproved). A modest folding card from 1989 bears the title 'A Proposal for the Celebration of the Bicentenary of the French Revolution'; inside, in large red letters, one reads simply: 'A REVOLUTION.' In 1984, he designed a medal (struck in bronze by Nicholas Sloan; Abrioux 223), one side of which shows two classical columns flanked by the word 'Virtue,' while the other side shows the two vertical columns of the guillotine, flanked by the word 'Terror.' Virtue and Terror become, quite literally, the two sides of the same coin. In Finlay's work, this conjoined evocation of Virtue, Terror, and the Sublime *within a political setting* is not simply an exercise in eighteenth-century antiquarianism, but a direct challenge to the political values of contemporary liberal, secular society.

One of the best commentaries on this challenge comes from Finlay himself, in a letter quoted by Yves Abrioux. Finlay is describing a 1984 Emblem (figure 3, p. 176), which juxtaposes a line from Herman Hesse, 'For the temples of the Greeks our homesickness lasts for ever,' with a drawing of a German battleship:

As you will appreciate, there is a comparison being made, between the small and perfect (aesthetically perfect) warship, and the Greek temple (Greek temples are usually small, too – of frigate-size, one might say, as opposed to Roman temple-cruisers or even battleships –); the ungiven, implicit text is Goethe's 'Kennst du das Land, wo die Zitronen blühn ...' – Do you know the country where the lemon trees flower – : which I am taking as an invocation of the South-land of classical culture – German 'homesickness' for which has always had an ambiguity, allegorised by the ambiguities of German classical architecture (whose longings, notoriously, were not confined to flowering lemon trees, or rather, which notoriously did not present itself as an actualisation of a merely verdant ideal). (The period of German idealist philosophy is also the period of the birth of German nationalism.) What the warship and the temple share, is an absolute (neither is a secular construction). This is why they can be interchanged, or is why the 'aesthetic' parallel is not merely whimsical. Democracies are not at ease with their weaponry, or with their art, since both involve (take their stand on) other values – those of the 'South-land'. Perhaps democracy should be homesick for its own unbuilt temples – alternatives to weaponry, a truly democratic pluralist art – or perhaps such alternatives, and such art, are just not possible. Classicism was at home with power; the modern democracies (whose secularism has produced extraordinary power) are not. The warship is an unrecognised, necessary temple. From the citizen armies of the post-Revolution

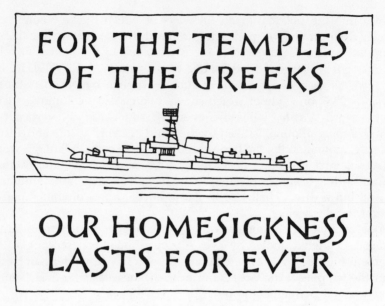

Figure 3: Emblem, 1984 (with Ron Costley)

period, there is a return to mercenary armies (the soldier as outsider). Pacifism, which should be the real 'creed' of democracy, is obviously no more than a form of the utilitarian (the convenient, the easy) (i.e. as presently understood and 'lived'). The homesickness for classical culture was an impetus towards wholeness, and since this clearly included the gods, and power (for gods without power are a contradiction), it had an ambiguous aspect; it was in our terms *dangerous*. (quoted in Abrioux 155–6)

This passage opens up many important topics in Finlay's work, not all of which I can explore here.[5] For the moment, I would just like to stress that extraordinarily suggestive phrase 'Democracies are not at ease with their weaponry, or with their art.' It offers some explanation for the tremendous uneasiness that greets Finlay's presentation of the guillotine – or, equally, his mounting of an Oerlikon anti-aircraft gun as a sculpture entitled *Lyre* (1977); or his substitution of a German Panzer tank for the gravestone in Nicolas Poussin's 'Et in Arcadia Ego'; or, indeed, almost any of his major works in the last twenty years. By its reinsertion of the Sublime (as Virtue, as Terror) into a society that finds such an equation *unacceptable*, Finlay's poetry underlines (at the very

least) the *distance* that separates our society from one that could, authentically, long for the Classical past. Stephen Bann writes of Finlay's 'inclination [towards] those moments of classicist sensibility, in which the new Classicism moulds itself – but in a minor key, as it were – on the major of the past. His Classicism is intimately linked to a sense of estrangement from the Classical, and, for that reason, it has its most clear affinities with the art of those epochs when estrangement from the past was the dominant tone' (1972, 11). There is, in fact, a *double* distancing here. The Jacobin idealists longed for a Roman past from which *they* felt separated; Finlay, as it were, longs for that longing. 'The world has been silent since the Romans left,' wrote Saint-Just elegiacally. For Finlay, one might say, the world has been empty since Saint-Just left; but his words remain, inscribed in stone at the base of a classical column that used to be set in the wildest, loneliest section of Little Sparta.[6]

In 1986, Stephen Bann again commented on this sense of distance and distancing, while writing about Finlay's use of the figure described by Walter Pater as 'the Hyperborean Apollo.'[7]

Pater, like Heine and Nietzsche, recounts the myth of the Greek God who is displaced from his original setting and visits the far-off northern regions: 'the hyperborean Apollo, sojourning, in the revolutions [sic] of time, in the sluggish north for a season, yet Apollo still, prompting art, music, poetry, and the philosophy which interprets man's life, making a sort of intercalary day amid the natural darkness; not meridian day, of course, but a soft derivative daylight, good enough for us.' It is to this deity that the Garden Temple at Little Sparta is dedicated. Inevitably he is a displaced deity, whose present situation can and must be treated on occasions with irony. Thus 'Apollo in Strathclyde' appears on one of Finlay's cards ... with the Homeric 'wine-dark sea' reinterpreted as Dunsyre's 'turnip-marbled field.' But irony is not the same as pastiche. Irony can comprehend both the pathos of estrangement and the insistence of an actual, historical situation. 'In Little Sparta he [the Hyperborean Apollo] is identified with Saint-Just.' (1986, 42)

The signs of this irony in Finlay's work are those of wit, and often of reduction of scale. (As Finlay proclaims, in a massive stone inscription, 'Small Is Quite Beautiful.') Questions of scale are always at the centre of Finlay's poetry, and of his gardening: he has often insisted that the art of garden design lies in the manipulation of perspectives. Thus, while the images of the modern Sublime are sometimes presented in their full force, they are equally subject to all sorts of ironic modulation of scale.

Take, for example, the aircraft carrier. In several of his *Heroic Emblems*, Finlay associates the aircraft carrier with the four elements (water as the element they sail on; earth as the landing strip they offer to their planes; air as the element of those planes; fire as their destructive power); these elements in turn are related to pre-Socratic philosophy. In one stunning juxtaposition, he identifies the Battle of Midway in the Pacific War with Dante's 'midway ... in a dark wood,' the first line of the *Inferno* (see Finlay and Costley, *Heroic Emblems* 31, 43; Abrioux 101). Yet at the same time, the garden at Little Sparta includes statues of aircraft carriers in which the bow and the stern have been cut off, as in classical torsos, and which are designed as bird-tables or bird baths, with little Scottish birds landing and taking off instead of warplanes. The effect, as always with Finlay, is a complex ironic interplay between different modes: the high Sublime of the aircraft carrier as the embodiment of elemental nature, and the mock-heroic reduction of the bird bath.[8] This interplay is further commented on by Miles Orvell, in relation to 'Pacific' (1975), a board game that Finlay developed, based on the Pacific war:

On the one hand, the simplified – even beautiful – designs suggest a respect for military machinery not unlike the serious respect rendered war by the traditional epic poet; on the other hand, the domestication of armaments within an ordered space implicitly mocks their power over our lives. But the playful reduction does not remove the charge of violence from the objects. Rather, it is the special order imposed on instruments of violent disorder that creates the tension and paradox in Finlay's armaments works. What gives PACIFIC its edge as a game is our not forgetting that behind the diagonal moves, the winning and losing amusement of a sunny afternoon, was a world of suicide pilots and forced crashes. Out in the Pacific – the blue ocean stretching like a field of play for aircraft carriers and planes – life was not very pacific. (22)

Finlay's irony, then, is always in some sense complicitous with its subject. The irony marks our irreducible historical distance from a society in which Virtue could be proclaimed without embarrassment as the goal of civic life; or, further, the irony marks the distance that is *always* present, the sense in which the Jacobins longed for the Romans, and the Romans in turn longed for Arcadia, and Arcadia itself was not free of the presence of death. It is an irony that for many critics is also marked by that problematic prefix 'post-': much of Finlay's work could be accounted for in terms of the theories of irony and parody that Linda Hutcheon advances as characteristic of postmodernism. For Finlay, how-

ever, the ironic prefix is more often 'neo-.' Consider another pamphlet of four images, to set alongside *4 Blades* and *4 Baskets*. This one is called *Four Monostichs* (1991). Each page is folded over, so that at first the reader sees only the title, and has to open up the fold to read the text:

Classical Biography
No man is a hero to his valley.

Classical Warfare
The capital fell to an enemy column.

Neoclassical Thaumaturgy
The gods fly faster than sound.

Neoclassical Statuary
The gods and heroes retain their arms.

The difficulty of 'reading' a poem such as this stems from the fact that Finlay places so much trust in his reader's ability to respond to nuances of tone and context. Each one of Finlay's works is itself small-scale (he prefers individual pamphlets or postcards or prints to conventional 'collections' of poems), yet they do also relate to each other and build up intricate patterns of cross-reference. (The joke on 'arms,' for instance, recalls several instances in which Finlay has reproduced classical statues, from which the 'arms' are often missing, and supplied them not only with complete limbs but also with machine guns and hand grenades.) No discursive statement is made: Finlay never says anything as crude as 'I approve/disapprove of aircraft carriers and/or guillotines.' Rather, he presents images in a context (both of his own works and of cultural history) in which the reader has to negotiate between several opposing views, and many layers of ironic distance.

If this reading is difficult enough with works consisting entirely of words, it becomes even more difficult when the works juxtapose words with visual images. The visual image is, for our society, always stronger and more potentially disturbing – it is also more difficult to 'read,' since we no longer have a cultural training in iconography, or the habit of responding in complex ways to non-discursive statements.[9] It is for this reason that Finlay is so interested in the tradition of the 'Emblem,' in which Renaissance books often provided pages of commentary for each visual image. The commentary was, in effect, *part of* the Emblem – or, I

would say, they were each other's supplements. In Finlay, the process of supplementarity, as I outlined it in chapter 1, is continuously at work. Arguments about whether he is a poet or a visual artist are, in this sense, beside the point. His visual art has always demanded the supplement of words, even if these words have largely been implied and unspoken. And his poetry (as I will discuss in more detail shortly) reached its crisis point when it felt the inadequacy of a merely verbal syntax. In one sense, Finlay's work is utterly individual; no other contemporary artist compares with him. But in another sense, in its compelling demonstration of the supplementary relation between word and image, I would argue that Finlay is the most representative artist of our time.

'A model of order even if set in a space filled with doubt.' Within the ironical mode in which Finlay situates both his admiration for the Jacobin revolution and his distance from it, it is now perhaps possible to see the extent to which the guillotine is indeed a 'model of order.' But the irony of Finlay's card stretches farther when one also situates the quoted text within *its* original context. It comes from a letter that Finlay wrote to the French poet Pierre Garnier on 17 September 1963; this letter has been widely reproduced[10] as one of the founding manifestos of Concrete Poetry.

One of the Cubists – I forget who[11] – said that it was after all difficult for THEM to make cubism because they did not have, as we have, the example of cubism to help them ... For myself I cannot derive from the poems I have written any 'method' which can be applied to the writing of the next poem; it comes back, after each poem, to a level of 'being,' to an almost physical intuition of the form ... to which I try, with huge uncertainty, to be 'true.' Just so, 'concrete' began for me with the extraordinary (since wholly unexpected) sense that the syntax I had been using, *the movement* of language in me, at a physical level, was no longer there – so it had to be replaced with something else, with a syntax and movement that would be true of the new feeling (which existed in only the vaguest way, since I had, then, no form for it ...). So that I see the theory as a very essential (because we are people, and people think, or should think, or should TRY to think) part of our life and art; and yet I also feel that it is a construction, very haphazard, uncertain, and by no means as yet to be taken as definitive. And indeed, when people come together, for whatever purpose, the good is often a by-product ... it comes as the unexpected thing. For myself, on the question of 'naming,' I call my poems 'fauve' or 'suprematist,' this to indi-

cate their relation to 'reality' ... (and you see, one of the difficulties of theory for me is that I find myself using a word like 'reality' while knowing that if I was asked, 'What do you mean by reality?,' I would simply answer, 'I don't know ...').[12] I approve of Malevich's statement, 'Man distinguished himself as a thinking being and removed himself from the perfection of God's creation. Having left the non-thinking state, he strives by means of his perfected objects, to be again embodied in the perfection of absolute, non-thinking life ...' That is, this seems to me, to describe, approximately, my own need to make poems ... though I don't know what is meant by 'God.' And it also raises the question that, though the objects might 'make it,' possibly, into a state of perfection, the poet and painter will not. I think any pilot-plan should distinguish, in its optimism, between what man can construct and what he actually *is*. I mean, new thought does not make a new man; in any photograph of an aircrash one can see how terribly far man stretches – from angel to animal; and one does not want a *glittering* perfection which forgets that the world is, after all, also to be made by man into his *home*. I should say – however hard I would find it to justify this in theory – that 'concrete' by its very limitations offers a tangible image of goodness and sanity; it is very far from the now-fashionable poetry of anguish and self ... It is a model, of order, even if set in a space which is full of doubt ... [13] I would like, if I could, to bring into this, somewhere the unfashionable notion of 'Beauty,' which I find compelling and immediate, however theoretically inadequate. I mean this in the simplest way – that if I was asked, 'Why do you like concrete poetry?' I could truthfully answer 'Because it is beautiful.' (as printed in Solt 84)

The 'model of order,' then, is Concrete Poetry itself, and it intervenes in the doubtful space of contemporary culture, countering the 'now-fashionable poetry of anguish and self.' As a model of order, it was based, for Finlay as early as 1963, on an idea of Classicism that was to evolve through the years to that state of neo-Classical irony in which its image would be the guillotine blade. Commenting on the 1991 card, and setting it correctly within the context of the 1963 letter, Edwin Morgan writes: 'The model of order is not really the guillotine, but the guillotined pages of a folding card or a flimsy booklet, produced with care and diligent collaboration to give the reader a shock not of recognition but of cognition, which is much harder and much more valuable' (46). I agree that the double-sense of 'guillotine' is present, and that the 1963 context suggests that the model of order does reside in the aesthetic sense of 'care and diligent collaboration' that has always characterized Finlay's work. But I think that Morgan is too defensive when

he claims that the model is 'not really the guillotine': there is, again, the liberal uneasiness with weaponry, a certain shying away (like Dr Guillotin himself) from the shadow of the Terror. Finlay's card is more of a challenge than that: it insists that there is a continuity in his work, and that those aspects of it that make his readers uncomfortable ('Terror is the piety of the Revolution') cannot be neatly separated from its more easily accepted and likeable motifs.[14]

At the same time, the letter to Garnier (and, by extension, the card that re-inscribes the letter) recognizes the danger of 'a *glittering* perfection which forgets that the world is, after all, also to be made by man into his *home.*' Another of Finlay's folding cards (1989) proclaims the very Classical slogan 'Order Is Repetition,' and adds as a subtext, 'as in Rat-a-Tat.' The multilevelled irony of Finlay's evocation of Jacobin or Nazi models never fails to recognize their destructive potentiality, or that 'piety' is all too often reinforced by machine guns. The catastrophic Sublime is not, after all, exactly the same thing as the 'theoretically inadequate' Beautiful.

The letter to Garnier indicates also the extent to which Finlay's aesthetic was formed by the artistic movements of the early twentieth century; its reference points are Cubism, Fauvism, and Suprematism. The recourse to painting arose, the letter explains, at the point where verbal language in itself seemed inadequate: 'with the extraordinary (since wholly unexpected) sense that the syntax I had been using, *the movement* of language in me, at a physical level, was no longer there.' Painting – or, more generally, 'visual language' – provided (for Finlay, and for many other poets at the time) a way out of this impasse: not by discarding words, but by supplementing them. The 'movement' of language became a visual movement, because poetry is already implicated in images, and painting is already a linguistic structure. Thus, Cubism was a particularly apt model for Finlay, since it is exemplary among modern movements for its self-consciously semiotic character (see above, chapter 5).

The distinguishing point of Concrete Poetry has always been its relation to syntax. In ordinary language, and thus in conventional poetry, it is syntax that provides the connectives, that ties one word to the next and advances the reader in a linear manner through the poem. Poetry has often utilized other schemes of connection (rhyme and metre; metaphor and image-pattern) that run counter or across the linear progression of syntax; poetry, in other words, has always aspired towards a spatial form that will inhibit its progression in time. But only Concrete

Poetry has succeeded in establishing convincing alternatives to syntax. It is at this point also that the possible analogy between Concrete Poetry and Cubism becomes most suggestive, in terms of an analogy between linear syntax in poetry and linear perspective in painting.[15] Those movements in modern painting that abandoned figuration altogether also, by definition, abandoned perspective; other movements, like Impressionism and Fauvism, came to uneasy compromises, in which elements of traditional perspective survive, as it were, squashed up to the surface. Only Cubism succeeded in establishing a means of organizing representational pictorial space that was a fully coherent alternative to perspective. In the same way, Concrete Poetry reorganized poetic space in non-syntactic ways without abandoning referential language.

Even those concrete poems that retain a syntactical element usually subordinate that element to the visual design of the poem. That is, the way in which one reads a concrete poem, the connections one makes between its different components, and the conclusions one draws from these connections are all determined visually, not by a discursive movement of linear syntax. Take as an example (and it relates directly to the Garnier letter) Finlay's *Homage to Malevich* (figure 4, p. 184).

This poem retains, obviously, a high degree of semantic content, in the meanings and associations attached to the words 'black,' 'block,' 'lack,' and 'lock.' But the relationships between these meanings are suggested not by syntactic means but by visual ones: the fact that the words form a black block which is locked together; or that 'lock' and 'lack' are formed by the lack of the b, which runs down the right-hand edge, lacking its completion; or that the insistence on black in this square (and in Malevich's) suggests the lack of white, or the locked-in binary of black and white; and so forth. The reference to Malevich, and to his famous Suprematist painting of the black square, places this verbal construct within a pictorial context. As with the later Emblems, the visual image calls for the supplement of commentary. And as so often in Finlay's work, it is Stephen Bann who provides it:

Here it is a question of the equivocal status of the edge, the bordering limit which both separates language formally from the surrounding 'blank' space and also (as it were) bisects the semantic units 'black' and 'block,' leaving an oscillation of the resolved and the unresolved in the terms 'lack' and 'lock.' Finlay expresses a tension that will prove crucial to his further development as an artist: that of form and non-form, language and non-language, being set not merely in opposition, but *in a dialectical relationship*. If Malevich, in his 'Square'

```
lackblockblackb
lockblackblockb
lackblockblackb
lockblackblockb
lackblockblackb
lockblackblockb
lackblockblackb
lockblackblockb
lackblockblackb
lockblackblockb
lackblockblackb
lockblackblockb
lackblockblackb
```

Figure 4: Homage to Malevich

series, achieves dialectical expression of the painter's problem of figure and ground, Finlay carefully avoids the implication that such a problem can simply be transposed into poetic terms. For language is in itself presence and absence, in terms of Saussure's distinction it comprises both *signifier* and *signified*. In 'Homage to Malevich,' the space 'of doubt' is not simply the white page, but the dimension of meaning whose incompatible signs (lack/lock) are in contrast with the certainty of typographic structure. (1977, 11)

So the *Homage to Malevich* too is a 'model of order': not only in its typographic fixity, and not only in its evocation of the formal ideals of Suprematism, but also in its adherence to the generic conventions of the *hommage*. In a 'homage,' one artist brings his or her own sensibility to bear upon another's; the result is a statement about each artist individually, and also about the way they relate to each other in the continuity of culture. The homage is paid, indeed, not just to the artist named but to that very continuity; the homage asserts the continued vitality of the

past, at the same time as it marks a certain distance from it. Just as Finlay's tributes to Robespierre and Saint-Just contain an elegiac element, an implicit statement of loss, so too the *Homage to Malevich* locks into the present the lack of Malevich's presence.

In Finlay's homages, that distance is often marked by an ironic wit, what Bann called 'a minor key': a diminution of scale that is friendly and playful, but not without a certain edge to it. The *Homage to Pop Art* (1973), for instance, restates Cézanne's 'the cylinder, the sphere, the cone' in terms of an ice-cream cone (Abrioux 126); the *Homage to Seurat* (1972) transforms the artist's pointillism into a connect-the-numbered-dots painting kit. Other homages are less obviously playful, but no less complex. The *Homage to Vuillard* (1971; Abrioux 149) consists of the single word SINGER, printed in warm shades of yellow and brown that recall the intimacy of Vuillard's interiors. The literal meaning of the word (Vuillard as the 'singer,' or celebrator, of domestic life) is both reinforced and slyly commented on by the association of 'Singer' as the leading trade name of sewing machines. Most generally of all, the print *Homage to Modern Art* (1972), realized by Jim Nicholson (Abrioux 20), shows a sailing boat, in deep, subdued browns and blues, with a vividly printed insignia on its sail: a yellow triangle inside a blue triangle inside a yellow triangle. The bright colours of the insignia set up an immediate figure-and-ground problem that goes straight to the heart of modern art's problematic of surface and depth: the yellow and blue stand out 'in front of' their ostensible support (the sail), and are ostentatiously 'flat,' whereas a 'realistic' image would require them to reflect the uneven surface of the sail. The yellow and blue triangles are, in the words of Maurice Denis (1890), 'a flat surface covered in colours arranged in a certain order.' In the established heraldry of naval flags, no specific meaning attaches to this design: it is pure pattern; it is, as it were, an abstract painting within a representational form.[16] Yet, as ground, the image of the boat retains its referential and associative force. This 'Homage to Modern Art' registers, in a controlled and witty way, the major debates and uncertainties of the modernist period; it is a model of order, even if set in a space filled with doubt.

For the concerns of this book, the most relevant of such Finlay homages is of course the one to Kahnweiler (1972; figure 5, p. 186). The reduction of 'Life and Work' to 'Knife and Fork' is in tune with this whole mode of affectionate distancing; but it also has further resonances, which may be seen by juxtaposing Finlay's homage to Kahnweiler with Gertrude Stein's homage to Juan Gris:

Figure 5: Homage to Kahnweiler

Therein Juan Gris is not anything but more than anything. He made that thing. He made the thing. He made a thing to be measured.

Later having done it he could be sorry it was not why they liked it. And so he made it very well loving and he made it with plainly playing. And he liked a knife and all but reasonably. (Gertrude Stein, 'The Life of Juan Gris The Life and Death of Juan Gris,' *transition* 4 [July 1927]).

So here is Juan Gris (1887–1927); and here is his knife ('reasonably': Gertrude Stein, in tribute to her friend); and here are his knife and his fork (and a glass, and a bottle: in, say, one of those gorgeous blue-grey proto-Cubist still life paintings from 1911–12, now in the Kröller-Müller museum at Otterlo, alongside Ian Hamilton Finlay's 'Sacred Grove');

and here are also his life and work, recorded faithfully by Daniel-Henry Kahnweiler (*Juan Gris: Sa Vie, son oeuvre, ses ecrits* [Paris: Gallimard, 1946]; *Juan Gris: His Life and Work* [translated by Douglas Cooper, 1947; revised edition, New York: Abrams, 1968]); and here is Ian Hamilton Finlay (Stonypath, 1974), paying tribute to Kahnweiler paying tribute to Gris (and of Finlay himself could it not well be said, here as everywhere, that he has 'made a thing to be measured,' and that he 'made it very well loving and he made it with plainly playing'?); and here, finally, is Ian Hamilton Finlay, in a letter to Stephen Scobie, 25 August 1970: 'I can't honestly say when I read [Kahnweiler], because you know I read a lot of books on Cubism when I was about fourteen, and the whole thing is surrounded by a romantic glow (the way I daresay poetry is, for some people) and sits as squarely in my heart, as fishingboats do ... Kahnweiler's book is crying out for a concluding chapter on concrete poetry – one could almost write it *for him* ...'

Finlay's attraction to Kahnweiler, and to Gris, can best be explained in relation to that phrase of Stein's: Gris 'made a thing to be measured.' More than that of any of the other major Cubist painters, Gris's work is distinguished by its *clarity*, its cleanness of conception and line. Kahnweiler defines Gris as a Classical artist, as opposed to the more Romantic Picasso (and also, surprisingly, Braque; see Kahnweiler 132). For Finlay, this Classical sense of clarity (the fine cutting edge, one might say, of the guillotine) is fundamental: one of his highest compliments is to call something 'uncluttered.' But Stein further perceives (what all too many of Gris's critics have failed to perceive) that Gris's clarity is not cold and unemotional: 'he made it very well loving and he made it plainly playing.' Kahnweiler says of Gris's painting, and of Cubism generally, that they 'made us "see" and love so many simple, unassuming objects which hitherto escaped our eyes' (168). This love for 'simple, unassuming objects' is clearly visible throughout Finlay's work, and the element of play is also plainly displayed.

Many of these themes are recapitulated in a later 'homage,' the 1982 'Analytical Cubist Portrait' of 'Daniel-Henry Snowman' (figure 6, p. 188). The 'snowman' is perhaps a joke on the reputed 'coldness' of Gris's work; if so, it resituates that coldness within the friendly warmth of a children's game. The highly recognizable pipe[17] is a parodic allusion to the recognizable details that Picasso, especially, would include in his Cubist portraits – such as the precise little moustache in his *Portrait of Daniel Henry Kahnweiler* (1910; Rubin 1989, 181), or indeed the pipe in *Man with a Pipe* (1911; Rubin 1989, 200) – and that Kahnweiler would

Figure 6: Analytical Cubist Portrait, Daniel-Henry Snowman

insist on as 'clues' to the legibility of Cubist paintings. The pipe is also cross-referenced in a booklet entitled *Picturesque* (1991), which reads:

'It is hardly necessary to remark
how the view from the house would
be enlivened by the smoke of a
cottage – '

– or a Picasso portrait by the
inclusion of a recognisable
pipe.

The quotation that makes up the first half of this poem is taken from Humphry Repton (1752–1818), one of the great figures in the history of English gardening. The various associations and ramifications of this booklet will provide an opening into the richness and complexity of Finlay's own 'picturesque' garden at Little Sparta.

The booklet *Picturesque* is itself an expansion of an idea that occurs in one of Finlay's 'Unconnected Sentences on Gardening': 'In cubist portraits the pipe has the homely air of a cottage chimney.' Finlay has issued several series of 'Unconnected' or 'Detached Sentences on Gardening' (Abrioux 38),[18] the model being William Shenstone's 1764 essay, 'Unconnected Thoughts on Gardening.' Among Finlay's more memorable Sentences, I would pick out the following:

Superior gardens are composed of Glooms and Solitudes and not of plants and trees.

Gardens are always for *next* year.

Garden centres must become the Jacobin Clubs of the new Revolution.

British Weather is often warmer at *weeding* level.

Certain gardens are described as retreats when they are really attacks.

Shenstone's garden at The Leasowes in Warwickshire, created between 1745 and 1763, is one of the few precedents for Finlay's garden at Little Sparta. The *Oxford Companion to Gardens* describes The Leasowes thus: 'The visitor followed a prescribed route which presented scenes of grandeur, beauty, and variety. Latin inscriptions and dedications invoked classical associations, and urns were dedicated to the memory of friends to provide a desirable tinge of melancholy. There were also modest garden buildings, a grotto, bridges, numerous cascades and waterfalls, and the picturesque ruins of the priory' (Jellicoe 331). 'Picturesque' – when the term was first introduced, in the eighteenth century, it had the specific meaning of 'making landscapes in the manner of pictures, in particular the drawings of Claude Lorrain and Gaspar Poussin, the brother-in-law of Nicolas Poussin' (Jellicoe 431). Progressively, the term degenerated, until today it means little more than a superficial kind of prettiness: the exact opposite, really, of The Sublime. But in the 1790s,

the picturesque was championed in England in a series of essays and books by William Gilpin, Payne Knight, and Uvedale Price. The odd coincidence of dates should not pass unnoticed: Gilpin's essays were published in 1792, the year in which Dr Guillotin's machine was first put to public use in Paris; and Knight and Price both published their major books in 1794, the year in which Robespierre and Saint-Just were executed, in the month of Thermidor, on the day designated in the new Revolutionary calendar as Arrosoir, the Watering Can.[19] In their advocacy of the picturesque, Knight and Price were particularly critical of the landscape designs of Humphry Repton, who replied to their attacks in his *Sketches and Hints on Landscape Gardening* (1795).

For Finlay to quote Repton in a pamphlet entitled 'Picturesque' is not, then, without irony. 'While mouldering abbeys and the antiquated cottage with its chimney smothered in ivy may be eminently appealing to the painter,' Repton wrote, 'in whatever relates to man, propriety and convenience are not less objects of good taste than picturesque effects' (quoted in Jellicoe 431). The difference, that is, is between a cottage chimney 'smothered in ivy' and a working one that 'enlivens' the scene with its smoke. Repton saw his interventions in landscape as 'improvements.' His goal was not simply the creation of an interesting visual effect, but the setting of the garden within a cultural context, 'whatever relates to man.' In 1967, on the first occasion that I met him, Ian Hamilton Finlay remarked to me: 'In an age when man has learned to control vast areas of his environment which were formerly left to chance and Nature, we simply cannot *afford* decadent art.'

Little Sparta contains many examples of the 'picturesque' in the original sense. Corners of the garden are carefully arranged to reproduce the effects of certain painters, and then their 'signatures' are inserted in the landscape. Blocks of masonry proclaim 'CLAUDI' (Abrioux 47); the monogram initials of Albrecht Dürer are hung from a tree. Beside a pond, a stone inscription reads 'See POUSSIN Hear LORRAIN.' Stephen Bann comments: '[I]t is the ambiguity of the landscape, which may be read as Poussin's visual clarity and stillness, or may vibrate to Claude's perceptibly more atmospheric touch, that engages our absorbed attention' (1981, 136).

What is involved here is an extremely subtle instance of what I have described, throughout this book, as the supplementarity of word and image. This piece presupposes, in the first instance, that the 'reader' will be familiar with the paintings of Poussin and Lorrain, and will be able to make the kind of association that Bann suggests, to Poussin's

'visual clarity' or Lorrain's 'atmospheric touch.' Like so many of Finlay's works, it situates itself within a continuity of culture, and not the least important of its assertions is the idea that a Scottish poet in the late twentieth century can make a meaningful response to French painters of the seventeenth. Finlay's words are themselves a commentary on (or a supplement to) the original paintings; they bring to the paintings a whole discourse on synaesthesia (how does one 'hear' a painting?) and the primacy of visual values in Classical art. At the same time, Finlay's words obviously need to be supplemented by the paintings; the poetic text is in itself incomplete. Both the paintings and the poetic text are in turn supplemented by the landscape in which they are set: an actual pond, a daily interaction of water and light on a Scottish hillside. In one sense, the pond is 'reality'; it is neither 'signifier' nor 'signified' (in Saussure's terms), but is the *referent* that stands behind those signs. Step into this poem and you'll get your feet wet. But at the same time, *the pond itself is also a sign*. It is a 'picturesque' landscape, 'improved' by Finlay. The stone inscription supplements the landscape, and so transforms it into a controlled image: a *framed* image. (And then a further layer of supplementarity is added when this poem is reproduced as a *photograph*, which selects a particular angle on this image, excluding the farther horizon. The photograph frames the image: but the literal frame of the camera only doubles the frame that is already implied by the placing of the stone.)

The gesture of 'signing' a landscape might be seen as an ultimate form of 'linguistic imperialism.' Is it not arrogant of Finlay thus to appropriate a natural spectacle, and claim it in the name of the signature? (For the signature itself is doubled: the stone may say 'Poussin' or 'Lorrain,' but both of those signatures are in turn 'signed by' the name of Ian Hamilton Finlay.) All art, one might say, is appropriation; since no work exists in a vacuum, what one signs is never 'original,' but only a part of the intertext. To a greater degree than either poetry or painting, gardening is always an art of supplementarity: the gardener never really controls nature, but must always cooperate with it (supplement it).[20] What Finlay insists upon is that gardening is also a discourse, that the very idea of 'a garden' is something already situated within language. Thus, the garden at Little Sparta, isolated among the hills of Lanarkshire, is nevertheless a social statement, as central to its culture as any publishing house in London or art gallery in Paris.

On the hillside above the farm buildings of Little Sparta, a small wooden sundial faces west (figure 7, p. 193). On it is carved an inscription

(I take the layout of the words not from the sundial, but from its earlier publication as a print):

EVEN

-ING

WILL

COME

THEY

WILL

SEW

THE

BLUE

SAIL

Considered as a brief lyric poem, the text is very beautiful. Rhythmically, the one-word-per-line arrangement gives it an 'uneven' movement that eventually 'evens' out, just as visually, on the page, the break of 'evening' into 'even/-ing' is an evening out of the line-length. Literally, the sewing of sails is something that might be done in an evening, after a day's work; but the association of evening with the end of day suggests also the end of a life, the sewing of a shroud. (And is there not a hint of something sinister in that unspecified 'they'?) Metaphorically, the 'blue sail' links the elements: it is the blue of both sky and sea, and the action of the sail unites air (wind) and water (boat). The sewing of the blue sail brings land and sea together, as the evening fall of darkness renders them indistinguishable from each other.

A lovely poem; but even a text as full as this one seeks the supplement of visual form. It was first published as a long, vertical print, the words in delicate white lettering against a rich blue background. As a sundial, however, the visual form is an even richer supplement. It is, of course, a working sundial; like Repton's cottage chimney, it 'smokes.' The curved line which marks the hours 'rhymes' (in the manner of Juan Gris) the shape of a sail. From Dunsyre, it faces west, towards a sea that it cannot see; but in the metaphorical interplay of elements, the sea is always a part of Finlay's inland garden. Facing west, it works as a sundial only in the even-ing hours, only when they sew the blue sail. Facing west, it also bears the full force of the Scottish weather – and, as the years have gone by, this sundial has weathered too. Moss grows on

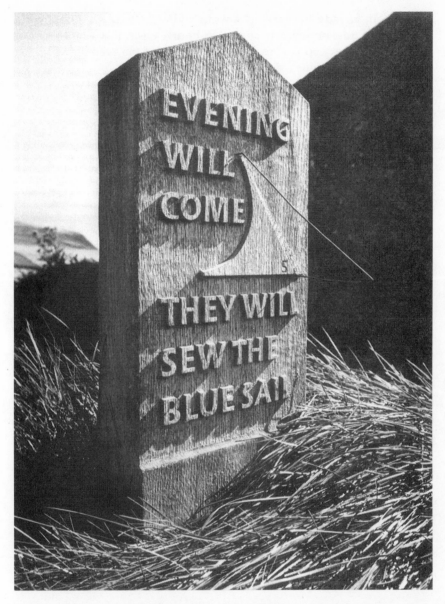

Figure 7: Westward-facing sundial, 1971 (with John R. Thorpe;
photo David Paterson)

the wood; already the carving is worn and evened down. Marking the passage of time on a yearly as well as hourly basis, the sundial too is a living thing that approaches its ending. For it too the evening will come; they will sew the blue sail.

Notes

Preface

1 Several years later, in her 1982 book, *The Colors of Rhetoric*, Wendy Steiner stated the same premise: 'There is no clearer working out of a cubist ideology than concrete poetry' (197).

2 In some postmodernist painting, by way of reaction, language has come very explicitly to the fore. In the works of artists like Robert Smithson, Joseph Kossuth, or Barbara Kruger (to name only a few of many), words have become part of the visual field to the extent that distinctions between 'painting' and 'literature' are difficult to maintain. Language invades postmodern painting, writes Craig Owens, 'with all the force of the return of the repressed' (126).

3 In this way, the book might, ironically, be seen to reflect one of the standard 'explanations' of Cubism: namely, that a Cubist painting views a single object from a number of different perspectives. I say 'ironically,' because this account of Cubism is (as I will argue in chapter 5) one that I myself find reductive and simplistic.

4 'Entr'acte' is also the title of a 1924 film by René Clair and Fernand Léger, the defining example of 'Cubist' cinema.

Chapter 1 The Supplement of Language

1 That is, while my use of the terms 'supplement' and 'frame' is certainly derived from Derrida, I do not pretend to account here for the full range of philosophical implication that these terms carry in his work. Rather, I have adapted certain aspects of his ideas that have proved useful or suggestive for my own argument, in ways that I hope will become clear in this first chapter.

2 Cf. Bal and Bryson: 'It is right to wonder to what extent the "expansion" proposed by a "general" science of signs may in fact be an attempt at appropriation, the absorption of the visual domain into the empire of linguistics' (193).

3 See, for example, Steiner: 'In painting there is no general consensus about whether minimal units are colors, geometrical shapes, brush strokes, figures, and the like, nor is there much hope for one. It is not that individual paintings do not contain such units, but that these units differ from work to work and painter to painter' (53). Mieke Bal and Norman Bryson reach a similar conclusion – 'If no minimal units for images can be found, then a visual semiotics, deriving from Saussure, must be an impossible endeavour' – but go on to argue that this objection 'may be misplaced ... To think of semiosis as process and as movement is to conceive the sign *not as a thing but as an event*, the issue being not to delimit and isolate one sign from other signs, but to trace the possible emergence of the sign in a concrete situation, as an event in the world' (194). In other words, Bal and Bryson are moving from a structuralist to a post-structuralist view of the sign.

4 For further discussion of this concept of the frame, see below, chapter 7.

5 On this point, see W.J.T. Mitchell, who argues that 'the primary aim [of modernist abstraction] is the erection of a wall between the arts of vision and those of language' (216); but he also argues (and I would agree with him) that such a project was and is doomed to failure. 'The interaction of picture and text,' Mitchell writes, 'is constitutive of representation as such; all media are mixed media, and all representations are heterogeneous; there are no "purely" visual or verbal arts' – though he acknowledges that such a view is in contradiction to 'the impulse to purify media [which] is one of the central utopian gestures of modernism' (5).

6 Drucker's whole discussion is very interesting, though I think that she tends to equate 'modernist' with 'formalist' too easily. I would still like to argue for a 'formalist' position that does not have to insist upon this 'antilinguistic' purity, but can in fact account for what Drucker calls 'the engagement of the visual elements with signifying practices outside the limits of the physical frame of the image' (84).

7 In literature, manuscripts and first editions are prized, but they do not hold the primary place that an original painting does. In music, the closest equivalent would perhaps be a live performance by the composer – though, as I have argued elsewhere, even live performance is structured in ways that deny full 'presence.' And such a performance does not, in any case, preclude further performances by other people.

8 Phillipson does not specifically evoke Derrida at this point, though he does
 so elsewhere; but the repetition of 'supplement,' three times in one para-
 graph, makes it likely that he had the connection in mind.
9 The phrase comes from Salim Kemal and Ivan Gaskell, in their introduction
 to *The Language of Art History* (3), but it is an idea shared by several
 contributors to that volume.
10 Nowadays it seems to be fashionable to dismiss Gertrude Stein as a critic of
 art. John Richardson, for instance, in his new biography of Picasso, speaks
 of Gertrude's 'lack of artistic judgment ... She comes up with remarkably
 few insights and hides her ignorance of basic concepts behind a barrage of
 simplistic repetition' (405). I strongly disagree. Stein's knowledge of
 painting was certainly spotty, idiosyncratic, frequently biased, and some-
 times loony; but she was also capable of penetrating insights and fascinat-
 ing theoretical formulations.
11 Some recent art criticism seems to operate almost wholly on this level of
 discourse. See, for example, Richard R. Bretell, *Pissarro and Pontoise* (1990),
 which documents in meticulous detail those aspects of Pontoise painted by
 Pissarro, counting how often he painted factories, determining whether the
 fields he painted were owned by large landholders or working peasants,
 etc. This approach produces fascinating results in terms of painting as a
 sociological discourse, but in terms of the total complexity of a painting's
 meaning, it seems drastically reductive.
12 In talking of the 'thingness' of the object, I am conscious that I am eliding
 an important philosophical debate on the nature of 'the thing.' Most
 relevant here would be Heidegger's essay 'The Origin of the Work of Art,'
 and Derrida's commentary in 'Restitutions' in *The Truth in Painting*.
13 See, for example, the public response to the National Gallery of Canada's
 purchase of Barnett Newman's *Voice of Fire* in 1990.
14 This distinction is one of the points being made by Magritte when he
 declares, 'Ceçi n'est pas une pipe,' and further problematizes the relation
 by *painting* the verbal sign as well as the visual. Magritte's formulation has
 proved endlessly fascinating, and has provoked responses from writers as
 diverse as Michel Foucault (*This Is Not a Pipe*) and Ian Hamilton Finlay (see
 chapter 9, n. 17).
15 For an excellent account of the changing status of the still life, see Norman
 Bryson, *Looking at the Overlooked*.
16 Let me repeat that I myself, in this chapter, am *not* trying to argue that
 painting *is* a language. My argument is (a) that painting exists, always and
 necessarily, within Language; and (b) that the relation of language and
 painting is one of reciprocal supplementarity.

17 This is not a hypothetical example. In the Hamburg Kunsthalle, two views of the same location, painted at the same time, by Cézanne and Guillaumin, hang side by side.

18 For a discussion of 'the linguistic turn,' and the possibility of its having been succeeded by a 'pictorial turn,' see W.J.T. Mitchell, *Picture Theory*, 11–34. For all the reasons set out in this chapter, I am not at all convinced that the 'pictorial turn' is not also, itself, linguistic.

19 Examples abound. Among the critics whose works I discuss in this book, see, for instance, Yve-Alain Bois, Rosalind Krauss, Johanna Drucker, W.J.T. Mitchell, etc. Or see (two examples among many) the works collected in the anthologies *Visual Theory: Painting & Interpretation*, edited by Norman Bryson, Michael Ann Holly, and Keith Moxey, and *The Language of Art History*, edited by Salim Kemal and Ivan Gaskell. Perhaps the most important and stimulating discussion of the visual arts within the context of post-structuralist theory is to be found in Michael Phillipson's *Painting, Language, and Modernity* (1985). For a recent survey of the situation, see the articles by Mieke Bal, Yve-Alain Bois, Irving Lavin, Griselda Pollock, and Christopher S. Wood gathered under the general title 'Art History and Its Theories' in *The Art Bulletin* 78.1, March 1996.

20 For example, Thierry de Duve's *Pictorial Nominalism: On Marcel Duchamp's Passage from Painting to the Readymade* is relentlessly verbal in its approach to Duchamp's art, relying heavily on conscious and unconscious puns. De Duve argues, for instance, that Duchamp's putative incestuous desire for his sister Suzanne is connected, through the similarity of the name, to his obsession with his artistic 'father,' Cézanne. Duchamp, of course, whose work is full of verbal and conceptual riddles, lends himself to this kind of approach. But even Cézanne himself can be subjected to it, as when a critic argues that any painting of the sea (la mer) carries the psychological charge of the mother (la mère).

21 For an interesting discussion of Picasso as the modern paradigm for the romantic myth of the artist as 'genius,' see Drucker, 112–19.

22 Richardson keeps on telling us how untrustworthy Picasso was, how often he lied. Yet at the same time, he keeps on appealing to the artist as a touchstone of interpretative authority. I regret that volume 2 of Richardson's biography appeared too late for me to be able to make use of it.

23 For a revealing discussion of attitudes towards the question of the author, and especially of authorial *intention*, see Zelevansky 86–7, 111–13. Here the participants in the Museum of Modern Art's Symposium on Braque and Picasso worry, at some length, about whether or not we can ever 'know

what Picasso was thinking' as he stood in front of his canvases. Literary studies have worked thoroughly through these questions in light of the problematics of 'The Death of the Author'; the conclusions reached by such participants as Robert Rosenblum and Leo Steinberg are much more traditional and conservative.

Chapter 2 'We Are a Man': The Narrativization of Painting

1 For a full discussion of this song, see my pamphlet *Visions of Johanna*, some passages from which are reworked here, in a different context.

2 In *Visions of Johanna*, I further argue that Duchamp's painting may have been deliberately evoked by Dylan later in the same verse, when he mentions a woman with a moustache.

3 'Highway' is standard drug terminology for the vein into which heroin is injected.

4 Within the broad range encompassed by this term (Marxist approaches, New Historical approaches, ethnographic studies, etc.), emphasis shifts back and forth between a study of the painting and a study of the social context. For me, the most rewarding instances are those critics who use historical details about the society being depicted to illuminate what is going on in the painting. On the other hand, I am less interested in those who use the paintings merely as illustrations for an account of the society. But this is, obviously, a personal preference determined by my own interests in the study of painting. This chapter should not be read as a criticism of sociological art criticism as such, but rather as a commentary on some of the verbal strategies that it often seems to entail.

5 That is, the fictional space of the narrative world.

6 I am thinking here of the whole line of feminist criticism concerned with the visual production of narrative through the gaze, especially in cinema, which includes the work of Laura Mulvey, Kaja Silverman, Stephen Heath, Teresa de Lauretis, and many others.

7 W.J.T. Mitchell notes that 'the treatment of the ekphrastic image as a female other is a commonplace in the genre' (168).

8 Note, in passing, another aspect of the story Steinberg is inventing. Why is the exposure 'sudden,' and why are the whores 'startled'? Don't prostitutes normally *expect* customers? There is no basis in the painting itself for this line of story-development. Indeed, 'cornered' and 'intrusion' import a suggestion of violence into the story, as if the women fear attack. Maybe, in Steinberg's version, 'we' are not simply a customer but Jack the Ripper.

Chapter 3 Apollinaire and the Naming of Cubism

1 Salmon was initially a friend and supporter of the Cubists, but by 1917 he
 had changed his opinion. A letter from Juan Gris to Léonce Rosenberg,
 dated November 1918, goes so far as to associate him with Louis Vaux-
 celles: 'Je me suis délecté avec la prose de Vauxcelles dans le catalogue
 que Lipchitz m'a envoyé. C'est bien banal et bien médiocre tout ce qu'il
 raconte, ce critique si distingué. Mais êtes-vous bien sûr que cet article de
 l'Oeuvre, signé l'Imagier est bien de lui? Moi je l'attribuerai plus volon-
 tiers à un sous-ordre de Vauxcelles, Max Goth, par example mais surtout
 je trouve que cet article sent le Salmon à plein le nez' (Derouet 65). This
 ironic and witty evocation of a 'sous-ordre de Vauxcelles,' in which some-
 thing smells fishy, seems worth quoting as a kind of secondary epigraph
 to this chapter.
2 Or, in the words of the cartoon character Calvin, 'Art isn't about ideas. It's
 about style. The most crucial career decision is picking a good "ism" so
 everyone knows how to categorise you without understanding the work'
 (*Calvin and Hobbes*, by Bill Watterson).
3 I realize that this argument is, potentially, a circular one. My own notion,
 ninety years later, of which artists 'have in any significant way lasted' is
 itself the product of a process of canon-formation in which Apollinaire
 played a significant role.
4 Vallier's essay appeared in the catalogue for an exhibition of Villon's work
 that I saw in Paris in 1975; the quotations here are in my own translation.
5 Princet was a mathematician, and a friend of Marcel Duchamp. The gossip
 history of Cubism records that his wife later left him and married André
 Derain.
6 Virginia Spate's *Orphism: The Evolution of Non-Figurative Painting in Paris,
 1910–1914* includes Delaunay, Kupka, Léger, Picabia, and Duchamp; but
 Spate plays her own version of Apollinaire's game by subdividing the
 movement into Mystical Orphism, Perceptual Orphism, and Psychological
 Orphism!
7 Vauxcelles did not return the compliment. As late as 1913, a year after
 Apollinaire's lecture, Vauxcelles was still attacking Cubism, and even
 regretting his own unwitting role in promoting it: 'Cubism has to be
 fought! The snobs of overrated paintings have all cried "Marvelous!" at the
 sight of them. A few sluggards from the press and some sloppy versifiers
 [Apollinaire?] joined the chorus. Even we contributed to this when we
 attacked this monstrous school, and in addition we made the mistake of
 feeding their insatiable appetite for publicity ... In fifteen years when we

look back on cubist paintings of 1910–1913 (if their creators haven't destroyed them by then), they will appear as a fleeting phenomenon without any relation to artistic movements ... Every room of the exhibit at the Grand Palais has its cubist the way every hospital has a dangerous psychopath' (quoted in Assouline 103–4).

8 For a detailed account of the history of these terms, see Gamwell 16–18, 33–5, 52, 95–100.

9 Christopher Green comments: '"Analysis" and "synthesis" are words that will always tend to figure in discussions of Cubism. They were words used by the Cubists, especially Gris, and by those who defended them. Now, however, their use as tools for gaining a purchase on Cubist painting and history has been rendered near obsolete either by criticism or neglect' (34).

Chapter 4 The Gospel According to Kahnweiler

1 Yve-Alain Bois reports an incident in which Kahnweiler's 'diatribes against abstraction became more and more dogmatic until, one day, Picasso took him aside' (1985, 43).

2 The major sources for biographical information about Kahnweiler are Isabelle Monod-Fontaine (1984) and Pierre Assouline.

3 While Kahnweiler was committed, intellectually, to all his artists, he certainly discriminated between them commercially, in the simple terms of the prices he charged. Francis Frascina notes that in 1912, for a size 25 painting, Kahnweiler paid Picasso 1000 francs, Derain 300, Braque 250, and Léger 75. Frascina compares these sums with the average wages for house-painters at the time, and with the fees André Salmon was receiving as an art critic; he concludes: 'With a 100% dealer mark-up, it would thus have cost Salmon his fees for 8–10 months to buy a size 25 canvas of Picasso's at 1912 prices. A house-painter would have had to spend his entire gross annual earnings to buy the same canvas' (176).

4 By birth Kahnweiler was a Jew, but there is little evidence that he took this seriously in a religious sense. In the 1930s and 1940s, of course, his Jewishness placed him in a position of considerable danger.

5 Kahnweiler knew Stein and, within limits, admired her work. He contributed an introduction to Painted Lace and Other Pieces, one of the volumes of the posthumous Yale edition of the unpublished writings of Gertrude Stein (1955).

6 The 'simple spectator' is a continuing bête noire in Kahnweiler's writing: perhaps too many of them passed through his galleries! But the 'simple spectator' is also, rather too obviously, a straw man set up for the argument.

7 Bois's argument is reworked, in slightly different terms, in 'Kahnweiler's Lesson' (1990, 95). For further discussion of Cubism as semiotics, and of Bois's interpretation of semiotics, see below, chapter 5.

8 But even on Kahnweiler's own terms, much abstract painting does provide a way of 'seeing' a world conceived in terms of modern physics, subatomic particles, and cyberspace.

9 There are a few exceptions to this statement, but they are so isolated as to prove the point. See for instance Braque's 'Geometrical Composition' (1912–14), catalogue illustration #9 in *Kubismus*, Joseph-Haubrich Kunsthalle, Köln, 1982.

10 It is ironic that the words Kahnweiler uses, even in the 1940s, are more generally associated with two schools of painting in which his own theory was either not much interested (Expressionism) or which it rejected entirely (Constructivism). Kahnweiler wrote that the German Expressionists confused their own Expressionist distortion with Cubist Constructivist distortion and so believed, mistakenly, that they had similar aims; he doubts 'whether many of their works will survive the test of time. The plastic poverty of so many of them will be the main reason for their playing no part in the history of art, and the same can be said of the majority of surrealist pictures' (136). I confess to a certain sympathy with this view of Surrealism.

11 Cf. the letter by Ian Hamilton Finlay cited in the preface, in which Finlay describes Kahnweiler's book as 'crying out for a concluding chapter on concrete poetry.' And see chapter 9 for further discussion of Finlay's debt to Kahnweiler.

12 See Dick Higgins, *George Herbert's Pattern Poems: In Their Tradition*. For further comment on Apollinaire's visual poetry, see chapter 7.

13 Cheerfully burlesqued by Finlay under the title 'Semi-Idiotic Poetry.'

14 Ian Hamilton Finlay, explicitly acknowledging Kahnweiler as his source, does the same thing in many of his early concrete poems. In *Rhymes for Lemons*, for instance, the shape of the lemon is 'rhymed' to the shape of the hull of a fishing boat. (See Abrioux 158–61.)

15 See for instance Mark Rosenthal: 'An object is presented by a minimal sign, and that sign has significance as a component in an overall harmony. Rhyming on the flat plane is a major characteristic of this clarified realm' (106). Christopher Green also uses the notion of 'rhyme,' but he is more willing than Kahnweiler to see its effect as being, indeed, metaphoric: 'In Gris' case, the guitar is a poetic "image" or "metaphor," not because ... it is *like* the bunch of grapes, but because it can *become* the bunch of grapes, so patently do the two share just one form' (63).

Chapter 5 The Semiotics of Cubism

1 Well, almost always. If you look hard enough, you can find Cubist paint-
 ings or drawings in which the guitar has six strings, but these are rare
 exceptions. See, for example, Picasso, *The Aficionado* (1912; Rubin 1989, 239);
 or Braque, *Table with Pipe* (1912; Rubin 1989, 259). Sometimes, also, the
 guitar has as few as four strings: see Picasso, *Table with Guitar* (1912; Rubin
 1989, 255). I haven't attempted a comprehensive count, but my guess
 would be that less than 10% of Cubist depictions of guitars show a full six
 strings.
2 For a comprehensive debunking of this approach, see John A. Richardson's
 excellent article, 'On the "Multiple Viewpoint" Theory of Early Modern Art.'
3 As is mentioned later in this chapter, Rosenblum was the first major critic
 to take seriously the *content* of the newspaper clippings Picasso used in his
 papiers collés. Recent critics, such as Patricia Leighten and Francis Frascina,
 have focused on the many references in these clippings to the war in the
 Balkans, and have thus argued for a reading that situates Cubist collage
 firmly within the political uncertainties of 1913.
4 On Princet, see above, chapter 3. On the 'fourth dimension,' see Linda
 Dalrymple Henderson.
5 The semiotic theory could, perhaps, be vulnerable to the same charges. But
 none of its advocates, to my knowledge, actually argues that Braque or
 Picasso *knew* Saussure's work; their arguments are based on a reading of
 the texts, and do not appeal to authorial intention.
6 For an argument directed specifically *against* the use of Saussure, see David
 Summers. As I go on to argue, many of my difficulties with the arguments
 put forward by Rosalind Krauss and Yve-Alain Bois derive from what I see
 as their privileging of Saussure.
7 I would argue that metaphors are generated more directly from language
 (symbols) than from visual images (icons). But perhaps all figurative
 language exemplifies a *supplementary* relation between icon and symbol. In
 any event, the division of 'icon' into image, diagram, and metaphor is not
 very widely observed; the term 'icon' is most often used interchangeably
 with the more exact 'image-icon,' and I have also tended to use this
 simplified form.
8 What kind of sign is the missing sixth string? It could be read as a symbol,
 in that it stands for the abstract idea of semioticity, of 'being-a-sign'; or as
 an index, in that it points directly to the material condition of the canvas as
 a two- rather than three-dimensional form; or as an icon, in that its absence
 physically resembles the absence of the 'real' guitar.

9 For another very interesting treatment of the index, see Richard Shiff. In the course of a fascinating discussion of the interaction of the metaphors of sight and touch, Shiff writes that 'touch is the gesture that deposits the painter's mark as an imprint or impression; we regard this mark as the indexical sign of the gesture' (134). Further, 'within the modernist tradition the indexical function has been privileged over the iconic: a mark refers to its maker (or cause) more emphatically than it refers to some detached object' (139). Shiff's essay suggests a whole approach to the semiotics of painting through the index.

10 See, however, Bois's own comments on how he finds Saussure and Peirce useful in different ways at different points in his argument (Zelevansky 216).

11 There is no hard-and-fast distinction between 'semiological' and 'semiotic.' For some time, 'semiological' was the term used in Europe, and 'semiotic' was more common in North America. One might observe, as a very broad generalization, that 'semiological' tends to be used in structuralist discourse to emphasize the regularity of the system, while 'semiotic' tends to be used in post-structuralist discourse to emphasize the fluidity and open-endedness of the system.

12 Andrew Harrison posits that, 'in pictures as in language, syntax is what makes semantics possible' (218). He also sees that syntax as 'astonishingly minimal' (229).

13 Resemblance itself, Poggi goes on to argue, is determined not by 'nature' but by convention; she cites familiar stories of primitive peoples being unable to 'recognize' photographs. Precisely: a sign is still a sign, even when it's iconic. There is no need for a sign to be fully 'symbolic' or 'semiological' in order for it to have to be read *as a sign*. Peirce's 'icon' will account for the conventional nature of resemblance just as adequately as Saussure's 'sign.'

14 The exchange begins with Rubin's essay 'Cézannisme and the Beginnings of Cubism' in *Cézanne: The Late Work* (New York: Museum of Modern Art, 1977), in which he argues for the importance of Braque's development of Cézanne for the birth of Cubism. Steinberg responded with a two-part article, in which he argues that Picasso, not Braque, is the prime mover of Cubism, and that the influence of Cézanne has been overvalued: 'Resisting Cézanne: Picasso's "Three Women"' appeared in *Art in America* (November–December 1978) and part two, 'The Polemical Part,' in *Art in America* (March–April 1979). The same issue contained Rubin's response, 'Pablo and Georges and Leo and Bill.'

The argument continues, and is restated many times in the discussions transcribed in *Picasso and Braque: A Symposium* (Zelevansky 1992). Here,

Rubin's praise of Braque takes the form of a decidedly left-handed compliment; speaking of *Le Portugais*, he says: 'I don't myself feel that Braque arrives at this level very frequently, and I'm always amazed when he does, because I don't think he was predestined to arrive there. On the other hand, Picasso has almost to manacle himself, or to fall something short of his best self, *not* to be successful ... Perhaps – not having genius, and being involved with effort – I identify with Braque; he represents the human condition, while Picasso's gift seems super-human, God-given' (ibid. 246). I disagree strongly with this statement; not only does it contribute to a naive and Romantic mystification of Picasso, it seriously undervalues the achievement of Braque, especially the later Braque. Of the participants in the *Symposium*, only Alvin Martin and Mark Roskill speak out strongly in support of Braque (see esp. Zelevansky 118, 242, 248).

15 Steinberg attributes this limerick to a friend of his named Telegrin Böse. I am indebted to one of the anonymous readers of this MS for pointing out to me (what I should have realized for myself) that 'Telegrin Böse' is an anagram for 'Leo Steinberg.'

16 In a recent article, Edward F. Fry attempts to reverse at least one of these dualities, arguing that it is Picasso who truly represents the 'classical' tradition. He does this by defining the classical principally in terms of its emphasis on the human body, noting (quite correctly) Braque's lack of interest and ability in depicting the human face and figure. Braque is then relegated to 'a rather more Northern, pre- or sub-classical tradition' (1992, 92). Apart from the pejorative connotations of 'pre-' and 'sub-,' this comment simply re-designs the terms of the argument to fit a preconceived position. Picasso's *use* of the human figure is almost always expressionist, romantic, and emotional. Insofar as the word 'classical' connotes calm, measured, patient, and rational contemplation, I would still argue (with the reservations noted in the main text) that it applies more to Braque than to Picasso.

17 Disputing the conventional view of Braque, Alvin Martin writes: 'His comportment in his private life or with his friends before 1914 gives a quite different image of his personality. The memory which people kept of him is of a large man, athletic and well built, who loved boxing and bicycling, but also singing and dancing, and who knew how to play on the accordeon. After 1907, he frequented a group of friends who made up some of the most spirited and eccentric personalities in Parisian arts and letters' (43).

18 'Pun' is one way of putting it. Another would be to describe the two shapes as 'rhymes': this linguistic, or poetic, metaphor was extensively used by Kahnweiler in relation to Gris, as I noted in chapter 4. Another way would be to describe the guitar and the woman as *metaphors* for each other. In this

chapter, I am trying to avoid the term 'metaphor,' since it will be extensively discussed in chapter 6. But when Fry, for instance, says that Braque uses words in his paintings only as 'associative analogy' (1992, 98), the term 'associative' invites the possibility that the distinction Fry, Krauss, and Bois are making between Braque and Picasso parallels the distinction between metonymy and metaphor. In this sense, the whole of chapter 6 could be read as an extended footnote to chapter 5.

19 In the definitive catalogue, *Georges Braque: Les Papiers collés* (Monod-Fontaine, 1982), the first collage to use a newspaper clipping is #27, dated 1913. For the remainder of this chapter, references to Braque's papiers collés will be noted parenthetically, using the numbers from this catalogue.

20 Christine Poggi comments that, in his use of papier collé, Braque 'strove to turn the technique of *trompe l'oeil* against itself, to make an art of illusion stand for an art of non-illusion' (Zelevansky 137). But as my comments here indicate, I think it is too simple to see papier faux bois as, unproblematically, 'an art of illusion.'

21 *Nature morte BACH* (#11) runs the black ' border' lines of the faux-bois directly into the pencilled lines of the violin strings, suggesting the equivalence (and thus the arbitrariness) of the two types of sign. Ironically, a reproduction of this collage appears in Christine Poggi's *In Defiance of Painting* on page 42, while on the facing page 43 she writes of how Picasso 'in contrast [to Braque] delighted in confirming the essentially *arbitrary* nature of signs.' That 'in contrast' is entirely disproved by the facing illustration.

22 The later Braque papiers collés are even more clearly 'semiological,' transformational, or metaphorical. See for instance *La Mandoline* (#47), and *Bouteille et instruments et musique* (#55), where corrugated paper is used to represent, respectively, the strings of a mandoline and the glass surface of a bottle. Or see *Le Violon* (#45), where the violin is represented by direct drawing, by papier faux bois, by newspaper clipping, and (verbally) by newspaper headline.

23 Malcolm Gee arrives at a similar conclusion: 'If Cubist signs are *not* primarily symbolic (i.e. arbitrary), there is probably less fundamental difference between early and late Cubist work than Krauss and company [i.e., Bois] suggest, and the case for Picasso has to be made differently, if at all' (139).

24 For an interesting account, see Butor.

25 By, for instance, Golding (92), who cites a rather ambivalent statement by Braque, to the effect that 'as part of a desire to come as close as possible to *a certain kind of* reality, in 1911 I introduced letters into my painting.' I have

added the italics to this quotation to emphasize the equivocation: the letters
are not reality itself, but rather a 'certain kind of' reality: the reality of
representation, of signs.

26 This painting is usually seen as the earliest example of a specifically 'Cu-
bist' use of lettering; e.g., by Golding (92) and by Françoise Will-Levaillant
(45). The dating in Rubin (1989) suggests that there may be earlier ex-
amples by both Braque (202) and Picasso (203). The exact chronology is
not important to my argument here.

27 For a counter-argument, see Zelevansky 247.

28 It is in this sense that I am always tempted to read the Cubist portrayals of
bottles of 'marc' or 'vieux marc.' Although the final 'c' is not pronounced, it
is seen, and to me it suggests at least a visual pun with 'marque': the sign
of the sign, the mark of the mark.

29 For a full list of the lexical possibilities of JOU, see Frascina 157. Frascina
quotes an amusing passage from Françoise Gilot's *Life with Picasso* in which
she talks about Picasso's fondness for elaborate puns.

30 Rosalind Krauss argues that 'un coup de thé' is not a possible idiomatic
phrase in French, in contrast to 'un coup de rouge,' which can mean a 'shot'
of red wine (1992, 286). But if the pun works, it is surely bilingual. Without
wanting to confine myself within the sterile arguments of authorial inten-
tion, or how much English Picasso knew, I might still point out that 'a cup
of tea' is a phrase he could easily have heard while paying his polite visits
to Miss Toklas and Miss Stein.

31 See Leighton's article 'Picasso's Collages and the Threat of War, 1912–1913,'
and her book *Re-Ordering the Universe: Picasso and Anarchism, 1897–1914* .
For a critical review of the book, see Robert S. Lubar, *The Art Bulletin* 72.3
(September 1990): 505–10. For further discussion about references to the
Balkan wars, see Zelevansky 76, 79, and 167 and Frascina 92–4. Frascina
also makes a convincing argument for extended intertextual references
between Picasso's work and the magazine *Les Soirées de Paris* (152–3).

32 Bois writes that Braque 'sometimes ... make[s] puns' (1992, 191–3), as if this
were unusual. The pun is of course linked to the 'symbolic' use of lan-
guage, which Bois wishes to downplay in Braque. Similarly, Fry comments:
'There are some puns in Braque. Of course, they don't really appear in
Braque until after they first appear in Picasso' (Zelevansky 117). But to
suggest that Braque needed Picasso's example in order to make jokes runs
counter to everything we know about Braque's temperament. The only
critic who has done justice to Braque in this respect is Mark Roskill, both in
his book *The Interpretation of Cubism* (especially 66–75), and in his article
'Braque's *Papiers Collés* and the Feminine Side of Cubism' (1992). A good

deal of what follows in my text is indebted to Roskill's discussions, even in cases where I had arrived at the same conclusions before reading him.

33 For more on this topic, see chapter 6, especially the celebration of domestic life in the writing of Gertrude Stein.

34 For the 'metonymic' nature of Cubist signs, see chapter 6; for the 'visual chatter' of Apollinaire's 'conversation poems,' see chapter 7.

35 The wind instrument in this collage, often referred to as a clarinet, has now been identified as a tenora, a Catalan instrument often depicted by Picasso: see Lewis Kachur, 'Picasso, Popular Music and Collage Cubism.' As for the guitar, I may be stretching things to read the sign this way: the papier faux bois could, more simply, represent a table.

36 See especially *Limited Inc* and *Signéponge / Signsponge*. See also my own discussion of signature in *Signature Event Cantext*, chapters 6 and 7.

37 Richard Shiff notes that 'Picasso often signed his name to paintings and collages with a very regular cursive script like that of printed calling cards. He thus gave his personal mark a commonplace form, presumably conscious of the irony that such mechanically reproduced cursive lettering had itself been designed to connote "personal touch"' (180).

38 For a good account of Braque's signature, within the same Derridean context as I am using here, see Dianne E. Sears, 'Bracketing Painting: Ponge's Criticism of Braque' (a title that itself performs a nice pun on the signature). Sears gives special emphasis to cases in which the question of the signature also involves the question of the frame (which I will discuss in chapter 7).

39 See Roskill (1992, 231–3). Picasso of course said that he would write Marcelle's name into all of his paintings; but he did so in its adopted form of 'Eva.'

40 Roskill makes the far-fetched but delightful suggestion that 'l'as de pique' can also be read as 'las de pique' – 'tired of bearing a grudge' (1992, 234)!

Chapter 6 Metaphor and Metonymy in Cubism and Gertrude Stein

1 A good example of metonymy would be the use of 'Ottawa,' the name of the city in which the Canadian federal government is located, to refer to the collective decision-making process of that government and its bureaucracy.

2 DeKoven's book is entitled *A Different Language: Gertrude Stein's Experimental Writing*; the emphasis on 'different' and 'experimental' implies a postmodernist view. But Jayne L. Walker's book, published a year later, is explicitly titled *The Making of a Modernist*.

3 Phillipson also makes extensive use of the metaphor/metonymy distinction
 in his discussion of painting, but along quite separate lines. He argues
 that 'metaphor' describes the static, spatial sense of the painting as a
 complete(d) unit of meaning, while 'metonymy' is temporal, describing the
 process by which meaning is created and read. 'Reading ... is the eyes'
 metonymic journey through the work, a journey ever-open to self-transfor-
 mation. The metaphoric dimension is the product of this journey – meta-
 phors are the conclusions, the moments of stasis, of the journey, for they
 represent conclusions about the significance of the work or elements of it ...
 Ultimately the work lives through a play of differences ... and any reading,
 as a process of movement and stasis is a dialectic of metonymy and
 metaphor' (134). I think that this redefinition could be a very useful way of
 approaching the topic; but in this chapter, since I am dealing with critics
 who remain within the Jakobsonian orbit, I will have to remain there too,
 and set Phillipson's usage aside.
4 Jayne L. Walker, as I will argue shortly, follows, with some modification,
 the same division. But Lisa Ruddick, in her excellent and extremely lucid
 book *Reading Gertrude Stein*, crosses the categories that Dubnick and Walker
 attempt to set up. Ruddick compares the 'opaque,' or later Stein style not to
 Synthetic but to Analytic Cubism. Ruddick may, however, simply be con-
 fusing the dating of these styles; she says, for instance, that '[t]he major in-
 spiration for [Stein's] opaque style ... was Picasso's development of collage
 techniques within analytic cubism' (180). But the traditional division sees
 collage as the initiation of *Synthetic* Cubism.
5 Even when Gris 'rhymes' a book, a guitar, and a mountain, the mountain
 can be seen through a window immediately behind a table on which the
 book and guitar are lying.
6 At this point, this whole chapter on metaphor and metonymy intersects
 with the discussion in the previous chapter, on semiotics. What Bois calls
 Picasso's 'semiological' use of the sign, its Saussurean sense of the arbi-
 trary, might well be interpreted as 'metaphor,' in contrast to what Bois sees
 as the less fully symbolic (more 'metonymic'?) use of the sign by Braque. In
 the previous chapter, I argued that the distinction between the two types of
 sign was less sharp than Bois proposed; and that Braque was just as
 capable as Picasso of using 'semiological' or 'symbolic' procedures. In the
 present context, it could be argued, for example, that Braque's semiological
 use of corrugated cardboard to represent the strings of a guitar (Monod-
 Fontaine 1982, #47) is 'metaphoric,' insofar as it foregrounds the difference
 between the cardboard and the guitar rather than their contiguity. But even

here, cardboard and guitar are still drawn from the same general area of 'café' imagery (corrugated cardboard would be used to wrap bottles – and in #55 that idea is literally represented, as the corrugated cardboard becomes the sign for the bottle itself). Braque very seldom uses 'metaphor' in the sense of jumping from one area of signification into a completely different one, or from the physical to the abstract (as in 'winds of change'). That is, I think it is possible for a Cubist sign to be 'semiological,' in Bois's sense, without necessarily being 'metaphoric.' While the two systems of classification overlap in interesting ways, they are not identical.

7 They are, indeed, quite uncharacteristic of Cubism, and point more towards those aspects of Picasso's art that, after 1914, could no longer be contained within the bounds of a shared style.

8 Willard Bohn, in his study 'Metaphor and Metonymy in Apollinaire's Calligrams,' also starts from the assumption that 'Cubist painting is highly metonymic' (167). Bohn provides a detailed structural analysis of Apollinaire's calligrams, and concludes that, while both metaphor and metonymy are present, and are often combined in the same poem, at the verbal level 'metonymy ... is clearly the governing principle' and '[v]isually, the calligrams are overwhelmingly metonymic' (180–1). Bohn's analysis of Apollinaire thus reaches broadly the same conclusions that I have argued for so far in this chapter in relation to Cubism, and that I will now argue for in relation to Stein.

9 Lacan describes the subject's introduction to the Symbolic Order as being produced by 'Le Nom du Père' (the Name of the Father, but also the prohibition, the Non du Père). This idea has been widely used by feminist theorists, and by writers on Gertrude Stein, though feminist reaction to Lacan is always highly ambivalent.

10 The name connotes two separate instances of patriarchal rule: Peter the Great, founder of the city and of the Russian state, and Saint Peter, the 'rock' of the Roman Catholic church. Slyly, Stein's phrase 'retreat from St. Petersburg' incorporates within itself the technique, 'repeat,' by which this denial is accomplished.

11 Within the Canadian context, the same argument could of course be made for bpNichol, who was a great admirer of Stein.

12 See the passage from The Autobiography of Alice B. Toklas (9) quoted as the epigraph to this book.

Chapter 7 The Window Frame: Delaunay and Apollinaire

1 Note, in cartoons, the convention of indicating 'glass' by a couple of diagonal lines.

2 In Derrida's work, all these terms (along with several others, such as spacing, pharmakon, hymen, and so forth) are linked to each other, without quite becoming interchangeable. In *Margins of Philosophy*, he describes them as 'the chain in which différance lends itself to a certain number of non-synonymous substitutions, according to the necessity of the context' (1982, 12). A further item in this chain would be 'signature' (in the sense discussed at the end of chapter 5). Signature and frame are linked to each other in very interesting ways: for an excellent discussion, which deals explicitly with the verbal elements in Braque's collages, see Dianne E. Sears.

3 Ironically, then, the roles of the classical myth are reversed: it is Delaunay (the painter) who takes on the figure of Orpheus (the poet), inspired by the god Apollo (the critic, Apollinaire).

4 It is also, of course, Sonia Delaunay whose collaboration with Blaise Cendrars produced one of the most striking examples in this period of collaboration between poetry and painting: their version of *La Prose du Transsibérien et de la petite Jehanne de France* (1913). If I have chosen in this chapter to neglect this work in favour of the collaboration between *Robert* Delaunay and Apollinaire, it is only because the thematic motif of their collaboration – the window – speaks so directly to the theoretical concerns of the frame and the supplement, and because of the further link that this motif later provides to the collaboration of Barbara Caruso and bpNichol.

5 For a discussion of this point, see Spate, appendix A.

6 There are several variants on this text, which are collected in Cohen, 81–6.

7 The two major monuments erected in Paris at the end of the nineteenth century – the Eiffel Tower and the Basilica of Sacré Coeur – may be seen in retrospect to symbolize the opposing tendencies of the period. The Tower is aggressively modern; it represents the triumph of technology and the confidence of modern civilization. It stands for all the values John Berger identifies in 'The Moment of Cubism,' and is in many ways the quintessential Cubist monument – it is only surprising that more of the Cubist painters did not picture it. Sacré Coeur, by contrast, is retrogressive, a piece of fake Orientalist architecture that belongs to the aesthetic taste of the worst Academic painters. It was erected after the Paris Commune, by public subscription, as an offering to God to expiate the sins of the Commune – not, that is, the sins of the French bourgeoisie who massacred the surviving communards in their hundreds and thousands, but the 'sins' of those who had dared to proclaim socialism, the 'sins' of feminists like Louise Michel, the 'sins' of the slaughtered workers of Paris. Sacré Coeur is, in the most literal sense of the term, a whited sepulchre.

8 It is relatively common for artists to paint an 'inner' frame illusionistically on the canvas, and then to transgress this frame by painting objects that

seem to overlap it. See Dianne E. Sears's article for a number of instances in which Braque does just this. What is not nearly so common (there are some examples by Seurat) is what Delaunay does here: to extend the painting onto the actual wooden frame.

9 The best-known example in English is George Herbert's 'Easter Wings.' For a good study of the form, see Higgins. For Kahnweiler's comments on this point, see chapter 4.

10 For some critics, such as Albert Cook, this 'mid-point' status is the great virtue of Apollinaire's calligrammes. Cook sees the 'minimalism' of Concrete Poetry as a dead end. The calligrammes, he writes, 'surpass the programmatic post-Dada simplicity of most modern concrete poems, which sacrifice the profusion firmly gained' by Apollinaire (82). My discussion of Ian Hamilton Finlay in chapter 9 will, I hope, demonstrate how little 'profusion' is lost in the best Concrete Poetry.

11 This passage is pointed to by Terence Diggory, who relates the 'inner frame' to Derrida's 'parergon.' But his article is mainly concerned with William Carlos Williams, and he does not follow up the argument in relation to Apollinaire's own poetry.

12 See above, chapter 6, for the use of the phrase 'word heaps' in conjunction with Jakobson's definition of metaphor, and with critical descriptions of Gertrude Stein's *Tender Buttons*. There is no evidence that Stein and Apollinaire read each other's work, but in some ways the similarities between 'Les Fenêtres' and *Tender Buttons* are quite striking. The abrupt juxtapositions, the progression by association of sound, the occasional abandonment of syntactic links, are all common to both texts. A passage like 'Towers/Towers are the streets/Well/Wells are the squares/Wells' would certainly not be out of place in Stein.

13 In their commentary on the poem, S.I. Lockerbie and Anne Hyde Greet describe the line as a 'poetic transformation of the kind of nineteenth-century color theory Delaunay attacked,' noting that 'red and green are complementary colors, whereas red and yellow form a dissonance and should not be juxtaposed; thus, according to Chevreul's color wheel, yellow "dies" en route from red to green ... [Apollinaire's] line has ironic overtones, since Delaunay's own theory of color simultaneity embraces any combination of colors in the spectrum' (*Calligrammes* 351). This explanation seems highly unlikely to me. Is it credible that Apollinaire, even in an ironic mode, would have given such prominence to a line that proclaimed an idea about colour to which Delaunay was opposed? And is it credible that Delaunay would then have welcomed the poem, and used it for the catalogue of his most important foreign exhibition? The Canadian painter

Barbara Caruso (in correspondence with me) has offered two other possible explanations of the line. (1) In terms of *value*, yellow is the lightest of the primaries, blue the darkest, and red has a middle value. So, when yellow is combined with blue, the resulting green is also of middle value. Caruso concludes: 'from "red" to "green" (both colours being of middle value), all "yellow" (the colour of highest value) *is dying* (i.e. it has lowered in value due to the darkness of blue).' Or (2) 'Imagine that Apollinaire is in some painter's studio where he witnesses the intermixture of pigments. On the painter's palette, he sees a swatch of red, one of yellow and one of blue, pressed fresh from the tubes. The painter takes his brush, and on a clear space on the palette, begins to intermix some of the blue and some of the yellow. The yellow, that was so light and bright, will suddenly *die* and a "green" appears.' Of course, neither of these explanations can be proved, but both of them seem to me to make a great deal more sense than any supposition that Apollinaire was being 'ironic' about theories to which Delaunay was opposed. (I cannot resist adding, probably totally irrelevantly, that the other place where yellow dies en route from red to green is in traffic lights! But were there already traffic lights in that colour pattern in Paris in 1912?)

Entr'acte: Signs of the Times

1 Pignatari was one of the leaders of the South American group 'Noigandres' (which took its name from an unidentified reference in one of Pound's Cantos), which also included the brothers Haroldo and Augusto de Campos. Ian Hamilton Finlay (in conversation, 1992) fondly remembered Pignatari as 'wee Decio.'
2 Stephen Bann, ed., *Concrete Poetry: An International Anthology* (1967); Emmett Williams, ed., *An Anthology of Concrete Poetry* (1967); Mary Ellen Solt, ed., *Concrete Poetry: A World View* (1968).
3 I am in broad agreement with these comments, though I would point out that Finlay, even in 1992, still thinks of what he is doing as being, in some sense, 'Concrete Poetry.' And indeed, could it not be argued that Finlay's garden at Little Sparta, taken in its totality, constitutes precisely the 'epic' of Concrete Poetry of which Bann speaks? Or, if not its epic, at the very least its (armed) pastoral. Similarly, bpNichol's *The Martyrology* stands to his earlier concrete work in a relation not at all dissimilar to that between Pound's *Cantos* and his Imagism.
4 For further discussion of this point, see chapter 9.
5 Of course, perception of a painting, or of a visual poem, is never fully, in

the literal sense, simultaneous. The eye does move around a canvas; there is a sequence to perception (and some compositional devices are specifically designed to direct that sequence). But in a broader sense, perception of a single image painting or poem is certainly much closer to simultaneous than is the activity of reading even a short poem, far less a novel.

6 In chapter 6, I discussed some of the implications of this division, and proposed that it was often less definite and clear-cut than might be suggested by any strict adherence to a binary model. So I reinvoke it here with some hesitation, and certainly with the understanding that both terms – metaphor and metonymy – are being deployed under the Derridean sign of erasure.

Chapter 8 Gadji Beri Bimba: Abstraction in Poetry

1 See Rickey 42; and also, of course, Tom Stoppard's *Travesties*.
2 Earlier experiments in 'sound poetry' included, at the very least, Italian Futurist 'parole in libertà' and the Russian 'zaum' poetry (discussed later in this chapter).
3 This is the text as given in Ball's diary. The version of the poem published in his *Gesammelte Gedichte* (Zürich: Der Arche, 1963) is longer, and has many variants. For a detailed discussion of the poem, see Henderson 125–31.
4 This quote, which is not included in Elderfield's edition of the diary, is given by Richter 41.
5 In this book, I have for the most part favoured the term 'non-figurative,' or sometimes 'non-representational.' In this chapter, following Osborne, I use 'non-iconic.'
6 See Joseph Masheck: 'We should remember that what Denis actually said was that a picture is a plane with colour patches arranged in order *before* it is something else. That is far from saying that it could not also *be* something else; in fact, it implies that the picture *will be* something else' (93).
7 That is, *verbal* language. In some of the wider senses of 'language,' as I suggested in chapter 1, this question would not arise in this form.
8 Teodor de Wyzewa (1885), quoted in Vergo 47.
9 Thus, in discussing sound poetry in the 1910s, I have concentrated so far on the Dadaists, and am about to mention the Russian 'zaum' poets, but I have said nothing at all about the Italian Futurists' 'parole in libertà.' This omission is mainly a matter of personal taste: I find Marinetti's poems bombastic and crude alongside those of Ball, Schwitters, or Nichol. In Kahnweiler's terms, Futurist poetry (like Futurist painting) tends to depend upon

expressionist rather than constructivist distortion – and the reader may by this time have deduced that I have very little interest in Expressionism.

10 See *Text-Sound Texts*: 'The first exclusionary distinction then is that words that have intentional pitches, or melodies, are not text-sound art but *song*' (Kostelanetz 1980, 15).

11 This phrase is of course mainly associated with feminist writing. Feminist sound poetry is certainly possible, but historically sound poetry has been a predominantly male domain. Of the 98 poets included in Richard Kostelanetz's anthology *Text-Sound Texts*, 17 are women.

Chapter 9 Models of Order: Ian Hamilton Finlay

1 It is difficult to give conventional citations for Finlay's works. Many of them appear in several different forms: as cards, pamphlets, prints, sculptures in wood, stone, or neon, landscape installations, etc. In this chapter, I have made use of seven reproduced figures; and in the case of some simple pamphlets, I have quoted the text in full. Otherwise, I have tried wherever possible to refer to works available in reproduction in Abrioux's *Ian Hamilton Finlay: A Visual Primer*, which also includes a very full bibliographic listing of Finlay's publications. Originals are available from Wild Hawthorn Press, Little Sparta, Stonypath, Dunsyre, ML11 8NG, Scotland.

2 Guillotin did not 'invent' the guillotine. Machines of similar design had long been used in Europe; Arasse's book contains several illustrations, including a device called 'The Maiden,' used in Scotland in the sixteenth century. Guillotin improved the efficiency of the design; his proposal for its use was a rather minor part of a sweeping, and very progressive, reform of criminal laws relating to punishment. For all his reasonable outlook, however, Guillotin came to share something of the terror that the machine evoked, and he bitterly resented the fact that his name had been attached to it. Arasse quotes a wonderfully ironic statement from the funeral oration delivered for Dr Guillotin when he died in 1814: 'How true it is that it is difficult to benefit mankind without some unpleasantness resulting for oneself.'

3 See Arasse, unpaginated; and Schama 620.

4 On this point, see Schama, especially 623: 'At each successive phase of the Revolution, those in authority attempted to recover a monopoly on punitive violence for the state, only to find themselves outmanoeuvred by opposing politicians who endorsed and even organized popular violence for their own ends ... The core problem of revolutionary government, then,

turned on the efforts to manage popular violence on behalf of, rather than against, the state.'

5 For example, the references to 'temples' allude to Finlay's continuing battle with Strathclyde Regional District over his classification of one of the buildings on his property as a 'garden temple,' a dispute that is especially instructive about the embarrassment of a secular government in trying to deal with an absolute (or with the Sublime). Further, I have confined this section to a discussion of selected Finlay works on French Revolutionary themes; I have not attempted here to extend the discussion into the even more highly charged and problematic area of Finlay's confrontation with the iconography and architecture of the Third Reich.

6 The farmhouse and land that Finlay occupies at Dunsyre, some 25 miles south-west of Edinburgh, used to be called, simply, Stonypath. Finlay's renaming of it as 'Little Sparta' carries a complex ironic charge. As 'Sparta,' it stands in an adversarial relationship to 'the Athens of the North,' as Edinburgh likes to deem itself; at the same time, as 'Little' Sparta, it accepts its own reduction in scale, and offers a friendly, almost cosy familiarity. 'How many times,' asks Stephen Bann, do [Finlay's] titles and his works employ the word "little"?' (1972, 13). Sparta, however, remains Sparta, and is quite prepared to fight its battles. Historically, 'Little Sparta' was the name given to the Parisian district of the Cordeliers, one of the strongholds of the Jacobins, by Camille Desmoulins (see Schama 499). Desmoulins, in employing the diminutive, was already an artist to whom one might apply Francis Edeline's charming coinage, 'très finléenne'!

7 Apollo, it should be remembered, carried weapons as well as lyres; so did Apollinaire. The Garden Temple at Little Sparta, which so disconcerts the bureaucrats of Strathclyde Region, is dedicated 'To Apollo His Music His Missiles His Muses.' Various Finlay works have reinterpreted the myth of Apollo and Daphne: she metamorphoses, not into foliage but into foliage-based army camouflage; or, in a rewording of Ovid:

AND EVEN AS SHE FLED
THE REPUBLIC CHARMED HIM
THE WIND BLEW HER GARMENTS
AND HER HAIR STREAMED LOOSE
SO FLEW THE YOUNG REVOLUTIONARY
AND THE SHY REPUBLIC
HE ON THE WINGS OF LOVE
AND SHE ON THOSE OF FEAR
 (*And Even As She Fled* 2, 1987)

(Again, the equation of Apollo with that 'young blade,' Saint-Just.)

8 See also the print (Abrioux 13) in which rows of warplanes on a carrier deck are depicted, with their wings neatly folded, under the title *Lullaby* (1975).

9 To some extent, Finlay courts mis-reading by his use of provocative visual symbols, such as the guillotine and, even more, Nazi emblems such as the lightning-flash double-S of the SS insignia. Some of his critics have argued that the very presence of these emblems visually overpowers any context in which they might be placed, and that any work containing the SS is ipso facto Nazi. This is a terribly simplistic argument, and it has lead to vicious and unfounded personal attacks on Finlay. But it is the unjustifiable overstatement of the difficulty that Finlay himself identifies in the very form of his works.

10 It appeared first in the British magazine *Image*. Its most influential reprint was in Mary Ellen Solt's anthology *Concrete Poetry: A World View* (84). Canadian readers may remember that it also appeared in the first (but not subsequent) edition of Gary Geddes's *20th Century Poetry and Poetics*.

11 Almost certainly Picasso. I have found two possible sources for what Finlay recalls. Gertrude Stein wrote: 'Picasso said once that he who created a thing is forced to make it ugly. In the effort to create the intensity and the struggle to create this intensity, the result always produces a certain ugliness, those who follow can make of this thing a beautiful thing because they know what they are doing, the thing having already been invented, but the inventor because he does not know what he is going to invent the thing he makes must have its ugliness' (Burns 14–17). More directly, there is a 1960 interview, included in Dore Ashton's *Picasso on Art: A Selection of Views*, in which Picasso himself states: 'Moreover, to know that we were doing cubism we should have had to be acquainted with it! Actually, nobody knew what it was. And if we had known, everybody would have known. Even Einstein did not know it either! The condition of discovery is outside ourselves; but the terrifying thing is that despite all this, we can only find what we know' (62–3).

12 This is a good example of what Derrida means by the necessity of putting certain terms 'under erasure.'

13 This is how the phrase appears in the letter as reprinted by Solt. I have no idea why the guillotine card alters the punctuation, and changes 'full of' to 'filled with.'

14 When I first became interested in Finlay's work, in the late 1960s, his major motif was the Scottish fishing boat; and much of my early writing on him extols the homely charms and warm friendliness with which he presented this theme. (And to this day, I cannot walk through Pittenweem harbour

without seeing, all round me, a certain kind of beauty that Finlay taught
me to see.) When the shipping in his work changed from fishing boats to
aircraft carriers, I was greatly disconcerted, and it took me many years to
come to terms with the gods and heroes who retain their arms.

15 Inter-artistic analogy is always difficult, since 'analogy' itself is such a
tricky and shifting concept. See, for instance, Wendy Steiner's whole
discussion of four-term and three-term analogy in *The Colors of Rhetoric*
1–19. So the propositions in this paragraph are put forward more as sugges-
tive points for consideration than as any kind of rigorous theory of analogy.

16 In a letter to me, dated 30 September 1996, Finlay comments: 'In the *Homage
to Modern Art* the yellow and blue triangles are not without "specific
meaning"; the pattern (if not the colours) was taken exactly from a photo of
a barge sail; certain firms (cement firms, brick firms, or whatever) had their
own specific "logos"; it was not an invention of mine. Likewise, as far as I
can remember, it bore a strong resemblance to a painting by Kenneth
Noland ... This is maybe not important but such coincidences and quota-
tions (from the actual world) always please me.'

17 A secondary allusion may be to Magritte's *Ceci n'est pas une pipe*, which has
become a *locus classicus* for the separation between sign and reality. Much
later, in 1992, Finlay also gave a challenging restatement to Magritte's
painting, where the title is attached to an image of a sub-machine gun, in
which the holes along the gun barrel do very much have the appearance of
the stop-holes on a (musical) 'pipe.'

18 Edwin Morgan connects Finlay's 'fondness for a large number (hundreds)
of individual cards and prints with his belief in individual sentences as
against connected discourse.' Morgan quotes one of Finlay's aphorisms –
'Consecutive sentences are the beginning of the secular' – and comments:
'If pre-Socratic gnomic sayings are numinous in a way that most post-
Enlightenment connected philosophical and scientific discourse is not, then
we must refresh ourselves at these antique springs (though in a contempo-
rary manner), [and] rediscover the fact that soul is the wit of brevity' (38).

19 Finlay has exhibited several installations on the theme of the days of
Thermidor, in which a small black ribbon is tied to the spout of the wat-
ering can. Equally, the watering can is connected to Getrude Stein, by way
of Gertrude Jekyll, through the punning inscription 'A rose is a rose is a
rose is a rose.'

20 Is there any finer illustration of what Derrida means by 'supplement' than
the compost heap?

Works Cited

Abrioux, Yves. *Ian Hamilton Finlay: A Visual Primer*. Edinburgh: Reaktion Books 1985

Adams, Ken. 'Orphism.' In Richardson and Stangos 88–95

Adéma, Pierre-Marcel. *Guillaume Apollinaire*. Paris: Le Table Ronde 1968

Alibert, Pierre. *Gleizes: Naissance et avenir du cubisme*. St Etienne: Aubin-Visconti 1982

Andrews, Bruce. 'Writing Social Work & Practice.' In Kostelanetz 1981, 91–4

Apollinaire, Guillaume. *Calligrammes*. Trans. Anne Hyde Greet. Intro. S.I. Lockerbie. Berkeley: U of California P 1980

Arasse, Daniel. *The Guillotine and the Terror*. Trans. Christopher Miller. London: Penguin 1989

Ashton, Dore, ed. *Picasso on Art: A Selection of Views*. New York: Viking 1972

Assouline, Pierre. *An Artful Life: A Biography of D.H. Kahnweiler, 1884–1979*. Trans. Charles Ruas. New York: Grove Weidenfeld 1990

Bal, Mieke, and Norman Bryson. 'Semiotics and Art History.' *The Art Bulletin* 73.2 (June 1991): 174–208

Ball, Hugo. *Flight Out of Time: A Dada Diary*. Ed. John Elderfield. Trans. Ann Raimes. New York: Viking 1974

Bann, Stephen. 'Apollo in Strathclyde.' *Cencrastus: Scottish & International Literature Arts & Affairs* 22 (Winter 1986): 39–42

– 'A Description of Stonypath.' *Journal of Garden History* 1.2 (1981): 113–44. Reprinted as pamphlet by Friends of Stonypath Garden

– *Ian Hamilton Finlay: Engineer and Bricoleur*. Ceolfrith 1970

– *Ian Hamilton Finlay: An Illustrated Essay*. Edinburgh: Scottish National Gallery of Modern Art 1972

– 'Ian Hamilton Finlay: An Imaginary Portrait.' In *Ian Hamilton Finlay* (exhibition catalogue), 7–36. London: Serpentine Gallery 1977

Bann, Stephen, ed. *Concrete Poetry: An International Anthology.* London: London Magazine Editions 1967

Barbour, Douglas, and Stephen Scobie. *The Pirates of Pen's Chance.* Toronto: Coach House P 1981

Barthes, Roland. *The Eiffel Tower and Other Mythologies.* Trans. Richard Howard. New York: Hill and Wang 1979

– *Elements of Semiology.* Trans. Annette Lavers and Colin Smith. London: Jonathan Cape 1967

– *Image-Music-Text.* Trans. Stephen Heath. Glasgow: Collins 1977

– *The Pleasure of the Text.* Trans. Richard Miller. London: Jonathan Cape 1976

Bennington, Geoff. 'Deconstruction and Postmodernism.' In Papadakis, Cooke, and Benjamin 85–7

Berger, John. *The Moment of Cubism and Other Essays.* London: Weidenfeld and Nicholson 1969

Berry, David. *The Creative Vision of Guillaume Apollinaire: A Study of Imagination.* Stanford French and Italian Studies. Saratoga: Anima Libris 1982

Bohn, Willard. 'Metaphor and Metonymy in Apollinaire's Calligrams.' *Romanic Review* 72 (March 1981): 166–81

Bois, Yve-Alain. *Painting as Model.* Cambridge, Mass.: MIT Press 1990

– 'Report from Paris.' *Art in America* 73.5 (May 1985): 37–43

– 'The Semiology of Cubism.' In Zelevansky 1992, 169–208

Braque, Georges. 'The Power of Mystery.' *The Observer*, 1 Dec. 1957, 16

Bretell, Richard B. *Pissarro and Pontoise.* New Haven: Yale UP 1990

Breunig, Leroy C., ed. *Apollinaire on Art: Essays and Reviews, 1902–1918.* Trans. Susan Suleiman. New York: Viking 1972

Bryson, Norman. 'Intertextuality and Visual Poetics.' *Style* 22.2 (Summer 1988): 183–93

– *Looking at the Overlooked: Four Essays on Still Life Painting.* London: Reaktion Books 1990

Bryson, Norman, Michael Ann Holly, and Keith Moxey, eds. *Visual Theory: Painting & Interpretation.* New York: HarperCollins 1991

Burke, Edmund. *A Philosophical Enquiry into the Origin of Our Ideas of the Sublime and Beautiful.* Ed. J.T. Boulton. New York: Columbia UP 1958

Burns, Edward, ed. *Gertrude Stein on Picasso.* New York: Liveright 1970

Butor, Michel. *Les Mots dans la peinture.* Geneva: Skira 1969

Carrier, David. *Artwriting.* Amherst: U of Massachusetts P 1987

Carter, Michael. *Framing Art: Introducing Theory and the Visual Image.* Sydney: Hale & Iremonger 1990

Chipp, Herschel B., ed. *Theories of Modern Art: A Source Book by Artists and Critics.* Berkeley: U of California P 1971

Clark, T.J. *The Painting of Modern Life: Paris in the Art of Manet and His Followers.* New York: Knopf 1985

Cohen, Arthur A., ed. *The New Art of Color: The Writings of Robert and Sonia Delaunay.* Trans. David Shapiro and Arthur A. Cohen. New York: Viking 1978

Compton, Michael, ed. *Towards a New Art: Essays on the Background to Abstract Art.* London: Tate Gallery 1980

Cook, Albert. *Figural Choice in Poetry and Art.* Hanover and London: UP of New England 1985

Cooper, Douglas. *The Cubist Epoch.* London: Phaidon 1971

De Duve, Thierry. *Pictorial Nominalism: On Marcel Duchamp's Passage from Painting to the Readymade.* Trans. Dana Polan with the author. Minneapolis: U of Minnesota P 1991

DeKoven, Marianne. *A Different Language: Gertrude Stein's Experimental Writing.* Madison: U of Wisconsin P 1983

Denis, Maurice. *Théories: Du Symbolisme au classicisme.* Paris: Hermann 1964. My translation.

Derouet, Christian, ed. *Juan Gris: Correspondance, Dessins 1915–1921.* Paris: Centre Georges Pompidou 1991

Derrida, Jacques. *Limited Inc.* Trans. Samuel Weber and Jeffrey Mehlman. Evanston: Northwestern UP 1988

– *Margins of Philosophy.* Trans. Alan Bass. Chicago: U of Chicago P 1982

– *Of Grammatology.* Trans. Gayatri Chakravorty Spivak. Baltimore: Johns Hopkins UP 1976

– *Signéponge / Signsponge.* Trans. Richard Rand. New York: Columbia UP 1984

– *The Truth in Painting.* Trans. Geoff Bennington and Ian McLeod. Chicago: U of Chicago P 1987

Diggory, Terence. 'William Carlos Williams's "The Title" as Apollinaire's "Inner Frame."' *Proceedings of the XIIth Congress of the International Comparative Literature Association.* Munich 1990: 556–61

Drucker, Johanna. *Theorizing Modernism: Visual Art and the Critical Tradition.* New York: Columbia UP 1994

Dubnick, Randa. *The Structure of Obscurity: Gertrude Stein, Language, and Cubism.* Urbana and Chicago: U of Illinois P 1984

Eagleton, Terry. *Literary Theory: An Introduction.* Oxford: Basil Blackwell 1983

Elderfield, John. *The 'Wild Beasts': Fauvism and Its Affinities.* New York: Museum of Modern Art 1976

Fifer, Elizabeth. 'Is Flesh Advisable? The Interior Theatre of Gertrude Stein.' *Signs* 4 (Spring 1979): 472–83

Finlay, Ian Hamilton. For a general note on the citation of Finlay's work, see chapter 9, n. 1.

– 'Letter to Pierre Garnier.' In Solt 84

Finlay, Ian Hamilton, and Ron Costley. *Heroic Emblems*. Intro. and commentaries by Stephen Bann. Calais, Vt.: Z Press 1977

Foucault, Michel. *The Order of Things: An Archaeology of the Human Sciences*. New York: Random House 1973

Frascina, Francis. 'Realism and Ideology: An Introduction to Semiotics and Cubism.' In Charles Harrison, Francis Frascina, and Gill Perry, *Primitivism, Cubism, Abstraction: The Early Twentieth Century*. New Haven and London: Yale UP (in association with The Open University) 1993

Fry, Edward F. 'Convergence of Traditions: The Cubism of Picasso and Braque.' In Zelevansky 1992, 92–106

– *Cubism*. New York: McGraw-Hill 1966

Gamwell, Lynn. *Cubist Criticism*. Ann Arbor: UMI Research Press 1980

Gee, Malcolm. 'Cubisms.' *Oxford Art Journal* 17.2 (1994): 137–9

Golding, John. *Cubism: A History and an Analysis 1907–1914*. 2nd ed. London: Faber 1968

Green, Christopher. *Juan Gris*. New Haven and London: Yale UP 1992

Gris, Juan. 'Notes on My Painting.' In Kahnweiler 194

Hanson, Sten. Untitled statement. In McCaffery and Nichol 47

Harrison, Andrew. 'A Minimal Syntax for the Pictorial: The Pictorial and the Linguistic – Analogies and Disanalogies.' In Kemal and Gaskell 129–80

Heath, Stephen. *Questions of Cinema*. London: Macmillan 1981

Henderson, Brian. 'Radical Poetics.' York University Ph.D. dissertation, 1982

Henderson, Linda Dalrymple. *The Fourth Dimension and Non-Euclidean Geometry in Modern Art*. Princeton: Princeton UP 1983

Herbert, Robert L. *Impressionism: Art, Leisure, and Parisian Society*. New Haven: Yale UP 1988

Higgins, Dick. *George Herbert's Pattern Poems: In Their Tradition*. West Glover, Vt.: Unpublished Editions 1977

Hoffman, Katherine, ed. *Collage: Critical Views*. Ann Arbor: UMI Research P 1989

Hollander, Anne. *Moving Pictures*. New York: Knopf 1989

Holmes, Wendy. 'Decoding Collage: Signs and Surfaces.' In Hoffman 193–212

Hoog, Michel. *R. Delaunay*. Paris: Flammarion 1976. My translation.

Ian Hamilton Finlay: Collaborations. Cambridge: Kettle's Yard Gallery 1977

Innis, Robert E., ed. *Semiotics: An Introductory Anthology*. Bloomington: Indiana UP 1985

Jakobson, Roman. 'Two Aspects of Language and Two Types of Aphasic Disturbances.' In *Selected Writings II: Word and Language*, 239–59. The Hague: Mouton 1971

Jellicoe, Geoffrey, Susan Jellicoe, Patrick Goode, and Michael Lancaster, eds. *The Oxford Companion to Gardens*. Oxford: Oxford UP 1986

Kachur, Lewis. 'Picasso, Popular Music and Collage Cubism.' *Burlington Magazine* 135 (April 1993): 252–60

Kahnweiler, Daniel-Henry. *Juan Gris: His Life and Work*. Trans. Douglas Cooper. Revised ed. New York: Abrams 1969

Kemal, Salim, and Ivan Gaskell, eds. *The Language of Art History*. Cambridge: Cambridge UP 1991

Kostelanetz, Richard, ed. *Aural Literature Criticism*. New York: Precisely 1981

– ed. *Text-Sound Texts*. New York: William Morrow 1980

– ed. *Visual Literature Criticism: A New Collection*. Carbondale and Edwardsville: Southern Illinois UP 1979

Krauss, Rosalind. 'The Motivation of the Sign.' In Zelevansky 1992, 261–86

– 'Re-presenting Picasso.' *Art in America* 68.10 (December 1980): 91–6

Kuspit, Donald. 'Foreword.' In Gamwell, xvii–xxi

– 'Traditional Art History's Complaint against the Linguistic Analysis of Visual Art.' *Journal of Aesthetics and Art Criticism* 45.4 (Summer 1987): 345–9

Lacan, Jacques. *Ecrits: A Selection*. Trans. Alan Sheridan. New York: Norton 1977

Leighten, Patricia. 'Picasso's Collages and the Threat of War, 1912–1913.' In Hoffman 121–70

– *Re-Ordering the Universe: Picasso and Anarchism, 1897–1914*. Princeton: Princeton UP 1989

Leighten, Patricia, ed. 'Revising Cubism.' Special issue of *Art Journal* 47.4 (Winter 1988)

Lemon, Lee T., and Marion J. Reis, eds and trans. *Russian Formalist Criticism: Four Essays*. Lincoln: U of Nebraska P 1965

Lodge, David. *The Modes of Modern Writing: Metaphor, Metonymy, and the Typology of Modern Literature*. Ithaca: Cornell UP 1977

Lyotard, Jean-François. 'Presence.' In Kemal and Gaskell 11–34

McCaffery, Steve. 'Discussion ... Genesis ... Continuity: Some Reflections on the Current Work of the Four Horsemen.' In McCaffery and Nichol 32–6

– *For a poetry of blood*. Published by the author. 1970

– *Intimate Distortions: A Displacement of Sappho*. Erin, Ont.: Porcupine's Quill 1979

– 'Text-Sound, Energy and Performance.' In McCaffery and Nichol 72–3

McCaffery, Steve, and bpNichol, eds. *Sound Poetry: A Catalogue*. Toronto: Underwhich Editions 1978

McCorkle, James, ed. *Conversant Essays: Contemporary Poets on Poetry*. Detroit: Wayne State UP 1990

Markov, Vladimir. *Russian Futurism: A History*. London: MacGibbon and Kee 1969

Martin, Alvin. 'Georges Braque et les origines du langage du cubisme synthétique.' In Monod-Fontaine (1982) 43–56. My translation.

Masheck, Joseph. 'The Carpet Paradigm: Critical Prolegomena to a Theory of Flatness.' *Arts Magazine* 51.1 (September 1976): 82–109

Meyerowitz, Patricia, ed. *Look at Me Now and Here I Am: Gertrude Stein, Writings and Lectures* 1909–1945. Harmondsworth: Penguin 1971

Mitchell, W.J.T. *Picture Theory: Essays on Verbal and Visual Representation*. Chicago and London: U of Chicago P 1994

Monach, Greta. 'Statements: Dated the 16th of July 1978.' In McCaffery and Nichol 23

Monod-Fontaine, Isabelle, ed. *Daniel-Henry Kahnweiler: Marchand, éditeur, écrivain*. Paris: Centre Georges Pompidou 1984

– ed. *Georges Braque: Les Papiers collés*. Paris: Centre Georges Pompidou 1982

Morgan, Edwin. 'Finlay in the 70s and 80s.' In Murray 37–46

Motherwell, Robert, ed. *The Dada Painters and Poets: An Anthology*. New York: Wittenborn 1951

Murray, Graeme, ed. *Ian Hamilton Finlay & the Wild Hawthorn Press*, 1958–1991. Edinburgh: Graeme Murray Gallery 1991

Nesselroth, Peter. 'Literary Identity and Contextual Difference.' In Valdés and Miller 41–53

Neuman, Shirley, and Robert Wilson. *Labyrinths of Voice: Conversations with Robert Kroetsch*. Edmonton: NeWest Press 1982

Nichol, bp. *JOURNEYING & the Returns*. Toronto: Coach House P 1967

– *Translating Translating Apollinaire: A Preliminary Report*. Milwaukee: Membrane Press 1979

Nichol, bp, and Barbara Caruso. *From My Window*. Toronto: Seripress 1978

Orvell, Miles. 'Poe and the Poetics of Pacific.' In *Ian Hamilton Finlay: Collaborations* 17–22

Osborne, Harold. *Abstraction and Artifice in Twentieth-Century Art*. Oxford: Clarendon Press 1970

Owens, Craig. 'Earthwords.' *October* 10 (Fall 1979): 121–30

Papadakis, Andreas, Catherine Cooke, and Andrew Benjamin, eds. *Deconstruction: Omnibus Volume*. New York: Rizzoli 1989

Penrose, Roland, and John Golding, eds. *Picasso in Retrospect*. New York: Praeger 1973

Phillipson, Michael. *Painting, Language, and Modernity*. London: Routledge & Kegan Paul 1985

Poggi, Christine. 'Braque's Early Papiers Collés: The Certainties of Faux Bois.' In Zelevansky 129–49

– *In Defiance of Painting: Cubism, Futurism, and the Invention of Collage.* New Haven and London: Yale UP 1992

Preziosi, Donald. *Rethinking Art History: Meditations on a Coy Science.* New Haven: Yale UP 1989

Prinz, Jessica. *Art Discourse / Discourse in Art.* New Brunswick: Rutgers UP 1991

Reich, Steve. 'Come Out.' Liner notes to *New Sounds in Electronic Music.* Odyssey 3216060

Richardson, John. *A Life of Picasso: Volume I, 1881–1906.* New York: Random House 1991

Richardson, John A. 'On the "Multiple Viewpoint" Theory of Early Modern Art.' *Journal of Aesthetics and Art Criticism* 53 (Spring 1995): 129–37

Richardson, Tony, and Nikos Stangos, eds. *Concepts of Modern Art.* Harmondsworth: Penguin 1974

Richter, Hans. *Dada: Art and Anti-Art.* London: Thames and Hudson 1965

Rickey, George. *Constructivism: Origins and Evolution.* London: Studio Vista 1967

Robbins, Daniel. 'Abbreviated Historiography of Cubism.' In Leighten 277–83

Robson, Ernest. 'The Concept of Phonetic Music.' In Kostelanetz 1981, 111–25

Rosenblum, Robert. *Cubism and Twentieth-Century Art.* New York: Abrams 1966

– 'Picasso and the Typography of Cubism.' In Penrose and Golding, 49–75

Rosenthal, Mark. *Juan Gris.* New York: Abbeville Press 1983

Roskill, Mark. 'Braque's *Papiers Collés* and the Feminine Side of Cubism.' In Zelevansky 1992, 222–39

– *The Interpretation of Cubism.* Philadelphia: Art Alliance 1985

Rubin, William. 'From Narrative to "Iconic" in Picasso: The Buried Allegory in *Bread and Fruitdish on a Table* and the Role of *Les Demoiselles d'Avignon*.' *Art Bulletin* 65.4 (December 1983): 615–49

– 'Pablo and Georges and Leo and Bill.' *Art in America* 67.2 (March–April 1979): 128–47

– *Picasso and Braque: Pioneering Cubism.* New York: Museum of Modern Art 1989

Ruddick, Lisa. *Reading Gertrude Stein: Body, Text, Gnosis.* Ithaca: Cornell UP 1990

Saint-Martin, Fernande. *Semiotics of Visual Language.* Bloomington: Indiana UP 1990

Saussure, Ferdinand de. *Course in General Linguistics.* Ed. Charles Bally and Albert Sechehaye, in collaboration with Albert Riedlinger. Trans. Wade Baskin. New York: McGraw-Hill 1966

Schama, Simon. *Citizens: A Chronicle of the French Revolution*. New York: Knopf 1989

Schapiro, Meyer. 'On Some Problems in the Semiotics of the Visual Arts: Field and Vehicle in Image-Signs.' In Innis 206–25

Schmitz, Neil. *Of Huck and Alice: Humorous Writing in American Literature*. Minneapolis: U of Minnesota P 1983

Scobie, Stephen. 'A Homage and an Alphabet: Two Recent Works by Ian Hamilton Finlay.' In Kostelanetz 1979, 107–13

– *Signature Event Cantext*. Edmonton: NeWest Press 1989

– *Les Toiles n'ont peur de rien*. Edmonton: privately printed 1979

– *Visions of Johanna*. Grand Junction, Colo.: Rolling Tomes 1992

Sears, Dianne E. 'Bracketing Painting: Ponge's Criticism of Braque.' *Dalhousie French Studies* 21 (Fall–Winter 1991): 1–13

Shattuck, Roger. *The Banquet Years*. New York: Vintage 1968

Shiff, Richard. 'Cézanne's Physicality: The Politics of Touch.' In Kemal and Gaskell 129–80

Shklovsky, Victor. 'Art as Technique.' In Lemon and Reis 3–24

Solt, Mary Ellen, ed. *Concrete Poetry: A World View*. Bloomington: Indiana UP 1968

Spate, Virginia. *Orphism: The Evolution of Non-Figurative Painting in Paris, 1910–1914*. Oxford: Clarendon Press 1979

Spies, Werner. 'Vendre des tableaux – donner à lire.' In Monod-Fontaine 1984, 17–44. My translation.

Steegmuller, Francis. *Apollinaire: Poet among the Painters*. New York: Farrar, Strauss and Co. 1963

Stein, Gertrude. *The Autobiography of Alice B. Toklas*. New York: Vintage 1960

– *Lectures in America*. Intro. Wendy Steiner. Boston: Beacon Press 1985

– 'The Life of Juan Gris The Life and Death of Juan Gris.' *transition* 4 (July 1927): 160–2

– 'A Long Gay Book.' In *Matisse Picasso and Gertrude Stein with Two Shorter Stories*. Boston: Something Else Press 1972

– *The Making of Americans: Being a History of a Family's Progress*. New York: Something Else Press 1966

– 'Tender Buttons.' In Meyerowitz, 161–206

Steinberg, Leo. 'The Philosophical Brothel.' *October* 44 (Spring 1988): 7–74

– 'The Polemical Part.' *Art in America* 67.2 (March–April 1979): 114–27

Steiner, Wendy. *The Colors of Rhetoric: Problems in the Relation between Modern Literature and Painting*. Chicago: U of Chicago P 1982

Summers, David. 'Conditions and Conventions: On the Disanalogy of Art and Language.' In Kemal and Gaskell 181–212

Tzara, Tristan. *Seven Dada Manifestoes and Lampisteries.* Trans. Barbara Wright. London: John Calder 1977

Ulmer, Gregory L. *Applied Grammatology: Post(e)-Pedagogy from Jacques Derrida to Joseph Beuys.* Baltimore: Johns Hopkins UP 1985

Valdés, Mario J., and Owen Miller, eds. *Identity of the Literary Text.* Toronto: U of Toronto P 1985

Vallier, Dora. 'Situer Jacques Villon.' In *Jacques Villon,* catalogue to the Villon Exhibition, Rouen and Paris, 1975: 15–35. Paris: Editions des Musées Nationaux 1975. My translation.

Vergo, Peter. 'Music and Abstract Painting: Kandinsky, Goethe and Schoenberg.' In Compton 41–63

Walker, Jayne L. *The Making of a Modernist: Gertrude Stein from Three Lives to Tender Buttons.* Amherst: U of Massachusetts P 1984

Warren, Rosanna. 'Orpheus the Painter: Apollinaire and Robert Delaunay.' In McCorkle 549–63

Williams, Emmett, ed. *An Anthology of Concrete Poetry.* New York: Something Else Press 1967

Will-Levaillant, Françoise. 'La Lettre dans la peinture cubiste.' In *Le Cubisme,* 45–62. Université de Saint-Etienne 1973. My translation.

Zelevansky, Lynn, ed. *Picasso and Braque: A Symposium.* New York: Museum of Modern Art 1992

Zurbrugg, Nicholas. 'Regarding Recorded Literature.' In Kostelanetz 1981, 61–74

Index

absence, 8, 13, 79, 86–8, 91, 101, 103, 118, 122, 124, 149, 184, 203n8. *See also* presence

abstraction, 12, 14, 15, 62, 64–5, 113, 129, 154, 157–8, 185, 196n5, 201n1, 202n8; abstract poetry, 72, 77, 154, 156, 159, 164, 166; non-iconic abstraction, 156–9, 161, 164; semantic abstraction, 156-9, 161, 164

Allard, Roger, 47, 53

Apollinaire, Guillaume, xi, xii, 59, 61, 76, 78, 128–9, 144, 146, 147, 153, 158, 163, 200n3, 211n3, 212n13, 216n7; as art critic, 37–40; role in the naming of Cubism, 40–55. WORKS: *Apollinaire on Art*, 37–8; *Calligrammes*, 73, 74, 136, 210n8, 212n10; 'Les Fenêtres,' 77, 134–42, 212n12; 'Lundi Rue Christine,' 77, 137, 138, 141; *Méditations esthétiques: Les Peintres Cubistes*, 54–5, 137; 'Orphée,' 140–1; 'Zone,' 163

Apollo, 140, 141, 177, 211n3, 216n7

Arp, Hans (Jean), 154, 162

Assouline, Pierre, 38, 41, 49, 60, 61, 201n2

author: authorial intention, 19, 84, 198n22, 198n23, 203n5, 207n30; death of the, 9, 19, 20, 116, 198n23; name of the, 101–2

Bal, Mieke, 7, 196n2, 196n3, 198n19

Ball, Hugo, 74, 153, 154–5, 157, 160, 164, 167, 214n3, 214n9

Bann, Stephen, 146, 147, 148–9, 177, 183, 185, 190, 213n3, 216n6

Barr, Alfred H., Jr, 41–2, 54

Barthes, Roland, 5, 15, 19, 131, 141, 166, 167

Berger, John, 83, 211n7

Berry, David, 139, 141, 142

Billy, André, 135, 137, 138

Birney, Earle, 24–5

Bohn, Willard, 210n8

Bois, Yve-Alain, 61, 63, 86, 88–91, 93–5, 97, 198n19, 201n1, 202n7, 203n6, 204n10, 206n18, 207n32, 209n6

Braque, Georges, xi, xii, 10, 18, 37–8, 40–1, 43, 45, 47, 49, 51, 53, 54, 59,

60, 67–8, 80, 82–3, 84, 94–5, 104,
137, 148, 158, 187, 201n3, 202n9,
203n1, 203n5, 204n14, 205n16,
205n17, 206n19, 206n20, 206n21,
206n22, 206n25, 207n26, 209n6,
211n2, 211n8; compared to
Picasso, 91–4. WORKS: selected
papiers collés, 99–101, 102–3;
Bouteille et instruments et musique,
206n22; *Geometrical Composition*,
202n9; *Houses at L'Estaque*, 82; *La
Guitare*, 95, 111; *La Mandoline*,
206n22; *Le Compotier*, 94; *Le
Portugais*, 96–7, 98, 204n14; *Nature
morte à la guitare*, 95; *Nature morte
BACH*, 206n21; *Table with pipe*,
203n1; *The Violin*, 102, 206n22;
Violin and Pitcher, 102
Bretell, Richard R., 29, 30, 197n11
Bryson, Norman, 7, 124, 196n2,
196n3, 197n15
Burke, Edmund, 173–4

Cage, John, 162–3
Carrier, David, 5–6
Caruso, Barbara, xi, 143, 212n13.
 WORKS: *From My Window*, 143–4
Cendrars, Blaise, xii, 74, 211n4
Cézanne, Paul, 10, 39, 40, 44, 51, 68,
83, 84, 92, 158, 185, 198n17,
198n20, 204n14; Gertrude Stein's
discussion of, 11–16
collage, 77, 87–8, 94, 98, 111, 137,
209n4. *See also* papiers collés
Concrete Poetry, ix–xii, 67, 68, 72–4,
77, 98, 136, 145–7, 148, 150–2, 180,
181, 182–3, 187, 195n1, 212n10,
213n2, 213n3. *See also* sound
poetry
Cooper, Douglas, 44, 54, 81

Cubism, ix–xii, 14, 31, 59, 79, 104,
109, 113, 126, 148, 150, 152, 156,
158, 180, 182–3, 187, 195n1, 195n3,
200n7, 204n14; critical approaches
to, conceptual, 63, 67, 77, 79–82;
—, relativist, 80, 82–4; —, semio-
logical, 88–91, 94; —, semiotic, 79,
84–91, 93–5; Kahnweiler on, 62–8;
naming of, 40–56; subclassifica-
tions of, analytical, 53, 86, 88, 103,
110–12, 113, 187, 201n9, 209n4; —,
instinctive, 51–4; —, kinetic, 54;
—, Orphic, 51–2, 128; —, physical,
51–2; —, rococo, 54; —, scientific,
51–2; —, synthetic, 39, 53–4, 86,
95, 110–12, 113, 201n9, 209n4. *See
also* Cubist poetry; Salon Cubists
Cubist poetry, 16, 76–8, 104–5, 110,
112–13, 122–3, 136–7, 182–3

Dada, xi, xii, 74, 83, 138, 147, 154,
160, 162
Da Vinci, Leonardo, 49, 50, 125, 134.
 WORKS: *Mona Lisa*, 22–4
Degas, Edgar, 26. WORKS: *Dancer in
Her Dressing Room*, 27–8
DeKoven, Marianne, 107, 208n2
Delaunay, Robert, xi, 39, 42, 44, 45,
48, 50, 52, 54, 65, 125, 128, 130–4,
135–6, 137, 138, 139–40, 142, 147–
8, 158, 200n6, 211n3, 211n4,
212n13. WORKS: *Les Fenêtres*
(series), xi, 130, 132–4; *Ville de
Paris*, 48
Delaunay, Sonia, 52, 74, 129, 134,
211n4
Denis, Maurice, 14, 62, 157–8, 185,
214n6
Derain, André, 40, 51, 53, 54, 58, 59,
60, 200n5. WORKS: *Baigneuses*, 51, 58

Derrida, Jacques, ix, 3, 5, 17, 69, 70, 107, 116, 121, 149, 168, 195n1, 197n8, 197n12, 211n2, 217n12, 219n20; on parergon (frame), 6, 36, 127–8, 133, 134, 137; on signature, 101–2; on supplement, 8–9

desire, 6, 8, 10, 122, 167

distortion (constructivist/expression-ist), 65–7, 92, 132, 202n10, 214n9

Drucker, Johanna, 7, 26–7, 28, 196n6, 198n21

Dubnick, Randa, 110, 113, 116, 123, 209n4

Duchamp, Marcel, 23, 40, 48, 83, 129, 198n20, 199n2

Dylan, Bob, 22–4, 199n2

ekphrasis, 24–5

Elderfield, John, 51, 160

Eliot, T.S., 21, 107, 148, 156

Fauvism, 35, 45, 46, 51, 53, 129, 183; Finlay's distinction Fauve/ Suprematist, 67, 148, 180, 182

Fennollosa, Ernest, 69, 72

Finlay, Ian Hamilton, ix, xii, 67, 74, 76, 78, 136, 148, 149, 151–2, 169–94, 197n14, 202n11, 202n14, 213n1, 213n3, 215n1, 216n5, 216n6, 216n7, 217n9, 218n14, 218n16, 218n17, 218n18, 218n19. LETTERS: to Pierre Garnier, 180–1, 182; to Stephen Scobie, xii, 187, 202n11. WORKS: 'Analytical Cubist Portrait' (figure 6), 187–8; Emblem (1984; figure 3), 175–6; *Evening Will Come* (figure 7), 191–3; *4 Baskets*, 172–3, 179; *4 Blades*, 171–2, 179; *Four Mono-stichs*, 179; *Heroic Emblems*, 178;

Homage to Kahnweiler (figure 5), 185–7; *Homage to Malevich* (figure 4), 183–5; *Homage to Modern Art*, 185; *Homage to Pop Art*, 185; *Homage to Seurat*, 185; *Homage to Vuillard*, 185; *Lullaby*, 217n8; *Lyre*, 176; 'A model of order ...' (figure 1), 169–71, 180, 181–2; 'Order Is Repetition,' 182; 'Pacific,' 178; *Picturesque*, 188–9; 'A Proposal for the Celebration of the Bicentenary of the French Revolution,' 175; *Rhymes for Lemons*, 202n14; 'See POUSSIN Hear LORRAIN,' 190–1; 'Sublime,' 173; *Two Landscapes of The Sublime* (figure 2), 173–4; 'Unconnected Sentences on Gardening,' 189

frame, 3–4, 6–7, 9, 10, 13, 19, 20, 36, 57, 91, 95, 124–8, 132, 133–4, 137–8, 139, 140, 142–3, 191, 211n2, 211n8

Freud, Sigmund, 18, 23, 83, 121, 122

Fry, Edward, 53, 205n16, 205n18, 207n32

Futurism, 50, 52, 132, 147, 156, 164, 214n2, 214n9

gaze, 5, 22, 28-30, 125, 132, 199n6

Gee, Malcolm, 89, 206n23

Gleizes, Albert, 40, 41–2, 43–5, 48, 50, 54, 55, 82, 137. See also Metzinger, Jean

Golding, John, 51, 80, 96, 98, 206n25

Gomringer, Eugen, 136, 145, 146

Green, Christopher, 100, 137, 201n9, 202n15

Greenberg, Clement, 7, 35–6

Gris, Juan, ix, xi, xii, 14–15, 48, 49, 54, 55, 57, 59, 60, 61, 65, 68, 75–6, 100,

112, 120, 148, 154, 158, 185–7, 192,
200n1, 201n9, 202n15, 209n5

Hausmann, Raoul, 74, 164
Heath, Stephen, 125, 199n6
Henderson, Brian, 160–1, 168, 214n3
Herbert, Robert L., 26–9
Hollander, Anne, 29–31

Impressionism, 25, 35, 64, 158, 183

Jacob, Max, 59, 61, 76–7
Jakobson, Roman, 105–6, 108, 109,
110–11, 114, 120, 148, 212n12
Jandl, Ernst, 145–6
Joyce, James, xii, 67, 107, 162–3

Kahnweiler, Daniel-Henry, ix–xii, 38,
40, 41, 42, 49, 57–8, 79, 81, 92, 97,
112, 132, 166, 185–8, 201n1, 201n2,
201n3, 201n4, 201n5, 201n6, 202n8,
202n10, 202n11, 202n14, 202n15,
214n9; biography, 58–61; on
painting, 62–8; on writing, 68-78.
WORKS: Confessions esthétiques, 61;
Der Weg zum Kubismus (The Rise of
Cubism), 54, 59, 61; Juan Gris: His
Life and Work, xii, 61, 62–78, 187
Kandinsky, Wassily, 157, 158, 160,
168
Kostelanetz, Richard, 159–60, 166,
215n10, 215n11
Krauss, Rosalind, 31, 87–8, 91, 93,
203n6, 207n30
Kroetsch, Robert, 107, 114
Kupka, Frantisek, 48, 129, 158, 200n6
Kuspit, Donald, 16–19, 35

Lacan, Jacques, 8, 18, 122, 210n9
language, 3–7, 10–11, 18, 21, 23–4, 36,

57, 62–3, 69–70, 73, 80, 85, 87, 105–
6, 122, 123, 127, 141, 144, 147, 149,
154, 159, 163–4, 165, 166–7, 168,
180, 182–3, 184, 191, 195n2, 196n5,
197n16, 203n7, 214n7
Laurencin, Marie, 40, 44, 45, 47, 52,
53, 54, 59, 137
Léger, Fernand, 40, 41, 42, 44, 45, 47,
129, 137, 195n4, 200n6, 201n3
Leighten, Patricia, 99, 203n3, 207n31
Lévi-Strauss, Claude, 107, 148–9
'linguistic imperialism,' 5, 9, 11, 24,
34, 87, 105, 141, 191
Lockerbie, S.I., 136, 141, 212n13
Lodge, David, 108–10, 113, 116–17,
123, 150

McCaffery, Steve, 163, 167
Malevich, Kasimir, 65, 157, 158, 181,
183–5
Manet, Edouard: WORKS: A Bar at the
Folies-Bergère, 28–9, 32; Chez la
Père Lathuille, 26–7
Martin, Alvin, 102, 204n14, 205n17
Matisse, Henri, 40–1, 51, 59, 133,
162
metaphor, 4–5, 8, 75, 80, 85, 91, 125,
192, 202n15, 205n18, 209n6,
212n12; metaphor and metonymy,
104–23, 148, 150, 209n3, 210n8,
214n6; metonymy, 125, 131, 143,
150, 208n1
metonymy. See metaphor
Metzinger, Jean, 40, 41–2, 43–6, 48,
49, 55, 137; WORKS: Du 'Cubisme'
(with Albert Gleizes), 49–50, 54–5
Mitchell, W.J.T., x, 7, 10, 196n5,
198n18, 199n6
modernism, x, 7, 69, 73, 76, 79, 106–
8, 131, 138, 147–8, 150, 151, 152,

185, 196n5, 196n6. *See also*
postmodernism
Monach, Greta, 155–7
Morgan, Edwin, 146, 181–2, 218n18
museum, 7, 10, 18–19, 20, 22–3, 35, 102
music, 3, 4, 7–8, 9, 48, 74, 79, 100, 148,
155–6, 157, 159, 161, 166
muteness, 10–11, 12, 15, 20–1, 105,
123

narrativization, 22–34, 153
Nesselroth, Peter W., 136, 138
Nichol, bp, ix, xi, 67, 74, 107, 146,
150, 210n11, 214n9. WORKS: *From
My Window* (with Barbara Caruso),
142–4; 'I Dreamed I Saw Hugo
Ball,' 153; *The Martyrology*, 150,
213n3; *Translating Translating
Apollinaire*, 163; 'You are city hall
my people' (Lament for d.a. levy),
161
non-figurative art, 12, 15, 64–5, 72,
129, 130, 156, 158, 214n5. *See also*
abstraction

Orphism, 52, 54, 128–9, 139, 140–1,
158, 200n6
Osborne, Harold, 154, 156–7, 158,
159, 161, 163, 214n5

papiers collés, 89, 93, 95, 98, 99–100,
102–3, 111, 203n3, 206n19, 206n20,
206n21
parergon, 6, 36, 127–8, 137, 138, 142.
See also frame
Pater, Walter, 8, 23, 157, 177
Peirce, Charles Sanders, 84–5, 87, 88,
91, 96, 204n13
perspective, 28, 47, 49, 66, 75, 80–2,
110, 125–6, 158, 183

Phillipson, Michael, 10, 107, 197n8,
198n19, 209n3
Picabia, Francis, 40, 129, 137
Picasso, Pablo, 19, 20, 30, 38–9, 41, 42,
43, 44, 45, 47, 48, 49, 53, 57, 59, 60,
61, 65, 67, 74, 80, 84, 88–9, 95, 98,
99, 101, 102, 103, 113, 120, 123,
137, 148, 158, 162, 187–8, 197n10,
198n21, 198n22, 198n23, 201n1,
201n3, 203n1, 203n3, 204n14,
205n16, 206n21, 206n23, 207n29,
207n30, 207n31, 207n32, 208n35,
208n37, 208n39, 209n4, 209n6,
210n7, 217n11; compared with
Braque, xi, 91–4. WORKS: *The
Aficianado*, 203n1; *The Architect's
Table*, 97–8; *Bottle on a Table*, 90;
Les Demoiselles d'Avignon, 31–4,
51, 58; *Man with a Pipe*, 187; *Por-
trait of Daniel-Henry Kahnweiler*,
67, 187; *Table with Bottle, Wine-
glass, and Newspaper*, 98–9; *Table
with Guitar*, 203n1
Pignatari, Decio, 136, 146, 213n1
Poggi, Christine, 90, 95, 206n20,
206n21
postmodernism, 16, 106–7, 108, 147,
148, 149, 150–2, 178, 195n2, 208n2.
See also modernism
post-structuralism, 5, 16–17, 19, 84,
106–7, 149, 152, 196n3, 198n19,
204n11. *See also* structuralism
Pound, Ezra, 69, 72, 146, 148, 213n1,
213n3
Poussin, Nicolas, 83, 172, 176, 190–1
presence, 9, 12, 17, 18, 28, 70, 86, 87,
101, 122, 138, 149, 167–8, 184,
196n7. *See also* absence
Preziosi, Donald, 16, 20
Princet, Maurice, 49, 84, 200n5

Reich, Steve, 161
Repton, Humphry, 188–90, 192
Reverdy, Pierre, xii, 38, 50, 59, 76–7, 78
rhymes, 75–6, 112–13, 120, 141, 192, 202n14, 202n15, 205n18, 209n5
Richardson, John, 19, 197n10, 198n22
Robbins, Daniel, 41–2
Robespierre, Maximilien, 171–2, 185, 190
Rosenblum, Robert, 82–4, 98, 203n3
Roskill, Mark, 93, 99, 102, 204n14, 207n32, 208n40
Rousseau, Henri, 39, 44
Rubin, William, 31, 33–4, 92, 93, 97, 204n14
Ruddick, Lisa, 115, 209n4

Saint-Martin, Fernande, 5
Saint-Just, Louis Antoine de, 148, 171, 177, 185, 190, 216n7
Salmon, André, 36, 55, 200n1, 201n3
Salon Cubists, 41–2, 44, 46
Saussure, Ferdinand de, 4, 5, 15, 84, 85, 86–7, 91, 94, 123, 149, 184, 191, 196n3, 203n5, 203n6, 204n10, 204n13, 209n6
Schapiro, Meyer, 126, 143
Schwitters, Kurt, 74, 164, 214n9
Sears, Dianne E., 208n38, 211n8
Section d'Or, La, 48–50, 51, 52, 53, 54, 55
Seurat, Georges, 39, 185, 211n8
Shattuck, Roger, 147–8
Shenstone, William, 189
Shklovsky, Victor, 72, 97
sign, 7, 11, 13–14, 63, 69–72, 73–4, 77, 79, 80, 88–91, 94–5, 96, 97, 99, 103, 111, 113, 145, 149, 151, 184, 191, 196n2, 196n3, 203n8, 204n13,

206n21, 206n23, 206n25, 207n28, 209n6; Peirce's classification of, 84–6; Saussure's definition of, 86–7
signature, 101–3, 138, 139, 140–2, 162, 190–1, 208n36, 208n37, 208n38, 211n2
simultanism, 129–31, 147–8
Solt, Mary Ellen, 146, 150, 217n10
sound poetry, 74, 145, 151, 155–68, 214n2, 214n9, 215n11
Spate, Virginia, 129, 132, 200n6
Spies, Werner, 62, 68
Steegmuller, Francis, 37–8
Stein, Gertrude, ix, xi, xii, 44, 59, 67, 77–8, 95, 98, 104–23, 153, 162, 185–7, 197n10, 208n2, 209n4, 210n9, 212n12, 217n11, 218n19. WORKS: *The Autobiography of Alice B. Toklas*, 39, 61, 121; 'The Life of Juan Gris The Life and Death of Juan Gris,' 185–7; *A Long Gay Book*, 108, 109, 114–16, 117–21; *The Making of Americans*, 108, 110, 114–15; *Painted Lace and Other Pieces*, 201n5; 'Pictures,' 11–15; *Tender Buttons*, 16, 108, 109, 110, 116–17, 118, 119, 121; *Three Lives*, 108
Steinberg, Leo, 30, 92, 93, 198n23, 199n8, 204n14, 205n15. WORKS: 'The Philosophical Brothel,' 31–4
Steiner, Wendy, xi, 24, 85–6, 148, 195n1, 196n3, 218n15
structuralism, 5, 17, 84, 90, 94, 106–7, 148–9, 152, 196n3, 204n11. *See also* post-structuralism
Sublime, 173–5, 176, 177–8, 182, 189, 216n5
supplement, 3, 7, 8–9, 10–11, 13, 15,

18, 20–1, 22, 24, 35, 36, 57–8, 72, 78, 80, 89, 90, 104, 123, 126–8, 133, 142, 150, 153, 154, 168, 180, 182, 183, 190–1, 192, 195n1, 197n8, 197n16, 203n7, 219n20
Suprematism, xii, 67, 148, 157, 180, 182, 183–4
Surrealism, 62, 75, 109–10, 117, 138, 139, 150, 202n10
syntax, 5, 13, 73–4, 77, 90, 98, 106, 108–12, 116, 136, 147, 156, 180, 182–3, 204n12

text-sound, 166, 215n10
Toklas, Alice B., 118, 120–2, 207n30
Tzara, Tristan, 154, 162, 165–6

Vallier, Dora, 41, 44, 45, 48–9, 52–3, 200n4
Vauxcelles, Louis, 35, 36, 40–1, 42, 43, 45, 47, 53, 59, 200n1, 200n7
Villon, Jacques, 48–9, 52, 200n4
Vlaminck, Maurice, 40, 51, 53, 58, 59
Vuillard, Edouard, 133, 185

Walker, Jayne L., 110–11, 112, 113, 114, 116, 117, 123, 162, 208n2, 209n4
Warren, Rosanna, 40, 141
Will-Levaillant, Françoise, 96, 97, 207n26

zaum, 164–5, 214n9

Da...

SEP 24 2007

PRINTED IN U.S.A. CAT. NO. 24 161